EXHIBITING

Smithsonian

Institution

Press

Washington

and London

EXHIBITING CULTURES

This book
was published
in cooperation with
the American
Association of
Museums.

The Poetics

and Politics

of Museum

Display

Edited by

Ivan Karp and

Steven D. Lavine

CULTURES

The introduction to this book first appeared as "Museums and Multiculturalism: Who Is in Control?" in *Museum News*, March/April 1989, copyright © 1989 by the American Association of Museums. All rights are reserved. Reprinted with permission.

A portion of chapter 17 first appeared as "Making Exhibitions Indian: Aditi and Mela at the Smithsonian Institution," in Michael Meister, ed., *Making Things in South Asia: The Role of Artists and Craftsmen,* copyright © 1988 by the South Asia Regional Studies Program, University of Pennsylvania, Philadelphia. Reprinted with permission.

Chapter 20 copyright © 1990 by Barbara Kirshenblatt-Gimblett.

All other rights are reserved.

Designed by Linda McKnight.
Edited by Susan Warga.
Production editing by Rebecca Browning.

Library of Congress Cataloging-in-Publication Data
Exhibiting cultures : the poetics and politics of museum display /
 edited by Ivan Karp and Steven D. Lavine.
 p. cm.
 Based on papers presented at a conference entitled 'Poetics and Politics of Representation,' held at the International Center of Smithsonian Institution, Sept. 26-28, 1988; sponsored by the Rockefeller Foundation and other institutions.
 ISBN 1-56098-020-6 (cloth).—ISBN 1-56098-021-4 (paper)
 1. Exhibitions—Evaluation—Congresses. 2. Museum techniques—Evalution—Congresses. 3. Museums—Public relations—Congresses. 4. Culture diffusion—Congresses. 5. Museums—Educational aspects—Congresses. I. Karp, Ivan. II. Lavine, Steven, 1947– . III. Rockefeller Foundation.
AM151.E94 1991
069'.5—dc20 90-10188

British Library Cataloging-in-Publication Data is available.

Manufactured in the United States of America.
5 4 3 2 1
95 94 93 92 91

∞ The paper used in this publication meets the minimum requirements of the American National Standard for Permanence of Paper for Printed Library Materials Z39.48-1984.

On the cover and title page: *Aboriginal dancers at the opening ceremonies of the Commonwealth Games, Brisbane, Australia, 1982.* Photo by Eckhard Supp. Reproduced by permission of the photographer.

Contents

Acknowledgements

The essays in this volume were first presented at a conference entitled The Poetics and Politics of Representation, held at the International Center of the Smithsonian Institution 26–28 September 1988. This was the first of two conferences on the presentation and interpretation of cultural diversity in museums; the essays from the second conference, Museums and Communities, will be published in a separate volume. Both conferences were sponsored by the Rockefeller Foundation and, at the Smithsonian Institution, by the International Directorate, the Offices of the Assistant Secretaries for Museums and Research, and the National Museum of Natural History and its Department of Anthropology. We thank these institutions for their generous support.

At the Rockefeller Foundation, Alberta Arthurs, director for Arts and Humanities, encouraged this project from its inception; Ellen Buchwalter, Rose Marie Minore, and later Tomas Ybarra-Frausto provided patient logistical assistance and advice throughout.

At the Smithsonian Institution, Robert McC. Adams, Francine Berkowitz, David Challinor, Tom Freudenheim, Elaine Heumann Gurian, Robert Hoffmann, John Reinhart, and Ross Simons aided the project in all its phases. Christine Helms worked with us on the conception of the project and in its initial phases. Robert Leopold and

Susan Ruder took on the responsibilities of seeing that the conference ran smoothly.

For opening their museums for special sessions of the conference we thank Milo Beach, director of the Arthur M. Sackler Gallery; Roger Kennedy, director of the National Museum of American History; and Sylvia Williams, director of the National Museum of African Art.

Throughout we have benefited from the advice of scholars and museum professionals, many of whom participated in planning sessions as well as in the conference. In addition to the authors in this volume (who also contributed to the volume's final design), these include JoAllyn Archambault, Mary Jo Arnoldi, Ken Brecher, Bernard Cohn, Francis Deng, Zahava Doering, Michael Fischer, Neil Harris, Mary Huber, Adrienne Kaeppler, Corinne Kratz, Gary Kulik, Doran Ross, Roy Sieber, Kathy Dwyer Southern, and Michael Spock.

Daniel Goodwin of the Smithsonian Institution Press guided our preparation of this book, and Susan Warga graciously edited the individual papers that form this collection of essays. Kathy Dwyer Southern of the American Association of Museums forged the link between her organization and the Smithsonian Institution Press, the copublishers of this volume.

Ivan Karp wishes to thank the present and past directors of the National Museum of Natural History, Frank Talbot and Robert Hoffmann, and the present and past chairs of the Department of Anthropology, Donald Ortner and Adrienne Kaeppler, for enabling our project to go forward. Steve Lavine gratefully acknowledges Judy McGinnis for facilitating his move from the Rockefeller Foundation to the California Institute of the Arts; Alberta Arthurs for encouraging the development of a museums program at the Rockefeller Foundation; and Janet Sternburg, his wife and collaborator in every undertaking. Finally, we thank Christine Mullen Kreamer, who made everything happen, accepted few of our compromises, and made this a better volume through her own special knowledge of the arts and museum exhibits.

Introduction:
Museums and
Multiculturalism

STEVEN D. LAVINE AND IVAN KARP

Every museum exhibition, whatever its overt subject, inevitably draws on the cultural assumptions and resources of the people who make it. Decisions are made to emphasize one element and to downplay others, to assert some truths and to ignore others. The assumptions underpinning these decisions vary according to culture and over time, place, and type of museum or exhibit. Exhibitions made today may seem obviously appropriate to some viewers precisely because those viewers share the same attitudes as the exhibition makers, and the exhibitions are cloaked in familiar presentational styles. We discover the artifice when we look at older installations or those made in other cultural contexts. The very nature of exhibiting, then, makes it a contested terrain.

In the United States at this historical moment, especially given the heightened worldwide interest in multicultural and intercultural issues, the inherent contestability of museum exhibitions is bound to open the choices made in those exhibitions to heated debate. Groups attempting to establish and maintain a sense of community and to assert their social, political, and economic claims in the larger world challenge the right of established institutions to control the presentation of their cultures. They challenge exhibitions that overlap with their concerns, demand real power within existing institutions, and

establish alternative institutions. Inevitably, even those curators and museum directors who respond to these concerns find themselves in difficult territory, fearful of the passion of the debates and often insufficiently aware of the unconscious assumptions that underlie their own exhibitions. Their efforts, moreover, are compromised by the complex interactions of competing parties and interests that exist in any museum.

The Te Maori exhibition from New Zealand's Maori people, organized by the Metropolitan Museum of Art in 1984, provides a good example. The organizers of the exhibition consulted with Maori elders to secure consent for their *taonga* (treasures) to travel. Because all but one of the *taonga* already were the property of museums, this process was not strictly necessary, but rather reflected the feeling among white, middle-class New Zealanders that their identity was traceable to the Maori and that the Maori still had a spiritual right to the *taonga*. The ultimate effect of the consultation was to increase awareness among the Maori of the status of their *taonga* as art objects and to focus their attention on the ways in which their culture was presented in museums. Tensions rose especially over the ethnological and historical background provided in the exhibition catalogue, which the Maori elders considered pure nonsense.

In the wake of the exhibition, pressures have mounted in New Zealand for the development of procedures and institutions that will allow the Maori to define their own heritage. The question now, as researcher Adrienne Kaeppler has suggested in an unpublished paper, is how imaginative museums in New Zealand will be in response to the situation: "Are Maoris and their heritage to be considered separate from . . . other Pacific islanders who make New Zealand their home? Will museums be on the forefront of cultivating new kinds of identity and educating the population about them? . . . Should they echo the political climate or should they be a force for change?"[1] Such questions, difficult though they are, are inevitable.

Decisions about how cultures are presented reflect deeper judgments of power and authority and can, indeed, resolve themselves into claims about what a nation is or ought to be as well as how citizens should relate to one another. As Kaeppler notes in her paper, sometimes it is easier to understand the political and social implications of such decisions when one looks at the museums of other cultures. Fiji, for example, has dedicated itself to pluralism, but intermarriage is discouraged and there is no framing ideology of the "melting pot."

Directly expressing these assumptions is the fact that the majority of the Fiji Museum's exhibitions are Fijian, with only occasional exhibitions devoted to the large Chinese and Indian populations. In contrast, Papua New Guinea, which is home to more than seven hundred linguistic and ethnic groups, has made the forging of a shared national identity a national objective. Consequently, exhibitions in that country deliberately highlight continuities across cultures, showing, for example, similarities in pottery made by different ethnic groups.

It is much more difficult to uncover these connections within more familiar cultural settings. In recent years, however, there has been a series of incisive readings of both historical and current exhibitions in European and American museums. Carol Duncan and Alan Wallach have analyzed the architecture, decoration, and art-historical arrangement in what they call universal survey museums—the Louvre, the Metropolitan Museum of Art, and so on—and conclude that these elements create rituals of citizenship. They argue that together, these elements "claim the heritage of the classical tradition for contemporary society and equate that tradition with the very notion of civilization itself," all as part of the process of legitimating the modern state.[2] The new Musée d'Orsay in Paris was met with a wide array of analyses, all of which assumed that the construction put on the art must be accounted for on social and political as well as aesthetic grounds. Perhaps the most compelling analysis to date is Donna Haraway's reading of the Akeley African Hall and the Theodore Roosevelt Memorial at the American Museum of Natural History in New York. Haraway relates both the taxidermal preservation of the animal specimens and the iconography of the memorial to the era's concern with eugenics and conservation, the need to find "a prescription to cure or prevent decadence, the dread disease of imperialist, capitalist and white culture."[3]

Writing in 1971, Duncan Cameron usefully distinguished between two distinct museum-related stances, the traditional one of the museum as temple and a newer one of the museum as forum. As temple, he wrote, the museum plays a "timeless and universal function, the use of a structured sample of reality, not just as a reference but as an objective model against which to compare individual perceptions." In contrast, as forum, the museum is a place for "confrontation, experimentation, and debate."[4] Twenty years ago it still was credible to assert the possibility of the temple role, but now few serious museum practitioners would claim that a museum could be anything but a forum

(although exhibitions themselves often have failed to reflect this changed view). Nor have we thought carefully enough about who participates in the forum.

In art museums, a modified version of universalist aesthetics still persists. Curators rely on their eye, taste, and experience as the final arbiter in making judgments about what to collect and what to exhibit. But even in this context, curators often assert that theirs is only one of many possible points of view and that exhibitions done from other perspectives can be equally valid.

Perhaps the forumlike nature of the art museum is most clearly expressed in the increasing complexity of activity that confronts the museum visitor—from shops and restaurants to galleries, lectures, and performances. The story of Western art, which once was the central experience of the museum, now is complicated by the addition of arts from non-Western traditions and from minority cultures in the United States.

Despite the increasing diversity incorporated in art museums, curators and exhibition designers still are struggling to invent ways to accommodate alternative perspectives. This is especially true where exhibitions go beyond the individual artist and make some claim to present a culture or group. The enthusiastically received but much-debated exhibition Hispanic Art in the United States provides a helpful example. The curators, John Beardsley and Jane Livingston, set out to redress what they saw as an underestimation of Hispanic artists in discourse about and the market for contemporary art. Although they recognized that their subject matter was defined by such social criteria as the content of the art and the ethnic identity of the artists, the curators chose to select works whose quality was defined in relation to contemporary American art practice generally.

Within this framework, Beardsley and Livingston's exhibition strategy reflects good current thinking about the nature of pluralism within ethnic groups and the relation between art and ethnicity. Particularly valuable is their direct challenge to the idea that as artists approach the realm of high art, the elements of ethnicity in their work inevitably disappear. Indeed, the curators argue in the catalogue that "ethnicity, along with other forms of regional or cultural particularity, can now be perceived as one of the primary ingredients in the alchemy that is good art."[5] In identifying artists who might be included in the exhibition, the curators consulted extensively with professionals concerned with Hispanic art; the host institution, the Museum of Fine Arts, Houston, undertook the project as the beginning of a long-term

process of building a stronger bridge to local Hispanic communities. A committee of fifty Hispanic community leaders was organized and has been maintained subsequently.

The exhibition has been successful in achieving Beardsley and Livingston's central goal: a general audience not previously well acquainted with Hispanic artists has been introduced to their work. Even commentators who have been critical on other grounds have not quarreled with the quality of the selections. But Livingston and Beardsley have been criticized for the inadequacy of the exhibition's presentation of the history, range, and social and aesthetic goals of Hispanic artists (and, by inference, of Hispanic culture).

Specific criticisms of the exhibition have fallen into three general categories: (1) that by omitting murals and installations, the exhibition underestimates the overt political dimension of contemporary Hispanic art; (2) that the selections favor folkloric and "primitivistic" work, thereby displaying a naive understanding of the interaction of art and ethnic concerns; and (3) that the exhibition format strips the work of the linkage to the social arena that is fundamental to Hispanic art. Finally, some of the Hispanic art professionals consulted during research for the exhibition objected to the final result. They maintained that although their research and long commitment provided much of the basis for the exhibition, the authority granted to mainstream institutions such as the Museum of Fine Arts, Houston, made it almost inevitable that the power and resources to do the exhibition would end up in the hands of non-Hispanic institutions and non-Hispanic curators.

To each of these criticisms, Beardsley and Livingston have reasoned responses. Murals and installations cannot travel easily, and in any case, the exhibition is filled with images from which political and social implications can be drawn. The apparent emphasis on folkloric material is the result of how the show was mounted, with the more culturally idiomatic images displayed early as a way to make a diverse body of work intelligible. And some artists preferred that their work be judged without reference to their ethnic origins, but rather by the standards of mainstream cultural institutions.

The larger point, however, is that no matter how the exhibition was organized, it would have been disputed. The subject matter inevitably was open to multiple responses, based on the cultural assumptions of the curators and the viewers. Museums attempting to act responsibly in complex, multicultural environments are bound to find themselves enmeshed in controversy. Only when as a society we have

achieved sufficient opportunity for art and artifacts of "other" cultures to be seen can we expect this kind of controversy to become less heated. Now an exhibition often bears the burden of being representative of an entire group or region. With multiplied opportunities, each exhibition will be just one assertion in an ongoing discussion.

In the meantime, the museum world needs movement in at least three arenas: (1) the strengthening of institutions that give populations a chance to exert control over the way they are presented in museums; (2) the expansion of the expertise of established museums in the presentation of non-Western cultures and minority cultures in the United States; and (3) experiments with exhibition design that will allow museums to offer multiple perspectives or to reveal the tendentiousness of the approach taken.

In the first arena, significant progress has occurred during the past two decades. The first generation of museums dedicated to the work of African American and Hispanic artists, such as the Studio Museum in Harlem, the Museum of the National Center of Afro-American Artists in Boston, and El Museo del Barrio in New York, have weathered difficult times and established impressive records of accomplishment. Newer museums, such as the Mexican Museum in San Francisco and the Museum of Contemporary Hispanic Art in New York, have been inspired by their example.

Generally poorly funded and operating on a limited scale, these and smaller institutions identified with other minority populations in the United States have demonstrated an ability to identify heretofore unrecognized materials and issues, to serve nontraditional audiences, and—at their best—to suggest new possibilities for exhibition design. Two examples drawn from Native American museums are the Kwagiulth Museum and Cultural Centre in Cape Mudge Village, British Columbia, which exhibits material in conventional glass cases but arranges it according to original family ownership (an entirely new conceptual base for most non-Indian viewers), and the U'mista Cultural Centre in Alert Bay, British Columbia, which displays artifacts in a traditional big house and arranges them in the sequence of their appearance in the potlatch ceremony.

Not even the exhibitions mounted by these museums, however, can escape contestation. They face charges about who has the right to control the exhibition and how cultural and community identities are to be defined within it. The assumptions on which their exhibitions are organized are perceived as limited, and serious questions are raised

about the omission of diverse perspectives. Still, they are helping to expand our sense of the possibilities inherent in exhibition design and in the reconfiguration of the relation of exhibition to audience. Support must be found to allow them to function at full capacity; at the same time, we must recognize that, inevitably, some will be empowered at the expense of others.

Among established institutions, growth has taken place in the attention paid to non-Western cultures, from the Michael Rockefeller Wing and the Asian galleries at the Metropolitan Museum of Art in New York to the National Museum of African Art and the Arthur M. Sackler Gallery at the Smithsonian Institution in Washington, D.C., as well as other museums across the United States. There has been less activity in historical and ethnological museums, although there are definite signs of renewed energy there also. The challenge is to use this capacity well, especially in devising strategies that do not merely rehearse traditional Western ways of organizing experience and that respond imaginatively to the presuppositions of visitors not acquainted with the areas involved.

For example, we need experiments in which the artwork is organized according to the aesthetic categories of the cultures from which it derives. One such experiment, Essence of Indian Art, an exhibition mounted at the Asian Art Museum of San Francisco in 1984, arranged work according to the various *rasas* (sentiments) of Indian tradition. Also, more experiments are needed involving indigenous experts and the sharing of authority with cultural groups that have a special interest in a given exhibition. For example, at the Field Museum of Natural History in Chicago, where a major reinstallation of the African collection is under way, an extensive consultative process has been designed to involve Chicago's African American community. The organizers are trying to respond to the knowledge, background assumptions, and concerns their audiences will bring to the museum so that the resulting exhibition will speak intelligibly to them. Groups that previously have felt uncomfortable within the institution may come to have a voice in what is shown and said. The institution will gain through diverse aesthetic and intellectual inputs, new concerns, new approaches, and a new awareness of how a given exhibition is actually understood by viewers.

Finally, we need experiments in exhibition design that try to present multiple perspectives or admit the highly contingent nature of the interpretations offered. This will be a challenge: people are attracted by the authority of museums, and audiences could lose interest

if that authority is called into question. One of the most successful examples to date has been the Art/artifact exhibition, organized by the Center for African Art in New York. In the exhibition catalogue, Susan Vogel explains that

> this is not an exhibition about African art or Africa. It is not even entirely about art.
>
> Art/artifact is an exhibition about the ways Western outsiders have regarded African art and material culture over the past century. . . . An exhibition on how we view African objects (both literally and metaphorically) is important because unless we realize the extent to which our vision is conditioned by our own culture—unless we realize that the image of African art we have made a place for in our world has been shaped by us as much as by Africans—we may be misled into believing that we see African art for what it is.[6]

To this end, African art was exhibited in simulations of several different environments: the traditional art museum, the contemporary gallery, the ethnological-museum diorama, the cabinet of curiosities, and (via a video installation) some of the objects' original habitat. By bringing to consciousness the extent to which cultural presuppositions frame our view of both artworks and artifacts, the exhibition challenged us to begin to create installations that admit and clarify the limits of their own perspectives.

In December 1989, as the new year approached, New York mayor Ed Koch announced a "melting pot parade" to celebrate the city's racial and ethnic diversity. By the next day, the mayor's advisers had persuaded him to abandon the plan for fear that it would be taken as making light of serious racial problems. A prayer vigil was proposed instead.

It is not just New York but the entire United States that is debating its own pluralism—uncertain that the melting pot works or should work, in search of some territory of shared culture, uneasy about the place of the United States in the international arena. These debates— which are, after all, about how we will live in the future—echo in the precincts of the museum. If the museum community continues to explore this multicultural and intercultural terrain consciously and deliberately, in spite of the snares that may await, it can play a role in reflecting and mediating the claims of various groups, and perhaps help construct a new idea of ourselves as a nation.

NOTES

This essay appeared in a slightly different format as "Museums and Multiculturalism: Who Is in Control?" by Steven D. Lavine, in *Museum News,* March/April 1989, copyright 1989 by the American Association of Museums. All rights reserved. Reprinted with permission.

1. Adrienne Kaeppler, "Paradise Regained: The Role of Pacific Museums in Forging National Identity" (Dept. of Anthropology, National Museum of Natural History, Smithsonian Institution, Washington, D.C., photocopy), 12, 14, 18.

2. Carol Duncan and Alan Wallach, "The Universal Survey Museum," *Art History* 3, no. 4 (Dec. 1980), 451.

3. Donna Haraway, "Teddy Bear Patriarchy: Taxidermy in the Garden of Eden, 1908–1936," *Social Text* 11 (Winter 1984–85), 57.

4. Duncan Cameron, "The Museum: A Temple or the Forum," *Journal of World History* 14, no. 1 (1972), 201, 197.

5. John Beardsley and Jane Livingston, *Hispanic Art in the United States: Thirty Contemporary Painters and Sculptors* (New York: Abbeville, 1987), 46.

6. Susan Vogel, *Art/artifact: African Art in Anthropology Collections* (New York: Center for African Art, 1988), 11.

Culture and
Representation

IVAN KARP

What do exhibitions represent and how do they do so? Exhibitions are placed in museums that differ in age, collections, content, target audiences, national and regional orientations, and ambitions. The type or genre of museum may be a difference that cuts across all these other variables: art museums, cultural-history museums, and natural-history museums have different justifications for their activities and radically different conceptions of how to use and present their collections. Even within a single museum the staff may have differing attitudes and orientations; moreover, because they are organizations composed of diverse personnel with different interests, museums have difficulty developing an internal consensus and clearly defined objectives.

These are only some of the historical and institutional dimensions that affect exhibiting and museum practices. All exhibitions

are inevitably organized on the basis of assumptions about the intentions of the objects' producers, the cultural skills and qualifications of the audience, the claims to authoritativeness made by the exhibition, and judgments of the aesthetic merit or authenticity of the objects or settings exhibited.[1]

These issues arise within the boundaries of the Western traditions out of which museums emerged. They do not even begin to consider problems that arise when different cultures and perspectives come into contact, as they inevitably do. The multiple gazes found within and among cultures make far more complicated the great debates of the museum world, which were echoed and referenced in the papers and discussions of the conference that resulted in this volume. These debates include arguments about whether to privilege context or object, whether to highlight the aesthetics of objects or propositional knowledge about them, or whether a curator's message about the history of an object and its original context is more authentic than the provenance of the object itself.

Still, these debates do not interrogate fundamental assumptions about the exhibition as a medium of and setting for representation. The theme of this section, "Culture and Representation," allows us to examine the implicit definition of the exhibition as a forum for the re-presentation of other experiences and to begin to search for a more active definition of the exhibiting process. This quest is also taken up in more specific form in Part 3 of this volume, "Museum Practices."

In the conference itself, issues that were debated during the first session, "Culture and Representation," continued to be disputed throughout the conference. The participants tended to think of exhibitions as conforming to one of two models: either a vehicle for the display of objects or a space for telling a story. This in itself con-

formed to the great divide between participants from art museums and participants from cultural-history museums that was found among the paper presenters and in the audience as well. Of course, many participants recognized that it is not possible to have an exhibition that does not have traces of both models in it. Even the most rigorous defense made at the conference of museums as bastions of the aesthetic experience—Svetlana Alpers's argument that exhibitions bring out the "visual distinction" of crafted objects—assumes that the "museum effect," as Alpers calls it, has the potential to aid audiences to reexperience the act of craftsmanship. What we can conclude is that even aesthetic response must be based on experiences and skills derived from settings external to the singular experience of appreciating an object.

Alpers's paper is an impassioned defense of the discipline and training involved in appreciating the fashioning of visual art. She objects to the distractions of labels and wishes that the exhibition's story be told in a setting separated from the objects themselves. Even Alpers, however, acknowledges that the reception of the story depends on the degree to which knowledge and perceptual skills are shared between the artists and their audience. While she argues that the Musée d'Orsay's installation disturbs the appreciation of objects of "greater visual interest" in the museum, she acknowledges that some schools of art can benefit from displays that communicate something other than chronology and visual interest. For example, seventeenth-century Dutch landscape art resists being presented in terms of chronology, because the representational intentions of its artists have far more to do with other things than exhibition of chronology and individual artistry can tell us. The museum effect is clearly a force that is independent of the objects themselves. The mode of installation, the subtle messages communi-

cated through design, arrangement, and assemblage, can either aid or impede our appreciation and understanding of the visual, cultural, social, and political interest of the objects and stories exhibited in museums.

The consequences of putting objects into even the Spartan context of the art gallery makes the museum effect into an apparatus of power. If it can aid or impede our understanding of what artists intend and how art means, then its subtle messages can serve masters other than the aesthetic and cultural interests of the producers and appreciators of art. Surely this is why museums historically have been such important instruments for articulating national identity, a theme taken up in Carol Duncan's paper in Part 2.

The messages communicated through the museum effect do not have a predetermined content. Museums and their exhibitions are morally neutral in principle, but in practice always make moral statements; even the assertion that "art" is exempt from moral, social, and political judgments implies ideas about what is and is not subject to certain forms of criticism. The alleged innate neutrality of museums and exhibitions, however, is the very quality that enables them to become instruments of power as well as instruments of education and experience.

How the exhibition moves from neutrality to instrumentality is described in Michael Baxandall's contribution in this section. Baxandall describes exhibition as a field in which the intentions of the object's producer, the exhibitor's arrangement and display of the objects, and the assumptions the museumgoer brings to the exhibit all come into play. The parts of this set are always in complex and dynamic relationship to one another and change from exhibition to exhibition. Baxandall's formulation of these analytical categories allows us to perceive with special clarity that any exhibition experi-

ence is the end product of the mixing of different capacities and effects. The actors involved in the process bring to the making and experiencing of exhibitions different abilities, assumptions, desires, and interests. What each derives from the exhibition, in the end, is surely not entirely what he or she intended. The exhibition is inevitably the contested terrain Steven Lavine and I describe in our introduction to this volume. The struggle is not only over what is to be represented, but over who will control the means of representing. Other papers in this volume, especially Dawson Munjeri's account in Part 5 of the colonial formation of the museum in Zimbabwe, describe the struggle over objects and identities in stark terms. What is at stake in struggles for control over objects and the modes of exhibiting them, finally, is the articulation of identity. Exhibitions represent identity, either directly, through assertion, or indirectly, by implication. When cultural "others" are implicated, exhibitions tell us who we are and, perhaps most significant, who we are not. Exhibitions are privileged arenas for presenting images of self and "other."

From one point of view the most powerful agents in the construction of identity appear to be neither the producers of objects nor the audience but the exhibition makers themselves, who have the power to mediate among parties who will not come into face-to-face contact. Still, the audience has its ways of escaping control, from refusing to follow the exhibition plan to seeing *their* assumptions about identity confirmed in the design and arrangement of objects. In his comments on the conference session, Michael Spock argued forcefully for including "surrogates" for the visitor in the process of exhibition design, a process he acknowledged as explicitly political in that it generates disputes over interpretation among parties with rather different interests. This approach is advocated by

Elaine Heumann Gurian in her paper in Part 3, "Museum Practices."

Alpers and Baxandall are concerned with the museum as a Western cultural institution. The papers by Yamaguchi and Goswamy in this section raise the question of whether the museum effect has been produced in other cultures. If not, then we are forced to ask whether it is appropriate to attempt to display objects drawn from other times and places. The easy answer is no. We could argue that the museum is a uniquely Western institution, that exotic objects displayed in museums are there only because of the history of Western imperialism and colonial appropriation, and that the only story such objects can tell is the history of their status as trophies of imperial conquest. In the case of exotic objects, the museum effect becomes an "aura," as Walter Benjamin called it,[2] the consequence of which is to mask the intentions, meanings, and skills integral to the production and appreciation of the objects. These become irretrievably lost to the exhibition audience.

No participant in the conference took so pessimistic a position, and many of the papers provide examples of how to successfully exhibit meanings and intentions across cultural boundaries. More than any other paper, Stephen Greenblatt's account in this section of the contours of experience available to the exhibition audience provides a solution to the impasse of confronting an unintelligible world. Greenblatt describes two modes of experience available in an exhibition. The first is resonance, "the power of the displayed object to reach out beyond its formal boundaries to a larger world, to evoke in the viewer the complex, dynamic forces from which it has emerged and for which it may be taken by a viewer to stand." The opposite mode is wonder, "the power of the displayed object to stop the viewer in his or her tracks, to convey an arresting sense of

uniqueness, to evoke an exalted attention." Resonance and wonder are idealized distinctions that have the merit of isolating for us aspects of how an exhibition is experienced in the real world of exhibition-going. Through examining resonance and wonder we can think more systematically about the options available for making and experiencing exhibitions.

Greenblatt desires to defend wonder against what he sees as the extremes of context-oriented art exhibitions that deny to the audience the experience of appreciating the object for itself. But Greenblatt does not define wonder as an eternal, universal experience sought through the connoisseur's approach to art; rather, he historicizes and contextualizes the sense of wonder by arguing that wonder has a history and a content that changes over time. Greenblatt first shows that wonder is an experiential goal that has provided grounds for the display of objects from the Renaissance through the contemporary period. In the early Renaissance, wonder was manifested in the display of sumptuous and expensive objects. Eventually the definition of wonder changed from sumptuous display to the appreciation of crafted form that Svetlana Alpers argues is definitive of the museum effect. Greenblatt describes this historical movement as "a transformation of the experience of wonder from the spectacle of proprietorship to the mystique of the object." Michael Baxandall[3] demonstrates that a similar change in attitude occurred even within the Italian Renaissance itself, where the emphasis on expensive materials specified by the artists' patrons gave way to an appreciation of the effects on the viewer produced by the artists' command of consummate skill. The beginnings of change in the sense of wonder may have come rather early; the change occurred over a long period of time and the transformation is still incomplete.

Greenblatt's account enables us to conclude that such seemingly invariant experiences as "wonder" must be set within the context of their own cultural formations, subject to change over time and from place to place. Nor can we assume that wonder is not affected by the techniques of display. Greenblatt describes the contemporary use of "boutique lighting" as an attempt to impart wonder from outside, to give the object a sense of mystery that is derived not from itself but from the apparatus of commercial display. Boutique lighting thus provides an instance in which the spectacle of possession is presented as if it were the mystique of the object. Greenblatt almost suggests that the future history of the sense of wonder may be for it to return to its roots as a spectacle of possession. If this earlier sense of wonder coexists with wonder as the mystique of the object, then tension always exists between these two modes of aesthetic experience, and exhibitions have to struggle to resolve the tension in favor of one definition of wonder over the other.

Greenblatt succeeds in demonstrating that both wonder and resonance have a history. This achievement solves the dilemma of cross-cultural translatability raised above and provides a stronger foundation for the display of objects of other cultures in exhibitions that can combine both aesthetics and context. The difference between Greenblatt's approach and the assertion of universal aesthetic values that is so characteristic of the great survey museums is that for Greenblatt it becomes the responsibility of the exhibitors to construct for their audiences displays that show continuities and differences between the aesthetic evaluations and contexts in which the objects can be appreciated. The historicizing gaze advocated by Greenblatt implies that knowing and experiencing other times, other places, and other cultural formations can be achieved only by con-

trast and comparison. (Michael Baxandall also advocates using contrasting elements in exhibitions in his piece in this section.) This contrast and comparison is the only solution I see to the seeming impasse of being unable to present the objects of an "other" without replacing their view of how an object means with ours.[4] But this requires an exquisite degree of self-consciousness on the part of the exhibitors about their own assumptions and how they organize the representation of other cultures.[5]

If resonance and wonder can alter so much over time even within one culture and historical period, how much difference within these concepts can be discovered when we examine other cultures? Marshall Sahlins says of the worldview of the Hawaiian people that "Hawaiian history repeats itself, since only the second time is [something] an event. The first time it is myth."[6] He argues that the Hawaiians who killed Captain Cook were sacrificing a god whose appearance in the guise of Captain Cook was the fulfillment of a mythic prophecy. Cook and his crew were incorporated into a Hawaiian pantheon in a fashion that showed that the Hawaiians were guided in their response to historical events by the reality they attributed to myth. After Cook's death his relics became objects of ritual display. This Hawaiian attitude finds its echoes in Masao Yamaguchi's paper on Japanese attitudes toward display. Yamaguchi shows that in Japan objects are not transparently defined as simple elements of the material world. The very word for object, *mono,* formerly had the additional meaning of "spiritlike." This attitude is related to the Japanese technique of *mitate,* the art of citation, in which an object or reference is taken to stand for another time, place, or meaning. Yamaguchi finds this technique manifested in such diverse activities as parades and shop displays. For example, *mitate* is manifested in the wonderful Japanese art of creating imita-

tion culinary displays that serve as a means of advertising restaurant meals.

In Japanese display, objects are not so much appreciated for the crafted form they can be shown to exhibit, but for the degree to which they reproduce a mythic world. Crafted form is not an end in itself but is put in the service of representation. This may be a case in which resonance controls wonder. The strongest parallel Yamaguchi can find for the display of objects is with performance genres such as kabuki in Japan, in which fidelity to a script is highly valued. The result is that the object is not valued in and for itself, but for how well it represents the nonempirical imagined world. What appears to be at stake in the Japanese display of objects is resonance with shared cultural knowledge about mythic worlds. An exhibition of Japanese art that takes as its theme the evolving skills of the artists would miss the Japanese point of view, much as a chronological exhibit of Dutch landscape art would miss the intentions of the artists and their original audiences.

Yamaguchi concludes that the skill in representation so highly valued by contemporary Japanese is manifested not only in their arts but also in such quotidian settings as shop displays of toys. One can see parallels between his paper and Michael Baxandall's account of the three agents involved in exhibition. The producer, the exhibitor, and the audience must share a set of skills utilized in producing and appreciating objects if exhibitions are to achieve their effects. Baxandall may be drawing on his earlier account of Renaissance art[7] in which he showed that skills such as perspective were acquired by artist and audience alike in ordinary settings such as mathematics education, and that these skills were culturally based and very different from our own. The possible differences in cultural resources that are involved in the production and apprecia-

tion of objects we regard as being in our own tradition must make us wary of projecting our current assumptions onto objects drawn from other cultures. Nor can we blandly assume that the way we experience exotic objects in contemporary settings is similar to the way such objects are or were experienced in their original settings. Affinities need to be demonstrated rather than asserted. If in Japan objects are secondary and immaterial forms such as myths primary, what is the museum exhibitor to do?

A rigorous attempt to resolve problems of translation and to present another culture's aesthetic standards is described in Goswamy's paper on his curatorial role in the design of two exhibitions that were organized according to an indigenous Indian aesthetic concept called *rasa*. The concept of *rasa* is related to an Indian aesthetic theory based on immediate emotional response, known only in broad outline terms to the average Indian exhibit-goer but having an elaborate intellectual history known primarily to specialists. *Rasa* is one of those protean cultural concepts that have more or less content depending upon the context of use and the training of the user. Goswamy set as his theme the nine *rasas* of Indian art. His two exhibitions were organized not according to chronology, type of object, or artist, but by the aesthetic response of the viewer. A *rasa* is quite complex. It invokes synesthesia and is associated not only with feeling but with taste and color. Each *rasa* has its counterpart in a more specific feeling, called *bhava,* which is generated out of the experience of a specific object. Thus given the proper preconditions, the immediate feeling or mood (*bhava*) of love may be swiftly and blindingly transformed into an intense erotic sentiment (*rasa*). This is a good example of a difference in the cultural resources used to produce and appreciate objects. The emotional and aesthetic progress mandated by the theory of *rasa* exhibits an order

that is the reverse of that expected in the Western theory of person-
hood, in which the elevation of erotic feelings over love is thought
to be rather adolescent.

Goswamy organized his exhibition into sections defined by dif-
ferent *rasas*. (In the San Francisco installation, the designers cooper-
ated with him more than in Paris.[8]) The experience of the exhibi-
tion was heightened by having each room painted in a color
associated with the *rasa*. Still, how was it possible for an American
audience to experience the exhibition as an Indian audience would?
One answer that will come up again in the section on exhibition
practices is that the failure of conventional expectations to work
may give rise to an imaginative attempt by the audience to experi-
ence exhibitions in other than familiar ways. The experience of con-
trast or shock can lead to a reorganization of knowledge and expe-
rience, just as it does for the anthropologist in an alien culture or
for those of us entering a new occupational setting.[9]

Cross-cultural exhibitions present such stark contrasts between
what we know and what we need to know that the challenge of
reorganizing our knowledge becomes an aspect of exhibition experi-
ence. This challenge may be experienced in its strongest form in
cross-cultural exhibitions, but it should be raised by any exhibition.
Almost by definition, audiences do not bring to exhibitions the full
range of cultural resources necessary for comprehending them; oth-
erwise there would be no point to exhibiting. Audiences are left
with two choices: either they define their experience of the exhibi-
tion to fit with their existing categories of knowledge, or they reor-
ganize their categories to fit better with their experience. Ideally, it
is the shock of nonrecognition that enables the audience to choose
the latter alternative. The challenge for exhibition makers is to pro-
vide within exhibitions the contexts and resources that enable audi-

ences to choose to reorganize their knowledge. What these contexts and resources should be is the debate that animates the papers in this volume.

NOTES

1. Natural-history exhibits display objects that are not produced by human agents who have goals and intentions. The theory of evolution is used in natural-history exhibitions to explain how species evolve. These exhibitions do not examine the intentions of plants and animals. Problems arise when objects made by humans are exhibited in natural-history museums and the exhibitors believe that theories of nature can substitute for accounts of cultural factors such as beliefs, values, and intentions. A good example of the problems that arise is provided by the diorama, an exhibiting form that claims to present nature in an ideal form (see Donna Haraway, "Teddy Bear Patriarchy: Taxidermy in the Garden of Eden, 1908–1936," *Social Text* 11 [Winter 1984–85].) Not only are intentions presumed rather than exhibited, but the history of culture and society is wiped from the record as persons and things become ideal examples of certain types. In this way, the cultural and historical specificity of the human society is turned into an example of a universal natural history.

2. Walter Benjamin, "The Work of Art in an Age of Mechanical Reproduction," in *Illuminations* (New York: Schocken, 1969).

3. Michael Baxandall, *Painting and Experience in Fifteenth-Century Italy* (London: Oxford University Press, 1972).

4. See James Clifford, "Histories of the Tribal and the Modern," *Art in America* 74, no. 4 (Apr. 1985), on the concept of affinity used to justify the Museum of Modern Art's exhibition "Primitivism" in Twentieth-Century Art: Affinity of the Tribal and the Modern.

5. Anthropology has recently gone through this exercise, and numerous texts exist that describe the complex situation of fieldwork (see, for example, Ivan Karp and Martha Kendall, "Reflexivity in Fieldwork," in Paul Secord, ed., *Explaining Human Behavior* [Los Angeles: Sage Publications, 1982]), the assumptions that underlie the classificatory schemes into which cultures are slotted (see, for example, Johannes Fabian, *Time and the Other: How Anthropology Makes Its Object* [New York: Columbia University Press, 1983]), and how the rhetorical and literary devices used in writing about cultures communicate assumptions about them (see, for example, James Clifford and George Marcus, *Writing Culture* [Berkeley: University of California Press,

1986]). One of the goals of this volume is to extend the insights of this literature to forms other than the written text for representing cultures.

6. Marshall Sahlins, *Historical Myths and Mythical Realities* (Ann Arbor: University of Michigan Press, 1981), 9.

7. Baxandall, *Painting and Experience.*

8. The history of different installations of the same exhibition raises interesting issues we were unable to cover in this conference and volume. In our discussion we have tended to collapse the curator and designer into one category—the undifferentiated "exhibitor." Yet conflicts between people concerned with content and those responsible for execution are notorious in the museum world. Very often claims are made to represent important interests in these disputes, such as artistic integrity, the views of the audience, the values of the cultures to be represented, the integrity of a disciplinary point of view, and so on. These disputes are moments when the ideological armature that justifies different genres of museums often is brought into play, and much is heard from curators about "aesthetic values" (the art museum), "authenticity" (the history museum), or "science" (the natural-history or science-and-technology museum). How this affects the actual installation of exhibitions is a history yet to be written. James Clifford raises a very important and neglected dimension in his contribution to this volume, "Four Northwest Coast Museums: Travel Reflections." The genres he discerns are majority and minority museums, types that cut across the art/context distinction (though see his caveat about the term *minority*). He sees a difference in the visual narratives of these types of museums. Majority institutions tell a story that tends to universals, while minority and community institutions tend to personalize and express their narrative in terms of oppositional culture. Clifford puts his distinction forward as no more than a hypothesis, but he has brought into focus one of the effects that the relationship between museum and community can have on exhibiting practices.

9. Ivan Karp and Martha Kendall, "Reflexivity in Fieldwork."

CHAPTER I

The Museum as a Way of Seeing

SVETLANA ALPERS

One of the clearest memories from museum visits of my childhood is of a crab. It was a giant crab, to be precise, which was in a glass case, a quite hard-to-find case, in the Peabody Museum (actually, in the Museum of Comparative Zoology) in Cambridge. As I remember, it was the scale that was so astonishing. I had never seen a crab that size and had therefore not imagined that it was possible. It was not only the size of the whole but of each of its individual parts. One could see the way it was made: huge claws, bulging eyes, feelers, raised bumps of shell, knobbly joints, hairs that extended out around them. It was placed at the corner of a case so that one could walk around from the front to the side and take it in from another view: a smallish main body delicately supported on improbably long legs, like the tines of some huge fork or rake.

I could attend to a crab in this way because it was still, exposed to view, dead. Its habitat and habits of rest, eating, and moving were absent. I had no idea how it had been caught. I am describing looking at it as an artifact and in that sense like a work of art. The museum had transformed the crab—had heightened, by isolating, these aspects, had encouraged one to look at it in this way. The museum had made it an object of visual interest.

The museums of Europe have a long history of encouraging at-

tention to objects, crabs included, as visible craft. This was a good part
of the rationale of the early museums, those encyclopedic collections
of Renaissance princes. Much has been said of the ideology of power,
political and intellectual, engaged in both the collecting of objects and
the taxonomic manner of ordering them. But I want to stress that what
was collected was judged to be of visual interest (and even was en-
hanced by early museological concern that cases be in appropriate
colors). Spaces were set aside for the display of examples of natural
and human artifice from around the world. Rare sorts of fish were
displayed side by side with human oddities (two-headed or hairy),
Chinese porcelains, and antique busts.[1] In a special class were objects
that tested the border between the craft of nature and that of culture,
natural artifice and man's—goblets fashioned out of shell, for exam-
ple, or worked coral. Indeed, painters took up the challenge in their
own media: Dürer's watercolor crabs or the painted flowers and shells
of Jan Bruegel compete with what nature has made. The visual interest
accorded a flower or shell in nature is challenged by the visual interest
of the artist's representational craft. Providing paintings of rare flow-
ers and shells for attentive looking in encyclopedic collections was one
way that artists were involved with the museum from the start. Some
apocalyptic accounts of the modern museum's usurpation of the artist
and his or her art are misleading. From Bruegel's time to that of
Cézanne and Picasso, museums have been a school for craftsmen and
artists.

The taste for isolating this kind of attentive looking at crafted
objects is as peculiar to our culture as is the museum as the space or
institution where the activity takes place. (A separate space for images
is of course not totally exceptional among humans—prehistoric paint-
ings were in caves, Egyptian paintings were in tombs, and already in
the Renaissance Europeans had turned a chapel, Giotto's Arena
Chapel, into a viewing box where the ritual of attentive looking and
the display of skill went hand in hand with religious ritual.) If the crab
seems an eccentric example, we might consider instead a Greek statue,
removed from its sanctuary or stadium, eyes gone, color worn to an
overall pallor. The museum effect—turning all objects into works of
art—operates here, too. Though as an issue of national property some
Greek statues may be returned to their place of origin, no one would
deny—and I think no one has thought to protest—the museum effect,
through which Greek sculpture has assumed such a lasting place in our
visual culture. By contrast, in the exhibiting of the material culture of

other peoples, in particular what used to be called "primitive" art, it is the museum effect—the tendency to isolate something from its world, to offer it up for attentive looking and thus to transform it into art like our own—that has been the subject of heated debate.

The museum effect, I want to argue, is a way of seeing. And rather than trying to overcome it, one might as well try to work with it. It is very possible that it is only when, or insofar as, an object has been made with conscious attention to crafted visibility that museum exhibition is culturally informing: in short, when the cultural aspects of an object are amenable to what museums are best at encouraging. Romanesque capitals or Renaissance altarpieces are appropriately looked at in museums (*pace* Malraux) even if not made for them. When objects like these are severed from the ritual site, the invitation to look attentively remains and in certain respects may even be enhanced.

But objects are not always exhibited in such a way as to bring this out. Museums can make it hard to see. I shall begin with Dutch art and culture, the case I know best (the crustaceans of my grown-up days). A recent, highly acclaimed exhibition was entitled Masters of Seventeenth-Century Dutch Landscape Painting.[2] The organization of the exhibition was chronological by loosely described types and the catalogue was alphabetical by artist—both established art-historical categories of mind. But there was no visual evidence offered that the categories or the change over time was part of the enterprise of those making the pictures. Of course we know that any order we place on material is ours and not necessarily theirs. But in this instance there was contrary visual evidence, from the layout of the great maplike panoramic views of Koninck to the extraordinary backlit clouds and cows of Cuyp, that Dutch artists had other things on their minds than these proposed types and their sequence.

It is not that a chronological arrangement can never make cultural as well as pictorial sense. Until the rehanging of London's National Gallery in recent years, one could walk through rooms of Italian painting from the fourteenth through the sixteenth centuries and discover through looking that the sequence of those paintings—in terms of media, color, and handling and arrangement of figures and setting—resulted from a self-conscious experimental practice. It was not by chance that the model of art as history, as distinguished from other kinds of accounts of making art, is provided by Vasari writing on Italian Renaissance works such as these. The persistent adjustment and calibration of elements construed as problems and taken up suc-

cessively by certain artists is a distinctive aspect of this visual culture. To walk through the rooms was to see that for at least three hundred years those objects themselves constituted a history.

To offer another example in which the historical construing of visual culture is justified: Some of the most successful exhibitions of Western art in recent years have been monographic. The work of an individual artist is a characteristic form our culture takes. Therefore, setting out the lifetime production of one individual makes sense as visual culture. It makes sense to look even if the order that emerges from viewing seems to be obsessional (as Fragonard looked to me) rather than developmental in nature.

But the visual culture of Dutch pictures is different in kind. If one wants to offer it for viewing one might suggest exhibiting landscapes along with drawn or printed maps, which share both a pictorial format and a notion of knowledge. Or one might hang Cuyp's backlit cows and clouds with works in other genres (interiors, for example) that share his fascination with the problems of the representation of light; one might also try to show where else in the culture (in the pursuit of natural knowledge, for example) this optical interest can be traced.

Dutch painters have not been renowned for their history paintings, that major European genre dealing with significant human actions as narrated in central texts of the tradition. Nor did they make pictures of important public events: a map of a battleground or a portrait of a general with his family takes the place of what in another country might be the depiction in paint of a heroic battle or a surrender. What happens, then, when an exhibition is mounted that focuses on a major historical event? In 1979 the Central Museum of Utrecht commemorated the 1579 Union of Utrecht, the Dutch declaration of independence from Spain.[3] But the declaration of union itself was overwhelmed and lost amidst a feast for the eyes—documents, decorated plates, coins, engravings, illustrated journal entries, maps, and drawings of land holdings. One came to understand Dutch culture better but perhaps in a way contrary to the intention of the exhibition. (The catalogue title, which begins with a proverb posed as a question—"De kogel door de kerk?" or "The Die is Cast?"—and the decision to focus not on the event but on 1559–1609, the fifty years surrounding it, already reveal a curious diffidence about an event as the occasion for celebration.) It was as if the Dutch were so committed to recording and understanding in pictures that they could not focus on a single event or text. The museum played its part here: the orga-

nizers obviously tried to collect material of visual interest so that the exhibition would be museum-viable, and the museum in its turn made such objects of visual interest stand out. But nowhere in the exhibition or its catalogue was the proliferation of images itself recognized or assessed. This is not a case of pictures illustrating history, such as we can find in certain types of illustrated history books, but rather pictures themselves constituting a social fact.

The most famous recent attempt to consciously transform the exhibition of European art in the direction of the broader culture is the Musée d'Orsay in Paris. Both in the media displayed (furniture and decorative arts, photographs, and sculpture mixed in with painting) and in the choice of artists exhibited, this museum disputes the accepted canon—by which is meant twentieth-century notions of skill, ambition, and the achievement of art in the second half of the nineteenth century in France. The Orsay, paradoxically, makes seeing almost impossible. First of all, the way the pictures are sited and lighted and the presence of distracting hardware make the pictures hard to see. Secondly, works of lesser visual interest (e.g., Couture) are better placed for looking at than those of greater visual interest (e.g., Courbet), and the paintings of lesser visual interest are not visually improved by this exposure. One critic has defended the Orsay by saying that the social history of art is not about what is visible but about what is invisible. All well and good, but then one might ask: how, or why, exhibit it in a museum?[4]

I started with the hypothesis that everything in a museum is put under the pressure of a way of seeing. A serial display, be it of paintings or masks, stools or pitchforks (I have in mind here the Musée d'Orsay, the Musée National d'Art Populaire in Paris, and any older ethnographic museum), establishes certain parameters of visual interest, whether those parameters are known to have been intended by the objects' producers or not. This might also be accomplished in a museum by the exhibition of one sample of a class—a Couture in Japan, perhaps, or a baled fish net, as on the cover of the catalogue for the Art/artifact exhibition mounted by the Center for African Art in New York.[5] Each of my examples is a work exhibited outside its place of origin: difference from what is customarily seen is a spur to visual attention, while extending a sense of craft. But as the Orsay hugely demonstrates, when exhibited together certain objects in any class might repay attentive looking more than others. When the works of artists were seen amidst the pictures and even in the kinds of spaces and lighting to which the artists themselves aspired—Courbet beside

Géricault and Delacroix in the huge nineteenth-century room at the Louvre, the Impressionists in the intimate, quasi-domestic rooms of the Jeu de Paume—this was acknowledged and visual attention was possible.

The distinction a museum brings out between a Courbet and a Couture is comparable to that which it brings out between a highly decorated African stool (I am thinking here of the Baule word *aguin*[6]) and another, plainer one. But—particularly if the object was not made for such attentive looking—this distinction need not have been a cultural value for the maker and users, nor need the object be what we would call a work of art. What the museum registers is visual distinction, not necessarily cultural significance.

It is only recently that peoples or groups, nations, and even cities have felt that to be represented in a museum was to be given recognition as a culture, therefore giving rise, I suppose, to questions about how to do it right. It may not be politically or institutionally possible to suggest that justice to a people should not be dependent on their representation, or their representability, in a museum. Some cultures lack artifacts of visual interest. And politics aside, museums are perhaps not the best means of offering general education about cultures. It is not only that cultures are not the sum of their materials, but also that books and/or film might do the job much better. I remain puzzled as to how James Clifford would make a museum display in the manner of the anthropological text he praises, which describes the "inauthentic," heterogeneous living tradition of a Zuni Shalako ceremony.[7] The home setting of "tribal" art (e.g., a photograph of the interior of Chief Shake's house, Wrangel, Alaska, 1909) that Clifford offers as an alternative to the Museum of Modern Art's much-discussed "Primitivism" in Twentieth-Century Art show would look suspiciously like a Rauschenberg (if in two dimensions) or a Kienholz (if in three) if it were exhibited in a museum. Our way of seeing can open itself to different things, but it remains inescapably ours.

One measure of a museum's success would seem to be the freedom and interest with which people wander through and look without the intimidating mediation between viewer and object that something such as the ubiquitous earphones provides. Considered in these terms, the Museum of Modern Art in New York is a signal success. When MOMA applied some years back for support from the National Endowment for the Humanities (NEH) to put on an exhibition, a question was raised about evidence of educational content. Hanging pictures in a certain way on the wall was all right for art (for the

National Endowment for the Arts) but not for education (which is the province of NEH). MOMA came up with the device of a separate informational room, with much documentation on the wall and so forth, through which one passed on the way to the pictures that were there for the looking. It seems to me a practice worth imitating, though one might even dare to put the documentation after the pictures, not before. Or one could, like the National Gallery of Art in Washington, D.C., offer take-home sheets that do not interrupt and discourage looking while in the museum.

Perhaps more attention could be paid to the educational possibilities of installing objects rather than communicating ideas about them. Free viewers, in other words, and make them less intimidated about looking. One way of doing this is to pay as much attention to the possibilities of installation as to the information about what is being installed. Of course, the two are not separate—though one might argue that the collecting and cataloguing functions of a museum can continue behind the scenes while installations do more in the way of encouraging seeing and suggesting ways to see. Recent monographic shows in which the detailed documentation is put in a catalogue separated from the evidence offered by the works themselves provide one model for this. In the face of the American enthusiasm these days for turning museums into major educational institutions, it is a matter of redressing the balance. The way a picture or object is hung or placed—its frame or support, its position relative to the viewer (is it high, low, or on a level? Can it be walked around or not? Can it be touched? Can one sit and view it or must one stand?), the light on it (does one want constant light? Focused or diffuse? Should one let natural light and dark play on it and let the light change throughout the day and with the seasons?), and the other objects it is placed with and so compared to—all of these affect how we look and what we see.

The history of exhibiting practice makes clear that this idea is hardly new. A visit to museums such as the Pitti Palace in Florence or the Musée de l'Homme in Paris, which retain outdated modes of exhibition, suggests less that they were wrong and we can get it right than that the museum—as a way of seeing—itself keeps changing and that installation has a major effect on what one sees. A constant, however, is the issue of seeing. And the question to ask is, why and with what visual interest in view do we devise this or that display for particular objects?

My conclusion about the representation of culture in a museum is a bit troubling: Museums turn cultural materials into art objects. The

products of other cultures are made into something that we can look at. It is to ourselves, then, that we are representing things in museums. But museums provide a place where our eyes are exercised and where we are invited to find both unexpected as well as expected crafted objects to be of visual interest to us. The mixture of distance, on the one hand, with a sense of human affinity and common capacities, on the other, is as much part of the experience of looking at a Dutch landscape painting of the seventeenth century as it is of looking at a carved Baule heddle pulley of the twentieth. This, it seems to me, is a way of seeing that museums can encourage.

NOTES

1. For a study and catalogue of a partially reconstituted collection of this kind at Schloss Ambras, Innsbruck, see *Die Kunstkammer* (Innsbruck: Verlaganstalt Tyrolia, 1977).

2. Peter C. Sutton et al., *Masters of Seventeenth-Century Dutch Landscape Painting* (Boston: Museum of Fine Arts, 1987).

3. S. Groenveld et al., *De kogel door de kerk? De opstand in de Nederlanden en de rol van de Unie van Utrecht, 1559–1609* (Utrecht: De Walburg Pers, 1979).

4. See Linda Nochlin, "Successes and Failures at the Orsay Museum, or What Ever Happened to the Social History of Art?" *Art in America* 76, no. 1 (Jan. 1988), 88.

5. *Art/artifact: African Art in Anthropology Collections* (New York: Center for African Art, 1988).

6. Discussed in Susan Vogel's introductory essay to Baule art in *Perspectives: Angles on African Art* (New York: Center for African Art, 1987), 147.

7. James Clifford, "Histories of the Tribal and the Modern," in *The Predicament of Culture* (Cambridge: Harvard University Press, 1988), 204, 213.

CHAPTER 2

Exhibiting Intention: Some Preconditions of the Visual Display of Culturally Purposeful Objects

MICHAEL BAXANDALL

In order to get a minimal specificity of focus on the problem, I think I must begin by positing both a certain sort of exhibition and a certain sort of viewer. The sort of exhibition I have in mind is, broadly speaking, traditional, by which I mean that it consists of the display of objects for examination. The objects are presented in vitrines, on stands, or on walls and are accompanied by labels, leaflets, or a catalogue. There may be additional elements—video displays or films, theatrical or musical performances, perhaps even cuisine—but the center of the exhibition consists of objects offered for inspection and to some extent expounded. This may seem a very conservative sort of exhibition, but it seems likely, particularly in the case of permanent displays as opposed to temporary exhibitions, that an array of objects and artifacts offered for inspection will remain the central element.

As for the viewer, he or she is an adult member of a developed society. He (let us say) has the "museum set": he has a sense of the museum as treasure house, educational instrument, secular temple, and the rest. However, it is to two particular aspects of him that I want to point. First, he has come to the exhibition partly to look at visually interesting objects. He expects things to look at and he expects a large part of his activity in the exhibition to consist of looking. If this were not so he would have stayed at home and read a book about the

culture. And in looking at the objects he will find some more inter-
esting than others, for reasons coming out of his own culture—these
reasons being aesthetic, from vernacular anthropology, and other. But
(and this is the second aspect I want to point to) he is also disposed to
be interested in the purpose and function of the artifacts he sees. He
wants to know what an artifact is. Like his value judgments, his an-
alytical categories will be to a large extent culturally determined.

It seems axiomatic that it is not possible to exhibit objects without
putting a construction upon them. Long before the stage of verbal
exposition by label or catalogue, exhibition embodies ordering prop-
ositions. To select and put forward any item for display, as something
worth looking at, as interesting, is a statement not only about the
object but about the culture it comes from. To put three objects in a
vitrine involves additional implications of relation. There is no exhi-
bition without construction and therefore—in an extended sense—
appropriation.

It is clear that the viewer looking at an artifact from another
culture—whether the other culture is distant geographically or
chronologically—is in a complicated position. This predicament has
been the focus of elaborate discussion since the late eighteenth century.
The viewer of an artifact in an anthropological exhibition is subject to
further complications and pressures. Three cultural terms are involved.
First, there are the ideas, values, and purposes of the culture from
which the object comes. Second, there are the ideas, values, and, cer-
tainly, purposes of the arrangers of the exhibition. These are likely to
be laden with theory and otherwise contaminated by a concept of
culture that the viewer does not necessarily possess or share. Third,
there is the viewer himself, with all his own cultural baggage of un-
systematic ideas, values and, yet again, highly specific purposes.

Let us take the case of a European or American viewer with a
Kota *mbulu-ngulu* by itself in a case or on a wall. Because it has been
offered for inspection, he takes it that the object has been considered
worthy of inspection, either for its cultural importance or for its beauty
and the producer's skill. It is spotlit for some purpose. He may or may
not find it attractive, but for any of a number of reasons—the museum
set, the authority of the exhibitors, or his own curiosity about a visu-
ally interesting object—he reads a label or catalogue entry with a view
to learning about it. Let us say the label tells him something like the
following: The object is made of brass sheet over wood and is the
product of the Kota, who live in Gabon and the Republic of the

Congo. They venerate their ancestors, and these carvings are made to warn off evil spirits from the remains of ancestors. The label or catalogue entry also makes two other points. One is that the *mbulu-ngulu* is to be compared with a wooden Fang *bieri* head or figure elsewhere in the room, the Fang being neighbors of the Kota to the west who make the *bieri* figures with a similar purpose of protecting ancestors. The second is that the Kota *mbulu-ngulu* is an example of the class of object on which Picasso drew in making the protocubist paintings of 1907. But for the moment I shall leave aside these pieces of information and discuss the effect on the viewer of the basic information in the label about facture and function.

What the label says is not in any normal sense descriptive. It does not cover the visual character of the object. To do so would involve an elaborate use of measurements and geometrical concepts and reference to the representational elements, and would in any case be otiose, since the object is present. The label stands to the object in a relation of a different kind, not a descriptive but an explanatory relation. What the viewer sees in the object is in the first instance an idiosyncratic representation of a human being—an easily recognizable head with open mouth and cicatrices on the cheeks, surrounded by forms that can be read as representational of some kind of headdress, the whole set on a lozenge-shaped base he is likely to take as representational of a much-diminished body and legs. The interpretation offered by the label, therefore, is explanatory of the object in terms of cause.

The label offers the name of the object, *mbulu-ngulu*. That the object class has a name, even though the viewer's ignorance of the language prevents him from construing any signification or connotation in it, does signify that it is an object that plays a defined or established cultural role. That it has a name means it is a *sort* of thing.

The label also informs the viewer about the materials used, brass sheet and wood. This carries two kinds of explanatory implication. First, it accounts for certain characteristics of the stylization of form and decoration, which are in a fairly straightforward way medium-determined, or at least medium-reinforced. Second, it seems the product of a culture in which a specific kind of metalwork is both highly developed and highly esteemed.

The label also invokes an ancestor cult and the role of such figures as this as protectors of ancestral remains. The viewer is likely to go back to the figure with this information and put it to interpretive use. He will again infer that this object is an important object in its culture. And the information will also color his physiognomic inter-

pretation of the figure, so that the open mouth will be taken as mi-
natory and fierce rather than, say, joyful or anguished.

All this is very obvious, and my reason for so laboring it is to lay the
ground for a move away from the sense of exhibition as something
that represents a human culture. Rather than one static entity repre-
senting another, I would prefer, as more productive, a notion of ex-
hibition as a field in which at least three distinct terms are indepen-
dently in play—makers of objects, exhibitors of made objects, and
viewers of exhibited made objects. Two things are essential to this
model. First, all three terms are active in the exhibition. Second, the
activity of each of the three is differently directed and discretely if not
incompatibly structured. Each of the three is playing, so to speak, a
different game in the field.

The first agent, and clearly a very necessary one, is the maker of
the artifact. If one thinks of the maker's relation to his culture in terms
of the customary distinction between a participant's understanding
and an observer's understanding, the maker is the classic participant.
He understands his culture more immediately and spontaneously than
any outsider (exhibitor or viewer included) can. Much of his under-
standing of it takes place without rational self-consciousness; much of
his knowledge of it is dispositional. The Kota craftsperson making the
mbulu-ngulu is a person who understands his culture with a tact and
a flexibility no outsider, with however many years of fieldwork, can
aspire to. He may well have reflected on why and how he makes the
object, but it is not *necessary* that he should have done so; and if he
has done so, the conceptual medium in which he has reflected will not
have been ours. It would be possible for him to proceed with his craft
much as he proceeds with his language—in a mood of informal knowl-
edge and mastery. If he does reflect on his craft, he need not distinguish
very sharply between the culturally specific and the general condition:
between conditions set by the need to protect ancestors and conditions
set by the properties of brass sheet. But the maker is active in the field
of exhibition, in the artifacts that are the deposit of his activity.

The second agent in the field is an exhibitor. He is, of course, as
cultural an operator as the Kota craftsperson. One of the odder prod-
ucts of his culture is the equivocating notion, or notions, of culture
itself—a culturally specific concept with which he appropriates inter-
esting things about other people. As the arbitrageur may appropriate
the *mbulu-ngulu* by hanging it next to the 1907 Picasso in his living
room, the anthropological exhibitor may appropriate it by "hanging"

it next to the concept of ancestor cult in a subcultural universe of discourse. The purposes of the exhibitor's activity are complex. They include putting on a good show and instructing the audience, but if these purposes come under the rubric of representing a culture then they also include, functionally, validating a theory—namely, a theory of culture. There seems nothing sinister in this. But clearly the exhibitor's activity in the field of exhibition has purposes and conditions different from those of the first agent, the maker of the objects exhibited.

The third agent active in the field is the viewer. In order to be able to think about him at all, I started by making some stipulations about his sort. He is a being of his culture; with his museum set, he colludes in the project of exhibition; on a vulgar level, he participates in some concept of culture. But specific to him are (1) that he has come to look at objects of visual interest, and (2) that he seeks understanding of the objects, whether in functional or teleological terms. There is, of course, a reciprocal relation between these two. Explanatory information affects the way he looks, and problems met in looking give rise to a desire for explanation. Culturally, he shares much with the second agent, the exhibitor, even if he does not participate in the stricter anthropological subculture. This degree of cultural overlap between viewer and exhibitor is one of the things that lead to confusion between the two, distinct though their purposes are. But though they may have much in common constitutionally, functionally they are dissimilar.

If exhibition is to be seen as a field in which three agents, not constitutionally identical, are behaving in three differently directed ways, how are we to conceive of their activities coming into contact? Perhaps we can conceive of them coming into contact in the space between object and label.

In invoking a space between object and label I have in mind a sort of intellectual space in which the third agent, the viewer, establishes contact between the first and second agents, the maker and the exhibitor. And I use the word *label* here to denote the elements of naming, information, and exposition the exhibitor makes available to the viewer in whatever form: a label is not just a piece of card, but includes the briefing given in the catalogue entry and even selection or lighting that aims to make a point. To attend to this space, it seems to me, is to attend not only to the scene but to the source of the viewer's activity.

Space (intellectual) exists between label (in its extended sense) and artifact because the label is not directly descriptive of the object. It may offer a name: *mbulu-ngulu*. It may offer a material cause: brass sheet and wood. It may offer a final cause: protection of the remains of ancestors. It may offer an efficient cause: a Kota craftsperson. It does not describe the object. It describes the exhibitor's thinking about the object, or that part of his thinking he feels it to be his purpose to communicate to the viewer. The nearest thing the label offers to a description is the numerical statement of the object's dimensions—something of which the viewer, who can see the object, is unlikely to make very active use. To an extraordinary extent the exhibitor expounds by communicating pieces of information the viewer takes, at least in the first instance, as *causes*—material, efficient, final—of the object being as it is. The exhibitor may have been less interested in causes than effects; his interest in the pieces of information may well have been because they locate the object as an effect, or sign, of this or that cultural fact, one item in the larger pattern of culture he is charged with exhibiting. But the viewer, tackling these alien objects, seeks causes. This would give rise to more misunderstanding, and viewer and exhibitor would be even more at odds, if it were not that the viewer, being a doggedly cause-seeking animal, is at the same time constructing for himself a causal explanation of the exhibitor's behavior as well as the object maker's—but this is a complication I do not want to pursue here.

What I want to lay emphasis on is that the viewer, moving about in the space between object and label, is highly active. He is not a passive subject for instruction. He moves with great vitality between visually pleasurable (or at least intriguing) objects and equally pleasurable cause finding; then he moves back from information about causes to visually interesting objects, scanning the objects for applications of these causes. One can see this shuttling process in different lights. It can be seen as an attempt to reconcile two propositions about a culture—the participant's culturally conditioned action, or practical proposition, on the one hand, and the observer's implicit explanation, by selection of an item of information that potentially is a cause, on the other. It can also be seen as a case of the viewer demanding a certain kind of art criticism. He uses this or that item of information about cause to sharpen his perception of the object—attending anew to a manner of ornament or the significance of an open mouth, material or final cause at hand.

The purest causes—the least contaminated by our own culturally

determined conceptualizations—are the material causes. Names may differ, but an 80-20 copper-zinc alloy is transcultural both as a concept and in its properties. "Brass" is not intellectually appropriative, as "ancestor cult" is. But an exhibition that confined its exposition to material causality would fall short of representing culture. What is more, the viewer would not rest at this point. He works primarily with intention—intention not of course in the sense of mental events in the maker's mind, but a posited purposefulness about the object. The intention of the object is a relation between culturally conditioned goals or functions (it does not matter which) pursued with culturally enabled resources in culturally determined circumstances. Given information about goals (or functions), resources, and circumstances, the viewer will construct an intentional description of the object for himself. And deprived of these pieces of information, he probably will make them up.

What is the exhibitor, who is charged with representing a culture—and with doing so to a viewer whose posture in the field of exhibition entails not so much that he should take artifacts as individual effects of general cultures but that he should take individual cultural facts as causes of artifacts—to do? Obviously, I have been arguing in a general way that one thing the exhibitor might do is to acknowledge in a practical way that he is only one of three agents in the field, and to acknowledge in a practical way that between the exhibitor's own label and the artifact is a space in which the viewer will act by his own lights to his own ends. But I would finish by making three more specific points in extension of this.

First, the objects or artifacts least likely to cause misunderstanding between viewer and maker are objects *intended* for exhibition. I mean that objects designed to be looked at for their visual interest are those that properly can be displayed and examined for their visual interest. A viewer looking at an artifact that is not designed for looking at but that is exhibited as culturally interesting, culturally telling, or indicative of cultural or technical level is hard put not to be a voyeur, intrusive and often embarrassed. But I have more in mind the point that an object that has been made with a view to being examined for its visual interest—to signify, if you will, visually—is less likely to be misread by the viewer disposed to look at things for their visual interest. This is naturally a matter of degree. It is not only what we would call works of art that are designed, at least in part, to be visually admired: there may be a large element of this also in a canoe or a

fishing net, a little in an ax head. But we are less likely to mis-take an object made with a view to its visual effect, such as a *mbulu-ngulu* or a batik textile. In other words, there seems to me to be an issue of exhibitability. The exhibitable object is one made *for* visual exhibition or display. The viewer may indeed bring inappropriate concepts and standards to his examination of it (and this is something the exhibitor can do something about), but the visual curiosity itself will not be improper.

The second point I would make is that it is surely desirable to install actually within the exhibition itself the element of cross-culturality inherent in the viewer's situation, that is, in the display of objects from one culture to persons of another culture. My own feeling is that exhibitions in which different cultures are combined or juxta-posed are inherently more wholesome than exhibitions of single cultures. The juxtaposition of objects from different cultural systems sig-nals to the viewer not only the variety of such systems but the cultural relativity of his own concepts and values. On the other hand, faced by an assemblage of culturally coherent objects, the viewer is less alerted to his own cultural distance; cultural difference is not built into the display. An alternative to the culturally mixed exhibition is the exhi-bition that thematically addresses the relationship between another culture and our own. Thus one could argue that to exhibit the Kota *mbulu-ngulu* with the 1907 Picasso, at least without the further im-plications of a setting in an arbitrageur's living room, is precisely *not* to appropriate it but to acknowledge and signal cultural difference— any reflective viewer knowing that the circumstances of the Kota craftsperson and Picasso are different. The effect of visual similarity is to accent difference.

The desirability of recognizing the viewer's disposition to be ac-tive in the space between label and object is my third and last point. It is, yet again, the status of the viewer as an agent in the field of exhi-bition that I want to accent. The exhibitor can accommodate this status less by seeking to control or direct the viewer's mind in this space than by, as it were, enlarging the space. There are many ways in which he can do this. The one I would mention here is the offering of a cultural fact relevant to the object that demands that the viewer work to make the connection. He need not work very hard. If I offer as a fact relevant to a piece of Maori sculpture the fact that Maori carvers of wooden sculpture leave the chips that fall as they cut lying on the ground as they fell, not allowing themselves to clear or disturb them, the implications for the carver's sense of both skill and material

can be drawn, as can the implications of this sense for the object seen. To offer a pregnant cultural fact and let the viewer work at it is surely both more tactful and stimulating than explicit interpretation. Sufficient interpretation lies in the selection of the fact. This can be made even more wholesome by incorporating a concept, indeed a word, from the culture that produced the object. The systematic incompatibility of another culture's concept with one's own culture not only makes the viewer work, but reminds him of cultural difference. The best label for a Fang *bieri* would be an exposition of the Fang concept of *bibwe,* a culturally specific concept in the area of what we would call "balance." The most effective elucidation I know of Chinese painting is the Chinese concept of *pi-i* (literally, "brush-idea"), precisely because of the concept's difficulty and cultural strangeness.

Exhibitors cannot *represent* cultures. Exhibitors can be tactful and stimulating impresarios, but exhibition is a social occasion involving at least three active terms. The activity the exhibition exists for is between viewer and maker. If the exhibitor wants to help or influence this activity, it should not be by discoursing either directly or indirectly about culture, which is his own construct, but rather by setting up nonmisleading and stimulating conditions between the exhibitor's own activity (selection and label making) and the maker's object. The rest is up to the viewer.

CHAPTER 3

Resonance and Wonder

STEPHEN GREENBLATT

propose to examine two distinct models for the exhibition of works of art, one centered on what I shall call resonance and the other on wonder. By *resonance* I mean the power of the displayed object to reach out beyond its formal boundaries to a larger world, to evoke in the viewer the complex, dynamic cultural forces from which it has emerged and for which it may be taken by a viewer to stand. By *wonder* I mean the power of the displayed object to stop the viewer in his or her tracks, to convey an arresting sense of uniqueness, to evoke an exalted attention.

I should say at once that the scholarly practice that I myself represent, a practice known as the new historicism, has distinct affinities with resonance; that is, my concern with literary texts has been to reflect upon the historical circumstances of their original production and consumption and to analyze the relationship between these circumstances and our own. I have tried to understand the intersecting circumstances not as a stable, prefabricated background against which the literary texts can be placed, but as a dense network of evolving and often contradictory social practices. We do not have direct, unmediated access to these practices; they are accessible to us through acts of interpretation not essentially different from those with which we apprehend works of art. If, in consequence, we lose the sense of reas-

suring solidity that an older historicism seemed to promise, we gain in recompense a far richer sense of the vital and dynamic nature of nonliterary expressions. The idea is not to find outside the work of art some rock onto which interpretation can be securely chained but rather to situate the work in relation to other representational practices operative in the culture at a given moment in both its history and our own. And we can begin to understand something of the dialectical nature of these relations. In Louis Montrose's convenient formulation, the goal has been to grasp simultaneously the historicity of texts and the textuality of history.

Insofar as this approach, developed for the interpretation of texts, is at all applicable to art museums—and this remains to be seen—it would reinforce the attempt to reduce the isolation of individual "masterpieces," to illuminate the conditions of their making, to disclose the history of their appropriation and the circumstances in which they come to be displayed, to restore the tangibility, the openness, the permeability of boundaries that enabled the objects to come into being in the first place. An actual restoration of tangibility is obviously in most cases impossible, and the frames that enclose pictures are only the ultimate formal confirmation of the closing of the borders that marks the finishing of a work of art. But we need not take that finishing so entirely for granted; museums can and on occasion do make it easier imaginatively to recreate the work in its moment of openness.

That openness is linked to a quality of artifacts that museums obviously dread, their precariousness. But though it is perfectly reasonable for museums to protect their objects (and I would not wish it any other way), precariousness is a rich source of resonance. Thomas Greene, who has written a sensitive book on what he calls the "vulnerable text," suggests that the symbolic wounding to which literature is prone may confer upon it power and fecundity. "The vulnerability of poetry," Greene argues, "stems from four basic conditions of language: its historicity, its dialogic function, its referential function, and its dependence on figuration."[1] Three of these conditions are different for the visual arts, in ways that would seem to reduce vulnerability: painting and sculpture may be detached more readily than language from both referentiality and figuration, and the pressures of contextual dialogue are diminished by the absence of an inherent *logos*, a constitutive word. But the fourth condition, historicity, is in the case of material artifacts vastly increased, indeed virtually literalized. Museums function, partly by design and partly in spite of themselves, as monuments to the fragility of cultures, to the fall of sustaining insti-

tutions and noble houses, the collapse of rituals, the evacuation of myths, the destructive effects of warfare, neglect, and corrosive doubt.

I am fascinated by the signs of alteration, tampering, and even deliberate damage that many museums try simply to efface: first and most obviously, the act of displacement that is essential for the collection of virtually all older artifacts and most modern ones—pulled out of chapels, peeled off church walls, removed from decayed houses, given as gifts, seized as spoils of war, stolen, or "purchased" more or less fairly by the economically ascendant from the economically naive (the poor, the hard-pressed heirs of fallen dynasties, and impoverished religious orders). Then, too, there are the marks on the artifacts themselves: attempts to scratch out or deface the image of the devil in numerous late-medieval and Renaissance paintings, the concealing of the genitals in sculptured and painted figures, the iconoclastic smashing of human or divine representations, the evidence of cutting or reshaping to fit a new frame or purpose, and the cracks, scorch marks, or broken-off noses that indifferently record the grand disasters of history and the random accidents of trivial incompetence. Even these accidents—the marks of a literal fragility—can have their resonance: the climax of an absurdly hagiographical Proust exhibition several years ago was a display case holding a small, patched, modest vase with a label that read, "This vase broken by Marcel Proust."

As this comical example suggests, wounded artifacts may be compelling not only as witnesses to the violence of history but as signs of use, marks of the human touch, and hence links with the openness to touch that was the condition of their creation. The most familiar way to recreate the openness of aesthetic artifacts without simply renewing their vulnerability is through a skillful deployment of explanatory texts in the catalogue, on the walls of the exhibition, or on cassettes. The texts so deployed introduce and in effect stand in for the context that has been effaced in the process of moving the object into the museum. But insofar as that context is partially, often primarily, visual as well as verbal, textual contextualism has its limits. Hence the mute eloquence of the display of the palette, brushes, and other implements that an artist of a given period would have employed, or of objects that are represented in the exhibited paintings, or of materials and images that in some way parallel or intersect with the works of art.

Among the most resonant moments are those in which the supposedly contextual objects take on a life of their own and make a claim rivaling that of the object that is formally privileged. A table, a chair, a map, often seemingly placed only to provide a decorative

setting for a grand work, become oddly expressive, significant not as background but as compelling representational practices in themselves. These practices may in turn impinge upon the grand work, so that we begin to glimpse a kind of circulation: the cultural practice and social energy implicit in map making are drawn into the aesthetic orbit of a painting that has itself enabled us to register some of the representational significance of the map. Or again, the threadbare fabric on the old chair or the gouges in the wood of a cabinet juxtapose the privileged painting or sculpture with marks not only of time but of use, the imprint of the human body on the artifact, and call attention to the deliberate removal of certain exalted aesthetic objects from the threat of that imprint.

The effect of resonance does not necessarily depend upon a collapse of the distinction between art and nonart; it can be achieved by awakening in the viewer a sense of the cultural and historically contingent construction of art objects, the negotiations, exchanges, swerves, and exclusions by which certain representational practices come to be set apart from other representational practices that they partially resemble. A resonant exhibition often pulls the viewer away from the celebration of isolated objects and toward a series of implied, only half-visible relationships and questions: How did the objects come to be displayed? What is at stake in categorizing them as "museum quality"? How were they originally used? What cultural and material conditions made possible their production? What were the feelings of those who originally held the objects, cherished them, collected them, possessed them? What is the meaning of the viewer's relationship to those same objects when they are displayed in a specific museum on a specific day?

It is time to give a more sustained example. Perhaps the most purely resonant museum I have ever seen is the State Jewish Museum in Prague. This is housed not in a single building but in a cluster of old synagogues scattered through the city's former Jewish town. The oldest of these, known as the Old-New Synagogue, is a twin-nave medieval structure dating to the last third of the thirteenth century; the others are mostly Renaissance and Baroque. In these synagogues are displayed Judaica from 153 Jewish communities throughout Bohemia and Moravia. In one there is a permanent exhibition of synagogue silverwork; in another there are synagogue textiles; in a third there are Torah scrolls, ritual objects, manuscripts, and prints illustrative of Jewish beliefs, traditions, and customs. One of the synagogues shows the work of the physician and artist Karel Fleischmann, principally

drawings done in Terezín concentration camp during his months of imprisonment prior to his deportation to Auschwitz. Next door, in the Ceremonial Hall of the Prague Burial Society, there is a wrenching exhibition of children's drawings from Terezín. Finally, one synagogue, closed at the time of my visit to Prague, has simply a wall of names—thousands of them—to commemorate the Jewish victims of Nazi persecution in Czechoslovakia.

"The Museum's rich collections of synagogue art and the historic synagogue buildings of Prague's Jewish town," says the catalogue of the State Jewish Museum, "form a memorial complex that has not been preserved to the same extent anywhere else in Europe." "A memorial complex"—this museum is not so much about artifacts as about memory, and the form the memory takes is a secularized *Kaddish,* a commemorative prayer for the dead. The atmosphere has a peculiar effect on the act of viewing. It is mildly interesting to note the differences between the mordant Grosz-like lithographs of Karel Fleischmann in the prewar years and the tormented style, at once detached and anguished, of the drawings from the camps, but aesthetic discriminations feel weird, out of place. And it seems wholly absurd, even indecent, to worry about the relative artistic merits of the drawings that survive by children who did not survive.

The discordance between viewing and remembering is greatly reduced with the older, less emotionally charged artifacts, but even here the ritual objects in their glass cases convey an odd and desolate impression. The oddity, I suppose, should be no greater than in seeing an image of a Mayan god or, for that matter, a pyx or a ciborium, but we have become so used to the display of such objects, so accustomed to considering them works of art, that even pious Catholics, as far as I know, do not necessarily feel disconcerted by their transformation from ritual function to aesthetic exhibition. And until very recently the voices of the peoples who might have objected to the display of their religious artifacts have not been heard and certainly not attended to.

The Jewish objects are neither sufficiently distant to be absorbed into the detached ethos of anthropological display nor sufficiently familiar to be framed and encased alongside the altarpieces and reliquaries that fill Western museums. And moving as they are as mnemonic devices, most of the ritual objects in the State Jewish Museum are not, by contrast with Christian liturgical art, particularly remarkable either for their antiquity or their extraordinary beauty. There are significant exceptions—for example, some exquisite seventeenth- and eighteenth-century textiles used as Torah curtains and binders—but

on the whole the display cases are filled with the products of a people
with a resistance to joining figural representation to religious obser-
vance, a strong if by no means absolute anti-iconic bias.[2] The objects
have, as it were, little will to be observed; many of them are artifacts—
ark curtains, Torah crowns, breastplates, finials, binders, pointers, and
the like—the purpose of which was to be drawn back or removed in
order to make possible the act that mattered: not viewing but reading.

But the inhibition of viewing in the State Jewish Museum is par-
adoxically bound up with its resonance. This resonance depends not
upon visual stimulation but upon a felt intensity of names, and behind
the names, as the very term *resonance* suggests, of voices: the voices of
those who chanted, studied, muttered their prayers, wept, and then
were forever silenced. And mingled with these voices are others—of
those Jews in 1389 who were murdered in the Old-New Synagogue
where they were seeking refuge, of the great sixteenth-century Kab-
balist Jehuda ben Bezalel (who is known as Rabbi Loew and who is
fabled to have created the golem), and of the twentieth century's ironic
Kabbalist from Prague, Franz Kafka.

It is Kafka who would be most likely to grasp imaginatively the
State Jewish Museum's ultimate source of resonance: the fact that
most of the objects are located in the museum—were displaced, pre-
served, and transformed categorically into works of art—because the
Nazis stored the articles they confiscated in the Prague synagogues that
they chose to preserve for this very purpose. In 1941 the Nazi Hochs-
chule in Frankfurt had established an Institute for the Exploration of
the Jewish Question, which in turn had initiated a massive effort to
confiscate Jewish libraries, archives, religious artifacts, and personal
property. By the middle of 1942 Heydrich, as Hitler's chief officer
in the so-called Protectorate of Bohemia and Moravia, had chosen
Prague as the site of the Central Bureau for Dealing with the Jewish
Question, and an SS officer, Untersturmführer Karl Rahm, had as-
sumed control of the small existing Jewish museum, founded in 1912,
which was renamed the Central Jewish Museum. The new charter of
the museum announced that "the numerous, hitherto scattered Jewish
possessions of both historical and artistic value, on the territory of the
entire Protectorate, must be collected and stored."[3]

During the following months, tens of thousands of confiscated
items arrived from Jewish communities in Bohemia and Moravia, the
dates of the shipments closely coordinated with the deportation of
their "donors" to the concentration camps. The experts formerly em-
ployed by the original Jewish museum were compelled to catalogue the

items, and the Nazis compounded this immense task by also ordering the wretched, malnourished curators to prepare a collections guide and organize private exhibitions for SS staff. Between September 1942 and October 1943 four major exhibitions were mounted. Since these required far more space than was available in the existing Jewish Museum's modest location, the great old Prague synagogues, made vacant by the Nazi prohibition of Jewish public worship, were partially refurbished for the occasion. Hence in March 1943, for example, in the seventeenth-century Klaus Synagogue, there was an exhibition of Jewish festival and life-cycle observances; "when Sturmbannführer Günther first toured the collection on April 6, he demanded various changes, including the translation of all Hebrew texts and the addition of an exhibit on kosher butchering."[4] Plans were drawn up for other exhibitions, but the curators—who had given themselves with a strange blend of selflessness, irony, helplessness, and heroism to the task—were themselves at this point sent to concentration camps and murdered.

After the war, the few survivors of the Czech Jewish community apparently felt they could not sustain the ritual use of the synagogues or maintain the large collections. In 1949 the Jewish Community Council offered as a gift to the Czechoslovak government both the synagogues and their contents. These became the resonant, impure "memorial complex" they are—a cultural machine that generates an uncontrollable oscillation between homage and desecration, longing and hopelessness, the voices of the dead and silence. For resonance, like nostalgia, is impure, a hybrid forged in the barely acknowledged gaps, the caesurae, between words such as *state, Jewish,* and *museum.*

I want to avoid the implication that resonance must be necessarily linked to destruction and absence; it can be found as well in unexpected survival. The key is the intimation of a larger community of voices and skills, an imagined ethnographic thickness. Here another example will serve: in the Yucatan there is an extensive, largely unexcavated late-Classic Mayan site called Coba, the principal surviving feature of which is a high pyramid known as Nahoch Mul. After a day of tramping around the site, I was relaxing in the pool of the nearby Club Med Archaeological Villa in the company of a genial structural engineer from Little Rock. To make conversation, I asked my poolmate what he as a structural engineer thought of Nahoch Mul. "From an engineer's point of view," he replied, "a pyramid is not very interesting—it's just an enormous gravity structure. But," he added,

"did you notice that Coca-Cola stand on the way in? That's the most impressive example of contemporary Mayan architecture I've ever seen." I thought it quite possible that my leg was being pulled, but I went back the next day to check; anxious to see the ruins, I had, of course, completely blocked out the Coke stand on my first visit. Sure enough, some enterprising Maya had built a remarkably elegant shelter with a soaring pyramidal roof constructed out of ingeniously intertwined sticks and branches. Places like Coba are thick with what Spenser called the "ruins of time"—a nostalgia for a lost civilization that was in a state of collapse long before Cortés or Montejo cut their violent paths through the jungle. But, despite frequent colonial attempts to drive them or imagine them out of existence, the Maya have not in fact vanished, and a single entrepreneur's architectural improvisation suddenly had more resonance for me than the mounds of the "lost" city.

My immediate thought was that the whole Coca-Cola stand could be shipped to New York and put on display in the Museum of Modern Art. It is that kind of impulse that moves us away from resonance and toward wonder. For MOMA is one of the great contemporary places not for the hearing of intertwining voices, not for historical memory, not for ethnographic thickness, but for intense, indeed enchanted looking. Looking may be called enchanted when the act of attention draws a circle around itself from which everything but the object is excluded, when intensity of regard blocks out all circumambient images, stills all murmuring voices. To be sure, the viewer may have purchased a catalogue, read an inscription on the wall, or switched on a cassette player, but in the moment of wonder all of this apparatus seems mere static.

The so-called boutique lighting that has become popular in recent years—a pool of light that has the surreal effect of seeming to emerge from within the object rather than to focus upon it from without—is an attempt to provoke or heighten the experience of wonder, as if modern museum designers feared that wonder was increasingly difficult to arouse or perhaps that it risked displacement entirely onto the windows of tony dress shops and antiques stores. The association of that kind of lighting with commerce would seem to suggest that wonder is bound up with acquisition and possession, yet the whole experience of most art museums is about *not* touching, *not* carrying home, *not* owning the marvelous objects. Modern museums in effect at once evoke the dream of possession and evacuate it.[5] (Alternatively, we could say that they displace that dream onto the museum gift shop,

where the boutique lighting once again serves to heighten the desire for acquisition, now of reproductions that stand for the unattainable works of art.)

That evacuation is a historical rather than structural aspect of the museum's regulation of wonder: that is, collections of objects calculated to arouse wonder arose precisely in the spirit of personal acquisition and were only subsequently displaced from it. In the Middle Ages and the Renaissance we characteristically hear about wonders in the context of those who possessed them (or who gave them away). Hence, for example, in his *Life of Saint Louis,* Joinville writes that "during the king's stay in Saida someone brought him a stone that split into flakes":

> It was the most marvellous stone in the world, for when you lifted one of the flakes you found the form of a sea-fish between the two pieces of stone. This fish was entirely of stone, but there was nothing lacking in its shape, eyes, bones, or colour to make it seem otherwise than if it had been alive. The king gave me one of these stones. I found a tench inside; it was brown in colour, and in every detail exactly as you would expect a tench to be.[6]

The wonder-cabinets of the Renaissance were at least as much about possession as display. The wonder derived not only from what could be seen but from the sense that the shelves and cases were filled with unseen wonders, all the prestigious property of the collector. In this sense, the cult of wonder originated in close conjunction with a certain type of resonance, a resonance bound up with the evocation not of an absent culture but of the great man's superfluity of rare and precious things. Those things were not necessarily admired for their beauty; the marvelous was bound up with the excessive, the surprising, the literally outlandish, the prodigious. They were not necessarily the manifestations of the artistic skill of human makers: technical virtuosity could indeed arouse admiration, but so could nautilus shells, ostrich eggs, uncannily large (or small) bones, stuffed crocodiles, and fossils. And, most important, they were not necessarily objects set out for careful viewing.

The experience of wonder was not initially regarded as essentially or even primarily visual; reports of marvels had a force equal to the seeing of them. Seeing was important and desirable, of course, but precisely in order to make possible reports, which then circulated as virtual equivalents of the marvels themselves. The great medieval col-

lections of marvels are almost entirely textual; Friar Jordanus's *Marvels of the East*, Marco Polo's *Book of Marvels*, Mandeville's *Travels*. Some of the manuscripts, to be sure, were illuminated, but these illuminations were almost always ancillary to the textual record of wonders, just as emblem books were originally textual and only subsequently illustrated. Even in the sixteenth century, when the power of direct visual experience was increasingly valued, the marvelous was principally theorized as a textual phenomenon, as it had been in antiquity. "No one can be called a poet," wrote the influential Italian critic Minturno in the 1550s, "who does not excel in the power of arousing wonder."[7] For Aristotle wonder was associated with pleasure as the end of poetry, and in the *Poetics* he examines the strategies by which tragedians and epic poets employ the marvelous to arouse wonder. For the Platonists, too, wonder was conceived as an essential element in literary art: in the sixteenth century, the Neoplatonist Francesco Patrizi defined the poet as principal "maker of the marvelous," and the marvelous is found, as he put it, when men "are astounded, ravished in ecstasy." Patrizi goes so far as to posit marveling as a special faculty of the mind, a faculty that in effect mediates between the capacity to think and the capacity to feel.[8]

By the later Renaissance these humanistic ideas had begun to influence visual display, so that the ruler's magnificence was increasingly associated with not only possessing but showing wonders. Hence in Prague, in the late sixteenth century, Rudolf II ordered significant reconstruction of the imperial palace in order to provide a suitable ·setting for his remarkable collections. "The emperor's possession of a *Kunstkammer*, the world in microcosm," writes Thomas Kaufmann, "expressed his symbolic mastery of the world."[9] That mastery would be displayed and reinforced in the wonder experienced by those allowed to enter the specially designed rooms. But as admission was limited to visiting dignitaries and ambassadors, the large-scale cultural power of the marvelous remained even in this instance heavily invested in textual transmission; it was the diplomat's report on the wonder of things seen that would enhance the emperor's prestige.

Modern art museums reflect a profound transformation of the experience: the collector—a Getty or a Mellon—may still be celebrated, and market value is even more intensely registered, but the heart of the mystery lies with the uniqueness, authenticity, and visual power of the masterpiece, ideally displayed in such a way as to heighten its charisma, to compel and reward the intensity of the viewer's gaze, to manifest artistic genius. Museums display works of art in

such a way as to imply that no one, not even the nominal owner or donor, can penetrate the zone of light and actually possess the wonderful object. Hence the modern museum paradoxically intensifies both access and exclusion. The treasured object exists not principally to be owned but to be viewed. Even the fantasy of possession is no longer central to the museum gaze, or rather it has been inverted, so that the object in its essence seems not to be a possession but rather to be itself the possessor of what is most valuable and enduring.[10] What the work possesses is the power to arouse wonder, and that power, in the dominant aesthetic ideology of the West, has been infused into it by the creative genius of the artist.

It is beyond the scope of this brief paper to account for the transformation of the experience of wonder from the spectacle of proprietorship to the mystique of the object—an exceedingly complex, overdetermined history centering on institutional and economic shifts—but I think it is important to say that this transformation was shaped at least in part by the collective project of Western artists and reflects their vision. Already in the early sixteenth century, when the marvelous was still principally associated with the prodigious, Dürer begins, in a famous journal entry describing Mexican objects sent to Charles V by Cortés, to reconceive it:

> I saw the things which have been brought to the King from the new golden land: a sun all of gold a whole fathom broad, and a moon all of silver of the same size, also two rooms full of the armour of the people there, and all manner of wondrous weapons of theirs, harness and darts, wonderful shields, strange clothing, bedspreads, and all kinds of wonderful objects of various uses, much more beautiful to behold than prodigies. These things were all so precious that they have been valued at one hundred thousand gold florins. All the days of my life I have seen nothing that has gladdened my heart so much as these things, for I saw amongst them wonderful works of art, and I marvelled at the subtle *ingenia* of men in foreign lands [*Dann ich hab darin gesehen wunderliche künstliche ding und hab mich verwundert der subtilen ingenia der menschen in frembden landen*]. Indeed, I cannot express all that I thought there.[11]

Dürer's description is full of the conventional marks of his period's sense of wonder: he finds it important that the artifacts have been brought as a kind of tribute to the king, that large quantities of precious metals have been used, and that their market value has been reckoned; he notes the strangeness of them, even as he uncritically

assimilates that strangeness to his own culture's repertory of objects (which includes harnesses and bedspreads). But he also notes, in perceptions highly unusual for his own time, that these objects are "much more beautiful to behold than prodigies" (*das do viel schöner an zu sehen ist dan wunderding*). Dürer thus relocates the marvelous artifacts from the sphere of the outlandish to the sphere of the beautiful, and, crucially, he understands their beauty as a testimony to the creative genius of their makers: "I saw amongst them wonderful works of art, and I marvelled at the subtle *ingenia* of men in foreign lands."[12]

It would be misleading to strip away the relations of power and wealth that are encoded in the artist's response, but it would be still more misleading, I think, to interpret that response as an unmediated expression of those relations. For Dürer stands at an early stage of the West's evolution of a categorical aesthetic understanding—a form of wondering and admiring and knowing—that is at least partly independent of the structures of politics and the marketplace.

This understanding, by no means autonomous and yet not reducible to the institutional and economic forces by which it is shaped, is centered on a certain kind of looking, the origins of which lie in the cult of the marvelous and hence in the artwork's capacity to generate in the spectator surprise, delight, admiration, and intimations of genius. The knowledge that derives from this kind of looking may not be very useful in the attempt to understand another culture, but it is vitally important in the attempt to understand our own. For it is one of the distinctive achievements of our culture to have fashioned this type of gaze, and one of the most intense pleasures that it has to offer. This pleasure does not have an inherent and necessary politics, either radical or imperialist, but Dürer's remarks suggest that it derives at least in part from respect and admiration for the *ingenia* of others. This respect is a response worth cherishing and enhancing. Hence, for all of my academic affiliations and interests, I am skeptical about the recent attempt to turn our museums from temples of wonder into temples of resonance.

Perhaps the most startling instance of this attempt is the transfer of the paintings in the Jeu de Paume and the Louvre to the new Musée d'Orsay. The Musée d'Orsay is at once a spectacular manifestation of French cultural *dépense* and a highly self-conscious, exceptionally stylish generator of resonance, including the literal resonance of voices in an enormous vaulted railway station. By moving the Impressionist and Post-Impressionist masterpieces into proximity with the work of far less well known painters—Jean Béraud, Guillaume Dubuffe, Paul

Sérusier, and so forth—and into proximity as well with the period's sculpture and decorative arts, the museum remakes a remarkable group of highly individuated geniuses into engaged participants in a vital, immensely productive period in French cultural history. The reimagining is guided by many handsomely designed informational boards—cue cards, in effect—along, of course, with the extraordinary building itself.[13]

All of this is intelligently conceived and dazzlingly executed—on a cold winter day in Paris I looked down from one of the high balconies by the old railway clocks and was struck by the evocative power of the swirling pattern formed by the black and gray raincoats of the spectators milling below, passing through the openings in the massive black stone partitions of Gay Aulenti's interior. The pattern seemed spontaneously to animate the period's style—if not Manet, then at least Caillebotte; it was as if a painted scene had recovered the power to move and to echo.

But what has been sacrificed on the altar of cultural resonance is visual wonder centered on the aesthetic masterpiece. Attention is dispersed among a wide range of lesser objects that collectively articulate the impressive creative achievement of French culture in the late nineteenth century, but the experience of the old Jeu de Paume—intense looking at Manet, Monet, Cézanne, and so forth—has been radically reduced. The paintings are there, but they are mediated by the resonant contextualism of the building itself, its myriad objects, and its descriptive and analytical plaques. Moreover, many of the greatest paintings have been demoted, as it were, to small spaces where it is difficult to view them adequately—as if the design of the museum were trying to assure the triumph of resonance over wonder.

But is a triumph of one over the other necessary? For the purposes of this paper, I have obviously exaggerated the extent to which these are alternative models for museums: in fact, almost every exhibition worth viewing has elements of both. I think that the impact of most exhibitions is likely to be enhanced if there is a strong initial appeal to wonder, a wonder that then leads to the desire for resonance, for it is generally easier in our culture to pass from wonder to resonance than from resonance to wonder. In either case, the goal—difficult but not utopian—should be to press beyond the limits of the models, cross boundaries, create strong hybrids. For both the poetics and the politics of representation are most completely fulfilled in the experience of wonderful resonance and resonant wonder.

NOTES

1. Thomas Greene, *The Vulnerable Text: Essays on Renaissance Literature* (New York: Columbia University Press, 1986), 100.

2. My view of these Jewish artifacts was eloquently disputed in Washington by Anna R. Cohn, one of the organizers of The Precious Legacy, a traveling museum exhibition of Judaic objects from the State Jewish Museum. I am grateful for Ms. Cohn's intervention and wish to emphasize that I am only calling attention to what I regard as a *relative* difference between liturgical art in the Jewish and Christian traditions.

3. Quoted in Linda A. Altshuler and Anna R. Cohn, "The Precious Legacy," in David Altshuler, ed., *The Precious Legacy: Judaic Treasures from the Czechoslovak State Collections* (New York: Summit, 1983), 24. My sketch of the genesis of the State Jewish Museum is largely paraphrased from this important and moving account.

4. Altschuler and Cohn, "Precious Legacy," 36.

5. In effect, that dream of possessing wonder is at once aroused and evacuated in commerce as well, since the minute the object (shoe or dress or soup tureen) is removed from its magical pool of light, it loses its wonder and returns to the status of an ordinary purchase.

6. Jean de Joinville, *Life of Saint Louis*, in *Chronicles of the Crusades*, trans. M.R.B. Shaw (Harmondsworth: Penguin, 1963), 315.

7. Quoted in J. V. Cunningham, *Woe or Wonder: The Emotional Effect of Shakespearian Tragedy* (Denver: Alan Swallow, 1960 [1951]), 82.

8. Baxter Hathaway, *Marvels and Commonplaces: Renaissance Literary Criticism* (New York: Random House, 1968), 66–69.

9. Thomas da Costa Kaufmann, *The School of Prague: Painting at the Court of Rudolf II* (Chicago: University of Chicago Press, 1988), 17.

10. It is a mistake, then, to associate the gaze of the museumgoer with the appropriative male gaze about which so much has been written recently. But then I think that the discourse of the appropriative male gaze is itself in need of considerable qualification.

11. Quoted in Hugh Honour, *The New Golden Land: European Images of America from the Discoveries to the Present Time* (New York: Pantheon, 1975), 28. The German original is in Albrecht Dürer, *Schriftlicher Nachlass*, ed. Hans Rupprich (Berlin: Deutscher Verein für Kunstwissenschaft, 1956), 1:155.

12. Dürer's own words, *"wunderliche künstliche ding,"* carefully balance the attribute of wonder and the attribute of artfulness.

13. It could be argued that the resonance evoked by the Musée d'Orsay is too celebratory and narrow. The cue cards tend to exalt French culture at the expense not only of individual genius but of society: that is, while the cards help the reader grasp the vitality of collective genres and styles in this period, they say very little about the conflicts, social divisions, and market forces that figured in the history of the genres and the development of the styles. But even if the cards were "improved" ideologically, the overwhelming meaning of the museum experience would, I think, remain fundamentally the same.

CHAPTER 4

The Poetics of Exhibition in Japanese Culture

MASAO YAMAGUCHI

All of us already have the experience of being confronted with exposition. Toy shops, for example, may have been one of the first spaces of exhibition many of us encountered. These fascinating spaces provoke us with thousands of objects that stimulate the imagination. Ordinary shops, too, tend to be spaces for exhibition, although we are not usually aware of their effects, which can vary over time and from culture to culture. A consideration of the booths of the fairground throws into relief the deliberate nature of exhibition we see in shops. Usually the fairground booths are built in a space that is ordinarily empty. The appearance of built objects in this type of space signals a transmutation in the flow of time and in the continuity of ordinary space. The act of transformation that occurs in the fairground brings to overt consciousness the exhibiting frame that organizes the display of goods in shops.

When shopkeepers became aware of how goods could be exhibited, they started to use windows as a kind of showcase, foregrounding certain objects so as to seduce people into buying a wide range of goods. The shop window becomes a theater for merchandising in much the same way as a circus parade displays a portion of the main show in order to provoke onlookers into attending the entire performance being put on inside the circus tent. The rise of the great de-

partment stores in the nineteenth and twentieth centuries saw the store become an exhibition space for commercial goods.

A similar array of intentional exhibitions constitutes a major part of Japanese life, not only in highly stylized settings such as court life or theater but also in the contexts of everyday life, such as in shops and homes. One of the techniques with which Japanese accentuate the hidden aspects of objects in both everyday life and artistic contexts is called *mitate*. *Mitate* is, in a sense, the art of citation. When an object is displayed on ceremonial occasions, for example, a classical reference—one familiar to anyone knowledgeable about history or the classics—is assigned to that object so that the immediate object merges with the object that is being referred to. One well-known example of *mitate* is in an episode described in a collection of short essays called *Makura no soshi* (*Pillow-Book*), written by Sei Shonagon, a court lady of the late tenth and early eleventh centuries. In this episode a princess asks her ladies-in-waiting what name they would give a scene of a snow-covered mound in a garden. One of them immediately replies, "The snow on Mount Koro in China" (Koro is the mountain well known in the classics for the beauty of its scenery after a snowfall). The image of the snow-covered mound was given a mythological dimension by associating it with a well-known image from the Chinese classics. *Mitate*, then, is the technique used to associate objects of ordinary life with mythological or classical images familiar to all literate people.

Japanese use *mitate* to extend the image of an object. By so doing they transcend the constraints of time. *Yama*, for example, is a popular word in the Japanese vocabulary of the imagination. The word *yama* originally denoted mountain, but became associated with and assimilated to the place where deities reside. In this way *yama* took on the sense of a mediating space between humans and gods. A physical representation of *yama* can be either a small mound of sand or a cart with a stage on it that is carried by participants in a festival procession.

Other kinds of *yama*—that is, other kinds of spaces that mediate between humans and gods—have nothing to do with mountains and are not named after the word for mountain, but still represent gods and are thought to carry the messages of gods. In every Japanese house of traditional style there is a space called *tokonoma*, where decorated objects are shown. *Tokonoma* functions as a kind of space of exhibition in daily life and domestic settings. Usually an arrangement of flowers is shown against the wall, with a picture scroll hung behind it.

Each family changes the scroll according to the passing of the seasons and the varying arrangements of flowers. The idea of *yama* can also be found in objects placed on the roofs of traditional houses. In certain parts of Japan, such objects mark a particular part of the house as sacred space. As another example, samurai casques (helmets) were topped with decorations that certain scholars describe as a kind of *yama*.

The concept of *yama* is noticeable in the performing arts. In kabuki of the Tokugawa period (from the beginning of the seventeenth century until the middle of the nineteenth century), a huge picture was hung over the entryway. This is thought to have been the device whereby divine dynamism was mediated in the space of performance. The highly decorated clothes that actors wore are thought to have been yet another expression of *yama*. It was explicitly understood that it was the clothes that performed, rather than the actors themselves. Theater was a kind of showcase for the traces of gods, who showed their presence in the form of decorated clothes. Actors were the machinery of the gestural movement. The meaning of the clothes emerges clearly in an example from northeastern Japan. Each house in the region possesses one small figurine, called *osira-sama*. Once a year a shaman, called *itako*, visits the house and puts new clothes on the figurine. The clothing is changed annually because it absorbs the polluted elements of the house; a special ritual enables the *osira-sama* clothing to be disposed of safely. In this example, as in the example from kabuki, the spirits of gods are incorporated in the clothes themselves, not in the *osira-sama* figurine or the body of the actor. Figurines and actors are merely the objects that support the clothing, which is the real manifestation of gods.

Another example of the mediating role of clothing can be found in the folk theater performances called *yamabushi-kagura*, also in northeastern Japan. Family members who buy new clothes (especially those to be used in a daughter's marriage) ask *yamabushi-kagura* performers to wear the newly bought clothes so that the spirits of gods are absorbed into them. New clothes contain strange and dangerous forces that must be blocked from harming the people who wear them. A similar motive can be seen in the custom of manufacturers entrusting new styles of kimonos to strolling female performers: dangerous effects are blocked through the mobile exhibition of the new styles. Similar reasons account for the Japanese custom of drying washed clothes in the open. These examples are all kinds of exhibition in

everyday life, and demonstrate that the art of exposition has been long established in various forms as a significant means of communication in Japanese society.

By way of contrast, let us consider the way that self-conscious exposition developed in the West during the nineteenth century. In 1867 Louis Napoleon organized the Paris Exposition for the purpose of impressing the world with the stability of his government. The objects in the exposition became the heroes of this new type of festival, in which objects of everyday life were divorced from the contexts to which they originally belonged. Through exhibition these objects acquired new levels of significance as emblems of the power of the régime that organized the space of exposition.

Exhibitions in public spaces in European cultures more or less limited themselves to the display of objects. The space called the "museum" refused from the very beginning to admit the smells and sounds of everyday life. Until the 1867 exposition the experiences and scenes of everyday life had been excluded from pictorial space, which tended to portray ceremonies and scenes from classical mythology. The Paris Exposition encouraged the display of everyday objects in a manner similar to the display of high art in order to demonstrate the wide distribution of social wealth in the newly established society as it contrasted to the *ancien régime*. Via the exposition, the new régime was able to express contemporary feelings about objects and lives. The result was that objects originally meant for sale as commodities were elevated to the status of "art" by being associated (through the mode in which they were displayed) with paintings and sculpture that portray a mythical world. In a sense, this is the converse of Japanese exhibiting practices, in which unseen realities are authorized through their manifestations in objects.

Of course, commodities in their original contexts were not meant to be of artistic value. They turn into a kind of simulacrum of life once they are taken out of the flow of life, and acquire a kind of autonomy at the cost of their position in relation to everyday life. However, at least they start to be appreciated as art objects.

In England a similar process can be seen in the movement started by William Morris to find positive artistic value in crafts, which also promoted the independence of commodities from their initial contexts. One of its consequences was the Art Deco style, manifested in its most extreme form at the 1932 World Expo in Chicago. Art Deco went so far as to turn the objects of everyday life into a style for its own sake.

When things are taken out of everyday life, they are regrouped and renamed. The act of display thus involves the process of classification and presupposes naming. Museum collections were originally based on such an undertaking. In its initial stage, the museum was the space of display for collected and classified objects, and, naturally, was charged with the ideology of the sponsor who made the display possible. The Louvre provides an example: its origins are mainly in the collection of Louis XIV, and it was intended to show how the world was ordered around the France of the Bourbon dynasty. As another example, the political processions of Tudor England, under the artistic direction of Inigo Jones, took place in spaces in which artistic objects had been put together temporarily to meet the political needs of the time and reinforce the images of power.[1] In short, public displays are one of the means used to produce the meanings that are characteristic of an age. Expositions and museums are comparable in this regard.

An object, as we have noted, begins to reveal a somewhat different meaning when it is drawn out of its original context and put into a setting that evokes the totality of cultural relations and makes that totality part of its defining frame. The latent meaning that is implicit and unnoticed when an object is in its everyday context becomes manifest in display. The act of collection involves processes of making latent meaning manifest. Display, therefore, is the artistic creation of new sensitivities toward the world.

The classical style of display fixes an object in a certain space, which is arranged according to overtly known systems through which the world is classified. In art museums and cultural-history museums, objects are generally arranged according to their place in the historical succession of time. The relationships of objects in time are transposed into a spatial context, and that regrouping is imprinted in the memory of visitors. This transformative capacity of museums, their ability to function as machines for turning time into space, enables them to be used as an apparatus of social memory. The parallel with systems of totemic classification, whereby human groups are classed with natural species, should be obvious. Lévi-Strauss[2] showed totemism to be a system for classifying natural and social objects. We can extend his analysis and argue that totemism is an imaginary museum in which objects are mental, not physical.

Museums are only a special instance of a more general cultural and cognitive process whereby objects acquire their meanings through association with *knowing* rather than *sensing*. Frances Yates showed in her *Art of Memory*[3] that there exist alternative methods of display

that can function as means for the transmission of knowledge. One of her examples is drawn from theater. Theaters in the Renaissance period were built in terms of Neoplatonic systems of thought. They were mirrors designed to reflect the system of the universe: elements of their architecture and the actions that occurred inside them acquired meaning by representing the total system of the universe. According to Yates, this way of knowing the world is even extended to the way monuments are placed in urban squares and plazas as the means of completing the cosmological structure of urban space. Anthropologists have long noticed how, in other cultures, villages may be constructed according to cosmological schemes. They have taken interest in the ways that a culture's spatial concepts are manifested, for example, the way a village can be constructed on the basis of concepts of mythical topography. In these forms of construction, in ways of building things and placing objects, even in much modern architecture, the visible is merely a clue to the invisible.[4]

This last observation shows us that the Japanese material described in the beginning of the article is a culturally specific and highly elaborate instance of the more general tendency of cultures to display the invisible through the visible ordering of objects. In what follows, I discuss Japanese semantics and practices related to objects in order to demonstrate how a thoroughgoing theatrical worldview can organize even the appropriation of aspects of the material world.

The concept of object in Japanese is expressed by the word *mono*. Originally *mono* referred to the roots an object had in both the visible and invisible dimensions of the world. Only in recent times has the word *mono* come to be understood in a purely materialistic sense. *Mono* therefore used to be the expression of organic existence, in contrast to the modern definition of *mono* as something made of inorganic material.

Japanese culture developed techniques of display that were intended to make the invisible aspects of *mono* visible by means of materialized *mono*. Put another way, we can say that these techniques were used to demonstrate the chain of possible events by which the material world is constituted. This involves a dialectic whereby the visible emerges out of the invisible background that surrounds an object. The display of visible objects is also a means for perceiving the fullness of reality. This type of display is usually more feasible in the space of theater, as was shown by Frances Yates. In certain types of Noh theater, for example, there is always a shaman-priest character in the performance. The shaman-priest is able to perceive the existence of

local spirits in each of the places he visits in his journeys throughout the country. His perceptions lead to the apparition of demons closely related to the history or legends of that particular place. This capacity of the priest to make manifest the local demons is evidence of his competence to react to the calling of *mono*. This set of practices is an apparatus by means of which the submerged part of collective memory can take shape. Practices such as those of the shaman-priest are privileged entrées to the code with which the subconscious layer of cultural memory lying beyond the object can be read.

Objects (inanimate *mono*) connect the visible elements that constitute the surroundings of an individual with the invisible totality of the world. In contrast to the practices of the shaman-priest, this connection is nowadays typically achieved through display. The influence of *mono* results from the places in which objects are found and from the ways they are used. *Mono* connotes not a single existence, but rather plural existences constituted by virtue of their connection with other things. *Mono* has two faces, as I have noted above: an aspect amenable to classification and description, and another that easily escapes the analytical approach. The second aspect is usually understood as a random or chaotic element, like noise. Noise resists the classified order, and is considered to be evidence of entropy in most cultural systems. However, this seemingly random and chaotic phenomenon is actually the point at which a new system makes its first appearance.

Once again, the Japanese material I have discussed here is but a culturally specific instance of a more general process: the making, breaking, and remaking of systems of classification. We define the first appearance of a new system of meaning as "noise" because we do not know how to classify such a system. As an example, librarians are often confronted with the problem of classifying new types of books. New territories of subjects and topics are amalgamations of what cannot be placed in existing arrays. These new topics appear as total chaos when they are taking shape. However, there are people who take chaotic phenomena as manifestations of things hitherto unknown, perceiving them as a kind of syndrome. The same can be said of display. Acts of display do not necessarily cover territories that are well explained and easily classifiable. They involve an intellectual venture into that which is inexplicable and incapable of classification in order to search for new types of order. One of the senses of the word *cabinet* denotes the space in which unclassifiable things are kept for the while (e.g., the cabinet of Dr. Caligari). In Europe the first muse-

ums were derived from Renaissance cabinets of curiosities. The cabinet is an apt metaphor for the first act of classification. Sorting things follows the act of sweeping them up. Sorting is the act of bringing order to personal space in order to establish cosmic order at large.

So far I have been discussing Japanese representation of immobile objects. However, objects are often represented in processions. In Japan, procession is called *neri* (snake-going), and processions used to be a very familiar scene on streets of traditional cities. Festive processions were called *furyu* in Japanese. *Furyu* is associated with certain kinds of festivals exhibiting strong associations with the cult of the dead. In a word, *furyu* has a spirit similar to that of the baroque. It is not a radical novelty in reference to the objects used in the festival. It can be shown in the drawing on the huge lantern or in the masked dance.

Spirits of *furyu* supplied the art of representation in Japan with an essential vision. As an example, a cooked meal or cakes were one of the most important elements constituting the altar of classical temples in traditional Japan. The celebration of Matara in the Temple Motsu in Hiraizumi is a good example. During this celebration cakes are displayed on a small carrier shaped like three mountains surrounded by a paper called the cloud. A performance called "In Praise of the Cakes" is carried out. This mound of cakes is modeled after Mt. Meru, the center of the world in Japanese cosmology.

The fabrication of something that is modeled after a primordial object is called *tsukuri* (Figure 4-1). For example, the arrangement of raw fish on a plate is called *o-tsukuri* (*o* is an honorable prefix) and means the arrangement of slices of raw fish in the shape of Mt. Meru. *Tsukuri* is a device used to associate something in immediate view with the primordial things of distant part. This returns us to the beginning of this paper, for the very act of connecting is termed *mitate* by the Japanese.

Mitate is something close to the idea of a simulacrum, a concept made popular by Jean Baudrillard.[5] *Mitate* is always a pseudo-object. In kabuki, everything is a simulacrum of what has been extant for a very long time. However, primordial things, in turn, are simulacra of what belongs to gods. It is understood that Japanese gods do not appreciate true things; they do not accept things that are not fabricated by means of a device (*shuko*). One must add something to that which already exists in order to present it to gods or to show it in public. The art of flower arrangement (*ikebana*) originated in the

Fig. 4-1. *A platform in the shape of an island of furyu. On the back of a tortoise (which represents a cosmic island) are a crane, a pine tree, a Japanese apricot, and daffodils.* From Masakatsu Gunji, *Furyu no zuzoshi,* copyright 1987 by Sanseido Press, Tokyo.

tradition of *furyu,* and was meant to astonish gods with its ingenuity. It is the adding of something different—an act of eccentricity.

Mitate, in its original sense, was an exposition presented to the gods. The word *mitate* is itself composed of two words: *mi* (to see) and *tate* (to stand, to arrange). *Mitate* objects were often accompanied by *iitate* (*ii,* "to say"). *Iitate* is the narrative text that accompanies the *mitate.* Kabuki is explained by Masakatsu Gunji as having originated in *mitate* accompanied with *iitate* (or *tsurane,* a stylized form of discourse found in kabuki).[6]

Figure 4-2 shows an acrobatic performance in which an actor dramatizes the well-known historical event in which a three-year-old emperor was rescued, along with a sacred royal sword, when he was about to perish in the sea during the final battle of the twelfth-century civil war. In Figure 4-2 one can see the way in which the historical event is transformed in the theater into the shape of a mountain. This seems to have been the ideal of exposition: sacred reality is manifested through the mediation of history, mythological topography, performance, and exhibition of objects.

The Japanese are often accused of aping Western technology, and sometimes do not seem overly offended by that accusation. One of the

Fig. 4-2. *A celebrated actor of the Tokugawa period dramatizing a well-known historical event in which Tomomori Taira rescues the infant emperor, Antoku, and a sacred royal sword, using the point of an anchor.* From Masakatsu Gunji, *Furyu no zuzoshi,* copyright 1987 by Sanseido Press, Tokyo.

reasons for this may be that they think of imitation as following the tradition of *tsukuri.* In the middle of the nineteenth century, the Japanese believed the Western world to be something like a utopia presided over by gods. In the spirit of *mitate* the Japanese decided to transplant the constituent elements of the Western world into their own country. The force of tradition was largely responsible for the success of this endeavor. The Japanese attitude toward things is aptly expressed in the work of Baudrillard, the semiotician who started to use the word *simulacrum* not necessarily in a negative sense, denoting the fake, but as a description of a positive process. In this paper this sense of simulacrum is considered to be something like a rhetoric that turns the invisible into the visible.

Japanese myth contains several accounts of fake gods encountering real gods. In general, it seems to have been believed that the pseudogods appeared in the world first, and then were followed by the real ones. Sometimes fake things are thought to appear to be more real

than the real gods themselves. Japanese myth may be able to teach us a contemporary lesson. The dialectics of the real and the fake seem to be one of the most provocative aspects of the art of representation today. All exhibitions suffer from the condition of being fake. However, they acquire the status of the authentic when they are placed into a theatrical context. The art of representation in Japanese tradition shows this process of theatricalization clearly and self-consciously.

NOTES

1. *The King's Arcadia: Inigo Jones and the Stewart Court: A Quarter-Century Exhibition Held at the Banqueting House, Whitehall* (London: Arts Council of Great Britain, 1973).

2. Claude Lévi-Strauss, *Totemisme aujourd'hui* (Paris: PVF, 1962).

3. Frances Yates, *The Art of Memory* (Chicago: University of Chicago Press, 1966).

4. See James W. Fernandez, *Fang Architectonics* (Philadelphia: Institute for the Study of Human Issues, 1977), and T. O. Beidelman, *Moral Imagination in Kaguru Modes of Thought* (Bloomington: Indiana University Press, 1986).

5. Jean Baudrillard, *Pour une critique de l'économie politique du signe* (Paris: Gallimard, 1972).

6. Masakatsu Gunji, *Furyu no zuzoshi* (Tokyo: Sanseido, 1987).

CHAPTER 5

Another Past, Another Context: Exhibiting Indian Art Abroad

B. N. GOSWAMY

Pure aesthetic experience [*rasa*] is theirs in whom the knowledge of ideal beauty is innate; it is known intuitively, in intellectual ecstasy without accompaniment of ideation, at the highest level of conscious being; born of one mother with the vision of God, its life is as it were a flash of blinding light of transmundane origin, impossible to analyze, and yet in the image of our very being.

VISWANATHA KAVIRAJA

A work of art elicits and accentuates this quality of being a whole and of belonging to the larger, all inclusive, whole which is the universe in which we live. This fact, I think, is the explanation of that feeling of exquisite intelligibility and clarity we have in the presence of an object that is experienced with aesthetic intensity. It explains also the religious feeling that accompanies intense aesthetic perception. We are, as it were, introduced into a world beyond this world which is nevertheless the deeper reality of the world in which we live in our ordinary experiences. We are carried out beyond ourselves to find ourselves.

JOHN DEWEY

The two exhibitions upon the intimate experience of which I draw here (Rasa: les neuf visages de l'art Indien, Grand Palais, Paris, 1986; Essence of Indian Art, Asian Art Museum, San Francisco, 1986)[1] began with the first visit of a group of French colleagues to India in 1983. The holding of the Festival of India in France had been negotiated and

announced. Quite naturally, a major exhibition of Indian art was to figure prominently in it, but till then no real thought had been given to its theme or range. Things were wide open, and we were going to speak of various possibilities. In the course of discussions, when the subject of the exhibition of art at the Grand Palais came up, my French colleagues stated that they were interested in an exhibition that would not be just an expansion of the fine exhibition of Indian art that had been held at the Petit Palais a few years back,[2] nor a show that simply presented "masterpieces" of Indian art. They were interested in an exhibition that *said* something. They had a highly sophisticated museumgoing public that was not as easily appeased as audiences "elsewhere," one of them stated with a Gallic twinkle.[3] I responded quickly by asking them if they would be interested in an exhibition that approached Indian art through *rasa*. The idea and even the word were unfamiliar to them, but there was a sudden spark of interest. I explained, in the broadest possible manner, how *rasa* (roughly, "aesthetic delight") was related to art in the Indian tradition; conversely, how art was understood in the context of *rasa*. If one could take this approach to Indian art, it might become more accessible, I argued. An animated discussion ensued, at the end of which the mood was one of agreement and enthusiasm. Accessibility seemed to be the key word. We were vaguely aware that this was something of a dark plunge, for nothing along these lines had been essayed before in the area of the visual arts, even in India. Despite the hazard that such an approach involved, though, there was lurking excitement. We agreed to discuss and explore this idea further.

In the months that followed we all had our share of doubt and uncertainty. The French sent two bright young curators to work with me and to acquaint themselves with the collections that I was going to draw upon (and, I suspect, with the workings of my mind). They were legitimately unsure of how well the idea of *rasa* was going to come across to French audiences through objects. On my part, I was grappling with the concept and working out ways to present meaningfully what was, from the French viewpoint, an alien art and an alien conceptual framework. There was obvious appeal in the idea, but equally obvious pitfalls and difficulties. Not everything in Indian art could be approached from this angle; one might not be able to locate enough objects of high quality in each category of *rasa*; there was also the fear that because of the unfamiliarity of the concept, the exhibition might become too wordy and the concept might eventually come to overshadow the art. I thought of falling back upon alternative, more con-

servative approaches: it was possible to present a selection of great paintings and sculptures as high points in Indian culture, but that had been done all too often before. It would also be possible to explore a given period in depth through objects, but to an audience generally unfamiliar with the history of Indian art, or even of India, that might mean very little; in any case there was a general wish that the exhibition should cover a wide range of Indian art, establishing its antiquity as much as its breadth. One could take a sharply defined category of great works, such as Chola bronzes, Mughal paintings, or Gupta stone sculptures, but then that would leave out so much else. From the past of India it was not easy to take an individual artist and present his oeuvre, for identifying the work of a single artist from a tradition that is for the most part emphatically anonymous presents almost insuperable difficulties.

Compared to all these possibilities, relating art to the experience of art appeared to be a far more attractive idea. Through the concept of *rasa*, it might be possible to provide to the non-Indian general viewer an entrée into Indian art, for the nine *rasas* were central to the context of Indian art. It might be unfashionable to speak of *rasa* now, but it was an experience that the Indian viewer traditionally always associated with art. In presenting art objects with reference to the emotions they aroused or heightened in the viewer's mind, one would be using categories that were appropriate to the art.

Rasa is a key to Indian art, and deserves to be better understood. It is easily the most important of terms in the Indian theory of art. The first reasoned treatment of it is found in Bharata Muni's *Natyasastra*,[4] which is dateable to the early centuries of the Christian era and deals primarily with the arts of the theater. The term has been used most often in the context of the arts of performance—theater, dance, and music—even though it is mentioned specifically in other texts[5] as extending to all the arts, and literary theorists have always adverted to it. Among the most refined discussions of the theory of *rasa* are those by rhetoricians of the medieval period.

In the most general of ways, the average listener, viewer, or reader in India has often seen art as being intimately connected with *rasa*, indeed even as being valid only to the extent that it leads to a *rasa* experience (art being inherently "a well-spring of delight, whatever may have been the occasion of its appearance"[6]). The idea of *rasa* is something that the average viewer or listener feels at home with, even if its subtleties, and the discussions that have centered on it for several centuries, are often beyond his or her ken.

At the physical level the word *rasa* means sap or juice, extract, fluid. It signifies, in its secondary sense, the nonmaterial essence of a thing, the best or finest part of it—like perfume, which comes from matter but is not easy to describe or comprehend. In its subtlest sense, however, *rasa* denotes taste, flavor, relish; but also a state of heightened delight that can be experienced only by the spirit (*ananda*). When one experiences a work of art, the experience is likened to the tasting of a flavor, the taster being the *rasika* and the work of art the *rasa-vanta*. In the singular, *rasa* is used in the absolute sense, "with reference to the interior act of tasting flavour unparticularised."[7] In the plural, the word is used relatively with reference to the various, usually eight or nine,[8] emotional conditions that may constitute the burden of a given work and that the listener or viewer can experience. These conditions, or sentiments, are the erotic (*shringara*), the comic (*hasya*), the pathetic (*karuna*), the furious (*raudra*), the heroic (*vira*), the terrible (*bhayanaka*), the odious (*bibhatsa*), the marvelous (*adbhuta*), and the quiescent (*shanta*).

The notion is that *rasa,* or aesthetic delight, is a unity, but comes within the reach of the viewer through the medium of one of these sentiments. At the same time, *rasa* being essentially an experience, it does not inhere in the art object; it belongs exclusively to the viewer or listener, who alone can experience it. How *rasa* arises and is "tasted" has been the subject of a sustained, refined debate among scholars and theoreticians for close to fifteen hundred years. But, broadly, the process is conceived thus: each *rasa* has its counterpart in what is called a *bhava*, a dominant feeling or mood. Thus, the erotic sentiment, the *rasa* called *shringara,* has *rati* (love) as its corresponding *bhava;* the comic sentiment has *hasa* (mirth or playfulness) as its *bhava,* and so on. *Bhava* belongs to the work, and can be consciously aimed at by its maker or performer. How this *bhava* (enduring psychological state) comes into being in its own turn has been described in fine, eloquent words by past theorists. For a specific *bhava* to rise to the surface in a work or performance, the mood is carefully built up with the use of appropriately chosen *vibhavas* (determinants), essentially "the physical stimulants to aesthetic reproduction, particularly the theme and its parts, the indications of time and place and other apparatus of representation—the whole factibile."[9] Another input is that of *anubhavas,* or appropriate consequents, consisting of gestures and movements in consonance with the mood of the work. There are then the complementary (transient) emotional states (*vyabhichari bhavas*), especially relevant to the arts of theater and dance and comprising a

wide range of emotions, from agitation to fright to envy and indecision. It is these determinants, consequents, and complementary emotional states that work on the mind of the viewer or listener, "churning his or her heart." From this churning a dominant emotional state, a *bhava* that is durable, emerges.

But then suddenly something else happens: the *bhava* transmutes itself into *rasa*, which the viewer or listener experiences. This does not happen uniformly every time. There are many preconditions that the texts speak of: the viewer must be cultured or sensitive enough; the work or performance must be alive with *bhava;* the moment must be right; the heart must be capable of receiving; and so on. But if these and other conditions are present, wonderful things happen: a spark leaps from the performance to the viewer, suffusing his or her entire being. *Bhava* turns into *rasa*. The experience can be overpowering, for it comes often like a flash of lightning, catching the viewer unprepared for the moment, and leaving him or her deeply moved. This is the moment when, as later writers put it, "magical flowers would blossom" in the viewer's awareness: *rasa* is tasted.[10] The experience cannot be consciously worked toward; the moment comes unpredictably; but when it comes, it does so with blinding swiftness, yielding the same inscrutable delight that the seeker experiences upon coming face to face with the unknowable.

It is clearly stated that the same viewer may have the *rasa* experience from viewing an object or performance at one time and not have it at another; the intensity one viewer experiences may be different from another's. There are many imponderables and many factors intervene, but the experience is real, and can be intense. It is stated again and again that the experience belongs to the viewer; the work of art is a vehicle. In the fine skein of this theory many strands of thought come together. Coomaraswamy puts it with his usual succinctness:

> The conception of the work of art as determined outwardly to use and inwardly to a delight of the reason; the view of its operation as not intelligibly causal, but by way of a destruction of the mental and effective barriers behind which the natural manifestation of the spirit is concealed; the necessity that the soul should be already prepared for this emancipation by an inborn or acquired sensibility; the requirement of self-identification with the ultimate theme, on the part of both artist and spectator, as prerequisite to visualization in the first instance and reproduction in the second; finally, the conception of ideal beauty as unconditioned by natural affections, indivisible, supersensual, and indistinguishable from the gnosis of God—all these

characteristics of the theory demonstrate its logical connection with the predominant trends of Indian thought, and its natural place in the whole body of Indian philosophy.[11]

Much of this sounds esoteric and mysterious, and one cannot be sure how much the intellectual operations behind *rasa* and *bhava* were understood by the average Indian viewer of the past. But there seems to be little doubt that art and *rasa* were very closely connected in the Indian mind. It was not easy to think of one without the other. I have cited elsewhere my encounter with that great connoisseur of the arts of India, the late Rai Krishnadasa of Benares, to whom I once took a small inquiry of mine concerning the date and the style of a painting. Rai Krishnadasa heard my questions out with his usual grace and patience, but then he leaned back on the comfortable round bolster of his simple divan and said softly: "These questions I will now leave to you eager historians of art. All that I want, at this stage of my life"—he was past seventy years of age then and in frail health—"is to taste *rasa*." Nobody knew better than Rai Krishnadasa the answers to the questions I had taken to him at that time, but somehow he had moved on to, or back toward, what in his eyes was the real meaning or purpose of art.

To get back to the exhibition: Quite obviously, presenting Indian art through the concept of *rasa* had its limitations. It ran the risk of being dismissed as old-fashioned (even though it had never been attempted before!) or viewed more charitably as quaint. It was clear at any rate that not all art in India could be brought within the compass of *rasa*. It was easy to think of whole areas of Indian art that would be difficult to relate to *rasa* in the conventional sense: there is a substantial part of art that is simply genre, related to daily life, observation that describes and records without direct reference to *rasa*. Many other significant areas springing from Islamic or mixed sources—Mughal and Deccani painting, for instance—could be described as showing no awareness of *rasa*. Portraiture would be left out almost as a matter of course. Even much religious art, with its iconic representations or narrative episodes, would not be included unless the traditional nine *rasas* were to be expanded to include the *rasa* of devotion (*bhakti*), as some writers did.[12] But all this notwithstanding, somehow *rasa* is—was—real, and integrally related to art in the Indian mind. It informed art as a whole; it was the golden thread that shot through it. To approach art through it, then, might not only bring the non-Indian viewer closer to a major segment of Indian art but—a greater gain—

closer to the Indian mind. This became the governing consideration when, casting doubts and hesitation aside, I chose finally to stay with *rasa* as the pivot of the exhibition.

This decision taken, I chose, from a very large number of Indian collections both public and private, such works as spoke to me in a clear voice. These I then ordered into nine sections, each corresponding to the *rasa* the works might evoke in the viewer. In determining the order of the works within the ambit of each *rasa*, with clear intent I mixed sculptures with paintings in the show, placing a sixth-century piece in stone next to an eighteenth-century miniature on paper, and so on. There was careful avoidance of any chronological framework. From this exhibition, no viewer could possibly have gained any idea of the historical development of Indian art, or become involved in the kinds of art-historical questions that so many exhibitions lead to. There was just the barest information concerning date or approximate date, place or approximate place, and school, subschool, or idiom in the catalogue entries, and virtually no discussion of these. The intention was to invite the viewer to ignore these issues, or at least postpone their consideration for the moment, and to lead him or her to view art *qua* art, to sense what the work of art was capable of saying to the viewer, placed as he or she was in a different time and place, or to ruminate on what it might have said in its original context to the Indian viewer of yesterday.

The subject matter of most Indian art being alien not only to the non-Indian viewer, but—sad to say—even to the majority of Indian viewers of today, it was necessary to state briefly in the catalogue entries the elements in each work that could be seen as determinants and consequents, or that brought out transitory or durable emotional states, as enunciated in the classical *rasa* theory (though the emphasis remained on pointing out these elements without being didactic). I was all too aware that I was offering in this exhibition a strictly personal point of view: another scholar, a different viewer, was apt to respond to a particular work quite differently, or perhaps not at all. When I heard from Indian colleagues later that had it been left to them, they would have placed a given work not in the category in which I had placed it but in another, I was not in the least surprised. As the theory of *rasa* says, we take back from a work of art what we bring to it. Hearts melt differently, and the theory states that we respond to works of art according to our own energies (*utsaha*) or capabilities (*pratibha*). As Coomaraswamy says, "He who would bring back the wealth of the Indies, must take the wealth of the Indies with him."[13]

Even though *rasa* was the word used for each section of the exhibition, it was its counterpart, *bhava*, that I was intent on pointing out in different works, at least as I saw them. Evidently, there was no expectation that each work of art would lead to a *rasa* experience, or that each "flower" that is *bhava* would necessarily turn into the "fruit" that is *rasa,* as the theorists state. If each work of art were to lead to a *rasa* experience, visiting the exhibition would have left one emotionally exhausted, thoroughly drained. This was not the intention, nor, I am sure, was this the result. All that I believed the exhibition might yield to the common viewer was an awareness of the elements that made Indian art what it was, along with a generalized sense of delight—perhaps even an intense experience—when confronted with one of the nearly three hundred works that made up this exhibition. None of this may have come to pass; in any case, I am not quite sure of how it all worked with a non-Indian audience for whom not only the objects but their contexts were unfamiliar. But judging from reactions in both Paris and San Francisco, I gather that two things did result: many a viewer got some insights into the art of India; and, through this approach, many came close enough to it to be able to feel the texture of the Indian mind.

The need to bring the viewer close to a work of art was, in my view, especially great when it came to Indian miniatures. The small scale on which these exquisite paintings were made (the average miniature is eight by ten inches) and the original context in which they were viewed (each was meant to be viewed by one person at a time, holding it in the hand at a short distance from the eyes, like a book) present inherent difficulties in the matter of presentation in a museum or exhibition setting. The average viewer takes very little from a miniature on view, for very little can be seen in it when it is displayed against a wall, an unnatural distance intervening between it and the viewer. For this reason, while presenting the paintings in the catalogue, I found it necessary to draw attention repeatedly to what I regarded as significant detail: the entwined tree and creeper, the craned neck of a bird looking up at a heroine, lightning darting through clouds while lovers embraced each other in golden pavilions, the tilt of the head, the disposition of the hands, and so on. But should the viewer fail to concentrate on taking in details like these, introduced with such loving care by the painter, the intended mood would not rise to the surface of the viewer's mind. Hence the insistent pointing out of these details in the catalogue entries.

When the exhibition was mounted in Paris it was unfortunately not possible to explore the aspect of the *rasa* theory that states that

each *rasa* has an equivalent color.[14] However, when the exhibition traveled to San Francisco, the display was quite different from what it had been at the Grand Palais in Paris: the walls of the different galleries, each devoted to a different *rasa*, were painted in the color equivalent of that *rasa*, the color having been picked in strict reference to classical theory.[15] The device worked admirably; there was palpable heightening of effect, and of feeling.

Several other ideas were tried out, but here I would like to draw attention to only two of them. We in India are aware that in painting, works were often conceived in a series, being either related to a text or visualized as belonging to a set. Exhibitions by their nature tend to ignore this fact, and of necessity present miniatures as isolated leaves, thus tearing them from their context and doing some violence to the original intent of the painter. In the show in Paris, we tried to approximate the original intention and context by designing three different polygonal tables with nine sides each in which paintings were displayed so that nine persons could sit around a table and view the works. The display was attached to a timer, so that each painting moved from one seated viewer to the next till all nine works in the series had been viewed. This seemed to work well in what came to be termed "the connoisseur's corner." But, regrettably, exigencies of space did not allow this device to be installed in San Francisco.

The second idea could never be tried out at all. I had wanted to round off the exhibition with a large, acoustically dead room, to which only one viewer at a time would be admitted. In the center of this room only one major sculpture from the quiescent category, such as the Buddha in meditation, would be on view.[16] The intention was that in this room, a viewer might come face to face with a work of art in a hushed, soundless setting, in subdued light, all the while hearing nothing else but the beating of his or her own heart. But considerations of expense and technical difficulties dictated otherwise. Had this idea been realized, it is possible that the viewer might have ended a visit to the exhibition on a note that would have resonated for a very long time.

NOTES

1. In 1983, the exhibition that was being discussed was meant only to figure in the Festival of India in Paris. It was decided at a much later stage that the Paris exhibition would travel to San Francisco in the fall of 1986. The cata-

logues of the two exhibitions, both written by me, vary somewhat from each other.

2. Apart from the 1960 exhibition Tresors de l'art de l'Inde, the Petit Palais saw another exhibition of Indian art in 1978—Inde: Cinq mille ans d'art.

3. It is to be remembered that arrangements for the exhibitions connected with the Festival of India on the East Coast of the United States had already been made final by this time.

4. Bharata Muni's *Natyasastra,* perhaps the most comprehensive treatise of its kind on the arts of India, is variously dated by different authors. An English translation by Manmohan Ghosh is available under the title *Natyasastra* (Calcutta: Manisha Granthalaya, 1967).

5. Most early texts on painting, sculpture, or literature contain passages on *rasa* and its applicability to the various arts, although the treatment varies in length and detail. Thus, the celebrated *Vishnudharmottara* (part 3, trans. Stella Kramrisch [Calcutta: Calcutta University Press, 1928]) has a whole chapter on *rasa.* Viswanatha Kaviraja's fourteenth-century *Sahitya-Darpana* (trans. J. R. Ballantyne and Pramada-Dasa Mitra [Calcutta: C. R. Lewis, Baptist Mission Press, 1875]) speaks of *rasa* at considerable length in relationship to literature.

6. Ananda K. Coomaraswamy, *The Transformation of Nature in Art* (New York: Dover, 1956).

7. Ibid., 48.

8. The *Natyasastra* mentions only eight *rasas,* but the ninth, *shanta,* was added by later theoreticians and is so widely accepted that one is wholly used to the phrase *nava-rasa* (nine *rasas*) in all the arts.

9. Coomaraswamy, *Transformation of Nature,* 52.

10. Among the first expositions of Bharata Muni's *rasa* theory is that by the great eleventh-century Kashmir scholar Abhinavagupta. It is he who speaks of these "magical flowers." See *Aesthetic Experience According to Abhinavagupta,* ed. Raniero Gnoli (Rome: Istituto italiano per il media ed estremo oriente, 1956).

11. Coomaraswamy, *Transformation of Nature,* 55.

12. Medieval writers very often plead for *bhakti* being added to the traditional list of *rasas.* Others argue the case of a *rasa* called *vatsalya* (parental affection), and so on.

13. This is one of those beautiful, aphoristic statements of Coomaraswamy that have been the cause of much comment by his critics.

14. Each of the *rasas* is described in the classical texts as having a color of its own. *Shringara* is thus blue-black, *hasya* is white, *raudra* is red, *bhayanaka* is black, and so on.

15. This imaginative decision was made by Clarence Shangraw, who was responsible for the design of the exhibition in San Francisco.

16. The idea of the acoustically dead room came originally from my friends Gira and Gautam Sarabhai, to whom I am grateful.

PART 2

Art Museums, National Identity, and the Status of Minority Cultures: The Case of Hispanic Art in the United States

STEVEN D. LAVINE

The primary lines of the debate about the exhibition Hispanic Art in the United States: Thirty Contemporary Painters and Sculptors are set out in the general introduction to this volume. The essays in this section take us more deeply into the problematics of exhibitions that attempt to find coherence in the art of a cultural "other" and to present that "other" in relation to the traditional European and American art found in a comprehensive art museum. In particular, the essays by Jane Livingston and John Beardsley, the cocurators of Hispanic Art in the United States, and Tomas Ybarra-Frausto, one of the exhibition's most articulate critics, highlight the difference between outsider and insider perspectives. For the outsider, the group's shared features stand out as the result of identifying them as a group. For the insider, internal differences emerge more forcefully, although similarities may be stressed to achieve a specific social or political goal in

the larger surrounding society. Inevitably, these fundamentally different perspectives lead to different emphases in framing and interpreting exhibitions.

The essays by Peter Marzio, the director of the Museum of Fine Arts, Houston, and a prime mover behind Hispanic Art in the United States, and Carol Duncan help frame the terms under which minority and non-Western art may be included in comprehensive art museums. Marzio insists upon general European and American art history as the necessary background against which to view these categories of works, although he grants that they may expand the "aesthetic boundaries and definitions of fine art." For him, the challenges are financial and practical as a museum attempts to move responsibly into a domain in which it has limited previous experience. Carol Duncan outlines the ways comprehensive art museums have, in the past, organized their holdings as rituals of citizenship. She finds that the core narrative of such museums has lost coherence in recent years. Her argument (particularly when read against Ybarra-Frausto's critique of pluralism as a guiding concept) challenges us to think about the consequences, in terms of the image of the *polis*, when an exhibition such as Hispanic Art in the United States is featured in a comprehensive museum.

In their essay, Livingston and Beardsley make clear that their primary concern was to revaluate upward the achievements of a number of contemporary artists who share a set of features that can be traced to their Latin American origins, and to provide an example that would encourage the commercial and art-museum community to think more broadly about the diversity of American art. With this goal in mind—a goal in many ways coincident with Susan Vogel's account in Part 3 of her concern with African art— Livingston and Beardsley array Hispanic art along a scale from

community-based (best exemplified by the Chicano mural) to indi-
vidualistic. They explain that they emphasized the latter in their se-
lections because, in their view, the art museum is the site for "the
more purely artistic and poetic impulses of the individual."

Preserving the diversity of Hispanic art within the exhibition
became a particular problem for them. Exhibitions, they maintain,
require a measure of visual and thematic consistency (and perhaps
simplicity) to allow visitors unfamiliar with the body of work to
orient themselves. Inevitably, this must raise a question for all exhi-
bitions: what sorts of skewing, elision, and even mystification result
from the exhibition makers' attempt to create a powerful overall
poetic and affective thrust? Livingston and Beardsley speak of the
"aesthetic will" of the curator as the ultimate referent in creating
this unity. Their essay makes clear that their aesthetic expresses it-
self in a balance between formal concerns—expressionistic and
otherwise—shared by contemporary artists generally, and a set of
thematic motifs—"the image of the Madonna, the icon of the out-
law or the dispossessed," etc.—ultimately traceable to the Latin
American roots of or sources used by these artists. This aesthetic
relates closely to what they describe as "the classic pattern in Amer-
ican history," wherein other cultures clash with the American main-
stream, "attempting somehow to reconcile the competing claims of
resistance and assimilation." Consequently, though Livingston and
Beardsley stress that they made their selections on aesthetic
grounds, one cannot escape the sense that those aesthetic grounds
are deeply infused with their social views.

Tomas Ybarra-Frausto's history of the Chicano art movement
since 1965 rests on the assertion that this art is deeply rooted in
social reality and requires a simultaneous social and aesthetic read-
ing. His account of the vernacular sources of Chicano art—in *alma-*

naques (calendars), *estampas religiosas* (religious images), *altares* (home religious shrines), etc.—enforces a sense of the art's distinctness in a way that challenges the homogenizing tendency of the category Hispanic art. The difference here is one of perspective. Livingston and Beardsley have reservations about the term *Hispanic* but, from their perspective outside any particular Hispanic community, conclude that the term does usefully enclose a set of shared concerns. Ybarra-Frausto, writing as an insider in the Chicano community, finds a density of reference and a range of creative transformations that require separate consideration. Moreover, Livingston and Beardsley's emphasis on shared motifs and concerns—especially as highlighted by the selection process that was necessary to give aesthetic coherence to the exhibition—seem to impute a stable identity, a reclamation or persistence of tradition, to this group of Hispanic artists. Ybarra-Frausto emphasizes Chicano artists' creative appropriation and transformation of vernacular sources as they move back and forth "between multiple aesthetic repertoires and venues. . . . Contemporary revisions of identity and culture affirm that both concepts are open and offer the possibility of making and remaking oneself from within a living, changing tradition."

Could an exhibition do justice to this process of creative transformation? Perhaps, if it were devoted solely to the range of Chicano art. But even then the museumgoer previously unfamiliar with Chicano art and quite possibly harboring stereotypes of Chicano culture might well see as central the persistence of a set of traditional "Hispanic" cultural icons. One might escape this trap by contextualizing the art against its vernacular sources, juxtaposing artists who have taken quite different paths. But as Peter Marzio, Susan Vogel, and others in this volume suggest, this contextualizing approach, at least as it is understood in art museums, might be taken

as apology or special pleading, which is dangerous in the case of art to which a place in the museum is not universally granted. Whatever approach to this challenge were taken, it would have to begin from a recognition of the limitations of every perspective, even that of an insider in a given group. Each of us participates in multiple communities: Livingston and Beardsley might well argue that as curators of contemporary art they are members of a loosely knit art-making community that includes the artists in this exhibition and excludes Ybarra-Frausto, whose discipline is literature.

Ybarra-Frausto also challenges the notion of pluralism as a political and aesthetic strategy for incorporating "alternative representations . . . and antagonisms." Pluralism as an ideology makes a peripheral place for new possibilities without allowing them to challenge the central idioms of "Euro-centered art." Most often, this incorporation occurs under "categorizations of 'ethnic art' as primitivistic and folkloric"—that is, on much the same terms that African and Oceanic art have entered comprehensive art museums. Ybarra-Frausto hints at an alternative possibility when he describes current Chicano art as "a visual narration of cultural negotiation," as artists move easily between African American, Native American, European, and mestizo sources. Can one imagine the comprehensive art museum without an authoritative European canon at the center? Would it be possible to rethink the sum of world art as a set of parallel lines of development, with ongoing processes of negotiation among them? Or is the dominance of a set of historically determined Euro-centered ways of seeing and imagining so strong, so central to the "museum effect" (as Alpers describes it), that inclusion in a comprehensive art museum can only be in relation to that tradition?

Peter Marzio's essay does not question the centrality of this Eu-

ropean canon. Rather, he argues that minority art should become a vital part of museums' programs because a museum should be responsible to the diverse populations that make up its constituency and because, judged by the aesthetic standards of comprehensive art museums, this art deserves inclusion. With Beardsley and Livingston, he assumes that there are general aesthetic criteria of sufficient universality such that this art can be exhibited without contextualization, just as the museum exhibits a Renaissance predella for which the visitor may have even less context for understanding. What is at stake in these two cases may not be very different. In the museum, the predella is exhibited with only vestigial reference to its complex religious import and power, much as Ybarra-Frausto and other Hispanic commentators argue that the Hispanic Art in the United States exhibition stripped its works of the social and lived contexts that give them a special presence and potency. Certainly, one side effect of the increased presentation of non-Western and American-minority art is likely to be increased debate about contextualization, both social and aesthetic.

As a museum director charged with the overall health of an institution, Marzio gives a dramatic sense of the challenges facing museums that accept their responsibility to minority art and audiences: the "apathy and disregard" of many colleagues and most audiences, the costs of original research in heretofore understudied areas, the risks to the institution's identity as it casts its net more widely, the undercapitalization of museums generally, and the refiguration of the museum's relation to particular populations. Marzio treats Hispanic Art in the United States as but one step in bringing his museum closer to the Hispanic populations of Houston, and, indeed, the continuation of the museum's special committee of Hispanic community leaders may in time prove more important than

the exhibition itself. Although he emphasizes the extension of the museum's services to the Hispanic communities of Houston, it is also possible that the influence will be in the opposite direction, that there will be not only an expansion of aesthetic boundaries but a reconceptualization of the nature of the museum.

Carol Duncan's essay provides a basis for thinking about that revision of the idea of the art museum. She argues that comprehensive art museums, such as the Louvre and the Metropolitan Museum of Art, have historically deployed their art and architecture as a secular ritual in which "the spiritual heritage of the nation" is "distilled into an array of national and individual genius"; the great epochs and individuals of Western history—Greece and Rome, the Renaissance, nineteenth-century Europe—have been figured as the heritage of the present. However, Duncan finds that museum additions since the 1950s have obscured that notion. At the Museum of Fine Arts, Boston, the new East Wing places contemporary art as well as shops and restaurants up front for most visitors. At the Metropolitan Museum of Art, the Michael Rockefeller Wing and the new twentieth-century galleries behind it disrupt any clear sense of sequence. But even with these changes, museums retain "the power to define and rank people, to declare some as having a greater share than others in the community's common heritage."

Viewed either as a ritual of citizenship or, more humbly, as a certifier of quality, museums make an important statement when they admit a new body of work. Livingston and Beardsley and Marzio discuss Hispanic Art in the United States as part of a progressive social agenda; later in this volume, Susan Vogel makes much the same point in regard to African art. Indeed, each of them argues that minority and non-Western art should be displayed similarly to the other art in these institutions as a way of certifying their

quality and significance. When Ybarra-Frausto objects to pluralism as an adequate basis for inclusion, he implies that this liberal, ameliorative agenda is not enough, that a more fundamental challenge to the canon, to the principles of a core historical heritage, is required. Perhaps we can draw a parallel here between Ybarra-Frausto's search for a more fundamental challenge to the canon than that enabled by pluralism and James Clifford's account in Part 3 of how majority institutions enforce universalizing narratives that smooth over and deny the oppositional thrust of nonmajority institutions. Ybarra-Frausto celebrates oppositional vitality. The very construction of the category of Hispanic art seems to him to suppress what is most authentic and original in different particularized aesthetics.

Still, the breakdown, as Duncan describes it, of the traditional historical schema on which art museums formerly based their collections may open majority museums to new possibilities. If contemporary art, with its contestable and changeable valuations, has come to the fore, there may be an opportunity for museums to become fora, sites for debate rather than absolute judgment, places where differing voices and perspectives are given a hearing. This development will involve risks. Later in this volume, James Sims and Spencer Crew refer to "the social contract between the audience and the museum, a socially agreed-upon reality that exists only as long as confidence in the voice of the exhibition holds." If museums were to admit openly the contestability of their perspectives, if exhibitions were presented as partial and contingent, visitors might turn away. On the other hand, a different kind of authority, based on particularized and diverse voices and perspectives, might attract visitors who have heretofore felt intimidated, offended, or just baffled. Several writers in this volume raise this possibility. B. N. Goswamy and

Masao Yamaguchi provide glimpses of ways of seeing that are rooted in other national traditions. Patrick Houlihan and James Clifford find distinctive exhibition techniques in Native American museums, which reflect different ways of organizing experience. Elaine Heumann Gurian argues that the voices of museum visitors need to be heard and require an active response. It need hardly be added that these issues of voice and perspective are at the center of the contested terrain of the exhibit and of this volume as well.

CHAPTER 6

Art Museums and the Ritual of Citizenship

CAROL DUNCAN

The French Revolution created the first truly modern art museum when it designated the Louvre Palace a national museum. The transformation of the old royal palace into the Museum of the French Republic was high on the agenda of the French Revolutionary government. Already, public art museums were regarded as evidence of political virtue, indicative of a government that provided the right things for its people. Outside of France, too, educated opinion understood that art museums could demonstrate the goodness of a state or municipality or show the civic-mindedness of its leading citizens. By the middle of the nineteenth century, almost every Western nation would boast a national museum or art gallery. Even Washington, D.C., was, for a time, slated to have a national gallery of art in what is now the Renwick Building, which was designed in 1859 with the Louvre's architecture very much in mind.

The West, then, has long known that public art museums are important, even necessary, fixtures of a well-furnished state. This knowledge has recently spread to other parts of the world. Lately, both traditional monarchs in so-called underdeveloped nations and Third World military despots have become enthralled with them. Western-style art museums are now deployed as a means of signaling to the West that one is a reliable political ally, imbued with proper

respect for and adherence to Western symbols and values. By providing a veneer of Western liberalism that entails few political risks and relatively small expense, art museums in the Third World can reassure the West that one is a safe bet for economic or military aid.

So in 1975 Imelda Marcos put together a museum of modern art in a matter of weeks.[1] The rush was occasioned by the meeting in Manila of the International Monetary Fund. The new Metropolitan Museum of Manila—it specialized in American and European art—was clearly meant to impress the conference's many illustrious visitors, who included some of the world's most powerful bankers.[2] Not surprisingly, the new museum reenacted on a cultural level exactly the same relations that bound the Philippines to the United States economically and militarily. It opened with dozens of loans from the Brooklyn Museum, the Los Angeles County Museum of Art, and the private collections of Armand Hammer and Nathan Cummings.[3] Given Washington's massive contribution to the Philippine military budget, it is fair to assume that the museum building itself, an unused army building, was virtually an American donation.

The Shah of Iran also needed Western-style museums to complete the facade of modernity he constructed for Western eyes. The Museum of Contemporary Art in Teheran opened in 1977 shortly before the régime's fall.[4] Costing over $7 million, the multilevel modern-style structure was filled mostly with American art from the post–World War II period—reputedly $30 million worth—and staffed by mostly American or American-trained museum personnel. According to Robert Hobbs, who was the museum's chief curator, the royal family viewed the museum and its collection as simply one of many instruments of political propaganda.[5]

Meanwhile in the West, museum fever continues unabated. Almost weekly, newspapers publicize plans for yet another new museum or an expansion or renovation of an old one in London, Paris, New York, Los Angeles, or some other national or regional capital. As much as ever, having a bigger and better art museum is a sign of political virtue and national identity—of being recognizably a member of the civilized community of modern, liberal nations.

Recently, there has been much concern with how Western museums represent other cultures—how museum displays of "primitive," Third World, or non-Western art often misrepresent or even invent foreign cultures for what are ultimately political purposes. The question of what museums do to other cultures often leaves unexamined what I believe is a prior question: what fundamental purposes do

museums serve in our own culture and how do they use art objects to achieve those purposes? My essay, then, will be concerned not with the representation of foreign or non-Western cultures but with what art museums say to and about our own culture—what political meanings they produce and how they produce them. I should immediately say that I am concerned with the most familiar kind of public art museum, the typical capital or big-city museum dedicated to a broad sweep of art history. The Louvre is the prototype of this kind of museum.

THE MUSEUM AS RITUAL

I will be treating art museums as ceremonial monuments. My general approach grows out of work I have done in the past, much of it in collaboration with Alan Wallach.[6] In referring to museums as ceremonial monuments, my intention is to emphasize the museum experience as a monumental creation in its own right, a cultural artifact that is much more than what we used to understand as "museum architecture." Above all, a museum is not the neutral and transparent sheltering space that it is often claimed to be. More like the traditional ceremonial monuments that museum buildings frequently emulate—classical temples, medieval cathedrals, Renaissance palaces—the museum is a complex experience involving architecture, programmed displays of art objects, and highly rationalized installation practices. And like ceremonial structures of the past, by fulfilling its declared purposes as a museum (preserving and displaying art objects) it also carries out broad, sometimes less obvious political and ideological tasks.

Since the Enlightenment, our society has distinguished between the religious and the secular. We normally think of churches and temples as religious sites, different in kind from secular sites such as museums, courthouses, or state capitols. We associate different kinds of truths with each kind of site. The distinction, rooted in Enlightenment struggles against authoritative religious doctrines, makes religious truth a matter of subjective belief, while the truths belonging to museums, universities, or courts of law claim to be self-evident to reason, rooted in experience, and empirically verifiable. According to this tradition, we think of religious truth as addressed to particular groups of voluntary believers, while secular truth has the status of objective or universal knowledge and functions in our society as higher, authoritative truth. As such, it helps bind the community as a

whole into a civic body, identifying its highest values, its proudest memories, and its truest truths. Art museums belong decisively to this realm of secular knowledge, not only because of the branches of scientific and humanistic knowledge practiced in them—conservation, art history, archaeology—but also because of their status as preservers of the community's cultural heritage.

In contrast, our concept of ritual is normally associated with religious practices, with real or symbolic sacrifices or spiritual transformations. Clearly, such events can have little to do with so secular a place as a museum. But, as anthropologists now argue, our supposedly secular culture is full of ritual situations and events.[7] Once we recognize the ideological character of our Enlightenment vocabulary and question the claims made for the secular—that its truths are lucid, rationally demonstrable, and objective—we may begin to conceptualize the hidden (or perhaps the better word is *disguised*) ritual content of secular ceremonies. We can also consider the advantages of a ritual that passes as a secular, and therefore objective and neutral, occurrence.

The very architecture of museums suggests their character as secular rituals. It was fitting that the temple facade was for two hundred years the most popular signifier for the public art museum.[8] The temple facade had the advantage of calling up both secular and ritual associations. The beginnings of museum architecture date from the epoch in which Greek and Roman architectural forms were becoming the normal language for distinctly civic and secular buildings. Referring to a pre-Christian world of highly evolved civic institutions, classical-looking buildings could well suggest secular, Enlightenment principles and purposes. But monumental classical forms also brought with them the space of rituals—corridors scaled for processionals and interior sanctuaries designed for awesome and potent effigies.

Museums do not simply resemble temples architecturally; they *work* like temples, shrines, and other such monuments. Museumgoers today, like visitors to these other sites, bring with them the willingness and ability to shift into a certain state of receptivity. And like traditional ritual sites, museum space is carefully marked off and culturally designated as special, reserved for a particular kind of contemplation and learning experience and demanding a special quality of attention—what Victor Turner called "liminality."[9]

In all ritual sites, some kind of performance takes place. Visitors may witness a drama—often a real or symbolic sacrifice—or hear a recital of texts or special music; they may enact a performance them-

selves, often individually and alone, by following a prescribed route, repeating a prayer or certain texts, reliving a narrative relevant to the site, or engaging in some other structured experience that relates to the history or meaning of the site. Some individuals may use ritual sites more knowledgeably than others; they may be more educationally prepared to respond to their symbolic cues. Ritual is often regarded as transformative: it confers identity or purifies or restores order to the world through sacrifice, ordeal, or enlightenment.

So visitors to a museum follow a route through a programmed narrative—in this case, one or another version of the history of art. In the museum, art history displaces history, purges it of social and political conflict, and distills it down to a series of triumphs, mostly of individual genius. Of course, what the museum presents as the community's history, beliefs, and identity may represent only the interests and self-image of certain powers within the community. Such deceit, however, does not necessarily lessen the effectiveness of the monument's ritual structure as such.

THE POLITICS OF PUBLIC ART MUSEUMS

I want to return now to the question with which I began, namely the political usefulness of public art museums. Some museum history will help bring this political use into focus.

Ceremonial sites dedicated to the accumulation and display of treasures go back to the most ancient of times. It is tempting to extend our notion of the museum back in time and discover museumlike functions in the treasuries of ancient temples or medieval cathedrals or in the family chapels of Italian baroque churches. But however much the public art museum may resemble these other kinds of places as a structured experience, historically the modern institution of the museum grew most directly out of sixteenth- and seventeenth-century princely collections. These collections, often displayed in lavishly decorated galleries built especially for them, anticipated some of the functions of later museums. Beginning in the eighteenth century, public art museums would appropriate, develop, and transform the central function of the princely gallery.[10]

Typically, princely galleries were used as reception halls, providing sumptuous settings for official ceremonies and magnificent frames for the figure of the prince. Princes everywhere installed their treasures in such galleries in order to impress both foreign visitors and local

dignitaries with their splendor and, often through special iconographies, the rightness or legitimacy of their rule. This function of the princely gallery as a ceremonial reception hall wherein the state presented and idealized itself would remain central to the public art museum.

The Louvre was not the first royal collection to be turned into a public art museum, but its transformation was the most politically significant and influential. In 1793 the French Revolutionary government, looking for a way to dramatize the creation of the new republican state, nationalized the king's art collection and declared the Louvre a public museum. The Louvre, once the palace of kings, was reorganized as a museum for the people, to be open to everyone free of charge. It thus became a powerful symbol of the fall of the *ancien régime* and the creation of a new order.

The new meaning that the French Revolution gave to the old palace was literally inscribed inside, in the heart of the seventeenth-century palace, the Apollo Gallery, built by Louis XIV as a princely gallery and reception hall. Inscribed over its entrance is the French Revolutionary decree that called into existence the Museum of the French Republic and ordered its opening on 10 August 1793 specifically to commemorate "the anniversary of the fall of the tyranny" (Figure 6-1). Inside the Apollo Gallery, a case holds three crowns from the royal and imperial past, now ceremonially displayed as public property.

Other art museums could hardly boast such politically dramatic origins or so historically rich a setting. But every major state, monarchical or republican, understood the usefulness of having a public art museum. Such public institutions made (and still make) the state look good: progressive, concerned about the spiritual life of its citizens, a preserver of past achievements and a provider for the common good. The same virtues accrue to the individual citizens who, in the Anglo-American tradition, bring about public art museums. Certainly vanity and the desire for social status and prestige among nations and cities as well as among individuals are motives for founding or contributing to art museums, as they were in the creation of princely galleries. But such motives easily blend with sentiments of civic concern or national pride. And since public museums are, by definition, accessible to everyone, they can function as especially clear demonstrations of the state's commitment to the principle of equality. The public museum also makes visible the public it claims to serve. It produces the public as a visible entity by literally providing it a defining frame and giving

Fig. 6-1. *Entrance to the Apollo Gallery, the Louvre.* Photo by Carol Duncan.

it something to do. Meanwhile, the political passivity of citizenship is idealized as active art appreciation and spiritual enrichment. Thus the art museum gives citizenship and civic virtue a content without having to redistribute real power.

In all this, the work of art, now displayed as public property, becomes the means through which the relationship between the individual as citizen and the state as benefactor is enacted. In order for art to become useful in this way, however, older concepts of art and art collecting had to be reconceived. In the princely gallery, paintings, statues and other rare and precious objects were understood as luxurious decorations and enviable displays of wealth, or as trophies of military exploits.[11] In one way or another, displays of objects demonstrated something about the prince—his splendor, glory, or wisdom. To fulfill their task in public art museums, the same objects had to acquire yet another layer of meaning, a layer that could obliterate, contradict, or radically distort previous meanings and uses. In the

museum, the prince's treasures, along with other things—altarpieces, for example, taken from yet another ritual context—now had to become art-historical objects, repositories of spiritual wealth, products of individual and national genius. Indeed, the museum environment was structured precisely to bring out these meanings and to suppress or downplay others. The museum context is, in this sense, a powerful transformer: it converts what were once displays of material wealth and social status into displays of spiritual wealth.

The form that this new kind of wealth takes in the museum is the work of art as the product of genius, an object whose true significance lies in its capacity to testify to the creative vitality of its maker. This reinvestment of meaning was made possible by the new discipline of art history, whose system of classification was immediately employed by the state as an ideological instrument. Thus recontextualized as art history, the luxury of princes could now be seen as the spiritual heritage of the nation, distilled into an array of national and individual genius. Displayed chronologically and in national categories along the museum's corridors, the new arrangement illuminated the universal spirit as it manifested itself in the various moments of high civilization. Significantly, the new value discovered in the prince's old treasures could be distributed to the many merely by displaying it in a public space. To be sure, equality of access to the museum in no way gave everyone the relevant education to understand the new art-historical values of these old treasures, let alone equal political rights and privileges; in fact, only propertied males were full citizens. But in the museum, everyone was in principle equal, and if the uneducated were unable to use the cultural goods the museum proffered, they could—and still can—be awed by the sheer magnitude of the treasure.

In a relatively short time, the Louvre's directors (drawing on some German precedents) worked out a whole set of practices that came to characterize art museums everywhere. Very early on, the Louvre's galleries were organized by national school. By its 1810 reopening as the Musée Napoléon, the museum, now under the direction of Vivant Denon, was completely organized by school, and within the schools works of important masters were grouped together. The new art history thus provided the authoritative text upon which the public art museum was to structure its ritual. The vestibule of the Musée Napoléon (the Rotunda of Mars), dedicated in 1810 and still intact today, already states the new art-historical program. Four medallions in the ceiling celebrate what art history early designated as the most important moments in the history of art. Each contains a female personifi-

cation of a national school along with a famous example of its sculpture. Egypt holds a cult statue, Greece the *Apollo Belvedere* (Figure 6-2), Italy Michelangelo's *Moses,* and France Puget's *Milo of Crotona.*[12] The message reads clearly: France is the fourth and final term in a narrative sequence that comprises the greatest moments of art history. Simultaneously, the history of art has become no less than the history of the highest achievements of Western civilization itself: its origins in Egypt and Greece, its reawakening in the Renaissance, and its flowering in nineteenth-century France. As promised by the vestibule's decorations, the sculpture collection was organized as a tour through the great schools.

Even though almost two centuries have passed since the Louvre opened as a museum, and even though there have been and still are expansions, alterations, reorganizations, and reinstallations, the museum is still remarkably coherent both as a series of ceremonial spaces and as a programmed sequence of collections that maintains the nineteenth-century bias for the great epochs of Civilization. Strong doses of classical art are still administered early in the tour and visitors soon see Italian Renaissance art, the importance of which is stressed,

Fig. 6-2. *The School of Greece with the* Apollo Belvedere; *detail of the ceiling of the Rotunda of Mars.* Photo by Carol Duncan.

no matter what route one takes, by the monumentality and centrality of the halls devoted to it.

In the nineteenth century, when these museum meanings were still novel, the ruling authorities spelled them out on the Louvre's ceilings. At first, the ceilings hammered home the image of the state or monarch as protector of the arts. Using traditional princely iconography, images and insignia repeatedly identified this or that government or monarch in that role. But increasingly the iconography centered on artists. In the Musée Charles X, dating from the 1820s, ceiling after ceiling celebrates great patron-princes of the past—popes, kings, and cardinals (Figure 6-3); but famous artists are also abundantly present, their names or portraits, arranged into schools, decorating the entablatures. Ever greater expanses of overhead space would be devoted to them as the century wore on. Indeed, the nineteenth century was a great age of genius iconography, and nowhere are genius ceilings more ostentatious than in the Louvre. Predictably, after every coup or revolution, new governments would vote funds for at least one such ceiling, prominently inscribing their own insignia on it. Thus in 1848, the newly constituted Second Republic renovated and decorated the Salon Carré and the nearby Hall of the Seven Chimneys, devoting the first to great artists from foreign schools and the second to French geniuses, profiles of whom were alphabetically arranged in the frieze (Figures 6-4 and 6-5).[13]

It should be obvious that the demand for Great Artists, once the type was developed as a historical category, was enormous—they were, after all, the means by which, on the one hand, the state could

Fig. 6-3. Charles X as Protector of the Arts; *detail of ceiling, Musée Charles X, the Louvre.* Photo by Carol Duncan.

Fig. 6-4. *Detail of ceiling, Salon Carré, the Louvre.* Photo by Carol Duncan.

demonstrate the highest kind of civic virtue, and on the other, citizens could know themselves to be civilized. Not surprisingly, quantities of Great Artists were duly discovered and furnished with properly archetypal biographies by the burgeoning discipline of art history. We should

Fig. 6-5. *Detail of ceiling, Hall of the Seven Chimneys.* Photo by Carol Duncan.

also recall that artists such as Ingres and Delacroix were very aware of themselves as candidates for the category of Great Artist so lavishly celebrated on the museum's ceilings, and plotted their careers accordingly. The situation continues today in the institution of the giant retrospective. A voracious demand for Great Artists, living or dead, is obligingly supplied by legions of art historians and curators trained for just this purpose. Inevitably some of the Great Artists recruited for this purpose—especially premodern masters—fill out the role of museum art star with less success than others. Even so, a fair or just good Great Artist is still a serviceable item in today's museum business.

CIVILIZATION ON THE WANE

The United States followed the English tradition of relying mainly upon private citizens to found museums. Nevertheless, museums in the United States have played the same ideological role as their state-founded equivalents in Europe, just as they adopted the essentials of the ceremonial program first perfected by the Louvre.

New York's Metropolitan Museum of Art, for example, was directly inspired by the Louvre. Until a few years ago, the museum's commitment to the great-epochs approach was unmistakable. From the museum's vast, monumental entry hall, all the main axes led either to antiquity or to the Renaissance: Greece and Egypt to the right and left, Italy up the stairs. Other collections were fitted in behind these. Thus, as in the Louvre, the three great moments of Western civilization were programmatically emphasized as *the* heritage of the present. These arrangements were echoed by every major American museum and scores of minor ones. When no Greek or Roman originals were on hand, as they were not in many museums, the idea was conveyed by plaster casts of classical sculpture or Greek-looking architecture, the latter often embellished with the names of Great Artists; such facades are familiar sights everywhere (Figures 6-6 and 6-7).

The general museum ideal I have been describing went through a variety of particular developments in the various nations of the West, where it was subject to different sets of tensions and pressures. Nevertheless, it remained remarkably viable and coherent as an ideal until around the 1950s, when its hold on the museum community began to wane—at first in the United States and then internationally. The frenzy of museum building that began in the 1950s and continues to this day has left us with many new museums dedicated to modern art. Modern art museums (or modern wings in older museums) differ from tradi-

Fig. 6-6. *Facade, National Gallery of New South Wales, Sydney.* Photo by Carol Duncan.

tional museums not only because their collections consist of more recent art, but also, and more important, because they introduce a different museum ritual. The concept of the public and the reverence for the classical Western past that informed the older museum do not operate in the modern one, just as the new, more alienated kind of individualism celebrated there is very different from the idealized citizen-state relationship implicit in the older museum.

These shifts are dramatically visible in many traditional museums that, like the Museum of Fine Arts, Boston, have been expanded or altered in recent years. In the old Museum of Fine Arts, everything was organized around the central theme of Civilization. Behind the monumental classical entry facade, the entire sequence of world civilizations followed one upon the other: Greece, Rome, and Egypt on one side, balanced by their Eastern counterparts on the other. The rest of art history came after, all in its proper order, with the Renaissance centrally placed. This arrangement is still intact today, but the recent addition of the new East Wing has seriously disrupted the order in which it unfolds. Because the new wing has in practice become the museum's main entrance, the classical galleries, the old museum's opening statement, now occupy the most remote reaches of the building—remote, that is, in relation to the new entrance. The museum's opening statement now consists of a large gallery of modern art, three new restaurants, a space for special exhibitions, and a large gift-and-book store. It is now possible to visit the museum, see a show,

Fig. 6-7. *Detail of facade,*
National Gallery of New
South Wales, Sydney.
Photo by Carol Duncan.

go shopping, and eat, and never once be reminded of the heritage of
Civilization.

In the same way, the new primitive-art wing at the Metropolitan
Museum of Art decidedly upstages the Greek collection, which had to
be moved to create an access first to the new primitive-art galleries and
then later to the new twentieth-century wing, an arrangement that
decidedly blunts the museum's earlier claims about Greece as an an-
tecedent to modern civilization (Figure 6-8). As constructed by the
museum, the modern soul yearns not for the light of classical antiquity
but for the presumably dark and incomprehensible creations of sup-
posedly precivilized, ahistorical cultures. In other museums, so-called
primitive art is frequently mixed up with twentieth-century avant-
garde art, where it validates every possible modern style from early
cubism to surrealism to current neoexpressionism and neoprimitivism.

As we see so often in the papers in this volume, museums can be
powerful identity-defining machines. To control a museum means pre-

Fig. 6-8. *Entrance to the twentieth-century wing, Metropolitan Museum of Art, New York.* Photo by Carol Duncan.

cisely to control the representation of a community and some of its highest, most authoritative truths. It also means the power to define and rank people, to declare some as having a greater share than others in the community's common heritage—in its very identity. Those who are in the greatest accord with the museum's version of what is beautiful and good may partake of this greater identity. It is they who are best prepared to recognize the history presented by the program and who have most cultivated the skills to produce the particular kind of associations or, as the case may be, the aesthetic attention, implicitly demanded by the museum's isolated objects. In short, those who best understand how to use art in the museum environment are also those on whom the museum ritual confers this greater and better identity. It is precisely for this reason that museums and museum practices can become objects of fierce struggle and impassioned debate. What we see and do not see in our most prestigious art museums—and on what terms and whose authority we do or don't see it—involves the much larger questions of who constitutes the community and who shall exercise the power to define its identity.

NOTES

1. "How to Put Together a Museum in 29 Days," *ARTnews* (Dec. 1976).

2. *New York Times,* 5 Oct. 1976, 65, 77.

3. "How to Put Together A Museum."

4. Sarah McFadden, "Teheran Report," *Art in America* 69, no. 10 (Oct. 1981).

5. Robert Hobbs, "Museum Under Siege," *Art in America* 69, no. 10 (Oct. 1981).

6. See especially Carol Duncan and Alan Wallach, "The Universal Survey Museum," *Art History* 3 (Dec. 1980).

7. See, for example, Victor Turner, "Frame, Flow and Reflection: Ritual and Drama as Public Liminality," in Michel Benamou and Charles Caramello, eds., *Performance in Postmodern Culture* (Milwaukee: Center for Twentieth-Century Studies, University of Wisconsin, 1977), 33–35. See also the contribution to this volume by Masao Yamaguchi, which discusses a wide variety of secular rituals and "sacred spaces" in both Japanese and Western culture, including modern exhibition spaces.

8. See Nikolaus Pevsner, *A History of Building Types* (Princeton: Princeton University Press, 1976), 118ff.; Neils von Holst, *Creators, Collectors and Connoisseurs,* trans. Brian Battershaw (London: Thames and Hudson, 1967), 228f.; and Germain Bazin, *The Museum Age,* trans. Jane van Nuis Cahill (New York: Universe, 1967), 197–202.

9. Turner, "Frame, Flow and Reflection."

10. For princely galleries see Bazin, *The Museum Age,* 129–39; von Holst, *Creators,* 95–139 and passim; Thomas da Costa Kaufmann, "Remarks on the Collections of Rudolf II: The Kunstkammer as a Form of Representation," *Art Journal* 38 (Fall 1978); Pevsner, *History of Building Types,* 112ff.; and Hugh Trevor-Roper, *Princes and Artists: Patronage and Ideology at Four Habsburg Courts 1517–1633* (London: Thames and Hudson, 1976). For the beginnings of public art museums, see Bazin, *The Museum Age,* 141–91 and passim.

11. The princely gallery I am discussing is not the cabinet of curiosities, which mixed together found objects, such as shells and minerals, with manmade things, but the large, ceremonial reception hall, such as the Louvre's Apollo Gallery. For a discussion of the differences, see Bazin, *The Museum Age,* 129ff.

12. Christiane Aulanier, *Histoire du Palais et du Musée du Louvre* (Paris: Editions du Musées nationaux, n.d.), 5:76.

13. Aulanier, *Histoire du Palais* 2:63–66, 7:96–98.

CHAPTER 7

The Poetics and Politics of Hispanic Art: A New Perspective

JANE LIVINGSTON AND JOHN
BEARDSLEY

The exhibition Hispanic Art in the United States: Thirty Contemporary Painters and Sculptors was conceived in 1983 and organized by the authors over a three-year period, from 1984 to 1987. Its premise was that there exists a concentration of talent and stylistic affinity among contemporary artists in the United States who are of Hispanic descent and who express in their art a political and cultural self-awareness derived from their origins in or links to Latin America.

The large exhibition that resulted from this premise was organized by and premiered at the Museum of Fine Arts, Houston; it toured various United States cities, including Washington, D.C., Miami, Santa Fe, Los Angeles, and New York. The exhibition was sponsored by the Rockefeller Foundation and ARCO; the national tour was supported by AT&T. It was the most comprehensive and nationally visible exhibition of its kind yet undertaken—and, not unexpectedly, it has stimulated a wide range of responses from the public and from the special community it addresses.

The following remarks are made in a spirit of reflection on the show's inception and execution—and on some of the reactions that have so far been elicited by its presence in the world.

* * *

An exhibition is not unlike a photograph: it may be assumed to be a relatively accurate representation of reality. Yet, like a photograph, an exhibition freezes time; it can only express the state of art or the state of scholarship at any given moment. Moreover, it can only represent so much. In photography, it is generally true that the larger the aperture, the shorter the depth of field; in an exhibition, too, breadth of gaze comes at the expense of sharp focus.

It is widely acknowledged that in photography, much depends on who is holding the camera. The choice of subject, the type of lens, the angle of vision, the moment chosen for looking—all determine the character of the image. We know the same to be true of exhibitions. The utterly objective exhibition, like the completely unmediated photograph, is a phantasm. What strikes us as critical in this analogous construct is to recognize the point of view of the hypothetical curator behind the lens. Sometimes that viewpoint succeeds best the more it empathizes with the subject matter; sometimes it requires a mixture of empathy and objectivity.

Such considerations are relatively unimportant, however, in the monographic exhibition. One curator's view of one artist's production, though necessarily partial in every sense of the word, is adequate if competently presented. But when the subject is as large and complex as the art of an entire culture or, more accurately in the case of the exhibition we curated, an entire group of cultures, one curator's point of view cannot possibly represent all of the distinct images that different viewers would create, even though all would appear to be looking at the same subject. Thus the various publics of an exhibition such as Hispanic Art in the United States: Thirty Contemporary Painters and Sculptors presented a challenge to us as its curators: how to include many of those publics' points of view without sacrificing two fundamental requirements of any exhibition, coherence and a strong underlying assertion of aesthetic will.

In the main, when we embarked upon the exploratory phase of an exhibition involving Hispanic artists all over the United States, we were without specific stylistic preconceptions. Such biases as we had favored the possibility that pleasant surprises might lie in store, rather than disappointments. We were aware that a handful of Hispanic artists had begun to make their presence felt in the mainstream art world, some in a fairly universalized style, others in a more particularized one. We knew of a few self-taught, seemingly isolated Hispanic artists, and knew their work was beginning to have an effect on that of more schooled painters and sculptors. But aside from a gut-level

suspicion of a larger phenomenon, we bore few prior assumptions and no predetermined agenda. We thought this might actually be our chief strength, for it would allow the kind of open-minded exploration that could result in both the most empathic approach and the most even-handed one.

At the outset, we were guided by two intuitions, both of which proved to be confirmed. The first was demographic. We assumed that the regions of the country with the highest and longest-standing concentrations of the various Hispanic populations would be where we would find the largest number of Hispanic artists. Thus we began our search in the obvious places: San Francisco and Los Angeles, the Southwest, Texas, southern Florida, New York, Puerto Rico, and later Denver, Chicago, and San Diego. Our other intuition was that our best leads in locating artists and movements would come from artists themselves and from the institutional network that supports them within their respective communities. Beginning with the handful of recognized Hispanic artists, we sought advice on which studios to visit, which exhibitions to see, and which curators and critics to consult. Surprisingly, little skepticism greeted our inquiries. Although one noted artist declined, after lengthy (and friendly) discussions, to be considered for the exhibition, most artists, curators, and arts administrators seemed to agree that it was time the larger American institutions took note of Hispanic art. Indeed, we could hardly have begun, much less pressed on, without the full cooperation of the artists with whom we communicated, whether or not they were in serious contention for the exhibition itself.

In many places, we found a highly organized, preexisting cultural network that made our exploration quite straightforward. This was especially true in the more homogeneous communities—as among the Chicanos in Los Angeles, San Diego, or San Francisco respectively, for example, or the Cubans in Miami. It was even somewhat true in more heterogeneous places such as the various boroughs of New York, where the many Hispanic organizations have developed effective links with established communities and even with new immigrants. And always we found it essential to scratch beneath the surface, to keep our antennae out, to find the artist who had elected *not* to make contact with the Hispanic organization or had otherwise escaped the notice of organizations or even fellow artists.

If within most cities or states we found more or less organized subcultures, the same was not true everywhere. For example, in Texas and the Southwest geographic spread has worked against organiza-

tional effectiveness. And it was certainly not true on a national scale. When our exhibition opened at the Museum of Fine Arts, Houston, we discovered that no artist in it was familiar with all, or even half, of the other artists in the show. This again reflects the fact that we were exploring not a single culture, but a set of related ones. Similarly, the Hispanic community arts organizations in various cities tended to know their own scene thoroughly, but not to have a national focus. While a lack of resources that would allow outreach certainly accounts in part for this striking localism, some organizations deliberately maintain a focus on a particular region or national group.

The first phase of our project, then, consisted of amassing as much information as we could on the many Hispanic visual artists in the United States. The second and more difficult task was to shape this information into a coherent exhibition. We had seen in one context or another the work of over six hundred artists, and knew that we could show only a small percentage of them. To begin the challenging process of selection, we established several organizational guidelines.

The first was that this would be an exhibition of contemporary art, as we knew we could not do justice both to the history of Hispanic art and to its contemporary state. Learning that more historical surveys were under discussion at the Bronx Museum of the Arts and at the University of California, Los Angeles, we were even more drawn to limiting our scope to more contemporary work. This meant that some of the more important historical figures might not be included in our exhibition if they were no longer as active as they had been. It also precluded an examination of some of the most familiar manifestations of Hispanic art, urban murals and political posters. These seemed to be, at least to outsiders, the primary focus of Hispanic artistic activity—especially among Chicanos—in the late sixties and into the seventies, and a thorough familiarity with these kinds of works was important to us in developing an understanding of present-day Hispanic art. But, again, we found what we had originally suspected: that though some of the subject matter and style of these works has been carried over into more recent painting and sculpture, the mural and the poster are no longer the dominant forms of expression among the best Hispanic artists.

Moreover, from the outset we saw no reason not to focus purely on painting and sculpture. That is, we saw no reason to depart from the format one would ordinarily use in introducing any large body of unfamiliar new art. This admittedly excluded some powerful art forms, including photography, video, and performance art. As worthy

as Hispanic art in these media may be of exhibitions in their own right, though, we were certain that a clear focus on the rich activity in painting and sculpture was the logical first step in bringing an awareness of Hispanic art to a mainstream audience.

Third, we decided to show the work of each artist selected for the exhibition in some depth. We knew the potential limitations of the kind of survey exhibition in which each artist is represented by a single work, or two works: there is no way to judge whether the individual painting or sculpture is anomalous, or an indication of mature and sustained accomplishment. In a groundbreaking exhibition such as ours that was a particularly critical issue, for a superficial survey could easily result in questions about the depth and the staying power of all Hispanic art. If we could show the mainstream audience that thirty Hispanic artists were producing substantial bodies of accomplished painting and sculpture, we felt viewers would be more inclined to look beyond our exhibition for further demonstrations of achievement in the larger community of Hispanic artists.

Organizational guidelines are relatively easy to define. The aesthetic realities that ultimately prove most important in shaping an exhibition are less so. We knew we wanted the underlying spirit of this exhibition to be artistic, not sociological, though of course we knew that, especially in this case, art and social context are inseparable. Within Hispanic art, one cannot be unaware of a constant tension that often is connected with a split between work that draws its impetus and meaning from the community (and that often takes the form of the mural, the publicly commemorative sculpture, or the mass-produced poster) and simple painting or sculpture of a more private character, produced in the studio. However, the art museum is still widely defined in our society as the arena for the more purely artistic and poetic impulses of the individual. We largely concur with this definition, and we saw no reason not to conform to the usual museum practice of concentrating on painting and sculpture. By definition, we thought, the museum exhibition provides a context for artists to express their more personal artistic natures.

All this is not to say that we were either unaware of or predisposed against the more community-based forms of Hispanic art. Indeed, the popular and didactic symbols and vocabulary of Hispanic culture—the complex values of family and religion, both worshiped and rebelled against; the myths from the pre-Columbian and African pasts; the obsession with patterns of conquest and totalitarianism—were everywhere in the exhibition. They may have tended to be more

subtle than they would be in works intended for mass edification, but they were there. When in the studio, artists often tend to leave behind the overtly political or didactic agendas they may pursue as a matter of conscience in order to communicate something more subjective and private.

In selecting work for the exhibition, we struggled for a balance among the widely differing styles practiced by contemporary Hispanic artists. The matter of diversity within Hispanic culture seemed to us especially important to convey. It led us, for example, to juxtapose the gestural abstractions of Ibsen Espada (Figure 7-1) with the geometric abstractions of Jesús Bautista Moroles, or the devotional sculptures of Félix López with the parodic paintings and sculptures of Pedro Perez. We interpreted diversity to mean the inclusion of both self-taught and highly trained artists. We even allowed this inclusiveness to embrace the extraordinarily sophisticated classical figure sculptures of Robert Graham, an artist securely placed in the mainstream establishment and seldom identified as Hispanic.

At the same time, we wanted the exhibition to express some underlying coherence. To the rare person highly familiar with Hispanic art, it may be understood as a phenomenon with far more range in subject matter and style than we were able to convey. Yet we felt a responsibility to that great majority of our audience, both Hispanic and non-Hispanic, for whom the works in this exhibition would be largely if not completely unfamiliar. Any audience is likely to be alien-

Fig. 7-1. *Ibsen Espada,* Warriors in the Park, *1985.* Reproduced by permission of the artist.

ated if the presentation is either too narrowly didactic or too encyclo-
pedic. So we certainly did, if sometimes half-consciously, allow certain
images or themes to recur throughout the exhibition, in works of
widely differing characters. The image of the Madonna, the icon of the
outlaw or the dispossessed, the mask, the figure that is half-human,
half-animal—these and other subjects became a kind of echoing, lay-
ered refrain throughout the exhibition and catalogue. These themes
were not arbitrarily imposed: they reflect the concerns of Hispanic
artists as we found them.

Finally, within our organizational guidelines and within our quest
to somehow reconcile coherence and diversity, selections for this ex-
hibition, as for any other, expressed the personal aesthetic judgments
of the curators. The processes by which these are made is perhaps the
most complex aspect to define of any in the crafting of an exhibition.
For these judgments are in some measure intuitive, based on years of
familiarity with many forms of art, both historical and contemporary.
No experienced curator should consider these judgments to be abso-
lute: we are all too well aware that prevailing standards are subject to
change. Nor can they be considered universal: different cultures value
different things in a work of art. And different individuals gravitate to
special subjects and particular moments in history. Yet we believe that
there are enough shared forms and concerns in art to permit us to look
across cultural frontiers with confidence that we would eventually
comprehend and empathize with our subject. And it seems to us far
more unfortunate, in art as in political diplomacy, that this intercul-
tural communication should not occur than that it should fail to be
perfect.

It happens, in the case of this particular subject—Hispanic visual
culture within the United States—that for us, its interpreters, certain
personal experiences sensitized us to the language of the art. For ex-
ample, a childhood in southern California and, consequently, expo-
sure to Mexican American culture may have triggered an initial curi-
osity about and gravitation toward this aesthetic. But once we were
fully engaged in a systematic exploration of the subject in all its com-
plexity and fluidity, whatever early imprints in our consciousnesses
that initially may have led us to deal with it were soon superseded by
the realities we encountered.

The fact is that our subject was essentially American art, albeit
American art of a somewhat distinct sort. Though it is created in its
own hybridized language, it is a language fraught with mythic and

popular Americanisms. Much of the work that was in the exhibition is done in a spontaneously expressionistic style, with formally or parodically exaggerated compositional elements, jarring chromatic juxtapositions, disjunctive linearism, and distorted space—all the "new expressionisms" now prevalent in mainstream American art. It was one of the premises of the exhibition that Hispanic artists anticipated, even helped establish, the hegemony of this recent and still-current style.

Even were it not the case, however, that the work of Hispanic artists overlaps at every turn with that of their mainstream compatriots, the exhibition still would have addressed a fundamentally American phenomenon. It affirmed a classic pattern in American history of distinct cultures colliding with the mainstream and attempting somehow to reconcile the competing claims of resistance and assimilation. Thus we were not merely representing Hispanic art to the mainstream: we were representing American art to itself, and arguing (as we have in other exhibitions) for a more fluid, more heterodox vision of American culture.

In sum, we were confident that our aesthetic would be fundamentally in agreement with, first, that of the artists we were exhibiting, and, second, that of the wider art world. Moreover, we were certain that the disagreements that would arise over our aesthetic judgments would be in some ways identical to those that surround all contemporary exhibitions, which by nature introduce rather than resolve qualitative debate. Any survey exhibition invites questions as to why one artist and not another was included, why this work and not that work; ours would be no exception. But we were proven correct in our assumption that if we trusted our aesthetic inclinations, we could shape an exhibition that would establish Hispanic art as a phenomenon specific not only to a culture but to a historical moment, and as an artistic movement of a high order of achievement. Indeed, insofar as there was criticism of our exhibition, it almost categorically was on other than aesthetic grounds. Even the most severe critics agreed on the high caliber of Hispanic art, as demonstrated by the works selected for the exhibition. None argued about its timeliness.

While popular and critical reaction to the exhibition was generally positive, often jubilantly so, a number of writers dissented. To some degree, the criticism tended to be an extension of long-established debates about the position of Hispanic culture relative to the Ameri-

can mainstream. Moreover, it expressed the preexisting wide range of opinion and attitude among the various groups of Hispanics. Peter Applebome summarized the debate this way for the *New York Times:*

> [M]uch of the reaction to the show has reflected the differences in Hispanic culture at least as much as the common elements. Within the Hispanic world, it has been criticized in Los Angeles for leaving out the angry, political Chicano art, and in New York for not including enough art by Puerto Ricans. It has been accused of favoring stereotyped folkloric art and, conversely, of offering too much of an academic, art-for-art's sake response to a visceral, ethnically rooted art form.[1]

As Applebome went on to observe, some of the most bitter criticism attending the exhibition's debut in the spring of 1987 related to a perceived lack of political content. We acknowledge that the overt politics of revolution or dissent did not play the strong role in this exhibition that they sometimes have historically in Hispanic art. Likewise, we recognize that public murals and some temporary installation art with an almost exclusively political focus are still being made in the United States and Latin America alike; some of these works are of great quality and interest. But murals are not transportable and installations are generally so site-specific or ephemeral as to preclude their inclusion in a three-year traveling exhibition.

In the main, however, we would argue strongly with the imputed lack of political content in our show. As discussed above, the exhibition was saturated with images of social alienation, dispossession, and even confrontation, though they were usually more subtle, and certainly more complex, than the slogans one encounters on the street. Moreover, given the general nature of institutions, the fact of the exhibition itself—and therefore its content—cannot fail to make a political and sociological point, no matter how pure the aesthetic intent. Indeed, it seemed to us a greater risk that the exhibition would be dismissed as purely political, and therefore become *artistically* invisible, than that it should distort the true character of Hispanic art by stressing artistic values over political ones.

A related criticism holds that the exhibition tore Hispanic art from its community roots and thus transmuted or somehow distorted its character. This view was advanced by, among others, Jane Addams Allen in the *Washington Times,* who spoke with Tomas Ybarra-Frausto of Stanford University. Criticism, she wrote,

centers on the elimination of what many call the core of Hispanic art in the United States, its communal base and content. "European art is usually art based on technical matters, while Latin American art is based on social content," says Tomas Ybarra-Frausto, Stanford University Professor in the department of Spanish and Portuguese Literature.

"Hispanic art is an art which has an outward thrust to the social arena, a linkage of the imagination with society, and that linkage is what is fundamental about Hispanic art," continues Mr. Ybarra-Frausto. . . . "I think the show is a magnificent introduction to Hispanic art in the United States. But it does not present the basis for the expression which is community-based and politically grounded."[2]

In various guises, this debate has swirled around Hispanic art for a number of years now, especially as the art has begun to be acknowledged by mainstream institutions. In the review of an exhibition of mural paintings on canvas by Chicano artists held at Los Angeles's Craft and Folk Art Museum in the early 1980s, for example, art historian and critic Shifra Goldman charged that the exhibition "placed a framework around East Los Angeles muralism which decontextualizes it and violates its function." For Goldman, the issue for Chicano artists was whether they should remain true to "the same matrix of social change and community service that brought their movement into existence" or join the mainstream, "perhaps shedding in the process their cultural identity and political militancy."[3]

One of the artists in the exhibition, Judithe Hernández de Neikrug, took exception to the idea that growing stature in the mainstream would compromise her self-identification or commitment as a Chicano. She asked, "Are Chicano artists so shallow and corruptible that at their first chance at mainstream success they'll forget who they are?" Answering her own question, she wrote that although their work would no doubt change, "Chicano art and Chicano artists, I am sure, will always pay homage to the traditions of the Mexicano/Chicano culture."[4]

In statements such as this we came to understand that many Hispanic artists themselves do *not* see their inclusion in a mainstream artistic context as an abandonment of their community roots. Our exhibition, like that at the Craft and Folk Art Museum, both expressed and intensified this recognition and inclusion of "ethnic" art as part of the mainstream culture. No museum exhibition, even if it wanted to, could present work in the same way it is seen in its original context. Yet as Hernández pointed out, much of the traditions—family, reli-

gion, even community—remains in the art. Our exhibition provided numerous examples of the "linkage of the imagination with society"— the portraits of César Martinez (Figure 7-2) and Luis Jimenez, for example, or the satirical paintings of Gronk and Luis Stand—while still allowing a place for the more formal concerns of Roberto Juarez or Manuel Neri (Figure 7-3).

It is perhaps inevitable in any survey exhibition, especially one that attempts to examine as large a phenomenon as Hispanic art in the United States, that one will be faulted for failing to present the subject in all its complexity. The most explicit charge of this nature against our show came from Shifra Goldman in an article entitled "Homogenizing Hispanic Art." According to Goldman, "[the curators] jettison both the history and resulting particularities of the heterogeneous populations they have undertaken not only to explain but to unify according to their own vision."[5] In particular, she faulted us for an insufficiently broad representation of different national groups and for not being adequately explicit about the national origin of each artist (although that information was prominently given in each artist's biography).

The principal rationale for charging us with homogenization, however, seems to relate to our use of the designation *Hispanic*. In an

Fig. 7-2. *Cesar Martinez,* Bato con Sunglasses, *1985.* Reproduced by permission of the artist.

Fig. 7-3. *Manuel Neri*, Annunciation No. 2, *1981–82*. Reproduced by permission of the artist.

introductory note to her essay, Goldman wrote that the term came into use in the late 1970s "for government and marketing purposes to 'package' a heterogeneous population." She continued:

> Lost in the "Hispanic" usage were national and racial/cultural signifiers (particularly Indian and African) employed as proud reaffirmations of identity during the 1960s and 1970s in [the] face of prevailing and rampant racial, cultural, and political—not to mention economic—discrimination. "Hispanic," then, was the first signifier of homogenization; it is now defended as convenient, comprehensive, and universally acceptable.[6]

By implication, therefore, our use of the term *Hispanic* is inherently homogenizing. By using it we do concur that it is "convenient, com-

prehensive, and universally acceptable." However, we state again, as we have on other occasions, that we did not particularly like the term ourselves, and wrestled endlessly with alternatives. No other term seemed any better. To use *Latin American* seemed to suggest that the artists were not North American; in fact, nearly two-thirds of them were born in the United States. *Latino* seemed to exclude the Spanish Americans of the Southwest. *Chicano* excluded those not of Mexican origin. Compelled by necessity to include some descriptive term in the title of the exhibition, we decided *Hispanic* was the least incorrect (it is also used by organizations such as the Museum of Contemporary Hispanic Art in New York). Moreover, we think it reflects fairly the fact that there are legitimate shared characteristics, both in terms of subject matter and style, among artists in the North American environment who share New World Spanish–Native American roots. That is, there are ways in which "Hispanic" culture, no matter how diverse internally, is distinct from mainstream European American or African American culture, a point to which Octavio Paz addressed himself at great length in our catalogue.

Goldman found homogenization also in a supposed emphasis on "primitivism" within the exhibition. She wrote, "The curators' view of ethnicity is shallow and even 'primitivistic': it is composed of what is folkloric, naive, popular, exotic, religious, and traditional."[7] Leaving aside the issue of whether or not generally visible elements of folkloric, religious, or traditional imagery are "shallow and primitive" expressions of culture, much in the exhibition disputed this claim. The artists in the show, after all, are individuals whose hard-won achievements are as much the product of European and Latin American modernism as of popular or traditional culture. Moreover, their own feelings for which of their works would most truly and advantageously represent them figured importantly in what was selected for this show. It is difficult to impute a tendentious motive to anyone dealing with these artists when the subjects of their efforts are not only alive and kicking, but effectively vigilant about their best political and artistic self-interests. In any case, a close reading of Ms. Goldman's text reveals that her primary objection to our notion of ethnicity is that we failed to equate it simply with economic and political colonization.[8]

In some measure, confusion about our supposedly primitivistic bias may have resulted from the manner in which the exhibition was installed in Houston and Washington. In both places, the installation began by juxtaposing the abstract stone sculptures of Jesús Bautista Moroles (Figure 7-4) with the drawings of Martin Ramirez (Figure

Fig. 7-4. *Jesús Bautista Moroles*, Texas Facade, *1986*. Reproduced by permission of the artist.

7-5). This was intended to demonstrate at the outset the extraordinary range in both artistic expression and personal experience that would be encountered in the exhibition. Ramirez was self-taught and isolated by personal circumstances; Moroles received a formal education in art and is very much a part of the contemporary art scene. Ramirez's work was primarily representational; Moroles's is predominantly abstract. Yet we suggested that even in work so apparently dissimilar there were some affinities: both Ramirez and Moroles blend traditional images with modernist compositional devices. But there was no judgment here, either explicit or implicit, about primitivism.

In both Houston and Washington, the exhibition went on to show some of the more obviously traditional works: the religious images of the Southwest, the animal sculptures of Felipe Archuleta and Gregorio Marzán, the highly realistic portraits of César Martinez and Carmen Lomas Garza (Figure 7-6). Some observers saw in this further evidence of a primitivistic "floor" under the exhibition.[9] In our minds, however, it was another effort to make the exhibition intelligible. We determined to begin with the work done in more familiar and histor-

Fig. 7-5. *Martin Ramirez, Untitled, 1954.* Reproduced by permission of Jim Nutt and Gladys Nilsson.

ically more longstanding styles, and then move on to painting and sculpture more obviously derived from modernist sources—whether American, Latin American, or European.

Finally, whatever the precise terms of the debate about our exhibition, we recognize two things about it. First, it was motivated by a sincere interest in the way Hispanic art is perceived by the mainstream and thus by a concern for what position this distinctive culture ultimately will achieve with respect to the dominant one. Second, the debate was similar to that which surrounds any large survey exhibition of contemporary art. Thus we are certain that the debate will continue to have a productive life well beyond that of our exhibition, at least among those who are directly touched by it.

We view the most damaging criticism instead to have been of a

Fig. 7-6. *Carmen Lomas Garza,* Abuelitos Piscando Nopalitos, *1979–80.* Reproduced by permission of the artist.

less-accessible kind: that of indifference to or disdain for, not the work itself, but the very notion of our project. Much of the direct or implied criticism of this sort, always off the record, came from our mainstream professional colleagues. This was perhaps to be expected: the exhibition posed a challenge to customary ways of looking at art. The avant-garde is no less an academy than anything else. Our exhibition suggested that curators can and should look for demonstrations of achievement outside the establishment to which they are bound and which they help sustain. Apparently, many people still view this kind of enterprise as inherently more compromised by political or sociological concerns than other exhibitions.

The articulate criticisms from one large part of our audience— those deeply invested in our subject—and the skepticism of some of our institutional colleagues suggest that there is a great deal of negativity about this kind of exhibition, perhaps so much as to extinguish the motivation for doing future exhibitions of this sort. Yet we hope others will not be deterred from projects of a similar nature. For the

overwhelmingly positive popular and critical reaction to our exhibition amply rewarded the decision to pursue a project that no one ever assumed would be easy or safe. Even more important is our recent observation of the dramatically increased public awareness of the rich Hispanic talent in our midst. This project, alongside many current breakthroughs in music, theater, and film, testified to an artistic phenomenon that we as a society, founded on and invigorated by both passion and diversity, can only celebrate.

NOTES

1. Peter Applebome, "The Varied Palette of Hispanic Art in America," *New York Times,* 21 June 1987, sec. 2.

2. Jane Addams Allen, "Hispanic Artists, Scholars Condemn Show," *Washington Times,* 9 October 1987, sec. E.

3. Shifra Goldman, "Chicano Art: Looking Backward," *Artweek* 12 (20 June 1981), 3–4.

4. Judithe Hernández de Neikrug, letter in "Reader's Forum," *Artweek* 12 (1 August 1981), 16.

5. Shifra Goldman, "Homogenizing Hispanic Art," *New Art Examiner* 15, no. 1 (Sept. 1987), 31.

6. Ibid., 30.

7. Ibid., 31.

8. The pertinent passage here is as follows: "Affirmation of ethnicity is only one aspect of a political and social whole, and is relevant primarily to populations of longstanding residence who have had to resist attacks against their national cultural attributes as part of a pattern of economic, political, and social domination." Ibid., 32.

9. The relevant texts here are Goldman, "Homogenizing Hispanic Art," 33, and Jane Addams Allen, "Hispanic 'High Art,' According to the Corcoran," *Washington Times,* 9 October 1987, sec. E.

CHAPTER 8

Minorities and Fine-Arts Museums in the United States

PETER C. MARZIO

In their article in this volume, Jane Livingston and John Beardsley give a vivid account, from a curator's point of view, of the organization, philosophy, and analysis of the exhibition Hispanic Art in the United States: Thirty Contemporary Painters and Sculptors. I agree with their analysis and would like to comment further on their carefully worded description of the "silent criticism" from professionals within the art establishment. The lesson that is clearest in my mind, as described by Livingston and Beardsley, is that those of us who care about making the minority arts a vital part of mainstream museum programs must work together. When curators, art critics, college professors, and museum directors debate about exhibition format or style, we must remember that we are trying to improve our efforts, raise our standards, and make our message clearer to a larger audience. The enemy is not within our group but beyond the debating arena. Apathy and disregard among the general public and professionals toward minority art, particularly when that art is placed in the general-art-museum environment, must be changed to cooperation and understanding. We must keep that ultimate goal in mind as we explore this complex subject.

My duty here is to give the museum director's point of view. As director of the Museum of Fine Arts, Houston, which organized His-

panic Art in the United States, assumed financial risks, and raised the funds, I was impressed by how difficult this project was. When I gave the curators a mandate to find the best art, I had no idea of the problems that would follow.

Despite the fact that many people "know" about contemporary Hispanic art, we found not a single individual who had both strong curatorial credentials and a catholic viewpoint on the subject. This meant that the curators—Livingston and Beardsley—had to carry out in-depth, primary research on a national scale; and they had to do it quickly enough so that the word *contemporary* in the exhibition's title retained its meaning. If the ARCO Foundation and the Rockefeller Foundation had not stepped in at the research stage of this project, the exhibition would not have been possible. The reason: basic research is expensive. Since contemporary Hispanic art is not studied in many universities or reviewed in professional or mass-circulation periodicals, information about the artists and their works is not coherent or easy to locate. The curators had to spend enormous amounts of time assembling the kind of fundamental information that is readily available for the traditional art-historical disciplines in any library. Because contemporary minority art, by virtue of its recency and subject, has not been researched, one must prepare to undertake a massive effort if one wants to do the job well.

Gathering the information and putting it in a narrative form may be sufficient for the art historian, but it is only the start for a curator. These curators were looking for the "best." There were few art dealers who could advise and guide them in this process; many Hispanic arts organizations had local or regional missions, and their recommendations had to be translated to a national level. A process as simple as gathering slides for comparison became a complex project. Every step along the path that led to selecting the artists and the artworks was difficult. There were no well-illustrated catalogues raisonnés or university slide libraries of Hispanic art. The curators often went back two or three times to view an artist's work. Comparing and sorting art for an exhibition of contemporary minority art is expensive and time-consuming.

Within the contexts of basic research and looking for great works of art, this project, like all large contemporary exhibitions, was the topic of endless discussion and debate. In the field of contemporary art, everyone has an expert opinion. Add to this the ethnic element. Some people debated that non-Hispanics had no right to curate a Hispanic exhibition, others complained that one Hispanic group was

being favored over another, and some leaders in Hispanic arts orga-
nizations fought against the exhibition because they felt that the art
and artists were being taken from the Hispanic organization's sphere
of influence. In organizing this kind of exhibition, an enormous
amount of time must be spent in communication with the minority
establishments. Silence can be misinterpreted and can lead to fear,
mistrust, and malicious, destructive rumors. An efficient communica-
tion system will not eliminate all these evils, but it helps to create a
foundation of understanding that is essential in an exhibition of this
kind. This is a significant difference from most of the art exhibitions
that I have worked on during my twenty-year museum career.

My goal in directing this project was to help broaden the pro-
gramming in mainstream art museums and to begin a long-term com-
mitment to bringing the Museum of Fine Arts, Houston, closer to the
diverse Hispanic communities that make up the city's population. This
latter goal is in concert with the belief broadly shared among art
museums that they must provide educational and community service
to all constituents. During the time that the exhibition was in Hous-
ton, there were approximately 150,000 visitors. Approximately thirty
percent were Hispanic, based on sample audience surveys. There were
major symposia, film festivals, artists' and writers' book festivals, con-
certs, family days, tours in Spanish and English, and a host of other
activities in Houston during the run of the exhibition. A special com-
mittee of fifty Hispanic community leaders helped the museum with
outreach and publicity. When the exhibition closed in Houston this
committee remained with the museum, helping the Education Depart-
ment to recruit Hispanic docents and to bring general art education
into the Hispanic communities via church groups, schools, and other
organizations. Moreover, the museum was introduced to numerous
Hispanic businesses and organizations that now work with and for the
museum on a regular basis. In short, the exhibition was a small but
important step forward in bringing the general art museum and the
Hispanic peoples of Houston closer together.

In another sense, the exhibition went against the tide of today's
art museums. Most directors I know believe that great museums must
specialize. In this sense, adding a new kind of exhibition to the pro-
gram can be seen as confusing an institution's identity and taking
funds away from an older, dedicated purpose. This exhibition is a
good example. Approximately one-half of the cost of the exhibition
was paid out of the operating budgets of the Museum of Fine Arts,
Houston, and the other five museums on the tour. The other half came

from grants from the Rockefeller Foundation, the ARCO Foundation, the AT&T Foundation, and the National Endowment for the Arts (NEA).

In the long run, the barrier to placing minority arts in the general art museum may be part of a much larger issue. Despite the enormous success of art museums in the United States during the last two decades, the fact remains that among the 150 top museums all but a handful are undercapitalized. Look closely at their budgets and you will see that few of our museums have the funds needed to carry out basic research or to expand into new program areas. For more and more institutions an overwhelming effort is being put into raising funds and earning income—not to create massive expansion programs, but to remain effective at present levels. Also, the traditional funding mechanisms for eleemosynary institutions are being altered gradually, making program innovation and expansion even more difficult. First, the budgets of the NEA and the National Endowment for the Humanities have remained relatively flat in the last eight years, losing ground to inflation. The incentives for philanthropy in the private, corporate, and foundation sectors have been reduced and in some cases eliminated by changes in the Internal Revenue Code. By reducing federal funding for the arts and eliminating incentives, the federal government has forced, and even encouraged, art museums to earn a higher percentage of their incomes. I have argued elsewhere that this pressure has tended to make art museums and other nonprofit institutions act like commercial or profit-oriented entities. This pressure to earn revenue has many ramifications for minority arts. Whether anyone is willing to say it or not, the question museum directors must ask themselves is simple: Can the large, established art museum afford minority-art exhibitions? Can the cost be offset by income? If a director does not ask that question, then he or she should look for another job.

The challenge for those of us who are dedicated to placing high-quality minority exhibitions in the broad context of general art museums is to find a way to make these projects a part of "normal" operations. In Houston there was concern that attendance would be low for an exhibition of Hispanic art. As I have said, the result was nearly 150,000 visitors, which is considered very good by Houston standards. A special public-relations plan, aimed at the major Hispanic neighborhoods and carried out by a Hispanic firm, was a huge success. In addition, while the exhibition was open in Houston, two other popular exhibitions were on view: Drawings by Holbein from the Court of Henry VIII and The Quest for Eternity, a major exhibi-

tion of Chinese tomb sculptures including life-size soldiers and horses from Xian. Hispanic Art in the United States benefited from the crossover attendance stimulated by these two great exhibitions. In addition, the visitors attracted by Hispanic Art in the United States were treated to great works of art from other cultures that may not have interested them initially.

I feel strongly about the role of general art museums in the presentation of minority exhibitions because in my experience, while minorities appreciate exhibitions dedicated to their unique art forms, people do not want a steady diet of their own work. The message that the Museum of Fine Arts received was loud and clear: Make the broad range of fine art understandable and accessible to minorities.

The general art museum is uniquely suited to achieve these goals. By intelligent scheduling of exhibitions, the "high-risk" exhibitions can be placed in a favorable position, thus hedging the risks of low attendance and low income. This allows these innovative programs to become gradually better known and more readily accepted, and thus supported by the community at large.

Placing minority exhibitions in general art museums also makes important statements about quality. A recent survey in Houston showed an overwhelming preference for European Old Masters over all other art forms, including American Western art. Our museum is fortunate to own great works by artists such as Rogier van der Weyden, Fra Angelico, Chardin, Monet, van Gogh, and many others. Important works by these artists were on view while Hispanic Art in the United States was open. Many of the artists in the exhibition expressed to me a tremendous sense of satisfaction that they were under the same roof with such hallowed colleagues. In short, we organized the Hispanic Art in the United States exhibition because many artists we showed met and sometimes exceeded the standards of past masters. The unique contribution of the general art museum is that it can demonstrate this by exhibiting concurrently these different works.

In exhibiting minority artists in the same manner as Italian Renaissance artists or French Impressionists, the Museum of Fine Arts, Houston, also addressed another controversial issue: how much interpretive information should be provided and how should it be presented? In our ongoing programs related to the permanent collection, we follow a fairly rigid philosophy. Exhibition labels are kept to a minimal size to encourage visitors to focus on the works of art themselves. We do not believe in installations that try to place art in context by installing large reproductions or long labels that "explain" the art.

This approach is balanced by our Education Department, which aggressively provides visitors with tours, pamphlets, catalogues, films, teacher-student packets, and other pedagogical tools. This translates into the belief that a minority artwork should be able to stand alone—apart from its cultural context, if you will—just the way a panel painting from a Renaissance predella, for example, may hang alone, out of context, in a museum. In our philosophy, the context is supplied in educational materials.

I mention this because in doing this exhibition I found an attitude that puzzles me to this day: the belief that contemporary minority art needs a kind of anthropological or sociological interpretation. I am not against museums that follow this attitude, but I—as director of the Museum of Fine Arts, Houston—want the right to exhibit contemporary artists the way I exhibit Old Masters.

In emphasizing the general art museum's role in presenting minority art, I am not in any way denigrating the institutions that specialize in African American, Hispanic, or any other minority art. On the contrary, the general art museum cannot function in this area without the specialized museum. Unfortunately, in my experience I have not seen much of an established network between the mainstream and minority spheres. The fault lies on both sides. The director of the general art museum is racing full speed ahead just to keep his or her institution operating at its current level. The directors of minority-oriented institutions, on the other hand, are sometimes fearful that cooperation will somehow hurt their identity and their unique role in their communities. And when it comes to the funding formulas of various government agencies—city, county, state, and federal—I have seen too much confrontation: too often battle lines are being drawn between big and little, general and specialized, minority and establishment. When art museums fight among themselves, everyone who cares about art loses. Our goals must be to enlarge audiences, to increase funding, to work together to rise above the status quo, and to make innovation a popular cause. I say this because my experience with the Hispanic Art in the United States exhibition as well as other exhibitions of minority art tell me that while bigotry is, to a certain extent, ingrained in our society, the real obstacle to overcome is the lack of exposure and, therefore, the lack of experience of the general public and art-history professionals. This simple fact is not sufficiently understood by those of us who want to expand the aesthetic boundaries and definitions of fine art. We expect too much from any single exhibition or book on minority art. These high expectations are the prod-

ucts of frustration and hype. Artists who finally get a chance to be seen by the general public and professionals might have expectations that are unrealistic. Curators who work for years on a minority exhibition find out that it is received like any other exhibition. And that is just the point. Moreover, as museums strive to fund an exhibition and stimulate attendance, they can easily overemphasize the words *first* or *new* and create expectations that are not met. I see each exhibition and book as building blocks, parts of a large edifice that includes academic, critical, and commercial elements as well. All are needed to establish and sustain any vital art form in our society. I hope we will arrive at a point where the minority exhibition will be received with the same thoughtful review process that serious Old Master exhibitions receive, with the same potential commercialism, and with the same in-depth study. Those will be the ultimate signs of acceptance.

CHAPTER 9

The Chicano Movement/
The Movement of
Chicano Art

TOMAS YBARRA-FRAUSTO

Born in the tumultuous decade of the 1960s, Chicano art has been closely aligned with the political goals of Chicano struggles for self-determination. As an aesthetic credo, Chicano art seeks to link lived reality to the imagination. Going against mainstream cultural traditions of art as escape and commodity, Chicano art intends that viewers respond both to the aesthetic object and to the social reality reflected in it. A prevalent attitude toward the art object is that it should provide aesthetic pleasure while also serving to educate and edify. In its various modalities, Chicano art is envisioned as a model for freedom, a call to both conscience and consciousness.[1]

PHASE I, 1965–1975: CREATION OF THE PROJECT

Although struggles for social, political, and economic equality have been a central tenet of Chicano history since 1848, the efforts to unionize California farmworkers launched by Cesar Chavez in 1965 signaled a national mobilization, known as La Causa, among people of Mexican descent in the United States. The Chicano movement, or El Movimiento, was an ideological project closely aligned with the tactics, formulations, and beliefs of the civil-rights movement, the rise of Black Power, the political agenda of the New Left, the onset of an

international student movement, and the struggles of liberation throughout the Third World. In retrospect, the Chicano movement was extremely heterogeneous, cutting across social class and regional and generational groupings.

Impelled by this mass political movement, Chicano artists, activists, and intellectuals united to articulate the goals of a collective cultural project that would meld social practice and cultural production. A primary aim of this project was to surmount strategies of containment by struggling to achieve self-determination on both the social and aesthetic planes. It was the Chicano movement—through various political fronts such as the farmworkers' cause in California, urban civil-rights activities, the rural-land-grant uprisings in New Mexico, the student and antiwar movements on college campuses, the labor struggles of undocumented workers, and the rise of feminism—that gave cogency to the cultural project.

Artists were integrated into the various political fronts of El Movimiento in unprecedented numbers and in significant ways. They organized, wrote the poems and songs of struggle, coined and printed the slogans, created the symbols, danced the ancient rituals, and painted ardent images that fortified and deepened understanding of the social issues being debated in Chicano communities.

An urgent first task was to repudiate external visions and destroy entrenched literary and visual representations that focused on Mexican Americans as receptors rather than active generators of culture. For the creative artist, whether painter, dancer, musician, or writer, this meant appropriation of his or her own self. Novelist Tomas Rivera further defines the enterprise:

> The invention of ourselves by ourselves is in actuality an extension of our will. Thus, as the Chicano invents himself he is complementing his will. Another complement. This is of great importance because these lives are trying to find form. This development is becoming a unifying consciousness. The thoughts of the Chicano are beginning to constantly gyrate over his own life, over his own development, over his identity, and as such over his own conservation. . . . Chicano literature has a triple mission: to represent, and to conserve that aspect of life that the Mexican American holds as his own and at the same time destroy the invention by others of his own life. That is—conservation, struggle and invention.[2]

This triad of conservation, struggle, and invention became a theme of Chicano literature. It served also as a core assumption in the production of energetic new forms of visual culture.

Sustained polemics by artists' groups throughout the country established the forms and content of Chicano art. Though few collective manifestos were issued, aesthetic guidelines can be gleaned from artists' statements, community-newspaper accounts, and oral interviews. Typical of this florescence of socially engaged artistic consciousness was the formation of the Mala Efe group (Mexican American Liberation Art Front) in the San Francisco Bay area. The artist Esteban Villa recalls:

> *Esto fue por eso del ano '68. . . . Era la época del* grape boycott *y del* Third World Strike *en* Berkeley. We would meet regularly to discuss the role and function of the artist in El Movimiento. At first our group was composed mainly of painters and we would bring our work and criticize it. Discussions were heated, especially the polemics on the form and content of revolutionary art and the relevance of murals and graphic art. Posters and other forms of graphics were especially discussed since many of us were creating *cartelones* as organizing tools for the various Chicano *mitotes* [spontaneous "happenings"] in the Bay Area.
>
> Our group kept growing and soon included local poets and intellectuals like Octavio Romano. In March of 1969, we decided to hold an exhibition in a big old frame house on 24th Street here in Oakland. The spacious but slightly *rasquache* house had been christened La Causa. The exhibition was called Nuevos Simbolos for La Nueva Raza and attempted to visually project images of *el hombre nuevo*: the Chicano who had emerged from the decolonization process.
>
> Opening night was *a todo dar* with *viejitos, wainitos,* and *vatos de la calle* walking in, checking it out and staying to rap. *Algunos poetas locales* read their work and there was music and *plática muy sabrosa.* We all sensed the beginning of an artistic rebirth. *Un nuevo arte del pueblo.*[3]

This "*nuevo arte del pueblo*" (a new art of the people) was to be created from shared experience and based on communal art traditions. Necessarily, a first step was to investigate, and give authority to, authentic expressive forms arising within the heterogeneous Chicano community. In opposition to the hierarchical dominant culture, which implicitly made a distinction between "fine art" and "folk art," attempts were made to eradicate boundaries and integrate categories. An initial recognition was that the practices of daily life and the lived environment were primary constituent elements of the new aesthetic.

In the everyday life of the barrio, art objects are embedded in a

network of cultural sites, activities, and events. "The way folk art fits
into this cultural constellation reveals time-tested aesthetic practices
for accomplishing goals in social, religious and economic life. And
these practices are on-going; they point not to an absolute standard or
set of truths."[4] Inside the home, in the yard, and on the street corner—
throughout the barrio environment—a visual culture of accumulation
and bold display is enunciated. Handcrafted and store-bought items
from the popular culture of Mexico and the mass culture of the United
States mix freely and exuberantly in a milieu of inventive appropria-
tion and recontextualization. The barrio environment is shaped in
ways that express the community's sense of itself, the aesthetic display
projecting a sort of visual biculturalism.

As communal customs, rituals, and traditions were appropriated
by Movimiento artists, they yielded boundless sources of imagery. The
aim was not simply to reclaim vernacular traditions but to reinterpret
them in ways useful to the social urgency of the period.

Some Vernacular Sources of Chicano Art

ALMANAQUES *Almanaques* (calendars) are a common feature in Chi-
cano households, given to favored customers each year by barrio busi-
nesses. *Almanaques* traditionally feature images from Mexican
folklore. Favorite images include nostalgic rural landscapes, interpre-
tations of indigenous myths or historical events, bullfighting and cock-
fighting scenes, and the full pantheon of Catholic saints. Two of the
most common images from the *almanaque* tradition are the Virgin of
Guadalupe and an Aztec warrior carrying a sleeping maiden, which is
a representation of the ancient myth of Ixtacihuatl and Popocatepetl
(two snow-covered volcanoes in the Valley of Mexico).

Almanaques are printed in the United States, but the lithographed
or chromolithographed images are generally imported from Mexico
because of the immense popularity of famous *almanaque* artists such
as Jesus Helguera and Eduardo Catano.[5] Their pastel, romanticized
versions of Mexican types and customs are saved from year to year
and proudly displayed in homes.

In the *almanaque* tradition, many community centers began issu-
ing *calendarios Chicanos* in the mid-1970s.

ESTAMPAS RELIGIOSAS In many Chicano households, images of
Catholic saints, martyrs of the faith, and holy personages are mingled
with family photographs and memorabilia and prominently displayed
on home altars or used as wall decorations.

Dispensed at churches or purchased in religious-specialty stores, the *estampas religiosas* (religious images) vary from calling-card-size to poster-size. *Estampas* represent Catholic saints with their traditional symbols: for example, St. Peter with a set of two crossed keys, St. Clement with an anchor, or St. Catherine with a wheel. The images are folk religious narratives, depicting miracles, feats of martyrdom in defense of the faith, or significant stories from the lives of the saints. Parents refer to the *estampas* as they recount the heroic episodes depicted, both socializing their children and introducing them to the tenets of the Catholic church. The saints of the *estampas* become guides to proper behavior and are many a child's first encounter with traditional Christian symbols.

ALTARES Artists also focused on *altares* (home religious shrines) as expressive forms of cultural amalgamation. In their eclectic composition, they fuse traditional items of folk material culture with artifacts from mass culture. Typical constituents of an *altar* include crocheted doilies and embroidered cloths, *recuerdos* (such as flowers or favors saved from some dance or party), family photographs, personal mementos, *santos* (religious chromolithographs or statues) especially venerated by the family, and many other elements. The grouping of the various objects in a particular space—atop a television set, on a kitchen counter, atop a bedroom dresser, or in a specially constructed *nicho* (wall shelf)—appears to be random but usually responds to a conscious sensibility and aesthetic judgment of what things belong together and in what arrangement. *Altares* are organic and ever-changing. They are iconic representations of the power of relationships, the place of contact between the human and the divine. *Altares* are a sophisticated form of vernacular *bricolage*, and their constituent elements can be used in an infinite number of improvised combinations to generate new meanings. A number of Chicano artists, among them Amalia Mesa-Bains and Rene Yanez, became known as *altaristas* (makers of altars), experimenting with the *altar* form in innovative ways.

CARTELES Mexican *carteles* (theatrical posters) and the ubiquitous commercially designed advertisements for barrio social events, such as dances or artistic caravans of visiting Mexican entertainers, were also significant image sources.

EXPRESSIVE FORMS FROM YOUTH CULTURES Chicano youth cultures were acknowledged as guardians and generators of a style, stance, and visual discourse of pride and identity. Urban iconography melds customs, symbols, and forms of daily-life practices in the metropolis. *Placas* (graffiti), tattoos, customized *ranflas* (low-rider cars), gang regalia, and countless other expressive forms evoke and embody a contemporary barrio sensibility. It is a sense of being that is defiant, proud, and rooted in resistance. Gilbert Lujan, Willie Herron, John Valadez, Judith Baca, and Santos Martinez are among legions of artists who experiment with barrio symbology in their work.

Rasquachismo: *A Chicano Sensibility*

Beyond grounding themselves in vernacular art forms, Movimiento artists found strength from and recovered meaning sedimented in consistent group stances such as *rasquachismo*. *Rasquachismo*[6] is neither an idea nor a style, but more of a pervasive attitude or taste. Very generally, *rasquachismo* is an underdog perspective—a view from *los de abajo*. It is a stance rooted in resourcefulness and adaptability, yet ever mindful of aesthetics.

In an environment in which things are always on the edge of coming apart (the car, the job, the toilet), lives are held together with spit, grit, and *movidas*. *Movidas* are whatever coping strategies one uses to gain time, to make options, to retain hope. *Rasquachismo* is a compendium of all the *movidas* deployed in immediate, day-to-day living. Resilience and resourcefulness spring from making do with what is at hand (*hacer rendir las cosas*). This utilization of available resources makes for syncretism, juxtaposition, and integration. *Rasquachismo* is a sensibility attuned to mixtures and confluence. Communion is preferred over purity.

Pulling through and making do are not guarantors of security, so things that are *rasquache* possess an ephemeral quality, a sense of temporality and impermanence—here today and gone tomorrow. While things might be created using whatever is at hand, attention is always given to nuances and details. Appearance and form have precedence over function.

In the realm of taste, to be *rasquache* is to be unfettered and unrestrained, to favor the elaborate over the simple, the flamboyant over the severe. Bright colors (*chillantes*) are preferred to somber, high intensity to low, the shimmering and sparkling over the muted and

subdued. The *rasquache* inclination piles pattern on pattern, filling all available space with bold display. Ornamentation and elaboration prevail and are joined with a delight in texture and sensuous surfaces. A work of art may be *rasquache* in multiple and complex ways. It can be sincere and pay homage to the sensibility by restating its premises, i.e., the underdog worldview actualized through language and behavior, as in the dramatic presentation *La Carpa de los Rasquaches*, by Luis Valdez. Another strategy is for the artwork to evoke a *rasquache* sensibility through self-conscious manipulation of materials or iconography. One thinks of the combination of found materials and the use of satiric wit in the sculptures of Ruben Trejo, or the manipulation of *rasquache* artifacts, codes, and sensibilities from both sides of the border in the performance pieces of Guillermo Gomez-Peña. Many Chicano artists continue to investigate and interpret facets of *rasquachismo* as a conceptual lifestyle or aesthetic strategy.

Fronts of Struggle, Forms of Art

The initial phase of the Chicano cultural project (circa the mid-1960s) was seminal in validating emancipatory communal practices and codifying the symbols and images that would be forcefully deployed in adversarial counterrepresentations. By that time, visual artists had been well integrated into the various political fronts of El Movimiento, within which they were gestating a Chicano art movement that was national in scope and developed outside the dominant museum, gallery, and arts-publication circuit. Fluid and tendentious, the art produced by this movement underscored public connection instead of private cognition.

Inscribed in multiple arenas of agitation, artists continued to evolve *un arte del pueblo* that aimed to close the gap between radical politics and community-based cultural practices. The rural farmworkers' cause and the urban student movement are prime examples of this rapprochement.

La Causa, the farmworkers' struggle, was a grass-roots uprising that provided the infinitely complex human essence necessary for creating a true people's art. One of the early purveyors of *campesino* expression was the newspaper *El Malcriado* (The Ill-Bred). Established primarily as a tool for organizing, the periodical soon came to function as a vehicle that promoted unity by stressing a sense of class consciousness while building cultural and political awareness. In artistic terms, *El Malcriado* lived up to its name by focusing on art forms

outside the "high-art" canon, such as caricature and cartoons. The pervasive aesthetic norm was *rasquachismo*, a bawdy, irreverent, satiric, and ironic worldview.

In California, among the first expressions of this *rasquache* art were the political drawings of Andy Zermano, which were reproduced in *El Macriado* starting in 1965. With trenchant wit, Zermano created Don Sotaco, a symbolic representation of the underdog. Don Sotaco is the archetypal *rasquache*, the dirt-poor but cunning individual who derides authority and outsmarts officialdom. In his cuttingly satirical cartoons, Zermano created vivid vignettes that are a potent expression of *campesinos'* plight. His drawings clearly point out the inequalities existing in the world of the *patron* (the boss) and the agricultural worker. To a great extent, these graphic illustrations of social relations did much to awaken consciousness. With antecedents in the Mexican graphic tradition of Jose Guadalupe Posada and Jose Clemente Orozco, the vivid imagery of Andy Zermano documents the creation of art for a cause.

The farmworkers' journal *El Malcriado* was also significant in its efforts to introduce Chicanos to a full spectrum of Mexican popular art. Its pages were full of people's *corridos* (ballads), poems, and drawings. Its covers often reproduced images garnered from the various publications of the Taller de Grafica Popular (Workshop for Popular Graphic Art), an important source of Mexican political art. Through this journalistic forum, Chicano artists became acquainted with the notion that art of high aesthetic quality could substantially aid in furthering Chicano agrarian struggles.

As a primary impetus toward collaboration between workers and artists, *El Malcriado* planted the seed that would come to fruition in many other cooperative ventures between artists and workers. The creative capacities of artists were placed at the service of and welcomed by those struggling for justice and progress.

Simultaneously with the cultural expression of the farmworker's cause, a highly vocal and visible Chicano student movement emerged during the mid-1960s. Related to the worldwide radicalization of youth and inspired by international liberation movements, especially the Cuban revolution, the Black Power movement, and varied domestic struggles, the Chicano student movement developed strategies to overcome entrenched patterns of miseducation. Institutionalized racism was targeted as a key detriment, and cultural affirmation functioned as an important basis for political organization.

Chicano culture was affirmed as a creative, hybrid reality synthe-

sizing elements from Mexican culture and the social dynamics of life experience in the United States. Scholars such as Octavio Romano published significant essays debunking orthodox views of Chicano life as monolithic and ahistorical. Contrary to these official notions, Chicano culture was affirmed as dynamic, historical, and anchored in working-class consciousness.

Within the student movement, art was assigned a key role as a maintainer of human signification and as a powerful medium that could rouse consciousness. Remaining outside the official cultural apparatus, the student groups originated alternative circuits for disseminating an outpouring of artistic production. As in the nineteenth century, when Spanish-language newspapers became major outlets for cultural expression in the Southwest, contemporary journals functioned as purveyors of cultural polemics and new representations. Although varying in emphasis and quality, most student-movement periodicals shared a conscious focus on the visual arts as essential ingredients in the formation of Chicano pride and identity. For many readers, it was a first encounter with the works of the Mexican muralists, the graphic mastery of Jose Guadalupe Posada, the Taller de Grafica Popular, and reproductions of pre-Columbian artifacts. Equally important, Movimiento newspapers such as *Bronze, El Machete, El Popo, Chicanismo*, and numerous others published interviews with local Chicano artists while encouraging and reproducing their work.

Knowledge about the Hispanic–Native American art forms of the Southwest came from neither academic nor scholarly sources, but rather from venues within the movement such as *El Grito del Norte*, a newspaper issued from Espanola, New Mexico, starting in 1968. This journal had a grass-roots orientation and placed emphasis on preserving the culture of the rural agrarian class. Often, photographic essays focusing on local artisans or documenting traditional ways of life in the isolated *pueblitos* of northern New Mexico were featured. Cleofas Vigil, a practicing *santero* (carver of *santos*) from the region, traveled widely, speaking to groups of artists. The carvers Patrocinio Barela, Celso Gallegos, and Jorge Lopez, all master *santeros* who were collected, documented, and exhibited by Anglo patrons during the first part of the century, gained renewed influence within the budding associations of Chicano artists. Old and tattered exhibition catalogues, newspaper clippings, and barely legible magazine articles that documented their work were examined and passed from hand to hand to be eagerly scrutinized and savored. Primarily through oral tradition and

the informal sharing of visual documentation, Chicano artists became aware of a major ancestral folk art tradition. And aside from the Movimiento press, literary and scholarly journals such as *El Grito* and *Revista Chicana Riqueña* often published portfolios of artists' works. All these alternative venues inserted art into life, propagating enabling visions of Chicano experience.

Asserting that Chicano art had a basic aim to document, denounce, and delight, individual artists and artists' groups resisted the formulation of a restricted aesthetic program to be followed uniformly. The Chicano community was heterogeneous, and the art forms it inspired were equally varied. Although representational modes became dominant, some artists opted for abstract and more personal expression. Artists in this group felt that internal and subjective views of reality were significant, and that formal and technical methods of presentation should remain varied.

Alternative Visions and Structures

By the early 1970s, Chicano artists had banded together to create networks of information, mutual support systems, and alternative art circuits. Regional artists' groups such as the Royal Chicano Air Force (R.C.A.F.) in Sacramento, the Raza Art and Media Collective in Ann Arbor, Michigan, the Movimiento Artistico Chicano (MARCH) in Chicago, the Con Safos group in San Antonio, Texas, and many others persisted in the vital task of creating art forms that strengthened the will and fortified the cultural identity of the community.

With militant and provocative strategies, Chicano arts organizations developed and shared their art within a broad community context. They brought aesthetic pleasure to the sort of working people who walk or take the bus to work in the factories or in the service sector of the urban metropolis. In its collective character, in its sustained efforts to change the mode of participation between artists and their public, and, above all, as a vehicle for sensitizing communities to a pluralistic rather than a monolithic aesthetic, the Chicano alternative art circuit played a central and commanding role in nurturing a visual sensibility in the barrio.

POSTERS The combative phase of El Movimiento called for a militant art useful in the mobilization of large groups for political action. Posters were seen as accessible and expedient sources of visual information and indoctrination. Because they were inexpensive to repro-

duce and portable, they were well suited for mass distribution. More-over, posters had historical antecedents in the Chicano community.[7] Many of the famous *planes* or political programs of the past had been issued as broadsides or posters to be affixed on walls, informing the populace and mustering them for political action.

The initial phase of Chicano poster production was directly in-fluenced by both the work of Jose Guadalupe Posada and images from the Agustin Casasola photographic archives, which contained photos documenting the Mexican revolution.[8] Early Chicano poster makers appropriated images from these two primary sources and merely re-produced and massively distributed Posada and Casasola images em-bellished with slogans such as *Viva La Causa* and *Viva La Revolución.* Francisco "Pancho" Villa and Emiliano Zapata, iconic symbols of the Mexican Revolution, were among the first images that assaulted Chi-cano consciousness via the poster. Poster images of Villa and Zapata were attached to crude wooden planks and carried in picket lines and countless demonstrations. Quoting from Mexican antecedents was an important initial strategy of Chicano art. Having established a cultural and visual continuum across borders, Chicano artists could then move forward to forge a visual vocabulary and expressive forms correspond-ing to a complex bicultural reality.

Used to announce rallies, promote cultural events, or simply as visual statements, Chicano posters evolved as forms of communica-tion with memorable imagery and pointed messages. The superb craftsmanship of artists such as Carlos Cortes, Amado Murillo Pena, Rupert Garcia, Malaquias Montoya, Ralph Maradiaga, Linda Lucero, Ester Hernandez, and a host of others elevated the poster from a mere purveyor of facts into visual statements that delighted as well as in-formed and stimulated. Formal elements such as color, composition, and lettering style echoed diverse graphic traditions: the powerful, socially conscious graphics of the Taller de Grafica Popular in Mexico, the colorful, psychedelic rock-poster art of the hippie counterculture, and the boldly assertive style of the Cuban *affiche.*

Such eclectic design sources taught graphic artists how to appeal and communicate with brevity, emphasis, and force. Chicano posters did not create a new visual vocabulary, but brilliantly united various stylistic influences into an emphatic hybrid expression. The two salient categories are political posters and event posters. The primary func-tion of both forms was ideological mobilization through visual and verbal means.

Chicano posters generally were issued in hand-silkscreened editions of several hundred or lithographed runs of several thousand. They were posted on walls, distributed free at rallies, or sold for nominal prices. Within many sectors of the community, Chicano posters were avidly collected and displayed in personal spaces as a matter of pride and identification with their message. For a mass public unaccustomed and little inclined to visit museums and art galleries, the Chicano poster provided a direct connection to the pleasures of owning and responding to an art object. Chicano posters were valued both as records of historical events and as satisfying works of art.

MURALS The barrio mural movement is perhaps the most powerful and enduring contribution of the Chicano art movement nationwide. Created and nurtured by the humanist ideals of Chicano struggles for self-determination, murals functioned as a pictorial reflection of the social drama.

Reaching back to the goals and dicta of the Mexican muralists, especially the pronouncements of David Alfaro Siqueiros, in the mid-1960s Chicano artists called for an art that was public, monumental, and accessible to the common people. The generative force of Chicano muralism was also a mass social movement, but the artists as a whole did not have the same kind of formal training as the Mexican muralists, and they fostered mural programs through an alternative circuit independent of official sanction and patronage.

For their visual dialogue, muralists used themes, motifs, and iconography that gave ideological direction and visual coherence to the mural programs. In the main, the artistic vocabulary centered on the indigenous heritage (especially the Aztec and Mayan past), the Mexican Revolution and its epic heroes and heroines, renderings of both historical and contemporary Chicano social activism, and depictions of everyday life in the barrio. Internationalism entered the pictorial vocabulary of Chicano murals via iconographic references to liberation struggles in Vietnam, Africa, and Latin America and motifs from cultures in those areas. The muralists' efforts were persistently directed toward documentation and denunciation.

Finding a visual language adequate to depict the epic sweep of the Chicano movement was not simple. Some murals became stymied, offering romantic, archaicizing views of indigenous culture, uncritically depicting Chicano life, and portraying cultural and historical events without a clear political analysis. Successful mural programs,

Fig. 9-1. *Malaquias Montoya,* Undocumented, *1981.* Reproduced by permission of the artist.

however, were most significant in reclaiming history. As the community read the visual chronicles, it internalized an awareness of the past and activated strategies for the future.

Apart from the aesthetic content, muralism was significant in actualizing a communal approach to the production and dissemination of art. Brigades of artists and residents worked with a director who solicited community input during the various stages of producing the mural. Through such collaborative actions, murals became a large-scale, comprehensive public-education system in the barrio.

In retrospect, it can be affirmed that Chicano art in the 1960s and 1970s encompassed both a political position and an aesthetic one. That art underscored a consciousness that helped define and shape fluid and integrative forms of visual culture. Artists functioned as visual educators, with the important task of refining and transmitting

Fig 9-2. *Rupert Garcia*, Nose to Nose, *1981*. Reproduced by permission of the artist.

through plastic expression the ideology of a community striving for self-determination.

A Chicano national consciousness was asserted by a revival in all the arts. Aesthetic guidelines were not officially promulgated but arose within the actual arena of political practice. As opposed to mainstream art movements, where critical perspectives remain at the level of the work (art about itself and for itself), the Chicano art movement sought to extend meaning beyond the aesthetic object to include transformation of the material environment as well as of consciousness.

PHASE II, 1975–1990: NEUTRALIZATION AND RECUPERATION OF
THE PROJECT

The late 1970s and the 1980s have been a dynamically complex juncture for the Chicano cultural project. Many of its postulates and aims have come to fruition during this time. Three of these aims are: (1) the creation of a core of visual signification, a bank of symbols and images that encode the deep structures of Chicano experience. Drawing from this core of commonly understood iconography, artists can create

counterrepresentations that challenge the imposed "master narrative" of elite art practice; (2) the maintenance of alternative art structures, spaces, and forms. For more than two decades, Chicano arts organizations have persisted in the arduous task of creating a responsive working-class audience for art. A principal goal of these efforts has been to make art accessible, to deflect its rarefied, elitist aura, and especially to reclaim the art from its commodity status with the ideal of returning it to a critical role within the social practices of daily living; and (3) the continuation of mural programs. Although there has been a diminution in the number of public art forms such as murals and posters, what has been produced since 1975 is of deeper political complexity and superior aesthetic quality.

According to the muralist Judith Baca,

> Later works such as the Great Wall of Los Angeles developed a new genre of murals which have close alliance with conceptual performance in that the overall mural is only one part of an overall plan to affect social change. Muralists such as ASCO [a performance group] began to use themselves as the art form, dressing themselves like

Fig. 9-3. *Rupert Garcia*, For Caravaggio and the ALB, *1985*. Reproduced by permission of the artist.

Fig. 9-4. *David Avalos,*
El Nopal, *fragment of*
Loteria Chicana, *1983.*
Reproduced by permission
of the artist.

murals and stepping down off walls to perform. Experiments with portable murals and new social content continue. There is a shift of interest from the process to the product. While fewer murals are being painted, they are of higher quality and the forms of image-making continue to be viewed as an educational process.[9]

Such accomplishments are especially praiseworthy, having transpired during a period of intense change and transformation in Chicano communities. The utopian buoyancy that sustained a national Chicano art movement has eroded. As the groundswell of collective political action has dispersed, as more Chicanos enter the professional class and are affected by its implied social mobility, and as public art forms have diminished in frequency, tracings of a new agenda of struggle have surfaced.

Given demographic data indicating that the number of people of Latin American descent in the United States is growing, and given

Fig. 9-5. *Carmen Lomas Garza,* Una Tarde (One Afternoon). Reproduced by permission of the artist.

sociological data indicating that Spanish-speaking groups remain definitely "other" for several generations, new cultural undercurrents among Chicanos call for an awareness of America as a continent and not a country. In the new typology an emergent axis of influence might lead from Los Angeles to Mexico City and from there to Bogotá, Lima, Buenos Aires, Managua, Barcelona, and back to the barrio. For the creative artists, such new political and aesthetic filiations expand the field with hallucinatory possibilities. As performance artist Guillermo Gomez-Peña points out:

> The strength and originality of Chicano-Latino contemporary art in the U.S. lies partially in the fact that it is often bicultural, bilingual and/or biconceptual. The fact that artists are able to go back and forth between two different landscapes of symbols, values, structures and styles, and/or operate within a "third landscape" that encompasses both. . . .[10]

To-ing and fro-ing between multiple aesthetic repertoires and venues including mainstream galleries, museums, and collectors as well as alternative infrastructures created by El Movimiento, Chicano artists

Fig. 9-6. *John Valadez,* Broadway Mural (*detail*), *1981–82.* Reproduced by permission of the artist.

question and subvert totalizing notions of cultural coherence, wholeness, and fixity. Contemporary revisions of identity and culture affirm that both concepts are open and offer the possibility of making and remaking oneself from within a living, changing tradition.

In contemporary Chicano art, no artistic current is dominant. Figuration and abstraction, political art and self-referential art, art of process, performance, and video all have adherents and advocates. The thread of unity is a sense of vitality and continual maturation. The mainstream art circuit continues to uphold rigid and stereotypical notions in its primitivistic and folkloristic categorizations of "ethnic art." This is an elite perspective that blithely relegates highly trained artists into a nether region in which Chicano art is inscribed in an imagined world that is a perpetual fiesta of bright colors and folk idioms—a world in which social content is interpreted as a cultural form unconnected to political and social sensibilities.

For the denizens of the arts establishment, Chicano art is uneasily accommodated within two viewpoints. It can be welcomed and celebrated under the rubric of pluralism, a classification that permissively allows a sort of supermarketlike array of choices among styles, techniques, and contents. While stemming from a democratic impulse to

validate and recognize diversity, pluralism serves also to commodify art, disarm alternative representations, and deflect antagonisms. Impertinent and out-of-bounds ethnic visions are embraced as energetic new vistas to be rapidly processed and incorporated into peripheral spaces within the arts circuit, then promptly discarded in the yearly cycle of new models. What remains in place as eternal and canonical are the consecrated idioms of Euro-centered art. Seen from another perspective, the power structure of mainstream art journals, critics, galleries, and museums selectively chooses and validates what it projects, desires, and imposes as constituent elements of various alternative artistic discourses. For "Hispanic" art, this selective incorporation often foregrounds artwork deemed "colorful," "folkloric," "decorative," and untainted with overt political content. While elements of these modalities might be present in the artistic production of "Hispanic" artists, they do not necessarily cohere into consistent and defining stylistic features.

Inscribed within multiple class-based and regional traditions, Chicanos in the United States have activated complex mechanisms of cultural negotiation, a dynamic process of analysis and the exchange of options between cultures. In an interconnected world system, traditions are lost and found, and angles of vision accommodate forms

Fig. 9-7. *John Valadez*, La Butterfly, *1984*. Reproduced by permission of the artist.

Fig. 9-8. *Luis Jimenez,* Honky Tonk (*detail*), *1981.* Reproduced by permission of the artist.

and styles from First and Third World modernist traditions as well as from evolving signifying practices in the barrio. What is vigorously defended is a choice of alternatives.

In the visual arts, this process of cultural negotiation occurs in different ways. At the level of iconography and symbolism, for example, the Chicano artist often creates a personal visual vocabulary freely blending and juxtaposing symbols and images culled from African American, Native American, European, and mestizo cultural sources. Resonating with the power ascribed to the symbols within each culture, the new combination emerges dense with multifarious meaning. Beyond symbols, artistic styles and art-historical movements are continually appropriated and recombined in a constant and richly nuanced interchange. Current Chicano art can be seen as a visual narration of cultural negotiation.

Presently in the United States, entrenched systems of control and domination affirm and uphold distinctions between "us" and "them." Dichotomies such as white/nonwhite, English-speaking/Spanish-speaking, the haves/the have-nots, etc., persist and are based on social reality. We should not dissemble on this fact, but neither should we maintain vicious and permanent divisions or permit dogmatic closure.

My own sense of the dialectic is that in the current struggle for

Fig. 9-9. *Amalia Mesa-Bains,* Altar for Santa Teresa, *1985 installation at the De Saisset Museum.* Photo by Wolfgang Dietze. Reproduced by permission of the artist.

cultural maintenance and parity within the Chicano community, there are two dominant strategies vying for ascendancy. On the one hand, there is an attempt to fracture mainstream consensus with a defiant "otherness." Impertinent representations counter the homogenizing desires, investments, and projections of the dominant culture and express what is mainfestly different. On the other hand, there is the recognition of new interconnections and filiations, especially with other Latino groups in the United States. Confronting the dominant culture leads to a recognition that Anglos' visions of Chicanos and Chicanos' visions of themselves support and to an extent reflect each other.

Rather than flowing from a monolithic aesthetic, Chicano art forms arise from tactical, strategic, and positional necessities. What Carlos Monsivais has called *la cultura de la necesidad* (the culture of necessity) leads to fluid multivocal exchanges among shifting cultural

Fig. 9-10. *Amalia Mesa-Bains,* Grotto of the Virgins, *1987 installation at the INTAR Latin American Gallery, New York.* Reproduced by permission of the artist.

traditions. A consistent objective of Chicano art is to undermine imposed models of representation and to interrogate systems of aesthetic discourse, disclosing them as neither natural nor secure but conventional and historically determined.

Chicano art and artists are inscribed within multiple aesthetic traditions, both popular and elite. Their task is to recode themselves and move beyond dichotomies in a fluid process of cultural negotiation. This negotiation usually reflects cultural change, variation by gender and region, and tensions within and among classes and groups of people, such as Mexican nationals or other ethnic minorities in the United States.

In the dynamism of such a contemporary social reality, interests are culturally mediated, replaced, and created through what is collectively valued and worth struggling for. The task continues, and remains open.

NOTES

1. This text is a reworking of my unpublished manuscript *Califas: California Chicano Art and Its Social Background*. Sections have been excerpted in *Chicano Expressions: A New View in American Art* (New York: INTAR Latin American Gallery, 1986) and *The Mural Primer* (Venice, Calif.: Social and Public Resource Center, 1987). My analysis parallels ideas in James Clifford, *The Predicament of Culture: Twentieth-Century Ethnography, Literature and Art* (Cambridge: Harvard University Press, 1988).

2. Tomas Rivera, *Into the Labyrinth: The Chicano in Literature* (Edinburg, Texas: Pan American University, 1971).

3. Esteban Villa, taped interview, 1979, in possession of the author.

4. Kay Turner and Pat Jasper, "La Causa, La Calle y La Esquina: A Look at Art Among Us," in *Art Among Us: Mexican American Folk Art of San Antonio* (San Antonio: San Antonio Museum Association, 1986).

5. See the catalog *Jesus Helguera: El Calendario Como Arte* (Mexico City: Subsecretaria de Cultura/Programa Cultural de Las Fronteras, 1987).

6. Tomas Ybarra-Frausto, "Rasquachismo: A Chicano Sensibility," in *Rasquachismo: Chicano Aesthetic* (Phoenix: Movimiento Artistico Del Rio Salado, 1988).

7. See Shifra M. Goldman, "A Public Voice: Fifteen Years of Chicano Posters," *Art Journal* 44, no. 1 (Spring, 1984).

8. Victor Sorell, "The Photograph as a Source for Visual Artists: Images From the Archivo Casasola in the Works of Mexican and Chicano Artists," in *The World of Agustin Victor Casasola: Mexico 1900–1938* (Washington, D.C.: Fonda del Sol Visual Arts and Media Center, 1984).

9. Judith Baca, "Murals/Public Art," in *Chicano Expressions: A New View in American Art* (New York: INTAR Latin American Gallery, 1987), 37.

10. Guillermo Gomez-Peña, "A New Artistic Continent," *High Performance* 9, no. 3 (1986), 27.

PART 3

Museum Practices

STEVEN D. LAVINE

Voice has emerged as a crucial issue in the design of exhibitions. Whose voice is heard when a curator works through an established genre of exhibition, such as the monographic account of an artist's career or the ecological and social explanation of the lives of "primitive" peoples in the diorama of a natural-history museum? How can the voice of an exhibition honestly reflect the evolving understandings of current scholarship and the multiple voices within any discipline? How can museums make space for the voices of indigenous experts, members of communities represented in exhibitions, and artists? How can the widely varying voices of museum visitors be heard by exhibition makers and reflected in their designs? Can an exhibition contain more than one voice, or can a voice exhibit more than one message?

Spencer Crew and James Sims, examining the current situation of American historical museums, address these issues head-on. Their

assertion that objects have no voice places great weight on the voice of the curator. The challenge, as Crew and Sims set it out, is to achieve a high degree of authenticity in that voice as measured against the best current scholarship. To meet this challenge, curators must overcome habitual practices that reflect historical myths they would sometimes like to share. As Crew and Sims's particular concern is American social history, the challenge is doubled by the necessity of giving voice to groups excluded by other historical accounts—"African Americans, women, ethnic communities, common laborers, and other groups, who in the past were seen as peripheral to the main currents of American history." Complicating this task further are, on the one hand, the myths and background assumptions viewers bring to the historical museum and, on the other, the scarcity in museums of the objects necessary to document social history.

Exhibitions of social history are driven by interpretive ideas and are usually organized as narratives. As a result, objects are not made the primary focus of exhibits but retain significance as corroborative evidence. The attendant demystification of objects may in fact bring them closer to the lives of the visitors and release emotional and imaginative possibilities. All this requires a fine tact if the museum's interpretive authority is to be maintained. Crew and Sims refer to "the social contract between the audience and the museum, a socially agreed-upon reality that exists only as long as confidence in the voice of the exhibition holds." Clearly, that contract can come under strain as curators ask the audience to attend to issues in the past that are not very attractive or self-fulfilling as mythologies. Furthermore, that contract must be maintained in a highly theatrical environment in which the event of the visit takes primacy over any object, label, or expla-

nation and in which the visitor is inevitably a cocreator of any meaning.

As sensitive as Crew and Sims are to the task of giving voice to those hitherto silenced by history, their strategies require no fundamental transfer of institutional authority. Museums may have to invest more in research and alter their collecting policies, but it is left to the curator to organize the meaning and experience of the exhibition. There is no suggestion, for example, that African Americans be questioned about what they would like to see in the museum's representation of their forebears.

In contrast, Elaine Heumann Gurian argues that because visitors are inevitably creators of meaning, their voices must be heard in the design of exhibitions. For her, the experiments of Michael Spock at the Boston Children's Museum and Frank Oppenheimer at the Exploratorium in San Francisco provide a baseline. Their methods for incorporating the questions of the audience into the development of exhibitions and then creating a nonintimidating style of exhibiting provide a norm against which other museum work must be measured. Historically, she argues, museums have been preserves for the wealthy and those who promote their views. It becomes a primary obligation of the exhibition maker to undo this past so as to "enfranchise the learner." In this process, style is content and the essential experience frankly affective and imaginative. Indeed, Gurian doubts that linear, narrative exhibitions of the sort Crew and Sims find essential in recovering voices of the past can work. The public resists, keeping its freedom, choosing what it will attend to, at best taking away an impression and "an inventory of items" that can be "bank[ed] for later consideration."

Overall, Gurian's appeal is for a directly theatrical and affective style of exhibition, based on an understanding gained during the

development of the exhibition of the questions audiences are likely to ask. Possibly this method works best in children's museums, where an element of homogeneity results from the ages of the visitors. By contrast, whom would one interrogate about the representation of African Americans in the National Museum of American History? Would there not be inevitable conflicts between the desire for positive representation and some of the facts as given by history? When the scholar and curator line up on one side and a portion of the audience on the other, who takes precedence? But, as in Crew and Sims's example from the Field to Factory exhibition, in which all viewers must choose to pass through one of two doors, one marked White and the other Colored, it is possible that, by devoting sufficient attention to the audience, shared questions may be explored and encompassing theatrical effects achieved in any type of museum.

Like Gurian, Susan Vogel begins with a strong sense of the historically determined expectations of visitors to museums. But while Gurian hopes to subvert those expectations so as to democratize museums, Vogel desires to seduce the audience by playing on their expectations. She argues that with African art, we are "too far from the voices of the original owners and makers" ever to see as they do. Inevitably, one is locked into the perspectives of one's own culture. What one can do is take advantage of the museum's role as a place of intensified seeing and as a conferrer of value. By exhibiting African art just as Western art is exhibited, museums can encourage respect and admiration, which will in turn increase respect for Africans and people of African descent in all sectors.

Although Vogel takes advantage of the legitimating role of museums, she also questions "the authoritative voice commonly heard in museums of Western art and science." There is no institutional

stance adequate to another culture's art. Consequently, she has experimented with exhibitions that suggest the multiplicity of possible perspectives on African art. In a real way, these exhibitions are as much about Western ways of seeing as about the art itself or the cultures from which it comes. Here Vogel balances two apparently contradictory ambitions. On the one hand, the art is exhibited in the inconspicuous and reassuring style associated with the quintessential art museum, thereby implying that principles of aesthetic form familiar to the audience are adequate to this art. On the other hand, this core style is overlaid with a frank admission of the inevitable multiplicity of views and voices through which this work can be addressed. In the end, her approach acknowledges that exhibitions are contested terrains for interpretation and ideological assertion. Without giving up her own aesthetics, she seeks to turn the conflict of interpretations into an exhibiting tool.

Patrick Houlihan and James Clifford both observe Native American museums that attempt to speak to both Indian and non-Indian audiences. Houlihan, writing as a museum practitioner dedicated to the exhibition of Native American culture, argues that there are lessons to be learned by observing the practice of insiders in a given culture. The U'mista Cultural Centre in Alert Bay, British Columbia, arranges repatriated artifacts as they might appear in a potlatch, in the process forcing non-Indian viewers outside their normal context. For Houlihan, this moment of poetic confusion is essential to the exhibition of "other" cultures. His position is close to Gurian's in its insistence that feeling and impression be an integral part of exhibitions; at the same time, their positions are antithetical in that for Houlihan the effect works against familiarity by having us confront the unexpected. This experience is not unlike the context of learning during anthropological fieldwork, in which an-

thropologist and "native" are forced to confront their mutual experiences of having their indigenous cultural knowledge fail them. Ivan Karp and Martha Kendall[1] have described this experience as "shock" and think of it as a dialogical process, which perhaps for Houlihan is initiated by the poetic shock of the exhibition.

Houlihan suggests that the cosmological and poetic resources of another culture may also offer clues toward better exhibitions. He does not explain how these resources can produce resonance in viewers largely unfamiliar with the culture involved. He appears to assume a certain human universalism, which allows the deep truths of cultures to speak across the divide that separates preindustrial from industrial and postindustrial social organization. In practice, Houlihan advocates a moderate middle course, in which broad-based cultural and historical exhibitions alternate with and are balanced against a more purely poetic and suggestive style.

James Clifford compares four Native American museums, each responding to the postcolonial situation in a different way, each influenced by the charged political climate in which Native American people claim the right to represent themselves. The two cosmopolitan museums he describes—the University of British Columbia Museum of Anthropology and the Royal British Columbia Museum—have been pioneers in opening their collections and educational programs to Native American artists and cultural activists. The Royal British Columbia Museum places this activity in a scientific context; the UBC museum places work primarily in an aesthetic context. The two are united in their emphasis on qualitative judgment: the "best" art or most "authentic" cultural forms. In this, despite their opening to Native American culture, they are in the tradition of the comprehensive art museum described by Carol Duncan in Part 2 of this volume.

In contrast to these cosmopolitan museums, the U'mista Cultural Centre and the Kwagiulth Museum and Cultural Centre embody challenges to authority from local, ethnic, and regional sources. In the process, they reveal a "creative hybridism" that is in many ways similar to that described in Tomas Ybarra-Frausto's essay on Chicano art. Clifford outlines the key differences between these two types of institutions, which we can translate into terms of voice. However responsive to political and social pressures, the major cosmopolitan museum speaks for a general human or at least national patrimony. These alternative Native American museums speak for a local history and a local community. This specificity of local voices, argues Clifford, forces a change in the perceptions of the viewer: what is heard is a voice that the non-Indian, nonlocal viewer may well find unintelligible, except for the implicit claim made by its very existence that "we are here and our story is not yours." What Clifford seeks to examine explicitly is how differences in power and perspective radically affect exhibiting voices. He shows that even museums with opposed cultural policies can be united in the style of their discourse, universalizing in the case of majority museums and oppositional in the case of alternative kinds of museums.

Clifford concludes (as does Vogel, in a different way) that even the voice of major museums is and will increasingly come to be perceived as contestable, as only one voice—albeit a loud one—among many. Vogel has devised strategies for multivocal exhibitions. Clifford suggests that strategy or no, the voices contesting for dominance will be heard, either as museums such as the one at the University of British Columbia strive to offer alternative voices a space within their larger frame, or as viewers, moving between major and

oppositional museums, carry the sense of multivocality with them on their visits.

NOTES

1. Ivan Karp and Martha Kendall, "Reflexivity in Fieldwork," in Paul Secord, ed., *Explaining Human Behavior* (Los Angeles: Sage Publications, 1982).

Locating Authenticity:
Fragments of a Dialogue

SPENCER R. CREW AND JAMES E. SIMS

Facts can very seldom be caught without their clothes on, and as you
rightly say, they are hardly seductive. BERTOLT BRECHT

The problem with things is that they are dumb. They are not eloquent, as some thinkers in art museums claim. They are dumb. And if by some ventriloquism they seem to speak, they lie. The mendacity of objects is all too familiar to makers of collections and exhibitions: once removed from the continuity of everyday uses in time and space and made exquisite on display, stabilized and conserved, objects are transformed in the meanings that they may be said to carry: they become moments of ownership, commodities. In his notes on the colonial-revival period in the United States, Kenneth Ames says:

> It is past associations that make the objects into collectible artifacts;
> nevertheless, age and authenticity are necessary rather than sufficient
> sources of value. For the early collectors it was also vital that the
> objects could be possessed and moved, bought and sold. . . . We
> might even argue that their role as present commodities outranks
> their historical roles. For the predatory collector the principal func-
> tion of history is to help limit the pool of comparable objects and to
> add a degree of difficulty and chance to the process of acquisition.[1]

Much of history museums' concern with the authentic object is rooted in habits of collecting and research in the fine and decorative

arts. Robert Trent characterizes this traditional curatorial perception: "Each object is to be valued as an autonomous event rather than as integral to a series of works."[2] This perception and valuing of the object as autonomous event either ignores its history or substitutes for that history genealogy in the form of provenance, its location in a simple linear progress of ownership. There are more voices that need to be placed in a cultural history:

> Objects have not a single past but an unbroken sequence of past times leading backward from the present moment. Moreover, there is no ideal spot on the temporal continuum that inherently deserves emphasis. . . . In elevating or admiring one piece of the past, we tend to ignore and devalue others. One reality lives at the expense of countless others.[3]

It is not only the commodification of objects that prevents our hearing their multiple authentic voices; sometimes curatorial collection-management policy leads to falsity in the context of public presentation. In the National Museum of American History's exhibition After the Revolution there is a colonial-revival room, originally from an eighteenth-century house but received by the Smithsonian Institution in the 1920s with its woodwork unpainted, which was the taste of the time. It is most probably from a Connecticut River valley house much like that of Samuel Colton, whose story is told in this exhibition. But surely that upwardly mobile eighteenth-century merchant would have had this room painted up right (never plain deal), aping the River Gods, those merchant princes of the Connecticut River valley. Not a jot of paint remains on the well-stripped boards, however. The curator could not be moved to embrace another point in its past, before it was revived in the early twentieth century, and paint it. There it sits, in the context of an interpretive exhibition in social history, telling of the simple virtue of our forebears. It is not *faux* mahogany or marble, but plain, warm, and mendacious. One would suppose that we show what we know, and thus it is authentic. Or is it?

It is certainly authoritative, sitting as it does behind glass in the Smithsonian. Unfortunately it serves to authorize not Samuel Colton's social circumstances but a homey sense of the past, a story that is rooted in the colonial revival and arrives with the audience. No interpretive text disclaimer can outshout the room, with its rightness of scale and warmth of recognition.

This room is a powerful relic, given voice by the collective mem-

ory of a late-twentieth-century audience, meeting an urgent need to anchor our stories somewhere in a usable past:

> The ultimate uncertainty of the past makes us all the more anxious to validate that things were as reputed. To gain assurance that yesterday was as substantial as today we saturate ourselves with bygone reliquary details, reaffirming memory and history in tangible format.[4]

A more complex layering of past times is documented in the Mullikin-Spragins tenant-farm house, seen at the National Museum of American History in the Field to Factory exhibition. Here the provenance is established, the social history well researched, the collection history in the museum known. But the babel of voices that we as exhibition makers think we hear in this object make for a compromised interpretation.

The Mullikin-Spragins house was collected in the 1960s for installation in the museum. Thinking that it had been built in the 1870s, the staff discarded its outer weatherboarding in favor of the vertical plank underneath; of this, only enough for three sides was worth saving. The house was then installed (backward, it later turned out) with three exterior walls visible. By the time it was temporarily removed from display in the late 1970s, further research had indicated that the missing, unreconstructed fourth side was the front, it probably had been built in the twentieth century, and quite possibly the horizontal white weatherboarding that had been discarded was the original face of the house, over older timbers reused from another structure. When the house was reinstalled for Field to Factory, however, the curator in charge would not allow any alteration of the reconstructed house despite the museum's prior misinterpretation of it (which was part of the house's history, its provenance). In Field to Factory the house is shown with vertical boards; its missing fourth side (the front) is reconstructed from a photograph. Thus, despite what the staff had originally assumed, the house as it was found— weatherboarding and all—is authentic, if we mean accurate and true; the older materials lie, "speaking" of a past life the house never actually had.

Perhaps more significant are the interior walls, by any standard not so compromised as the exterior. They document in their layers of paint, whitewash, newspaper, and more whitewash continuous care and homemaking by the residents of the house. But because museum

practice generally holds the "authentic" object to be inviolable, the walls could not be modified for this part of the exhibition, which is set in 1920 and shows a family deciding whether to leave this home. The problem with this is that the worn, ruined condition of the walls is not appropriate to the life of the people depicted in the exhibition; indeed, it even contradicts the sense of place the exhibition seeks to present. At the same time it substantially confirms the audience's predisposition to see houses such as this as shacks.

Serving to counter the misstatement made by the ruined walls is the constellation of objects that the staff assembled for the room. These objects are not authentic in any sense to this particular house, but are documented in oral history and photographs. They have been assembled in such a way as to create an image of an event—Mama doing the washing. This authentic event arrests the audience and provides the context for historical discovery that the house as object does not; at least, that is the intention of the makers of this exhibition. It is certain that the event lives in the audience's imagination only because of its grounding in the material evidence of the event. The critical mass of artifacts pronounces a reality.

THE PROBLEM OF HISTORY AND AUTHORITY

> Although it is now evident that artifacts are as easily altered as chronicles, public faith in their veracity endures; a tangible relic seems *ipso facto* real.[5]

History museums have struggled with this problem of faith, veracity, and the authentic object for some time; in some museums the object is already not the reason for doing work. The chair of the Collections Committee at the Henry Ford Museum and Greenfield Village, Steven Hamp, says that "objects have no intrinsic value whatever." This might seem to be an astonishing statement in a profession that has heretofore placed such emphasis on acquiring objects. But it is representative of current thinking in history museums about the meaning of things: they don't mean much without the help of exhibition makers. And that help is quite significant to the audience: "we know they like us; they believe what we say," Hamp says, basing this validation on recent audience research at his institution.[6]

"Memories fade and cultures step in and take over," Michael Wallace has said.[7] The culture of the museum creates its own juxta-

positions, its pertinent locations of authenticity. These are framed by the uses of the past that this museum culture may choose. With objects transformed from one temporal continuity of use to another, their meanings are entirely reconstituted: the *proximity* of things to one another perhaps has more authority, more readable meaning than the things themselves. Together, George Washington's dentures and a poppy seed say more about the man's situation than either object could, alone, without interpretive text.

Authenticity is not about factuality or reality. It is about authority. Objects have no authority; people do. It is people on the exhibition team who must make a judgment about how to tell about the past. Authenticity—authority—enforces the social contract between the audience and the museum, a socially agreed-upon reality that exists only as long as confidence in the voice of the exhibition holds.

But creating a voice for exhibitions is not a straightforward task. Exhibitions have multiple voices—and many of these do not emerge until after the exhibition is in place and the audience comes to view it. However, in the earliest stages the exhibition team must settle on a voice that will run threadlike through the exhibition. Within history exhibitions this voice or point of view often is influenced by research taking place in academic circles. The work of university-based scholars is the voice of authority upon which history exhibitions frequently rely. It is the foundation on which many museum professionals base their exhibition interpretations and their use of objects. The difficulty for museums is that this voice has changed significantly in the past few years. It has altered because scholars' interpretations of history and the topics they consider important have changed.

For many years, the information about our past generated by scholars focused upon highly visible people and events. Historians wrote about political activities, military engagements, and conflicts that were documented in newspapers, legislative records, family papers, and other traditional sources. These studies provided information about well-known people and events of an earlier time, but offered little information about the vast majority of the population. Common folk were ghostly figures dimly visible in the background of important events and the lives of prominent individuals. Their activities and material goods had little value for scholars and other professionals interested in recreating and preserving the past.

The rise of social history, history from the bottom up, reshaped the orientation of many historians. How common people lived, where they educated their children, what their thoughts were about local and

national issues, and numerous additional questions captured the attention of many scholars. They employed new techniques to explore these questions, since traditional sources did not offer enough insight into the everyday life of the past. Census records, probate documents, diaries, tax records, and material culture discovered on archaeological digs provided new sources of information for scholars. The manuscripts and articles resulting from this work changed our vision of the world of our ancestors. It was more diverse and complicated than first pictured. We learned that African Americans, women, ethnic communities, common laborers, and other groups, who in the past were seen as peripheral to the main current in American history, in reality were important contributors. As voters, consumers, and producers, the choices and actions they took in a variety of areas greatly influenced the politics, the economy, and the social concerns of the country.

For example, new research discovered that slaves did not passively accept bondage or the control their masters had over their lives, as many early historical accounts reported. They resisted bondage directly by running away and rebelling. Passive resistance took the form of work slowdowns and the destruction of farm implements. They also created lives for themselves, separate from the master; these lives provided some shelter from the brutality of the system under which they lived. As a result of their research, for example, social historians learned that the relationship between slave and master was more complicated than had been believed initially. Their research also better explained slaveholders' fears about the possible impact of abolitionist activities on slaves who did not docilely accept their plight.[8]

The methods of inquiry pioneered by social historians and the new views they presented had a tremendous impact upon historical scholarship inside and outside of academic circles. Among museum professionals, especially those individuals working in history museums, social-history modes of inquiry encouraged them to reconsider the types of exhibitions they created. Many of the ethnic groups served by these institutions had made significant contributions to the community, the region, and the country; museums had largely overlooked these contributions in the past. As social historians revealed new information about the activities of these groups, pressure increased on history museums to reinterpret their exhibitions and illustrate more of these contributions.

Responding to the new information uncovered by social historians and creating exhibitions that reflected the heterogeneous nature of American society was not a simple process. As museum professionals

discovered, the holdings within their institutions created major stumbling blocks. Many times their collections did not contain the objects they needed. The artifacts that were most suitable for collecting and that had the best-documented provenance frequently had belonged to people of comfortable means, who had the time, space, and funds to save historic objects, documents, or family furnishings over several decades along with the information to authenticate their provenance. Though these objects did not represent a broad range of economic or ethnic groups, museums collected them because of the documentation that accompanied them. Museum holdings, as a result, often tended to favor objects belonging to the well-to-do classes of society.

Another factor limiting the breadth of collections was the individual object choices made by curators. Objects that reinforced traditional historical viewpoints had the greatest appeal for them, and so until recently it was often only artifacts connected to significant political and intellectual figures or objects associated with important historical events that found their way into museum collections. Materials belonging to less notable figures or connected with the lives of ordinary individuals were less likely to wind up there because these objects did not have the same historical significance in the eyes of curators or other scholars.

Because of these collecting biases, when museum professionals considered creating exhibitions based on social-history research, the scope of their collections severely limited their choices. This shortcoming was difficult to overcome, since exhibition ideas traditionally have been based on the objects available in a collection.

In such object-driven exhibitions, the artifacts control the focus of the exhibition; they shape the themes and the concepts presented to the public, and are the vehicles through which the ideas of the curator are transmitted to the visitor. So, if objects are not available to support a particular theme or to raise an issue, that theme or issue is not stressed in the presentation.

The paucity of objects available for use in social-history exhibitions has forced museums to expand their collecting efforts. Museum professionals began reexamining the criteria for accepting and rejecting objects. Artifacts in the hands of groups and organizations previously considered of lesser importance were perceived in a different light. Material culture belonging to street cleaners, servants, small entrepreneurs, and other unheralded individuals acquired greater importance. Their stories had become an important part of the American past. Objects belonging to these individuals had to be located and

secured if museum exhibitions wished to present a realistic picture of the diversity inherent in American history and culture.

Passive collecting strategies were not very effective for acquiring the material culture of ordinary people. More aggressive outreach tactics were needed. To create the Field to Factory exhibition, contact was made with a wide variety of museums, community organizations, and private individuals in order to locate artifacts, since the National Museum of American History did not possess sufficient holdings in its collections to mount an exhibition on African American migration or on the lives of common people in the twentieth century. It took extensive work with community organizations and private collectors to acquire the artifacts needed to develop the exhibition. The collecting conducted for Field to Factory allowed the museum to offer new kinds of presentations to the public as well as identify objects that could be used in future exhibitions.

While efforts to locate objects for this kind of exhibition were sometimes successful, museums were not always able to obtain all of the materials they needed. Historians and museum professionals' previous lack of interest in the history and material culture of average Americans had not encouraged ordinary people to save their artifacts and documents. Many objects had been thrown away or lost over the years because their owners did not believe they were important. Individuals who had saved these artifacts and documents were the exceptions to the rule. Locating potential donors and identifying objects was a time-consuming and arduous task. Several years of searching might result in very little or no success.

At times, this problem of not having enough objects whose documentation links them directly to the subject matter of an exhibition poses a dilemma for museum professionals. Should they proceed and mount exhibitions on social-history topics using the objects they have, or should they wait until they accumulate more materials?

Similar issues faced historians who wished to learn more about the lives of unheralded Americans but realized that traditional historical sources alone could not provide the information they needed. To overcome this problem, they creatively used traditional sources and developed new methods of inquiry about topics that intrigued them. Out of their determination and creativity, social historians developed fresh ways of viewing and understanding the American past. Their efforts resulted in a renewed interest in history by the general public, who saw more of their own past reflected in history texts.[9]

Parallel difficulties face museum professionals wishing to create

exhibitions based on social history. Frequently, the range of provenances represented in a museum's collections is too narrow to allow the staff to develop new exhibitions. Additional collecting efforts, no matter how innovative, do not always produce sufficient objects. In many instances these efforts fall short not because the objects do not exist, but because locating the exact artifacts needed may take years to accomplish—longer than an exhibition team may be able to wait.

Creators of exhibitions have several choices when faced with a shortage of artifacts with the proper provenance. They can delay producing exhibitions with social-history content until they acquire enough authentic artifacts. They can produce social-history exhibitions that overlook issues for which authentic artifacts do not exist. Or they can break from the concept of object-driven exhibitions and produce presentations controlled by historical themes rather than by available objects.

Each of these choices has its drawbacks as well as its advantages. Probably the most circumspect choice is the first option, which involves building supportive collections before creating social-history exhibitions. Using this method, museum professionals would launch systematic collecting efforts to locate the artifacts needed for assembling one or several exhibitions. Accumulation of the desired artifacts, rather than other considerations, would dictate when the exhibition opened. In a show developed under this criterion, provenance would not be an issue. Every object would be authentic and presented in the proper historical time and setting.

Certainly there are many advantages to waiting until the last artifact is in place, but the passage of time can work against the successful completion of the task. Locating the needed objects could take many years—or the objects might never come to light. In the interim, the exhibition team cannot produce the exhibit and its plans remain indefinitely on hold. More importantly, museums that choose this path cannot capitalize on the newest research produced by historians and have difficulty producing exhibitions that reflect these changing visions of the American past. While not all of the exhibitions presented by museums need reflect the work of social historians, it is incumbent upon them to offer some exhibitions that include this historical perspective. Waiting to collect all the authentic objects in every instance undoubtedly would slow the process of broadening historical interpretations available to museum visitors.

As an alternative, museum staffs can choose to use available objects and produce exhibitions limited in scope. The objects would

dictate which topics to include and which ones to eliminate. When objects with the proper provenance could not be located, the exhibition would bypass that aspect of the subject. For example, an exhibition on household workers would not discuss their personal lives if the objects were not available. Instead it would place its emphasis on the relationship between employer and servant, for which more artifacts existed. Limiting the focus to the interplay between maids and their employers, for example, would make use of social-history research and many of the insights it offers. Excluding discussions of the lives of maids away from their employers' households, however, would deny the visitor important insights that would help explain why women work as maids despite the problems inherent in the job. This kind of information is some of the most interesting social historians are currently producing about household workers.[10] Excluding it leaves out important aspects of the story. While the artifactual foundation of such an exhibition would be made stronger by grounding the exhibition in the objects, the historical base would be weaker. The question then becomes whether omitting certain historical information undermines the validity of the exhibition more than would venturing into areas where the core of authentic artifacts is not extensive.

Like historians, who, rather than allowing traditional methods of thinking to restrict their interests, consciously moved toward innovative ways of thinking about the multitude of institutions and peoples who contributed to the development of the United States, museum professionals using social history to broaden the concepts presented in their exhibitions also need to consider alternative approaches. As new sources of information, new research methods, and new interpretations come to light, it is important that exhibition techniques parallel the progress made by academic historians. Traditional approaches to exhibition, which put the artifact at the center of the presentation, limit the issues available for discussion. Concepts that stretch beyond the available artifacts, but are important points of consideration, are precluded in this traditional model.

SOME LOCATIONS OF AUTHENCITY

Ideas and historical themes are important parts of the interpretations presented in exhibitions. Through them, visitors are introduced to the intricate interplay between people and events that constitutes the his-

torical process. This alters the concept of history, changing it from a succession of dates of important events to a maze filled with unexpected turns, surprises, and sometimes dead ends. These are the aspects of history that excite historians and engage the public.

Thoughtfully presented historical ideas should not play a secondary role to objects in molding the focus of exhibitions. Both approaches are important to the success of these projects. Either one can serve as the centerpiece and primary interpretive device of an exhibition. Either option can lead to exciting results, but the choice of one over the other affects the nature of the presentation. As exhibit creators develop new projects, they need to consider whether historical themes or available objects will drive the presentation. Their choice is especially crucial for those exhibitions where the artifactual evidence is uneven, but the historical data is rich and the topic significant.

In these instances, exhibit creators must think creatively and boldly about the best method of presentation. Allowing the historical data and themes to drive these exhibitions gives exhibitors greater latitude. In areas where the artifact with the proper provenance cannot be located, the exhibition can still address the ideas. Focusing on the data allows the story told by the exhibition to unfold naturally and to explore all the crucial aspects of the event. The exhibition can then take full advantage of newly unearthed information.

Choosing to place greater emphasis on ideas over objects does not undermine the importance of authentic objects in the exhibition any more than an emphasis on objects diminishes the importance of historical themes in more traditional presentations. In idea-driven exhibitions, objects remain one of the most important vehicles for transmitting the themes of the exhibition. They offer tangible evidence of the information presented in the exhibition. But in this model, objects do lose their preeminence as the primary source of authority in the presentation; they no longer control the discussion. More importance is given to the research done by scholars affiliated with the exhibition team. The database created by their research becomes the final source of authority and of authentication for the exhibition.

This database represents extensive work on the part of the exhibition team. It often takes many months of research to build an information base for the exhibition, especially in the case of a social history–oriented project. Often with social history, the research available on the topic is not definitive. Because of the relative newness of the field, scholars are constantly developing new methods and inter-

pretations. This aspect of the field is what makes it so exciting, but its volatility places more responsibility on the research team to fill in gaps in existing research that relates to its project.

Research efforts, consequently, must extend beyond exploring the standard secondary sources. Primary sources must be reviewed to determine if, within the context of the exhibition, they offer new insight into the subject matter. Often when an institution examines a topic from a particular point of view, secondary sources do not explore the topic in enough detail to fully develop the perspective of the exhibition. It is the responsibility of the research team to perform additional research in primary sources to fill in these gaps. Reviewing local newspapers, exploring the records of local institutions, examining the holdings of historical organizations in the region, and talking with participants in the event are some of the methods used to expand the information base for the exhibition.

As the database for the exhibition increases, so does the expertise of the members of the research team. Working their way through a variety of sources, struggling with new ideas, and weighing various points of view heighten their sensitivity to the nuances of the topic. As with scholars researching a manuscript, the research team's immersion in the sources provides it with valuable insights into the topic. These insights become reference points that help guide the development and presentation of the topic to the public.

The expertise gained by the research team is an important tool in the construction of the exhibition. In the case of objects, the team's knowledge guides them in the selection of the proper artifacts. The provenance of an artifact is matched with its most appropriate point of representation in the exhibition. In ideal circumstances an object that actually belonged to the individual discussed or was a part of the event described can be used to strengthen the themes of the exhibition.

Increasing the importance of historical interpretation in the exhibition changes the way artifacts are used. Objects continue to document the story line of the exhibition, but their provenance dictates less about how they are used. What assumes greater importance is the context in which artifacts are presented and the authenticity of the historical concepts that the artifacts represent.

As the exhibition team increases the use of historical interpretation at the expense of provenance, it also accepts greater responsibility for the content of the exhibition. Its vision of the historical events controls the direction and point of view of the exhibition. It conse-

quently becomes even more important that the team presents its ideas accurately and bases its interpretations on extensive documentation.

The room setting in the northern home in Field to Factory, for example, is composed of a variety of artifacts from different lenders. Much of the material belonged to African Americans during the period the exhibition examines (1915–1940), but not all objects have a verifiable connection to African Americans or to the migration experience. The room setting is based on extensive photographic and historical research, which provided the exhibition team with an understanding of the objects likely to appear in a African American home in the urban north. While the provenance of every object in the setting is not specific to the room, they are historically correct and provide an accurate image of a typical working-class African American home.

Artifacts do not lose their importance or power when historical interpretation directs an exhibition, although they do lose their primacy. Rather than shaping the exhibition, their use is shaped by the themes of the exhibition. Their provenance becomes less important than their corroborative powers. This does not mean that provenance has no importance. The best use of artifacts is when their history precisely matches their use within an exhibition; it gives added force to the argument. But lack of an exact match between the provenance of the object and the historical interpretation offered at different points in the exhibition need not preclude the effective use of the artifact. The historical expertise of the exhibition team offers another source of authority that can ascertain authentic uses of artifacts.

The exhibition team's ability to determine the authentic use of objects is grounded in its research. The team's acquired knowledge guides it in establishing the circumstances in which a specific object would have been used as well as the types of objects used in specific circumstances. This expertise enables the team to identify suitable substitutes when an object with the exact provenance is not available. Objects presented within an exhibition in this manner are used generically, offered as representative of the types of objects that could have been used in that setting. Research by the exhibition team insures the authentic use of the object and makes the exhibition less dependent upon the survival of specific objects to tell its story. For certain topics the ability to use objects in this fashion is the only way of telling the story fully and accurately, and so this approach gives the exhibition team greater latitude in the topics and ideas it can explore.

While this approach appears to vary from the typical use of artifacts in exhibitions, in reality it reinforces another rationale for collecting artifacts. Objects that wind up in museums frequently have been acquired because of their association with an important individual or event. They may also have been collected for their representativeness, because they exemplify a particular type of furnishing, clothing style, cultural statement, work tool, or other aspect of American history. Many times the provenance of the object—who owned it or who used it—is significant, but it need not be the only reason for acquiring the object. The object's embodiment of larger traditions and cultural trends is another measure of its importance. In these instances it is the curators' expertise and familiarity with the objects that guides them in acquiring an artifact. With the application of stringent guidelines, generic objects can serve as effective and historically accurate representations of key concepts within the exhibition.

As exhibitions explore nineteenth- and twentieth-century topics, the generic use of objects becomes more palatable. Mass consumption of many goods makes it increasingly difficult to distinguish between clothing worn or furnishings used in different parts of the country. Department stores and catalogue companies offered these items to anyone who wished to purchase them. Factory workers in Detroit could order the same items as farmers in Georgia. The settings in which they were used might have differed, but the objects were the same.

Recognizing and making use of these characteristics of mass-produced objects gives the exhibition team greater latitude for developing interpretations. It allows the team to explore issues that adhering to the exact provenance of available objects might not allow. It offers the team the chance to advance new interpretations and challenging ideas firmly supported by its research but not necessarily by the artifact base. It also allows the team to experiment with objects and ideas in new ways.

As more exhibitions turn to twentieth-century topics, their ability to engage visitors in a dialogue increases. The topics under discussion often touch the life of a visitor, either directly or through the experiences of a relative or friend. New ways of presenting objects in combination with new interpretations of these topics can reshape visitors' views. By emphasizing the narrative possibilities of artifacts rather than their specific provenance, exhibitions can encourage visitors to think more broadly about things and their meanings. They can help to demystify objects, removing them from the realm of the sacred and

putting them in the class of commonly used, mass-produced goods—objects that visitors can recognize as things their grandparents, parents, or they themselves may have used. Artifacts so framed make an immediate claim on the visitor's time and can turn a museum visit into an encounter with past lives.

THE EXHIBITION AS EVENT: THE POETICS OF PRESENTATION

Objects, ideas, and people are met in the interpretive exhibition, a kind of narrative form. It is a narrative concerned with re-presenting the past, making present that which is not usually present. This work can be seen as a kind of dramatic art. David Cole suggests that "theatre, and theatre alone of human activities, provides an opportunity of experiencing imaginative truth as present truth. . . . Imagination and presence come up against each other in a way that allows us to test the strengths of each against the claims of the other."[11]

In the exhibition site, as in the theater, this testing is carried out by witness and exhibition maker alike. A narrative is being constructed by the audience, whether the exhibition developers like it or not. The space between the object and the label is an active one, as Michael Baxandall suggests in Part 1. The political choice to be made by the exhibition maker is, then, in what way, when, and how much to intervene in the shaping of this event. In Field to Factory, the encounters the audience can have are shaped and ordered in a significant way by the physical layout of the exhibition. A variety of sensory means and learning opportunities are available for different sorts of learners. The visitor can move between reasons for leaving the South and reasons for staying; issues of violence and segregation can be approached with whatever degree of engagement the individual viewer wishes. But everyone must go north, and walking into the segregated Ashland train station, everyone must make a choice that puts him or her into one of two categories, either "white" or "colored," thus encountering racism concretely. At the doors of the Ashland station, the condition of legal segregation is authentic. The object is a reproduction, somewhat diagrammatic in form but not metaphorical. Imaginative truth is experienced, for the aware audience collaborator, as present truth.

The poetics of representation is this crucial setting are borrowed from Bertolt Brecht: we are confronted with choice, but the dialectic is certain. For Brecht, confrontation is alienation that allows space for reflection, argument, and understanding the problem.

But another dialectical model exists for the shape of the narrative exhibition: Aristotle's *Poetics*. His elements of the dramatic structure are plot, character, thought, diction, music, and spectacle. Aristotle's list is not arbitrary. This understanding of the human condition is first framed by the event—the performance itself and the story being dramatized, being made present—in the plot, the shape of the relationships changing. Then the agents of the action and its special place of origin is characterized; then, with event and players established, can the audience and author intervene with point-of-view, with interpretation. Then comes verbal meaning, the shape of time (music), and the way things look. The visual form—the spectacle—is derived from choices made about the first five elements.

It is the event that is primary, not the things or even our directed thoughts about them. And it is in the place/time of the event that the audience takes part, becoming cocreators of social meaning. Authenticity is located in the event.

NOTES

1. Kenneth L. Ames, "Introduction," in Alan Axelrod, ed., *The Colonial Revival in America* (Wilmington, Del.: Henry Francis du Pont Winterthur Museum, 1985), 7.

2. Robert Trent, *Hearts and Crowns* (New Haven, Conn.: New Haven Colony Historical Society, 1977), 24.

3. Ames, "Introduction," 6.

4. David Loewenthal, *The Past is a Foreign Country* (Cambridge: Cambridge University Press, 1985), 191.

5. Ibid., 244

6. Panel discussion, 1988 meeting of the American Association for State and Local History, Rochester, New York.

7. Panel discussion, 1988 meeting of the American Association for State and Local History, Rochester, New York.

8. See John W. Blassingame, *The Slave Community* (New York: Oxford University Press, 1979); Eugene Genovese, *Roll Jordan Roll* (New York: Vintage, 1976); Herbert G. Gutman, *The Black Family in Slavery and Freedom* (New York: Vintage, 1976); and Nathan Irvin Huggins, *Black Odyssey* (New York: Vintage, 1977).

9. Peter N. Stearns, "The New Social History: An Overview," in James B.

Gardner and George Rollie Adams, eds., *Ordinary People and Everyday Life* (Nashville: American Association for State and Local History, 1983), 3–5.

10. See Elizabeth Clark-Lewis, *This Work Had A'End: The Transition from Live-In to Day Work*. Southern Women: The Intersection of Race, Class, and Gender, no. 2 (Memphis, Tenn.: Center for Research on Women, Memphis State University, 1985), and David M. Katzman, *Seven Days A Week* (New York: Oxford University Press, 1978).

11. David Cole, *The Theatrical Event: A Mythos, A Vocabulary, A Perspective* (Middletown, Conn.: Wesleyan University Press, 1975), 5.

CHAPTER 11

Noodling Around with Exhibition Opportunities

ELAINE HEUMANN GURIAN

Museum visitors receive far more from exhibitions than just information about the objects displayed. Let me suggest that visitors can deduce from their experience what we, the producers of exhibitions, think and feel about them—even if we have not fully articulated those thoughts to ourselves.

I will explore the notion that we, consciously or unconsciously, impose learning impediments in our exhibitions for some members of our current and potential audiences. We do so because we possess unexamined beliefs about our visitors' capacity to learn and because we want them to act in a style that reinforces our notion of appropriate audience behavior. We continue to do so regardless of our exposure to countervailing theories about learning or examples of experimentation in exhibitions. We design evaluation tools that measure only those things we wish the audience to learn rather than those the audience is actually learning. We espouse the goal of enlarging our audiences to include underserved populations and novice learners, and yet we continue not to accommodate them: we demand that they accommodate us and then wonder why they do not visit our galleries.

I will argue that it is not content that predetermines the exhibition design, strategies, and installations we use; rather, exhibition content and presentation are separable. While much has been written about

the choice of content (and there is still much to explore), very little has been written about choice of style as an expression of intention. Regardless of exhibition content, producers can choose strategies that can make some portion of the public feel either empowered or isolated. If the audience, or some segment thereof, feels alienated, unworthy, or out of place, I contend it is because we want them to feel that way.

It could also be suggested that we, the staff, are partly in collusion with a segment of our audience that wants exhibition presentation to reinforce the aspirations and expectations they have for themselves. This audience of traditional museum consumers does not wish to have others join their company, as that would disrupt their notion of their own superiority and their right to an exclusive domain. Pierre Bourdieu, in the introduction to his book *Distinction: A Social Critique of the Judgement of Taste*, writes:

> A work of art has meaning and interest only for someone who possesses the cultural competence, that is, the code, into which it is encoded. . . . A beholder who lacks the specific code feels lost in a chaos of sounds and rhythms, colours and lines, without rhyme or reason. . . . Thus, the encounter with a work of art is not 'love at first sight' as is generally supposed.[1]

The question we as producers of exhibitions must ask is, why do we participate in this collusion, and what we can do to change if we so desire?

An opportunity for change is provided by the way disciplines such as anthropology, art history, and history are reexamining their foundations and acknowledging that previously held beliefs about the objectivity of research and the impartiality of the investigator were never realistic. By applying these same techniques of self-examination to ourselves as museum professionals, we may gain insights that will enable us to approach our exhibitions—and their audiences—in new, fruitful ways.

MUSEUMS AND THEIR AUDIENCES:
IDENTITY, POLITICS, AND EQUALITY

In the catalogue for the National Museum of African Art's exhibition Images from Bamum, Christraud Geary writes about the role the viewer plays in the making of a photograph:

> In analyzing photographs, the roles played in the creation process by
> the photographer, the photographic subject, and the viewer need to
> be considered. A photograph is a cultural artifact that articulates a
> photographer's visions, biases and concerns. It also allows the con-
> templation of the photographic subject. . . . In addition to the pho-
> tographer and the photographic subject, a silent participant—the
> future viewer—influences the creation of photographs.[2]

Changing a few terms, the quote would apply equally well to
exhibitions: In analyzing exhibitions, the roles played in the creation
process by the producer of the exhibition, the content, and the audi-
ence need to be considered. An exhibition is a cultural artifact that
articulates a producer's visions, biases, and concerns. It also allows the
contemplation of the exhibition content. In addition to the producer
and the content, a silent participant—the audience—influences the
creation of the exhibition. It therefore makes sense to explore the
images museum professionals have of their audiences. Such an explo-
ration needs to consider, among other things, the people who found
museums, the people who direct them, and the politics of both groups.

Historically, it can be argued that museums have been created to
promote the aspirations of their creators. Art museums have been
created by wealthy patrons and collectors to reinforce their status and
aesthetic, while science-and-technology centers have been created by
wealthy merchants to enlist the public's concurrence about the
progress and future of industry. Historical societies have been founded
by people who wanted their personal and class histories preserved,
and children's museums have been founded by parents and educators
who were emboldened by the education theories of Dewey. Finally,
counterculture museums have been created by people of all classes
who want to preserve a particular viewpoint that has not been ex-
pressed in other museums.

Thus, a museum's relationship to its audiences might be
predicted—regardless of the discipline involved—by determining into
which of three roughly delineated political categories it falls: museums
that aspire to be establishment organizations, self-consciously liberal
museums, and counterculture museums. The Metropolitan Museum
of Art, the New Museum of Contemporary Art, and El Museo del
Barrio are examples of museums within the New York art scene that
exemplify each of these categories. In political terms, these museums
could be positioned right of center, left of center, and on the far left,
respectively. Historically, all museums tend to drift toward the right as
they become successful; thus, the counterculture museums become less

radical, the liberal museums become more mainstream, and the centrist museums tend to protect their elite status.

In addition to the political position of the museum, a revealing indicator of the museum-audience relationship might be the personal politics of the director, or even the exhibition producer. Directors can consciously alter the political position of the museum by force of personality and/or their own personal political convictions. Analysis of their individual political convictions might reveal not only the tone they take toward their audiences but the way in which they construct a work climate for their institutions' staffs as well.

For example, Frank Oppenheimer, director of the Exploratorium in San Francisco from 1968 to 1985, and Michael Spock, director of the Boston Children's Museum from 1962 to 1986, who independently but relatively simultaneously produced the unprecedented hands-on exhibitions of the 1960s, believed themselves to fall into that part of the political spectrum that advocated "power to the people." Each built staff organizations that operated as missionary bands. Oppenheimer's early radical political life may have found expression in his notion that the originators of exhibition ideas should be allowed to realize the exhibition themselves without help (or interference) from designers. In terms of the practices of exhibition design, his position was unique and radical: if someone only knew how to make his or her exhibition with chewing gum, then gum it was. He believed the audience would feel comforted by exhibitions that looked like they could be reproduced in a home workshop. Oppenheimer did not believe in the need for a uniform institutional style or a consistent aesthetic. He wanted the producer to speak directly to his or her audience. When I first met Frank Oppenheimer, he asked me how much time I spent on the exhibition floor watching the audience interact with the exhibitions. When I answered "very little," he promptly escorted me to his own exhibition space and taught me how to observe the visitor. He personally spent long hours prowling his own exhibitions, watching visitors struggle with his experiments; then he would modify them accordingly.

To Michael Spock, who grew up dyslexic in a well-known and politically liberal family, learning was understood to be risky business. This led to the use of materials such as wood and cardboard as a matter of museum aesthetics, so that the audience would feel comfortable and "at home." He hoped to give confidence to the learner in order to enable him or her to cope with the world outside of the museum. The subject matter was not his primary interest—

enfranchising the learner was. Spock felt that members of the public had something to offer us, the exhibition creators, and one another. I worked for Michael Spock for sixteen years. Before we produced an exhibition, we asked the visitors what they wanted to know about the subject. Then we would produce mock-ups and prototypes in order to get feedback from the audience before any exhibition had "hardened." Additionally, we produced a series of graphic audience-structured feedback boards on which the audience could write their comments, thereby putting the teachings of the audience beside the teachings of the producers.

The major experiments Oppenheimer and Spock initiated— introducing contextual, direct-experience interactivity to the exhibition floor—changed the face of museums permanently by inviting the audience to participate in their own learning. However, some twenty-five years after the initial experiments, there is still reluctance in some quarters to adopt Oppenheimer's and Spock's strategies even when they seem appropriate to the subject matter at hand. The reluctance, I propose, comes not from the realistic concern about the additional upkeep and staffing expense that these techniques engender, but rather from these exhibition strategies' inherent inclusionary assumptions about the audience, assumptions that are not universally shared.

Exhibitions such as Mathematica, designed by Charles Eames, were based on the Victorian tradition of visible storage and on the early cabinets of curiosities. The experience of visual clutter that Eames espoused was very liberating for the visitor: visitors instinctively understood that since they could not absorb all the visual information presented, they were free to sort and select. In Eames's productions (and subsequently in Ivan Chermyoff's exhibition Nation of Nations in the National Museum of American History, as well as in The California Dream, designed by Gordon Asby for the history section of the Oakland Museum), the previous authoritarianism of the staff member who selected the exhibition objects was replaced by an aesthetic smorgasbord that empowered the audience to select for themselves. Although in an Eames production the objects were also chosen by staff, his strategy resulted in an audience response that was less controlled by the exhibition creators, in contrast to exhibitions done in a "modern" style, in which the audience's attention is focused on single objects highlighted in individual cases. When I met Charles Eames, he was absorbed in his own personal visual investigation, walking around the Boston Children's Museum with a magnifying glass on a chain around his neck in order to see even the smallest detail; he wished out

loud that each viewer could be able to orchestrate his or her own visual banquet, independent of either the exhibitor's will or other viewers' choices.

SOME PARAMETERS OF LEARNING IN A MUSEUM

Chandler Screven, a longtime museum-exhibition evaluator, writes, "Museum learning is self-paced, self-directed, non-linear, and visually oriented."[3] This statement points out some of the ways in which exhibitions actually work. Museum exhibitions are certainly not school classrooms, which enforce incremental, cumulative learning through authoritarian leadership over rigidly defined, constant social units. Except for school groups, museum audiences are composed of unrelated social units who remain anonymous and display uneven previous knowledge about the subject matter. Exhibitions are places of free choice. Try as we might, the public continually thwarts our attempts to teach incrementally in an exhibition. They come when they want, leave when they want, and look at what they want while they are there. Therefore, linear installations often feel like forced marches.

Exhibition content can be understood by the audience immediately, can be reassessed and integrated at some later date, or both. The visitor receives an impressionistic, sometimes indelible, sense of the topic, and in addition creates a mental inventory of items that he or she can bank for later consideration. The one-time, indelible impression to which all subsequent exposures will be referenced has been described by Michael Spock and others as "landmark learning." The long-term integration often comes as an "aha phenomenon" when a second trigger is presented that makes the stored items understood in a satisfying way.

Good exhibitions are often conceptually simple. The more complex the verbal message becomes, the less understandable the exhibition turns out to be, since exhibitions are basically nonverbal enterprises. What can be displayed best are tangible materials that can be seen, sometimes touched, and often fantasized about. Exhibition topics deal with both concrete things and abstractions; we display objects that are simultaneously real and emblematic.

Objects in exhibitions can elicit emotional responses. The presence of certain artifacts can evoke memories and feelings. Mihaly Csikszentmihalyi and Eugene Rochberg-Halton's book *The Meaning of Things* suggests that it is the emotional overlay we place upon

impersonal objects that transforms them into objects of meaning.[4] If we are interested in changing our exhibitions into exhibitions of meaning, we will have to be prepared to include frankly emotional strategies.

IMPOSED LIMITS TO LEARNING

But we, the producers of exhibitions, have not fully exploited all exhibition tactics suggested by the parameters outlined above. Could this be because we are not entirely comfortable with what certain modes of exhibition might reveal about us? It is not only what we think about our audience that determines the exhibition designs we use; they are also determined by what we want the audience and our colleagues to think about us. Styles of exhibiting that enhance learning but are sensual and emotive may embarrass us and not conform with our descriptions of ourselves as erudite, intellectual, and respectable.

I believe that somewhere in the history of exhibitions, certain nonrational strategies were deemed theatrical. Being in the theater is still not wholly respectable. Museum professionals do not want to be in show business; we want to be in academia. And yet, like it or not, exhibitions are in part public entertainment. Perhaps it was the fate of the first history museum in America, founded by Charles Willson Peale, that reinforced this attitude. Gary Kulik has written:

> Peale's educational vision was lost. His effort to create a museum that was both serious and popular had foundered. By 1850, the building and collections had become the property of Moses Kimball and P. T. Barnum.
>
> Barnum and Kimball brought a new meaning to the term *museum*. Entrepreneurs of the bizarre, they tapped the voyeurism of the American people. Moving far beyond the Peales, they blurred the boundaries between museum and carnival sideshows, between the theatre and the circus, between the real and the contrived. Museums of the odd, the curious, and the fake proliferated in antebellum America.[5]

Today, our own fascination and ambivalence with Disneyland has compounded the problem. Surely the most effective and popular attraction of our time, Disneyland uses techniques that may educate while creating enjoyment but, like P. T. Barnum, they have "blurred

the boundaries between museum and carnival sideshows," and the museum world would not want to be identified with that!

Another reason we have not fully exploited the sensory possibilities and opportunities that displaying objects can offer us may be that we have internalized certain cultural preferences for some modes of learning over others. For example, we have been taught that one mark of the civilized person is verbal ability, and so when explicating objects in, say, science or cultural-history museums, we concentrate on producing textual labels. Many of us also believe that in exhibitions focusing on aesthetics, the "visually literate" person should know how to use the visual cues provided by the objects without any additional assistance from us, and so we often do not write explanatory labels in art galleries and rarely use auditory, olfactory, or tactile techniques there. Worst of all, appealing directly to the emotions is considered pandering to the mob, so we do not dare to appear enthusiastic. As a result of these internalized preferences, then, exhibitions often become places in which we, the exhibition makers, use certain styles of exhibiting to demonstrate our own mastery of these modes of learning, not only to ourselves but also to our colleagues and our audiences.

Nor do we want to appear friendly, because we believe that informality would reduce the importance of our work. If the audience is having fun, we may be accused of providing a circus and not behaving in a sufficiently reverential manner. If we have a Calvinistic view of our purpose, we will not permit ourselves to be informal. But if we as exhibition producers begin to think that playfulness is a permissible part of learning (as learning theorists would have us believe[6]), different exhibition strategies may take over. For example, collections may be placed so that they are not immediately apparent, or objects may be installed in a way that reveals visual jokes. The label will reveal that there is a task of interpretation in the very act of looking. Such an attitude may also make more apparent the humor of artists or cultures, which is often omitted because humor is considered frivolous.

ACCOMMODATING DIFFERENT STYLES AND LEVELS OF LEARNING

In *Frames of Mind*, Howard Gardner suggests that, regardless of our social history, every individual has his or her own set of gifts or talents, and a corresponding set of preferred learning styles.[7] He suggests that there are many forms of learning, which can be divided roughly into

seven categories: linguistic, musical, logical-mathematical, spatial, bodily-kinesthetic, interpersonal, and intrapersonal. These categories are not hierarchical but rather are parallel and have equal value. Most important for exhibition producers, one form of learning is not necessarily translatable into another; thus, tactile comprehension does not necessarily translate to verbal understanding.

Since, as Howard Gardner suggests, each individual in our audience has a different learning pattern, multisensory exhibition experiences that offer many entry points could facilitate a range of learning experiences, without prejudice. It follows, then, that should we wish all visitors to learn and understand, we must construct a wide palette of exhibition opportunities that utilizes all the senses. There are materials visitors long to touch. There are many objects that could be better understood if the audience has a chance to participate in a process or an experiment.

In addition to preferred learning styles, everyone is a novice about every subject at some time in his or her life. It is safe to assume that every exhibition will have novice learners in its audience, and yet most adults do not like to admit publicly their beginner status. It is much kinder for the exhibition producer to accommodate the novice than to assume that the exhibition should work only for the exhibit creator and his or her knowledgeable colleagues. The assumption that novice visitors need to feel welcome suggests the following (not exhaustive) list of obligatory strategies: defining all terms when used, providing an introduction to the social context for all exhibitions, locating all geographical references, and allowing all processes of art production to be understood.

Paterson Williams, Marlene Chambers, and Melora McDermott of the Denver Art Museum are conducting research, funded by the John Paul Getty Grant Program and the National Endowment for the Arts, on strategies for including the novice learner in an art museum setting. McDermott writes:

> Novices have very mixed feelings about hearing what experts think about art objects. While they acknowledge that the experts know something that might be useful to them in looking, novices are quite adamant that they don't want anyone to decide for them what is good or bad. They don't want someone to tell them that something they really like isn't "good.". . . They also don't want to be talked down to. . . . Novices also perceive experts as looking at objects in a very intellectual, unfeeling way. . . . As novices they tend to have their most pleasurable experience with art when they look at it in a very emotional, feeling-laden way.[8]

If we, the creators of exhibitions, think that viewers are inherently smart (though not necessarily well-educated or familiar with the subject matter) and that they are entitled to ask questions and receive answers, then we will address questions the audience has rather than tell them what we think they should know. It is logical, then, that the author will have to consult with the public before writing final copy. This implies the time-consuming task of audience interviews before the final installation is done.

Label Copy

Even for the writing of label copy there are techniques that can promote inclusion or exclusion. If the label writer believes the audience is composed of receptive students, and the information he or she wants to pass on is genuinely good for them, then the label writer will assume the role of a teacher transmitting information. The audience will be viewed as a passive but obedient recipient. The audience's only choice then is whether to read or not to read, to be willing or to be recalcitrant. However, failure to read labels is often perceived by the audience as something "naughty"; consequently, they feel guilty.

The role of teacher is not the label writer's only possible stance. He or she can choose instead to be coconspirator, colleague, preacher, or even gossip columnist. Altering these assumptions about the label writer's role might cause the audience to change their behavior as well. For example, if the writer sees the audience as a partner, then perhaps the audience might participate like a partner. There are also label-writing strategies that encourage interaction both between the viewer and the object and between the viewer and members of his or her party. Judy Rand of the Monterey Aquarium has set a new standard by writing label copy that is conversational in tone. The reader feels like he or she is chatting with a friend rather than being lectured to by a professor. I suspect that this chatty tone encourages discourse within the visitor's party.

There are also label-writing strategies that encourage the *audience* to become the teacher. These strategies, like Spock's "talk-back boards," identify the visitor as a resource in addition to the curator and the institution. This allows ownership of the exhibition to extend beyond the staff.

A number of museums, including the Decorative Arts Museum at the Louvre, have experimented with including text written for different reading levels on the same label (i.e., text for children and text for

the accompanying adult), which intentionally encourages interaction. Choosing to write label copy at a level that does not exclude children, the less well-educated, and those not fluent in the language in which the label is written helps make these groups feel included in a wider sense, whereas writing label copy that requires college-level fluency reinforces the notion that all others have come to the wrong place.

Additional Sources of Information

Some novice members of our audiences will become intermediate or even advanced learners within a single museum visit. An object that intrigues the visitor brings out the instantaneous need for more information. Adding information to an exhibition is always a problem, because we are mindful of detracting from the object and cluttering up the exhibit. We understand that not everyone wants the same additional information, but the individual who does want more information wants it then and there. Immediate access to information is satisfying to the audience; therefore, the task is to provide information in the exhibition in a manner such that the audience knows it is available without it being intrusive. Putting the catalogue in the gallery is one way to allow the visitor immediate access to more information about the subject at hand. Other strategies include installing computers and interactive videodiscs with branching programs, which have the capacity to hold additional information without cluttering the walls. Embedding a resource center within or next to the exhibition space has been used by many museums, including the M. H. de Young Memorial Museum in San Francisco.

Blurring the distinctions between kinds of museums works to the benefit of the audience as well. For the visitor, an object of interest provokes many questions that are cross-disciplinary; he or she is probably not interested in our museological territorial boundaries. For example, an entire environment about early music has been installed in the Museum of Fine Arts, Boston. This allows the visitor to see the instruments, hear them played either live or on recordings, and study books and facsimile sheet music—all within a climate-controlled space that is itself a storage unit. Information about art, craftsmanship, music history, biography, and social science is available all in the same location.

Visual-study storage areas are resources that may provide answers to additional questions from all sections of our audience, including experts. The Strong Museum, the Corning Museum, the Philadelphia Museum of Art, and now the Metropolitan Museum of Art,

among others, have experimented with placing visual-study collections close to the exhibition. Also, purpose-built activity stations that focus on a variety of subjects and encourage activity or touching without endangering the collection's objects have been successfully used, primarily by science centers and children's museums.

Identifying the Exhibition Creator

An alternative exhibition strategy that also allows the visitor to feel included involves creating an exhibition in which each object has been personally selected by an identifiable source, who self-consciously reveals the decisions surrounding the inclusion of each item. This strategy of making the curator the narrator invites the visitor to become a fellow traveler. The National Gallery in London invites famous artists to select objects for display from the gallery's collections and then explain to the visitor why these objects were chosen and why they are personally important to the chooser. An exhibition that is signed, uses the first person in the label copy, and/or reveals the personality of the artist is a personal, creative act analogous to a signed work of art, and intentionally becomes an autobiographical exhibition. While visitors expect to see the authors of works of art, music, and fiction identified, they are not used to perceiving exhibitions as the personal work of identifiable individuals. Unsigned exhibitions reinforce the notion that there is a godlike voice of authority behind the selection of objects. But presenting a curator as an individual usefully demonstrates that exhibitions are in reality like signed columns rather than news releases and that each producer, like each columnist, has a point of view. The exhibition Hispanic Art in the United States, curated by Jane Livingston and John Beardsley (discussed earlier in this volume), will probably be credited in the future with widening our perception of modern American art, but the furor caused by the seeming arbitrariness of the show's choices might have been ameliorated if the curators had been an identifiable presence who discussed their choices within the body of the exhibition itself.

The Museum as Gathering Place

Ellen Posner writes in the *Atlantic:*

> When museums were thought of primarily as places for the conservation, study, and display of works of art, new structures were de-

signed both to suggest that opportunities for repose and contempla-
tion were available within and to symbolize what were believed to be
the uplifting properties of art: hence, the park and suburban settings,
the important-looking colonnaded entrances and celestial domes, the
exhilarating flights of steps.

Now, however, although the art is still there someplace, muse-
ums stand at the center of social life. And the buildings themselves
are expected to attract and seduce the casual passerby, to deliver
glamour, panache, and chic, and to promise a good time to be had by
all.[9]

This point is reinforced by John Falk's work, which has demon-
strated that people visiting any exhibition spend a considerable
amount of time interacting with the people they came with and watch-
ing strangers.[10] The need to be in a congregative setting is perhaps
much more important than we in the museum business commonly
acknowledge. Exhibitions need to support both individual learning
and social interactions. Many people do not want to display their
ignorance in front of strangers, and so learning opportunities will need
to be designed that simultaneously encourage social interaction among
members of the visiting party and private contemplation. If we begin
to feel that it is within our mission to support sociability, then we will
feel more comfortable about promoting seating arrangements that,
quite frankly, reinforce social interaction as well as interaction with
the objects. For example, despite the conservation problems, cafés in
the middle of exhibition spaces, surrounded by the objects, might
enhance learning better than cafés separated from these areas.

CONCLUSIONS

While we may be reluctant to admit it, the production of an exhibition
is more akin to the production of a theater piece than any other form.
Like theater, exhibitions are formed by a group of people who have
highly individualized visions and styles, in a process in which com-
promise is the order of the day. The relationship among values ex-
pressed in the exhibition, content, and style has to be broadly agreed
upon, or else the team must be autocratically ruled in order to avoid
a cacophony of ideas.

The process of exhibition production and the loci of power within
the exhibition team are interesting topics in themselves and deserve

further study. For the purposes of this paper, however, I suggest that the resultant product—the exhibition—must have embedded within it either agreed-upon assumptions about the audience or a coherent view of the audience as articulated by a single prevailing power source.

In current practice, however, during production of an exhibition the team members rarely force themselves to reveal and share their views of the visitor. Of course, we can continue to keep our views of the audience hidden even from ourselves, but doing that reinforces messages that I am sure we would be too embarrassed to acknowledge. It follows that if, as part of the initial stages of exhibition formation, we develop tools to allow all of us to articulate our individual assumptions instead, we might be more willing to include strategies that reinforce what we would *like* to think about our visitors. Then exhibitions may be created that work for the audience—not because we necessarily inherently care about the audience, but because we *want* to care about the audience and will adjust our behavior accordingly.

As Stephen E. Weil, deputy director of the Smithsonian Institution's Hirshhorn Museum and Sculpture Garden, writes:

> The real issue, I think, is not how to purge the museum of values—that, in all likelihood, would be an impossible task—but how to make those values manifest, how to bring them up to consciousness for both ourselves and our visitors. We delude ourselves when we think of the museum as a clear and transparent medium through which only our objects transmit messages. We transmit messages too—as a medium we are also a message—and it seems to me vital that we understand better just what those messages are.[11]

NOTES

1. Pierre Bourdieu, *Distinction: A Social Critique of the Judgement of Taste* (Cambridge: Harvard University Press, 1984), 2–3.

2. Christraud M. Geary, *Images From Bamum* (Washington, D.C.: National Museum of African Art and Smithsonian Institution Press, 1988), 11.

3. Chandler Screven, "Museum Learning and the Casual Visitor: What Are the Limits?" Paper presented at the University of Toronto, 1987.

4. Mihaly Csikszentmihalyi and Eugene Rochberg-Halton, *The Meaning of Things* (London: Cambridge University Press, 1981).

5. Gary Kulik, "Designing the Past: History-Museum Exhibitions from Peale to the Present," in Warren Leon and Roy Rozensweig, eds., *History Museums and Historical Societies in the United States* (Urbana: University of Illinois Press, 1989).

6. This was the theme of the "Play and Inventiveness" colloquium held at the Smithsonian Institution in 1979.

7. Howard Gardner, *Frames of Mind: The Theory of Multiple Intelligences* (New York: Basic Books, 1983).

8. Melora McDermott, "Through These Eyes: What Novices Value in Art Experience" (preliminary draft of report prepared for the American Association of Museums Program Sourcebook, 1987, photocopy).

9. Ellen Posner, "The Museum as Bazaar," *Atlantic* 262, no. 2 (Aug. 1988), 68.

10. John Falk, "Predicting Visitor Behavior," *Curator* 28, no. 4 (1985).

11. Stephen E. Weil, "The Proper Business of the Museum: Ideas or Things?" *Muse* 12, no. 1 (Apr. 1989), 31.

CHAPTER 12

Always True to the Object, in Our Fashion

SUSAN VOGEL

lmost nothing displayed in muse-
ums was made to be seen in them.
Museums provide an experience
of most of the world's art and ar-
tifacts that does not bear even the remotest resemblance to what their
makers intended. This evident fact lies at the very heart of museum
work (which is a work of mediation) and should be a preoccupation
of all museum professionals, though most museum visitors seem prac-
tically unaware of it. An art exhibition can be construed as an unwit-
ting collaboration between a curator and the artist(s) represented,
with the former having by far the most active and influential role.
Ironically, the curator's name rarely even appears in the information
available in an exhibition (except as the author of the catalogue), and
the public is given the false impression of having come into contact
with "Goya," "Warhol," or "African art," for example. Museums, it
seems to me, have an obligation to let the public know what part of
any exhibition is the making of the artists[1] and what part is the cu-
rator's interpretation. Disentangling those two elements, however,
may not be easy, since at least some of the curator's understanding of
his or her material may rest on unquestioned and unexamined
cultural—and other—assumptions.

Virtually the only art made to be exhibited in galleries (as op-
posed to perhaps serving as decoration in galleries) is the art of our

own recent history, that is, Western art since the late eighteenth century. In some measure, we have attributed to the art or artifacts of all times the qualities of our own: that its purpose is to be contemplated, and that its main qualities can be apprehended visually. Egyptian tomb furnishings and Renaissance altars—to say nothing of African art—are routinely exhibited in art museums without a clear examination of even the most basic questions: Can they be regarded as art in our sense? Were they made by people who thought of themselves in terms that correspond to our definition of "artist"? If not, how do we acknowledge that while displaying them in art museums?

African art provides a useful and particularly sharp instance of the distortion produced by exhibiting in museums objects made for quite different purposes. African art has not been included in art museums long enough for its presence to be accepted unthinkingly. If the audience knows one thing about African art, it knows these objects were never meant to be seen in museum buildings. This makes it a fruitful subject for exploring museum presentations, or dislocations— or, as we might most profitably consider it, the recontextualization of objects in museums.

I am a museum practitioner, not a theorist. I have spent most of my professional life creating exhibitions: one permanent installation and many temporary exhibitions. They have been art exhibitions created of material objects in concrete settings, addressed to specific audiences in specific cities at specific moments in time. Mine have all been exhibitions of African art—an art not automatically recognized as art, from a place not politically neutral. While working on them I have taken into account what the audience knew or believed about Africa and have developed strategies to deal with their expectations. Maybe the strategies have resulted in theories.

Western culture has appropriated African art and attributed to it meanings that are overwhelmingly Western. We are aware that the meanings we give to the objects visiting in our homes and museums are not those that inspired their creators. We may be less clear about what the original status (art? craft? sacra?) and meaning might have been.

Many Westerners feel too sharply their ignorance of the original contexts of African art and are too ready to let it blind them to the art's visible qualities. They are less daunted by the impossibility of seeing *any* work of art with the eyes of the original audience, much less those of the artist. The cultural context of much of the world's art,

particularly that large segment which is religious in inspiration, is remote from the contemporary museumgoing public. If nothing else, the aura of faith and reverence with which it was regarded by its intended audience is missing for most of us. We can be insiders only in our own culture and our own time.

That said, I have come to feel that the museum dealing with culture (and even more with non-Western art) cannot adopt the authoritative voice commonly heard in museums of Western art and science. We are too far from the voices of the original owners and makers, too locked into the perspectives of our own culture to presume to be faithful to the object in any exalted way. We can be faithful only in our fashion, which often means we are, like Cole Porter's heroine, only barely faithful, or not at all. And we can be faithful only in the fashion of our time.

Several recent Center for African Art exhibitions have attempted to be faithful in different ways. All renounced the authoritative voice; each represented a strategy for dealing with the drastic recontextualization of African art in Western museums. One that dealt overtly with the selection of exhibition objects, The Art of Collecting African Art,[2] showed not only the objects that were the pride of the collector, but the works that had been passed over as mediocre, altered, restored, or forged. The exhibition invited the viewer to look closely and form his or her own opinion before reading the label that revealed my opinion. Labels were personal, opinionated, and informal in tone rather than didactic.[3] This exhibition was intended to encourage careful looking and did not attempt to teach connoisseurship.[4]

Two other exhibitions sought to empower the visitor to look critically at works of African art and at the same time to heighten awareness of the degree to which what we see in African art is a reflection of ourselves. The first, Perspectives: Angles on African Art, considered the ways we in the West project our needs and our fantasies upon Africa; the second was Art/artifact. Both exhibitions examined Americans rather than Africans: the audience was the subject of the first exhibition, the museum the subject of the second.

Perspectives: Angles on African Art[5] explored the different things African art has come to represent by inviting ten individuals who seemed to hold different points of view to select objects and to discuss their selections and perspectives. The ten cocurators were Americans and Africans who had some connection to African art, though only two were academically trained as African-art specialists. The labels in the exhibition consisted of signed comments by the cocurators. Most

were highly personal, arguable opinions that invited the visitor to
agree or disagree. The spectrum of outlooks interpreted African art as
a national patrimony; a personal heritage; objects in an art collection;
part of the study of art history, or of anthropology; an influence on
twentieth-century art; material for artists to draw upon in different
ways; and the expression of living religious and political beliefs.[6]

Despite their individuality and their differences, the cocurators
were all concerned with the dichotomy between appreciation and un-
derstanding, form and meaning; between what David Rockefeller calls
the artistic sense, and the scholarly one. It was not a question we
raised explicitly in the Perspectives interviews, though it was men-
tioned again and again. Ivan Karp, an anthropologist, put it most
clearly: "I'm really torn between the arguments that are made for
universal aesthetic criteria and the idea that we can only truly appre-
ciate something from the point of view of the people for whom it was
originally made—that aesthetics are 'culture bound.' "[7] This question
is fundamental to the consideration of all non-Western art: How do
we legitimately understand or appreciate art from a culture we do not
thoroughly know? I suspect most of our visitors are troubled by the
issue in an inexplicit way.

The artist cocurators were the least preoccupied by the cultural
context of the objects, which they confidently approached as pure
sculptural form. Nancy Graves said, "The art is here for us to appre-
ciate intuitively. One may get more information about it which en-
hances it, but its strength is here for anyone to see."[8] Iba N'Diaye
makes no reference to meaning in his commentaries, and describes
drawing objects as the way he learned to see them.[9] Romare Bearden
feels that information can even inhibit perception: "I had to put the
books down and just look at how I felt about it. The books get in the
way sometimes."[10] For James Baldwin, the only way to understand is
through direct experience. "You want to find out?" he asks. "Go and
expose yourself. You can't find out through a middleman anyway." He
also says, "There's this curious dichotomy in the West about form and
content. The form *is* the content."[11] In this he echoes the African
sculptor and diviner, Lela Kouakou, who recognizes no distinction
between the two.[12]

William Rubin argues that the distinction between form and con-
tent is theoretical, since neither an understanding of the cultural con-
text nor a personal appreciation is possible as a pure experience. "The
choices are not between a total contextual reconstruction—which is a
mythic pursuit—and a pure aesthetic response, whatever that is. We

don't respond to art objects with one particular set of responses that are isolatable as aesthetic. We respond to them with our total humanity."[13] Dr. Ekpo Eyo, a Nigerian archaeologist, goes further, suggesting that an intermingling of scholarship and emotional aesthetic response leads to understanding. Speaking of his personal experience with archaeological objects, he says, "The more I looked at them, the more I studied them, the more I appreciated their beauty over and above the information about their context. They were beautiful! The more I described them and handled them, the more emotionally attached to them I became. It's like having a baby: you look at the baby all the time, and you begin to discover many things about it which you could not see at first. My eyes opened."[14]

In Perspectives we did not abdicate completely our role as providers of information. We produced a checklist that contained information on the use and meaning the objects had for the original African owners. While I feel the authoritative voice inhibits the visitor, I hardly recommend uninformed free association before African objects—or any other intellectually determined objects—as a particularly full way to experience them if other means are available. But Perspectives was not about African art. It was about approaches to African art.

The exhibition that focused on the museum was Art/artifact.[15] Again, this exhibition was not about African art or Africa. It was not even entirely about art. It was an exhibition about perception and the museum experience, focusing on the ways Westerners have classified and exhibited African objects over the past century. With some objects considered art and others artifacts, our categories do not reflect African ones and have changed over time. The exhibition showed how we view African objects (both literally and figuratively), arguing that much of our vision of Africa and African art has been conditioned by our own culture. I felt that unless we acknowledge that African art as we see it has been shaped by us as much as by Africans, we cannot see it at all.

The exhibition approached the question of perception through individual objects and through installation styles. Recognizing that the physical setting of an object is part of what makes it identifiable as art, the installation showed art objects and nonart objects in such a way as to raise the question in the viewer's mind and to make the trickery of the installation evident. A hunting net from Zaire was one nonaesthetic, nonsignifying object that bore a spurious resemblance to some contemporary artworks. It was reverently displayed in a pool of light on a low platform. (Ironically, an unanticipated response demon-

strated the success of the trickery in some quarters; I and several African-art dealers received inquiries from art collectors about where they might acquire such a marvelous net.) The inverse of this was the display of some extraordinarily fine pieces of African figure sculpture, unemphatically shown in the style of natural-history museums in a case evenly filled with many objects of unequal aesthetic interest, quantities of text, and pictures, which created an all-over "anthropological wallpaper" effect. The indiscriminate assemblage made it hard to see the sculptures as great works of art, though they were perfectly visible.

The exhibition also considered the contexts in which Westerners have seen African art. It began with a clean white room in which African art and artifacts (such as the net) were displayed for their formal qualities only (Figures 12-1, 12-2). No information was provided above the most minimal: "Net, Zande people, Zaire." The next area was small but important: it contained an unedited and untranslated videotape showing the installation of a Mijikenda memorial post,

Fig. 12-1. *African objects presented as pure form—as if their form were their meaning. None was ever intended to be seen in the manner shown here. In their original contexts, the raffia textile on the wall was a Kuba woman's skirt wrapper; the rope bundle on the platform was a Zande hunting net, tied up for storage or transportation; the metal blade on the right served as currency in the payment of bridewealth in Kasai. Installation view of Art/artifact at the Center for African Art, New York, 1988.* Photo courtesy of the Center for African Art.

Fig. 12-2. *Mijikenda memorial posts displayed as sculptures. Posts from many graves have been assembled to create an aesthetic and spectral presence unlike anything ever seen by the Mijikenda. Such posts may or may not have been regarded as aesthetic objects by their makers and users. Installation view of Art/artifact at the Center for African Art, New York, 1988.* Photo courtesy of the Center for African Art.

accompanied by a label stating that only the original audience could have the original experience—that all other settings were inauthentic and arbitrary to a greater or lesser degree. The third area reconstructed a "curiosity room" from 1905 in which the mixture of manmade and zoological specimens and a lack of information implied that these were interesting but almost unknowable objects that demonstrated no aesthetic intent (Figures 12-3, 12-4) The fourth area showed objects in a natural-history-museum style, including the case described above (Figure 12-5), and a full diorama showing three men at the installation of a Mijikenda post (Figure 12-6). The last area displayed objects as in an art museum, as valuable treasures protected by Plexiglas and haloed in sanctifying spotlights (Figures 12-7, 12-8).

The exhibition was not meant to be chronological or arranged in ascending order of legitimacy. The labels pointed out that natural-history museums and dioramas are not out of date, and that a display very like the art-museum one was used by Alfred Steiglitz in 1914, about the time when African objects were beginning to be considered

Fig. 12-3. *Recreation of the curiosity room from the Hampton Institute, circa 1905.*
The mixture of zoological and ethnographic "curiosities" was typical of the period.
This style of presentation suggests that the African objects have no complex mean-
ings and implies that everything—sculptured figures, spears, the crocodile, beadwork,
and other objects—is of equal value and interest. In practice, Hampton's room
served as a very advanced learning tool where teachers used the collection for hands-
on instruction of the sort current in museums today. Installation view of Art/artifact
at the Center for African Art, New York, 1988. Photo courtesy of the Center for Af-
rican Art.

art. The exhibition stressed that these different styles reflected differ-
ences in attitude and interpretation, and that the viewer was manip-
ulated by all of them.

As visitors left the exhibition to wander into other displays, I
hoped they would be able to regard all museum activities with a wiser
and more critical eye, eventually to become aware of the less publicly
visible choices made by museums that influence what they see when
they look through the Plexiglas at an object.

Politically aware visitors often focus on the value and ownership of
museum objects, on questions regarding how the works arrived in the
museum, who paid for the exhibition, and who profits from it. But
these are only the most obvious issues among many more subtle ones.

Fig. 12-4. *Recreation of the Hampton Institute curiosity room with a Mijikenda post in the corner near a Cameroon drum. The unprotected, rather casual presentation of these objects suggests that they are not very valuable, and does not suggest that the visitor should regard them as works of art. Installation view of Art/artifact at the Center for African Art, New York, 1988.* Photo courtesy of the Center for African Art.

Fig. 12-5. *Display in the style of a natural-history museum. Objects are used to illustrate points about African culture (e.g., "The Place of the Dead in the World of the Living"), not for their intrinsic qualities. The evenness of the display indicates that all these objects are to be regarded equally, though some are in fact fine works of art and others are ordinary. In this context, the Mijikenda post takes on a banal appearance. Installation view of Art/artifact at the Center for African Art, New York, 1988.* Photo courtesy of the Center for African Art.

Fig. 12-6. *Diorama in the style of a natural-history museum, showing the installation of a Mijikenda post. The diorama allowed the museum to show many aspects of material culture, social interaction, and environment simultaneously. The presentation discourages the viewer from singling out the Mijikenda post for special attention, and makes its boundaries unclear—are the two smaller posts part of it? the cloths? the pot and gourds? Installation view of Art/artifact at the Center for African Art, New York, 1988.* Photo courtesy of the Center for African Art.

The museum is teaching—expressly, as part of an education program and an articulated agenda, but also subtly, almost unconsciously—a system of highly political values expressed not only in the style of presentation but in myriad facets of its operation. The banners in front of the building tell the visitor what really matters before he or she has entered the display. The museum communicates values in the types of programs it chooses to present and in the audiences it addresses, in the size of staff departments and the emphasis they are given, in the selection of objects for acquisition, and more concretely in the location of displays in the building and the subtleties of lighting and label copy. None of these things is neutral. None is overt. All tell the audience what to think beyond what the museum ostensibly is teaching.

The radical dislocation of most objects in museums has become a firmly established tradition in the West. Many museum visitors expect to see in art museums practically everything from tombs and altars to

Fig. 12-7. *African figures and utilitarian objects exhibited as in an art museum. Both figurative and nonfigurative objects are shown here, including spears similar to those displayed in the curiosity room (see Figure 12-3). Here, however, the presentation associates them with a metal sculpture and invites the viewer to consider their artistic qualities. Installation view of Art/artifact at the Center for African Art, New York, 1988.* Photo courtesy of the Center for African Art.

shoes and clocks; the visitors' relative lack of experience of these artifacts in their original contexts makes them unaware of how much the museum itself influences what they see.

The fact that museums recontextualize and interpret objects is a given, requiring no apologies. They should, however, be self-aware and open about the degree of subjectivity that is also a given. Museum professionals must be conscious about what they do and why, and they should inform the public that what it sees is not material that "speaks for itself" but material filtered through the tastes, interests, politics, and state of knowledge of particular presenters at a particular moment in time. The museum must allow the public to know that it is not a broad frame through which the art and culture of the world can be inspected, but a tightly focused lens that shows the visitor a particular point of view. It could hardly be otherwise.

Fig. 12-8. *Presentation of African sculptures in the style of an art museum. Each piece is isolated to be contemplated as a work of art. The presentation under Plexiglas suggests that each work is uniquely valuable and must be protected. The Mijikenda posts again appear, here as abstracted figure sculpture. Installation view of Art/artifact at the Center for African Art, New York, 1988.* Photo courtesy of the Center for African Art.

NOTES

1. If indeed they are to be considered artists in the African case. This is an example of a fundamental and potentially distorting assumption that remains an unexamined—or at least unarticulated—foundation underlying many African-art exhibitions.

2. The catalogue by the same title (published in 1988 by the Center for African Art) contains texts on collecting and illustrations of the objects in collections, but none of the comparative objects.

3. A case full of Baule masks had a label stating: "CAUTION: THERE ARE FAKES IN THIS CASE. Face masks; Baule, Ivory Coast; Wood, paint, metal, fiber. Such masks are worn in entertainment dances. Here are two blatant fakes, an honest reproduction, two extraordinary old masks, and two merely authentic masks." Beyond the case was a second label identifying the specific masks: "From left to right: 1. A forgery, betrayed by its excessive delicacy and insipid expression. Compare the timidity of the decoration around the chin,

and the meager little bird, with the others. 2. A fake. The lusterless surface and rote carving are typical of recent fakes. 3. An authentic mask probably dating from the 1940s or 1950s. Though the carving is vital and vigorous (compare this lusty bird with the others), it is heavy and the face is expressionless. 4. A reproduction, carved with competence, even virtuosity, but without deep conviction. No attempt has been made to age the mask or falsify the surface; no holes for the attachment of a putative costume have been made around the perimeter. 5. A great masterpiece. This mask, published early, probably dates from the nineteenth century. Its deeply contemplative expression, and the inspired reduction of the birds to just heads, reveal the hand of a great artist. It has preserved its original surface with all the variations of color and texture normally found on an old mask."

4. Some academics and those uninterested in the workings of taste and connoisseurship found this an unsatisfying exhibition, though it was popular with the public, who enjoyed testing their own judgment. If I were doing this show again I would include on the initial labels more information of the kind needed to judge the objects, or I would isolate and identify a good example for comparison.

5. Shown at the Center for African Art, New York; the Virginia Museum of Fine Arts; Richmond, the San Diego Museum of Art; and the Birmingham Museum of Art between February 1987 and March 1988. The catalogue by the same title was published in 1987 by the Center for African Art and Harry N. Abrams, Inc.

6. They were: Romare Bearden, Nancy Graves, and Iba N'Diaye, artists; Robert Farris Thompson, Africanist art historian; Ivan Karp, Africanist anthropologist; James Baldwin, writer; David Rockefeller, banker and collector; Ekpo Eyo, Africanist archaeologist; Lela Kouakou, Baule diviner and artist; William Rubin, modernist art historian.

7. *Perspectives: Angles on African Art*, 83.

8. Ibid., 99.

9. Ibid., 163.

10. Ibid., 67.

11. Ibid., 115.

12. Ibid., 148–59.

13. Ibid., 51.

14. Ibid., 35.

15. The catalogue of the same title was published in 1987 by the Center for African Art and Prestel Verlag. It contained contributions by Susan Vogel,

Arthur Danto, R. M. Gramly, Jeanne Zeidler with Mary Lou Hultgren, Enid Schildkrout, Thomas McEviley, Kim Levin, and James Farris. Art/artifact was seen at the Center for African Art, New York; the Buffalo Museum of Science; the Virginia Museum of Fine Arts, Richmond; the Dallas Museum of Art; the Henry Art Gallery, Seattle; the Carnegie Art Museum, Pittsburgh; the Denver Museum of Natural History; and the Wight Art Gallery, Los Angeles, between February 1988 and June 1990. The migration of the exhibition between art museums and science museums exactly reflects the issue it raises.

CHAPTER 13

The Poetic Image and Native American Art

PATRICK T. HOULIHAN

Virtually all of my professional life in museums, nineteen years, has been spent in institutions wherein Native American collections have been predominant. In directing museums from Arizona to New York, California to New Mexico, I have struggled with the issues that were the theme of the conference: the politics and poetics of representation. However, if the truth be told, it has been the politics of the institutions and their many constituencies that have occupied the greatest amount of my time, thought, and energy (and in some institutions that of the professional staffs as well).

In this article I wish to set aside the politics of representation and ponder a bit on the poetics of representation as they might apply to the presentation of Native American cultures—through art and artifacts—to largely non-Indian audiences. I think this important, this inquiry into the fuller meaning of Native American collections, because such collections are fast becoming one of the few tangible remains of the cultures that once existed on the North American continent.

In a short paper for a 1986 colloquium sponsored by the Rockefeller Foundation on obstacles to the exhibition of non-Western and minority cultures in museums, I suggested that one obvious source of insight for majority-culture museums into the sensitive and sensible portrayal of indigenous art was tribal museums. Here it may be pre-

sumed that Native American control and direction are most directly in operation and that exhibitions reflect an insider's interpretation of that culture, art, and history.

In the paper I presented the example of the U'mista Cultural Centre at Alert Bay, British Columbia. Unfortunately that museum provides only a limited view of a Native American culture exhibited by Native Americans, since its existence is linked so closely to the repatriation to the Alert Bay community of potlatch art and artifacts previously confiscated by the Canadian government. The confiscation occurred earlier in this century, when church and state were allies in the suppression of Indian culture and potlatches were forbidden by law. As a punishment for holding the outlawed potlatch, the personal property of Native Americans was confiscated. To accommodate the return of this property some sixty years later, the U'mista Cultural Centre was created, and it now houses these items. In addition, it also functions as a community and education center for that village, offering classes in language and crafts as well as a meeting place. (See James Clifford's contribution to this volume for a longer discussion of this museum.)

The presentation of Kwakiutl culture one sees here, then, is limited to the potlatch, and one of the underlying messages is certainly that of past oppression by the Canadian government. Beyond that story, however, the basic design of the exhibition forces the visitor to experience something of the potlatch itself. On the seating platforms surrounding three sides of the large, open dance area, where the actual performance of the potlatch might occur, the masks, rattles, and other ritual paraphernalia of the potlatch are arrayed (see Figure 14-10). By this placement, the expected positions of objects and visitor are reversed. The visitor is made to pass before the objects at rest in the places normally reserved for spectators. It is in this reverse placement that one experiences also the reversal and the confusion of roles. That is, the object becomes the viewer and the visitor becomes the object, or so it seems. And since many of the objects displayed are masks, with eyes, noses, mouths, ears, etc., the confusion is real. Who's on exhibit? This is the question forced on the visitor by this exhibition design, and it is a large part of the poetic impact of the exhibition at the U'mista Cultural Centre.

Before any further consideration of tribal-museum exhibitions— or Native American art or artifacts as sources for poetic imagery—I think we must begin with some understanding of poetry: not in the mechanics of its rhyme or meter, or even in the history or psychology

of its makers or readers, but in the phenomenology of its being; that is, in the ontology of poetry.

Certainly one of the most important postwar treatises on the philosophy of poetry is to be found in Gaston Bachelard's *The Poetics of Space*.[1] Bachelard is considered by many to be the father of contemporary French criticism and an important proponent of phenomenology, earlier in his career in the philosophy of science and later in the philosophy of art. In his lengthy introduction to *The Poetics of Space*, he explains the major tenets of his conception of poetry.

At the heart of Bachelard's view of poetry is the notion that one's response to poetic images does not rest on an "archetype lying dormant in the depths of the subconscious."[2] By this he means that "poetic image is independent of causality,"[3] a statement that I suspect most museum people find difficult to understand, trained (or at least exposed) as we are to the modern social sciences. That training or exposure emphasizes linear reasoning and psychological and/or cultural causation, which projects a telescoped explanation for cognition that orients any individual through his or her association with a social group(s) bearing a shared culture(s). As a result, we believe that our personal or social experiences of our culture define our understanding of any given phenomenon. So when confronting museum visitors with the objects of a "foreign" culture, we invariably immediately relieve the viewer of his or her uncertainty by exhibiting the unknown objects in the context of familiar and thus more friendly categories, for example, subsistence, religion, art, primitive art, folk art, etc. Yet this is precisely what the great poet, or, rather, the memorable poetic image, is least likely to do! As Bachelard states:

> At the level of the poetic image, the duality of subject and object is iridescent, shimmering, unceasingly active in its inversions.[4]

Bravo the confusion of object and visitor at the U'mista Cultural Centre!

> The image, in its simplicity, has no need of scholarship. It is the property of a naïve consciousness; in its expression, it is youthful language. The poet, in the novelty of his images, is always the origin of language. To specify exactly what a phenomenology of the image can be, to specify that the image comes *before* thought, we should have to say that poetry, rather than being a phenomenology of the mind, is a phenomenology of the soul. We should then have to collect documentation on the subject of the *dreaming consciousness*.[5]

Bravo the near-total absence of object labels at the U'mista Cultural
Centre!

> In many circumstances we are obliged to acknowledge that poetry is
> a commitment of the soul. A consciousness associated with the soul
> is more relaxed, less intentionalized than a consciousness associated
> with the phenomena of the mind. Forces are manifested in poems
> that do not pass through the circuits of knowledge.[6]

Perhaps an example—one personal to me—might help the reader
at this point. The contemporary Irish poet Seamus Heaney has a vivid
poetic image in a poem about his marriage to his now-middle-aged
wife, which ends in the refrain "and here is love / like a tinsmith's
scoop / sunk past its gleam / in the meal-bin."[7] To explain my liking of
this image, I could easily resort to my own Irish heritage or to my
mother's kitchen, etc. But if instead of a cultural or a psychological
source for identifying with this poetic image, I seek a phenomenolog-
ical one, as Bachelard suggests, then it is its "reverberations," not its
"resonances," that I hear and to which I respond.

> Since a phenomenological inquiry on poetry aspires to go so far and
> so deep, because of methodological obligations, it must go beyond
> the sentimental resonances with which we receive (more or less
> richly—whether this richness be within ourselves or within the poem)
> a work of art. This is where the phenomenological doublet of reso-
> nances and repercussions must be sensitized. The resonances are
> dispersed on the different planes of our life in the world, while the
> repercussions invite us to give greater depth to our own existence. In
> the resonance we hear the poem, in the reverberations we speak it, it
> is our own. The reverberations bring about a change of being. It is as
> though the poet's being were our being. The multiplicity of reso-
> nances then issues from the reverberations' unity of being. Or, to put
> it more simply, this is an impression that all impassioned poetry-
> lovers know well: the poem possesses us entirely. This grip that
> poetry acquires on our very being bears a phenomenological mark
> that is unmistakable. The exuberance and depth of a poem are al-
> ways phenomena of the resonance-reverberation doublet. It is as
> though the poem, through its exuberance, awakened new depths in
> us. In order to ascertain the psychological action of a poem, we
> should therefore have to follow the two perspectives of phenome-
> nological analysis, towards the outpourings of the mind and towards
> the profundities of the soul.[8]

But how many museum exhibits can really do that? Should they even try? It seems clear to me that not all parts of every exhibit of Native American art, culture, or history should "possess" the viewer, but a part of them should. And the secret to doing this may lie in the use of Native American people—artists (or "poets") from the culture involved—to force us to rethink how we create exhibits or portions of exhibits that both resonate and reverberate in our viewers, bringing forth some sense of the essential meanings in Native American cultures.

In seeking other examples of Indian-controlled museums or exhibitions wherein there is poetic imagery, I am hard put to cite examples. However, poetic imagery is not at all hard to find in Native American art or artifacts. In these cultures poetic images are rampant and need only to be brought forth by their presentation in exhibits, whether in tribal museums or in majority-culture museums. Three examples come easily to mind: jewelry, children's games, and language.

First jewelry. Turquoise is ubiquitous throughout the Southwest culture area, and it is used by both Pueblo and Navajo artists in their jewelry. It is well known to knowledgeable Indian artists (as well as Anglo collectors), who can often identify the very mine from which a given stone was extracted. For the last hundred years or so, turquoise has been set in silver and worn by Anglos and Native Americans as bracelets, earrings, necklaces, belt buckles, brooches, rings, hatbands, etc.

Today most museum exhibits of turquoise explain its history, technology, and use in terms of silver jewelry, which of course is what is important to Anglos, rather than in terms of turquoise, which is what is most important to Native American people. For the Pueblo, turquoise represents one of the four primary substances of this world, along with plants, clay, and salt. And among the Navajo, turquoise marks one of the four corners of their universe—in this case the southeast corner associated with Mt. Taylor, near Grants, New Mexico. This is also the home of Turquoise Boy and Girl, who figure prominently in Navajo myth and ritual and whose avenue of transport from one place to another is via the blue-colored arches of the rainbow.

The other three corners of the Navajo universe also have color and jewelry associations—northeast with white shell, northwest with black jet, and southwest with abalone. Quite apart from these substances and their locations is the fact that silver is nowhere in the Navajo universe. It has no place and no ritual association; indeed,

until about 1850 or 1860 it was not even worked by Navajo artists. The point of this example is that before we can make exhibits poetic, we must be certain that what we exhibit is in fact important in the culture.

Another example of an artifact from Navajo culture that has poetic imagery is a children's string game, commonly known as cat's cradle in English. In the past, Navajo children would be taught astronomy by reference to various string-game formations. When held aloft at night, the various configurations of the string are like schematic drawings for different star configurations. This knowledge of the stars is important for two reasons. One pertains to navigation—for example, finding one's way home with the family's sheep herd, if caught after dark when still a long way from home. However, equally important is the knowledge of where various spiritual beings reside in the world above the earth. Again with reference to making exhibits poetic, the didactic material needed may exist within the culture being exhibited and not in our own culture's graphics or exhibition technology.

Finally, a third example, from the Northwest Coast, helps to refute the argument, so often used by art historians, that some things in art are universal, namely form as form. On the Pacific coast of British Columbia and Alaska, two neighboring groups, the Haida and the Tlingit, speak an Athabaskan language. (In this regard they are linguistically related to the Navajo and Apache in the Southwest, who also speak Athabaskan languages.) In both the Haida and Tlingit cultures one word can be used to describe three distinctly different object forms: a curved wooden spoon, a wooden hair comb, and the end of a tree branch with multiple twigs. This single Athabaskan word (which is also used by Navajo and Apache speakers) means roughly "curved wooden form with or without multiple ends." Interestingly, as the word is used in Haida or Tlingit culture, there is no requirement that the object be either manmade or tree-grown. Only the form is defined by this Athabaskan word. Herein lies my third caveat for poetic exhibits: namely, a failure to understand indigenous languages can lead to serious distortions of indigenous cultures.

But what, then, am I suggesting? Are turquoise, a children's string game, or a single Athabaskan word enough to tell the story of Southwest or Northwest Coast cultures? Obviously not! At one level there is no real substitute for broad-based cultural and historical exhibits of Native American cultures. But they need not be in every museum or in every case or exhibit hall of a single museum's presentation of Native American cultures. So, for instance, in New York City, which hosts

large, permanent survey exhibitions of Native American cultures in the American Museum of Natural History and the Museum of the American Indian, is it necessary or even desirable for these exhibits to be mimicked in the Metropolitan Museum of Art or even in the temporary-exhibition galleries of the first two museums? I think not.

Much of the information that we present in large survey exhibitions is, I suspect, quickly forgotten by most museum visitors. If what is exhibited is important or interesting (or both) to the visitor, then a catalogue or book will be sought for future study. But if what is memorable is an object or exhibition and it is retained as a part of oneself, then a kind of poetic image has been created for the visitor that reverberates and not just resonates.

Ultimately poetic images in exhibits function to help us know and to explain ourselves and others. And herein I believe lies the importance of cultures that predate the Industrial Revolution. These are cultures that can help us find essential knowledge and truths that predate our material culture and technology. To pass on some of these truths and knowledge in our exhibit halls is a worthwhile endeavor, one we should undertake.

NOTES

1. Gaston Bachelard, *The Poetics of Space*, trans. Maria Jolas (Boston: Beacon, 1969).

2. Ibid., xii.

3. Ibid., xiii.

4. Ibid., xv.

5. Ibid., xv–xvi.

6. Ibid., xvii. In this passage *soul* means "breath" or "breathing," not the soul of the Judeo-Christian tradition.

7. Seamus Heaney, "Mossbawn: Two Poems in Dedication. I. Sunlight," in *Collected Poems, 1965–1975* (New York: Farrar, Straus, and Giroux, 1980), 161.

8. Bachelard, *Poetics*, xviii–xix.

CHAPTER 14

Four Northwest Coast Museums: Travel Reflections

JAMES CLIFFORD

The University of British Columbia Museum of Anthropology is itself a famous artifact. Arthur Erickson's glass-and-concrete adaptation of Northwest Coast Indian styles simultaneously soars and crouches on a dramatic clifftop, looking out toward Vancouver Island and the setting sun. In early evening the reflected light makes visible a towering wall of windows between crowds of old totem poles within the building and new ones scattered outside.

The Kwagiulth[1] Museum and Cultural Centre, on Quadra Island, just off the east coast of Vancouver Island, is built in the spiral shape of a sea snail, symbolizing the importance of the sea in the lives of this Native American fishing community. It stands beside an elementary school and a church in Cape Mudge Village, a line of houses facing Discovery Passage, through which on summer nights cruise ships glide on the inland route to Alaska. Behind the museum, the remains of a totem pole, covered with wire mesh, decompose in the grass.

The Royal British Columbia Museum is a large white box. It shares civic space in downtown Victoria with government buildings, hotels, and tourist shops featuring English and Scottish collectibles. The museum's entrance is dominated by a large gift shop selling Native American jewelry, artifacts, books, and curios. Outside, in an open shed, a Hesquiaht/Nuu-Cha-Nulth artist from western Vancouver Island, Tim

Paul, who has been senior carver at the museum since 1976, works on a replacement for an old totem pole in Vancouver's Stanley Park.

The U'mista Cultural Centre is located in Alert Bay, on Cormorant Island near the northern tip of Vancouver Island. It adjoins a looming brick structure, formerly the St. Michael's Residential School for Indian Children, which now houses the Nimpkish band's administrative offices. The center extends downhill toward the harbor, ending with an exhibition space in the style of a traditional big house. Up the hill, beside a much larger ceremonial house, stands the world's tallest totem pole, enshrined in the Guinness Book of World Records and supported with guy wires, like an enormous radio antenna.

I went to Vancouver in August of 1988 to teach in a summer institute. On long weekends I visited the four museums. What follows are reflections by an outsider, a white American visitor, lingering on the two institutions where I was able to spend the most time: the UBC Museum of Anthropology and the U'mista Cultural Centre. While I draw on conversations with curators and local people and on printed infor-

Fig. 14-1. *Royal British Columbia Museum, Victoria. Tim Paul, senior carver, working on a totem pole in the public carving shed.* Photo courtesy of the Royal British Columbia Museum.

mation, what follows are primarily personal impressions of locales, buildings, and styles of exhibition. I barely hint at the four museums' complex local histories, specific audiences, and internal debates. These reflections are closer to travel writing than to ethnography or historical research.

I had become interested in the four museums while writing an essay on collecting in Western museums and in anthropology.[2] The essay analyzed the "art-culture system," which has determined the classification and authentication of artistic or cultural artifacts in Europe and North America since the late nineteenth century. Why do certain non-Western objects end up in fine-art museums, others in anthropology collections? What systems of value regulate the traffic among diverse collections? The essay ended by evoking several contestations of the art-culture system by resurgent native groups that have not, as predicted, disappeared into modernity's homogenizing stream or into the national melting pot. Their current productions did not fit easily into prevailing definitions of either art or culture. I suggested that these groups had been both playing and subverting the dominant art-culture game. Theirs were different, not separate, paths through modernity (no one escapes the market, technology, and the nation-state). The repatriation of objects from national museums to new tribal institutions such as the U'mista Cultural Centre and the Kwagiulth Museum seemed to be a striking example of how a dominant practice of collection and display has been turned to unanticipated ends. Master narratives of cultural disappearance and salvage could be replaced by stories of revival, remembrance, and struggle.

Many Northwest Coast communities have survived and resisted the violence visited on them since the mid-nineteenth century: devastating diseases, commercial and political domination, suppression of the potlatch, forced education in residential schools and by missionaries.[3] Despite enormous damage to indigenous cultures and continuing economic and political inequality, many tribal groups and individuals have found ways to live separate from and in negotiation with the modern state. In the anthropological and museum milieus I frequented the political climate was charged in ways I had never felt in other metropolitan settings: New York, Chicago, Washington, Paris, London. On the Northwest Coast today, struggles over land claims, the repatriation of museum collections, and community constraints on scientific research are increasingly common. Indigenous art (carving, building, painting, printmaking, jewelry and blanket design), work participating simultaneously in market and museum networks and in

tribal ceremonial and political contexts, is a leading public manifestation of cultural vitality. A recurring pressure and critique—the threat at least of public embarrassment, and even of legal intervention—is felt by anthropologists and museum curators concerned with ancient and modern Northwest Coast Indian traditions.[4]

I had come to British Columbia expecting to focus on the two Kwagiulth tribal museums, but I found I could not ignore the province's "major" displays of Northwest Coast work in the museums at UBC and Victoria, which are responding in their own ways to the evolving context. They offer revealing counterpoints to the innovations at Alert Bay and Cape Mudge Village and help make clear that no museum in the 1990s, tribal or metropolitan, can claim any longer to tell the whole or essential story about Northwest Coast Indian artistic or cultural productions. Indeed, all four museums display the same kinds of objects—ceremonial masks, rattles, robes, and sculpture, as well as work produced for the curio and art markets. In four different contexts, these objects tell discrepant stories of cultural vitality and struggle. All four museums register the irruption of history and politics in aesthetic and ethnographic contexts, thus challenging the art-culture system still dominant in most major exhibitions of tribal or non-Western work. All mix the discourses of art, culture, politics, and history in specific, hierarchical ways. They contest and complement one another in response to a changing historical situation and an unequal balance of cultural and economic power.

It should be noted, however, that my overall comparative approach tends to limit what can be said about the four museums. They are seen less as specific articulations of local, regional, or national histories and more as variants within a unified field of representations. Such foreshortening is particularly questionable with respect to the tribal museums and cultural centers, institutions that both do and do not function on the terms of the dominant, majority culture. They are, in important aspects of their existence, minority or oppositional projects within a comparative museological context. But in other crucial aspects they are not museums at all: they are continuations of indigenous traditions of storytelling, collection, and display. Some of these Kwagiulth traditions are touched on in what follows. Overall, however, my comparative approach tends to stress entanglement and relationship rather than independence or an experience significantly outside the national culture. Moreover, the latter dimensions of tribal life are not adequately captured by terms such as *minority* (denoting a location defined in relation to majority power). The missing tribal

perspectives will have to be supplied in depth by other writers better placed and more knowledgeable than I am. This essay is strongly oriented, and limited, by the comparative museological context in which it seeks to intervene.[5]

The Royal British Columbia Museum in Victoria spreads its permanent installation over two large floors. The route through the exhibit is linear, chronological, and didactic, making extensive use of written and recorded explanations, period photographs, and documents. The first half of the installation, upstairs, focuses on precontact Northwest Coast aboriginal ecology and society. It explains adaptations to the environment, technology (weaving, canoes, costumes, houses, utensils, etc.), masks, and mythology. Elaborate traditional costumes are displayed on life-size mannequins. A silent video projection (from Edward Curtis's early film, *In the Land of the Headhunters*) shows traditional canoes with masked dancers in the bows. (It is mesmerizing to see these familiar masks and canoes in motion.) Early prints and wall-size photographs suggest the aboriginal world in the early years of contact. In a dark space, masks are illuminated sequentially, with recorded voices recounting their different myths.

White culture, commerce, and power arrive *in medias res* as one descends to the lower floor. At the bottom of the stairs, Haida shaman figures, carved for the first time in the 1880s and 1890s, reflect the decline of the traditional shaman's authority. A Tlingit sculpture of a Christian priest signals the new forces with which native populations would have to negotiate. Their initial success, a change and diversification of cultural and artistic production in response to outside stimuli, is illustrated with exhibits from the flourishing curio trade. However, this portrayal of noncatastrophic cultural contact is soon interrupted by dramatic evocation of the smallpox epidemic of the 1860s. The visitor walks through a passageway where the walls are covered with large, haunting Native American faces (Edward Curtis portraits) and where a recorded voice details the drastic population decline, cultural crisis, and subsequent struggle simply to survive. This harrowing passage is followed by an evocation of missionary influence (photos of students in uniform, a broken mask—but nothing on the complexity of conversion and what it may have meant from an Indian viewpoint). A section documenting the potlatch ceremony follows, with photographic and documentary evidence of its suppression by the Canadian government, newspaper accounts, and protests against the policy by Franz Boas. In this historical exhibit one can spend a good

deal of time reading texts, both modern explanations and contemporary documents.

The trail then leads into the largest room of the installation, containing a reconstructed chief's house, a cluster of totems, and, in surrounding cases, masks and other ceremonial and artistic objects arranged by tribe—Tsimshian, Bella Coola, etc. The exhibition continues through the dimly lit long house, atmospheric with simulated fire and recorded chants, into the final section, devoted to "The Land: 1763–1976." Here photographs and texts evoke the long struggle over land use and possession, including a Coast Salish delegation to London in 1906 and recent land claims (a large photo of Athabaskan Indians blockading a rail line in 1975).

Overall, the exhibit's historical treatment is unusual in its complexity and especially in its introduction of white power so early in the sequence. Change is not compartmentalized or added on at the end.[6] The large culminating room with its chief's house and old artifacts is preceded by missions and the potlatch suppression and is followed by

Fig. 14-2. *Royal British Columbia Museum, Victoria. Inside the Chief's House (Jonathan Hunt House)*. Photo courtesy of the Royal British Columbia Museum.

land struggles. Thus it cannot appear simply as an archaic traditional space, but rather as a powerful site of cultural authenticity surrounded by conflict and change. The historical sequence suggests that the traditional objects on display were not necessarily made prior to white power but in relation to and sometimes in defiance of it.[7] The general historical approach of the Royal British Columbia Museum is linear and synthetic. It tells a story of cultural adaptation, crisis, and conflict on a broad regional scale. History as experienced by specific groups and the contributions of mythic traditions and local political agendas to different historical narratives are subsumed in the overarching sequence. As we shall see, history has a different inflection at the U'mista Cultural Centre.

At the University of British Columbia Museum of Anthropology the objects on display sometimes seem to take second place to Arthur Erickson's building and its clifftop setting—something that cannot be said of the big windowless box in Victoria. Of the four museums, UBC is the only one that begins to do justice to the monumental aspects of Northwest Coast carving and spatial design. The structure provides large and small spaces, but is dominated by its Great Hall, a soaring room whose massive concrete beams recall a traditional big house. But unlike the traditional space, all shadow and flickering firelight, the UBC Great Hall is bathed in daylight, with one towering wall entirely of glass. In this space objects are guaranteed maximal visibility, often from several sides. The printed guide's first sentence announces: "The Museum of Anthropology displays Northwest Coast Indian artifacts in ways that emphasise their visual qualities, treating them as works of fine art."

On entering the museum, one descends a ramp directly into the Great Hall, which contains old totem poles, house posts, boxes, and feast dishes. Among them one discovers two marvelous large sculptures by Bill Reid (the contemporary Haida artist who is a kind of presiding spirit in the museum), a sea wolf with killer whales and a crouching bear. The label for *Bear* reads as follows:

cultural group	Haida
place	Vancouver, B.C.
date	1963
object description	Contemporary carving
A50045	*Bear*
	Carved by Bill Reid
	This sculpture can be gently touched.

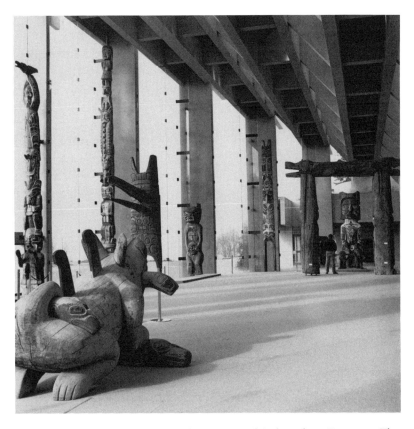

Fig. 14-3. *University of British Columbia Museum of Anthropology, Vancouver. The Great Hall.* Photo by W. McLennan. Reproduced courtesy of the University of British Columbia Museum of Anthropology.

Most labels in the Great Hall, equally terse, include small drawings of the work in its original setting. These unobtrusive, somewhat idealized contexts are designed not to compete with the visual impact of the artifacts. (There are no such drawings of the Reid sculptures, for an obvious reason: their original setting *is* the museum.)

In the Great Hall everything is larger than life, but accessible, translating to some degree the *presence* of these simultaneously monumental and intimate carvings. (At Victoria, the largest old poles are behind glass.) In their original settings the poles, posts, and entryways were often attached to dwellings, and lined public sidewalks. People passed among them every day. The Great Hall, with no glass separat-

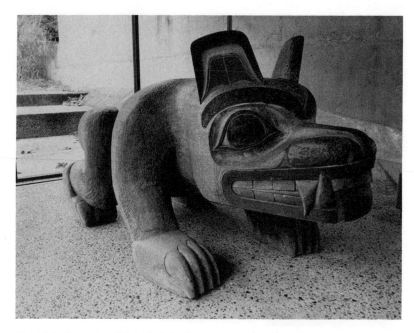

Fig. 14-4. *University of British Columbia Museum of Anthropology, Vancouver.* The Bear, *contemporary carving by Bill Reid.* Photo by W. McLennan. Reproduced courtesy of the University of British Columbia Museum of Anthropology.

ing visitors from the artifacts, with ways to walk around them, and with inviting places to sit nearby, reproduces something of this intimate monumentality.

A certain ambiguity of indoors and outdoors is also created. The Great Hall is designed so that totem poles and houses in the traditional style recently constructed behind the museum are visible from within, becoming part of the display. Two Haida houses and several poles were made between 1958 and 1962 by the Haida artist Bill Reid, helped by the Nimpkish (Kwagiulth) artist Doug Cranmer. (Their cooperation signals the fact that in the emerging general context, and especially in a major urban museum, the category of Northwest Coast art and culture often takes precedence over specificities of clan, language, or village.) Poles by other contemporary artists representing different traditions are scattered on the grounds. The proximity of these new works to the old artifacts gathered behind the wall of glass makes very clear the museum's most important message: tribal works are part of an ongoing, dynamic tradition. The museum displays its

Fig. 14-5. *University of British Columbia Museum of Anthropology, Victoria. In the foreground is a Haida house and totem poles made in 1962 by Bill Reid and Doug Cranmer.* Photo by James Clifford.

works of art as part of an inventive process, not as treasures salvaged from a vanished past.

Leaving the Great Hall, one passes from the monumental to the miniature. The Masterpiece Gallery contains small objects, chosen for their quality of workmanship: carvings in wood, bone, ivory, argillite; curios, combs, pipes, rattles, and jewelry. Again, the mix of old and new portrays traditional art in process. Elaborately engraved bracelets in the trade metals gold and silver by the late nineteenth-century artist Charles Edenshaw are placed beside comparable work by contemporary innovators Bill Reid and Robert Davidson. The gallery is dark; objects are displayed with boutique-style lighting and minimal labels, all emphasizing the message that these are fine-art treasures.

The theater, behind the Masterpiece Gallery, is used for small displays, lectures, film screenings, storytelling sessions, and demonstrations of Native American crafts. It adjoins a small temporary exhibit space and the UBC museum's best-known museographic innovation: its research collections organized as visible storage. Works from various North American native cultures as well as China, Japan, Melanesia, Indonesia, India, and Africa are stored in glass cases or in

drawers that can be freely opened by the public. Extensive documentation on each piece is available in printed volumes. Here the presentation runs opposite to the aestheticizing approach pervasive elsewhere in the museum. Massed, stored objects do not appear as art masterpieces. Instead, taxonomy is featured: a large case of containers holds boxes and baskets of all shapes and sizes from around the world.

The drawers full of small pieces provoke an intimate sense of discovery, the excitement of an attic rather than the staged sublimity of great art. The visible-storage section compensates for the selectivity and minimal explanation of the permanent installation with a surfeit of artifacts and information. What is excluded by the two strategies, an elaborated historical narrative, is signaled by the marginal inclusion of one object, tucked in a corner on the way out of the permanent installation. An angel carved in 1886 by the Tsimshian artist Freddy Alexei for a Methodist baptismal font points to the elaborate story of culture contact, missions, colonization, and resistance that is told in Victoria.

The Royal British Columbia Museum's "black-box" installation creates a dark, wholly interior environment where sequence and viewpoint are controlled for explicitly didactic purposes. The UBC Museum of Anthropology offers a large open space, bathed in light, linked to smaller galleries, and accessible from more than one direction. While there is a preferred general route through the Museum of Anthropology, it is not a linear progress, and the permanent installation's message does not depend significantly on sequential passage. Attention is directed to the individual objects rather than to any narrative in which they are embedded. Developed historical contextualization is largely absent.

One of the indices of a historical approach, in contrast to an aesthetic one, is the systematic use of photographs, particularly in black and white or sepia. (Color photographs signal currency, black-and-white the past.) Historical photographs show the exhibited objects, or objects like them, in use, often including "impure" or "irrelevant" surroundings. Impressive shots of Northwest Coast Indian villages around the turn of the century reveal what are now often considered to be sculptures or artworks attached to and holding up houses. Sometimes a person in suspenders or high button shoes can be seen on the boardwalk. Three of the four museums I am discussing make prominent use of old photos, sometimes dramatically enlarged. The UBC Museum of Anthropology, however, does not display any

Fig. 14-6. *University of British Columbia Museum of Anthropology, Vancouver. Angel carved by Tshimshian artist Freddy Alexei in 1886 for a Methodist baptismal font.* Photo by James Clifford.

photographs at all in its permanent installation. This fact signals its distinctive strategy.

While both the UBC and Victoria museums contextualize tribal objects in multiple ways, the dominant approaches of their permanent installations are strikingly different and complementary, one showing historical, the other aesthetic, process. The latter emphasis at UBC culminates in the rotunda area facing the visible-storage section, a space designed for Bill Reid's monumental carving *Raven and the First Men*, which depicts a Haida creation myth. Video programs document the production of this commissioned masterpiece, as well as the raising of a totem pole by Reid in the Queen Charlotte Islands and Nishga artist Norman Tait teaching young Native Americans to carve a canoe.

Over the past decade, the UBC Museum of Anthropology and the Royal British Columbia Museum have opened their collections and educational programs to Native American artists and cultural activists. Both their permanent and temporary Northwest Coast exhibitions reflect the currency of tribal art, culture, and politics. While the extent of their response is limited and their modes of display and

contextualization do not break sharply with traditional museum prac-
tices, the two museums are unusual in their sensitivity to the vitality
and contestation of the traditions they document.

The Royal British Columbia Museum has for some time encour-
aged Native American artists to use its objects as models and has hired
artists as staff members. It has commissioned new traditional works
and loaned them out for ceremonial use. An open, functioning work-
shop greets visitors on their way into the museum, while the conclu-
sion of the permanent Northwest Coast installation gives historical
depth to current land-claim movements, a struggle spanning more
than a century. The installation ends with a gallery of Haida argillite
carving, explaining the art form's origin in contact with white traders
and its recent revival. After documenting the loss and suppression of
very sophisticated carving techniques and principles of composition,
the exhibit ends with the statement: "Only recently have these prin-
ciples been rediscovered and mastered. Contemporary Haida art is
experiencing an inspired resurgence, and it is hoped that this exhibit
will contribute to its rebirth."

The UBC Museum of Anthropology makes room for work by
prominent twentieth-century artists—Reid and Davidson. In the mu-
seum theater, women from the nearby Musqueam band demonstrate
their revived weaving techniques. Major shows are being planned in
collaboration with Native American artists, and indigenous curators
have been instrumental in past exhibitions.[8] White staff at UBC speak
of moving from a "colonial" to a "cooperative" museology. Whatever
one's feeling about the obstacles to such a transition—the risks of
liberal paternalism, the stubborn custodial power of the museum, an
unwillingness to look critically at the history of specific acquisitions—
it is rare among North American museum professionals to hear such
priorities so clearly articulated.[9]

The Victoria and UBC exhibits show how a sense of cultural and
political process can be introduced into two important current con-
texts for displaying tribal works: the historical and the aesthetic. But
in roughly characterizing the two institutions I have focused on their
permanent installations, both planned in the early seventies, and not
on their more diverse temporary exhibitions or their archival, research,
and outreach activities. In these more flexible areas, we can see a
tendency to multiply explicit interpretive strategies, a trend character-
istic of the changing and contested political context. For example, the
familiar argument in major art and anthropology museums over the
relative value of aesthetic versus scientific, formalist versus culturalist,

presentations seems to be giving way to tactically mixed approaches. Some degree of cultural contextualization is present in all the museums I visited. So is an aesthetic appreciation. Indeed, the most formalistic treatment in my sample occurs in an anthropology museum, with a resulting impression of art as cultural process.

Treatment of artifacts as fine art is currently one of the most effective ways to communicate cross-culturally a sense of quality, meaning, and importance.[10] This need not be done in ways that simply equate non-Western and Western aesthetic criteria. Each of the four museums, with its distinct mix of contextualization and narration, leaves open a possible aesthetic appreciation of the objects on display. Each evokes both local and global meanings for the interpretive categories (or translation devices) of art, culture, politics, and history.[11]

The two tribal museums in my collection suggest another comparative axis. Along this axis, the aesthetics-oriented UBC museum and the history-oriented Victoria museum are more alike than different, both sharing an aspiration to majority status and aiming at a cosmopolitan audience. By contrast, the U'mista Cultural Centre and the Kwagiulth Museum are tribal institutions, aiming at local audiences and enmeshed in local meanings, histories, and traditions.

Speaking schematically, majority museums articulate cosmopolitan culture, science, art, and humanism—often with a national slant. Tribal museums express local culture, oppositional politics, kinship, ethnicity, and tradition. The general characteristics of the majority museum are, I think, pretty well known, since any art or ethnography collection that strives to be important must partake of them: (1) the search for the "best" art or most "authentic" cultural forms; (2) the interest in exemplary or representative objects; (3) the sense of owning a collection that is a treasure for the city, for the national patrimony, and for humanity; and (4) the tendency to separate (fine) art from (ethnographic) culture. (Carol Duncan's paper in this volume on the Louvre as the prototypical national museum provides some of the relevant genealogy.[12]) The majority museum's attitude to what it considers the local museum's "provincialism" and "limited" collection is familiar. The other side appears in a pointed comment about the UBC Museum of Anthropology by a staff member at one of the Kwagiulth tribal centers: "They've got a lot of stuff there, but they don't know much about it."

The tribal museum has different agendas: (1) its stance is to some degree oppositional, with exhibits reflecting excluded experiences, co-

lonial pasts, and current struggles; (2) the art/culture distinction is often irrelevant, or positively subverted; (3) the notion of a unified or linear History (whether of the nation, of humanity, or of art) is challenged by local, community histories; and (4) the collections do not aspire to be included in the patrimony (of the nation, of great art, etc.) but to be inscribed within different traditions and practices, free of national, cosmopolitan patrimonies.

The oppositional predicament of tribal institutions is, however, more complex than this, and here the tribal experiences recall those of other minorities. The tribal or minority museum and artist, while locally based, may also aspire to wider recognition, to a certain national or global participation. Thus a constant tactical movement is required: from margin to center and back again, in and out of dominant contexts, markets, patterns of success. Minority institutions and artists participate in the art-culture system, but with a difference. For example, the U'mista Cultural Centre produces and exploits familiar "museum effects."[13] But as we shall see, it also questions them, historicizing and politicizing positions of viewing. On the one hand, then, no purely local or oppositional stance is possible or desirable for minority institutions. On the other, majority status is resisted, undercut by local, traditional, community attachments and aspirations. The result is a complex, dialectical hybridity (as Tomas Ybarra-Frausto's paper on Chicano art and culture in this volume makes clear). This mix of local and global agendas, of community, national, and international involvements, varies among tribal institutions, as we shall see in the contrast between Cape Mudge Village and Alert Bay.

The Kwagiulth Museum and Cultural Centre is conventional in appearance. Beyond the reception area and gift shop, one large semicircular room with a loft displays traditional artifacts in glass cases, along with carved house posts, a totem pole, and a suspended canoe. Downstairs, a basement room is used for audiovisual presentations and school and community events. The overall aesthetic is modernist— clean-lined, brightly lit, uncluttered. Enlarged historic photographs of the region are distributed along the curving wall. A visitor from the city would not be immediately struck by anything unusual in this museum's style of display.

On closer inspection anomalies appear. The masks in glass cases are labeled with a descriptive phrase or two, sometimes including the information "used in such and such a ceremony." As I pondered the museum's role in a living Native American community the verb's tense

Fig. 14-7. *Kwagiulth Museum and Cultural Centre, Cape Mudge Village. Main gallery.* Photo by James Clifford.

became ambiguous. A question arose about the objects' current cultural or ceremonial use, a question I had never felt obliged to ask when viewing tribal artifacts in a metropolitan museum. Moreover, each label at the museum concludes with the phrase "owned by" and an individual's proper name. Are all the objects on loan to the museum? A question of property, never highlighted in such displays, is raised. In fact, the named owners are individual chiefs. The objects belong to specific families since, traditionally, there is no such thing as tribal property. Their current home in a tribal museum is the result of a political arrangement.

The objects displayed at the Kwagiulth Museum and at the U'mista Cultural Centre were acquired under duress by the Canadian government in 1922 following a major "illegal" potlatch, the largest ever recorded in the region. The potlatch was hosted in late 1921 by Dan Cranmer (a Nimpkish from Alert Bay) in collaboration with his wife, Emma Cranmer, and her family (Mamalillikulla from Village Island, where the potlatch was held), assisted by Chief Billy Assu (a Lekwiltok of Cape Mudge Village). Over six days, Dan Cranmer distributed an impressive collection of goods to a large group of guests participating at the ceremony. Because the potlatch was held in winter at a remote location

(Village Island is now uninhabited), it was hoped that even an occasion of this size could be hidden from the authorities. But the Indian agent at Alert Bay, William Halliday, a former Indian residential-school administrator imbued with civilizing zeal, learned of the event and decided that this would be a good opportunity to eradicate the "primitive," "excessive" potlatches in the region. Mobilizing the Royal Canadian Mounted Police, he had the participants arrested, tried, and condemned to prison.

A deal was then offered. If those condemned and their relatives would formally renounce the potlatch and surrender their regalia—coppers, masks, rattles, whistles, headdresses, blankets, boxes—there would be no imprisonment. Some resisted and served their time. But many, demoralized and fearful that their kin would suffer, gave up the cherished artifacts, a priceless collection of more than 450 items that ended up in major museums in Ottawa and Hull, as well as in the Museum of the American Indian in New York. The authorities offered token payments, amounts bearing no relation to the objects' value in the native economy. (Coppers, for example—highly prized plaques worth many thousands of dollars because of their prestigious histories of exchange—were "bought" for less than fifty dollars.) The punishments and loss of regalia dealt a severe blow to the traditional community: large-scale exchanges disappeared, and ceremonial life and social ties were maintained with difficulty in the face of socioeconomic change and hostility from government, missions, and residential schools.[14]

But the lost treasures were remembered, and with legalization of the potlatch and a general cultural resurgence in the 1950s and 1960s, a movement for repatriation emerged. It was all too clear that the artifacts had been acquired by coercion. Thus after considerable discussion the Museum of Man in Hull (now the Canadian Museum of Civilization) agreed to their repatriation. The Royal Ontario Museum followed suit later. But certain conditions were imposed. The objects could not be given to individual chiefs and families, since it was feared that they would not be properly cared for or would be sold for large sums to private collectors. The regalia had to be housed in a fireproof tribal museum. There was disagreement, however, over where the museum should be built. In the years since 1922, the survivors of the great potlatch and their descendants had gathered in two Kwagiulth communities, Cape Mudge Village and Alert Bay. Eventually, with government and private funding, two museums were built and the repatriated objects divided between them. Family authorities who had

a claim to specific objects decided where they would go. In case of dispute or uncertainty, the regalia was distributed following a principle of equal quantities to each locale.

The two museums are different in many respects: architecture, form of display, local political significance, range of activities and reputation. The U'mista Cultural Centre is part of a larger, more mobilized Kwagiulth community, and the area around Alert Bay is home to a number of widely known Native American artists. The center functions as an artistic and cultural catalyst for the region and is also connected with the wider museum world of Vancouver, Victoria, and beyond. Its director, Gloria Cranmer Webster, daughter of Dan Cranmer, academically trained and an active participant in national and international forums, gives the center an outward-looking dynamism. By contrast, the Kwagiulth Museum and Cultural Centre on Quadra Island has an intimate, somewhat sleepy feel about it. Its cultural activities are more circumscribed and village-centered. It has not, like U'mista, produced widely circulated videos on the suppression of the potlatch or the return of the lost regalia.[15] The Kwagiulth Museum presents its treasured heritage simply, with brief explanations of the pieces' history and traditional meaning. It shows the people they belong to. Here the objects are not cultural property (as in the majority museums) or tribal property (as in the U'mista Cultural Centre) but rather individual (family) property. The objects are displayed in ways that emphasize their specificity and visual appearance. A visitor can, without much distraction, engage them as great art. In its general style of contextualization the Quadra Island museum is compatible with the UBC Museum of Anthropology, though its use of historic photographs adds a different dimension. And unlike either the Royal British Columbia installation or, as we shall see, that of the U'mista Cultural Centre, the display does not subsume individual objects in a larger historical narrative.

Objects here are family and community memorabilia. To an outsider, at least, a great part of their evocative power—beyond their formal, aesthetic values—is the simple fact of their being *here*, in Cape Mudge Village. In a local museum, "here" matters. Either one has traveled to get here, or one already lives here and recognizes an intimate heritage. Of course, every museum is a local museum: the Louvre is Parisian, the Metropolitan a characteristically New York establishment. But while major museums reflect their city and region, they aspire to transcend this specificity, to represent a national, international, or human heritage. At places like Cape Mudge Village and

Alert Bay, the surrounding community and history is inextricably part
of the museum's impact. An outsider wonders about local involvement
with the institution, what it means to band members. In Cape Mudge
Village, kids ride up to the door on bikes: one wonders how often they
go inside (to see a relative working behind the desk?). What do they
think of the contents? What have they been taught about them? Ques-
tions like this do not immediately arise with regard to large metro-
politan museums and their public. (Why? Taking tribal museums se-
riously forces the question. Why is it hard to see majority museums in
terms of the imagined communities they serve and the local knowl-
edges, aspiring to universality, that they express?)

Cape Mudge Village is a relatively prosperous fishing village. The
wooden houses are strung out, one or two deep, facing the water,
reminiscent of the Kwagiulth communities in the old photos. The
museum lines up beside the school, the cemetery, a church. A woman
working in the gift shop responds to my comment about the band
members' reactions to the regalia's return by saying, "Yes, it's nice for
them to have the artifacts nearby." ("Nearby" . . . a daily presence and
feeling of kinship? A message of pride and local control? A remem-
bered history of loss? What are the local meanings of her word
nearby?) This specificity of meanings alters the perceptions of a visitor
accustomed to majority museums' exhibits of tribal art and culture.

I become conscious of the change while in the gift shop of the
Kwagiulth Museum. I notice that postcard photos by Edward Curtis
are for sale there, sepia portraits of Kwagiulth men and women from
the early part of the century. They are all too familiar to me. I know
them from coffee-table books, from calendars (with titles like *Shad-
ows*), from posters on dormitory walls. My first reaction is disappoint-
ment. Have I traveled all the way to Quadra Island to encounter these
well-known, even stereotypic, faces? I know how staged many of the
Curtis portraits are.[16] Perhaps some of these people are wearing the
wigs and costumes he carried with him and used to create a purified
image. In any event I strongly doubt that this man on a postcard—
with a ring through his nose, wearing bark clothing, holding a
copper—appeared that way in everyday life. Picking up a different
postcard I see a color portrait of a man wearing a vest decorated with
buttons and a fur headdress with a carved face inlaid in abalone. On
the back of the postcard the man is identified as "Kwakiutl chief,
Henry George of the Na-Kwa-Tok tribe in a Kla-sa-la (Peace) head
gear at the opening of the Kwakiutl Museum, June 1979." This is not

Fig. 14-8. *Kwagiulth Museum and Cultural Centre, Cape Mudge Village. Two postcards on sale in the gift shop.*

Henry George's everyday appearance. I look again at the Curtis post-
card and turn it over, expecting a caption like the one Curtis gave it:
"Nakoaktok Chief and Copper." That caption appears, in quotation
marks, and is surrounded by other specifications: the Nakoaktok are
identified as Kwakwaka'wakw (Kwakiutl); and the caption continues,
"Hakalaht ('overall'), the head chief, is holding the copper Wamistak-
ila ('takes everything out of the house'). The name of the copper refers
to its great expense, which is valued at five thousand blankets." Hold-
ing the Curtis portrait in Cape Mudge Village, I realize that is repre-
sents an individual, a named ancestor. What the image communicates
here may be quite different from the exoticism and pathos registered
by an audience of strangers.

Later I come across a similar revelation in Ruth Kirk's book, *Tra-
dition and Change on the Northwest Coast*. A Hesquiaht/Nuu-Cha-
Nulth elder, Alice Paul, looks at one of Edward Curtis's most striking
images—a woman, in traditional bark clothing and basket with head-
band, staring out to sea—and sees her mother. Alice Paul's mother
worked in a cannery while her husband shipped out on a sealing schoo-
ner. She was picked by Curtis because she was good at making the nec-
essary bark clothes and baskets quickly. "I always see her picture. . . .
Every time I look at the books, she's there. But they never use her name,
just 'Hesquiaht woman.' But I know her name. It's Virginia Tom."[17]
(Kirk relocates the old image in a narrative of Hesquiaht/Nuu-Cha-
Nulth women's accomplishments, juxtaposed with a contemporary
photo of Virginia Tom's granddaughter, a graduate of the University of
British Columbia's law school. This is emphatically not Curtis's story.)

I'm unexpectedly reminded of Cape Mudge Village in the gift
shop of the UBC Museum of Anthropology. An elderly man and a
teenager are commenting on a catalogue about Musqueam weaving,
searching in it for a picture of the girl's aunt. The Musqueam (Coast
Salish) reserve is just a few kilometers away. They find the picture.
After visiting the Kwagiulth Museum I can no longer forget the ques-
tions of kinship and ownership that must always surround objects,
images, and stories collected from living traditions—questions elided
in majority displays, where family relationships and local history are
subsumed in the patrimony of Art or the synthetic narrative of His-
tory. But what is the ongoing significance of collected objects, images,
and stories for Native American communities? For specific clans?

I'm not suggesting that the local connection is always present or
meaningful, just that I can no longer ignore the issue of ownership and
the history of collecting behind institutions such as the UBC Museum

of Anthropology. Nor can I accept without pause the sweeping Northwest Coast emphasis at either the UBC or Victoria installations. It is true that something important is represented: a regional history and aesthetic achievement in process, on a scale sufficient to contest for importance and power in the national, cosmopolitan milieu of the majority museum. But something is missed: a density of local meanings, memories, reinvented histories.

Revisiting the Museum of Anthropology I recognize local meanings in a temporary show installed in the theater, Proud to be Musqueam.[18] Its opening case contains an enlarged photo of band elders and small children in 1988, a blanket woven by Barbara Cayou in 1987, and a piece of basket three thousand years old. The main exhibit is a sequence of photos documenting the band's history from the late nineteenth century to the present. The exhibit's Musqueam curators, Verna Kenoras and Leila Stogan, consulted with band elders and amassed over 150 photographs. Their selection is displayed chronologically, making sure that each extended family on the reserve is represented. Labels are composed in the first person and individuals in the photos are identified by name and family relation (i.e., "son of," "daughter of"). For a pre-1900 image, the curators write: "We weren't so lucky with this picture because we didn't have the names of any of the ladies. That was really sad." According to museum staff, the exhibit's comment book registers an unusual level of interest from an international public, with reactions often addressed directly to the curators. When it leaves the Museum of Anthropology the exhibit will be housed permanently in the Musqueam Elders' Center.

Photographs and texts also construct history at the entrance to the U'mista Cultural Centre in Alert Bay:

> The Kwagu'l chiefs were discussing the creation of their ancestors while waiting for the second course of a feast given by one of the chiefs of Tsaxis. At first no one spoke for a while. Then Malid spoke, saying, "It is the Sun, our chief, who created our ancestors of all the tribes." And when the others asked him how this was possible, for the Sun never made even one man, the chief was silent. Others said, it is the Mink, Tlisalagi'lakw, who made our first ancestors. Then spoke great-inviter saying, "Listen Kwagu'l, and let me speak a really true word. I see it altogether mistaken what the others say, for it was the Seagull who first became man by taking off his mask and turning into a man. This was the beginning of one of the groups of our tribe. And the others were caused when the Sun, and Grizzly Bear, and

Fig. 14-9. *University of British Columbia Museum of Anthropology, Victoria. Section of the Proud to be Musqueam exhibition, August 1988. Text reads:*

1. *Joe Dan, Howard Grant, May Roberts, Wendy (Sparrow) Grant, Eileen (Charles) Williams. Courtesy of Mr. and Mrs. Vernon Dan. "This is a really nice picture. It's one of my favorites. This is a picture of a confirmation. In a lot of the families they had to go to first communion. Church was a big thing then."*

2. *Bill Guerin, Johnny Sparrow, Andrew Charles. Courtesy the Vancouver Sun. "They were the first elected chief and council at Musqueam and the youngest in Canada. The picture was in the Vancouver Sun."*

3. *Matilda Cole, mother of Ed Sparrow; Lloyd Dan, son of Vernon and Elizabeth Dan; Alice Louie, grandmother of Lloyd and Joe Dan.*

4. *James Point, father of Tony Point and Johnny Sparrow, son of Rose and Ed Sparrow. Courtesy Vancouver Sun. "James Point is signing over the chieftanship. Johnny Sparrow's the next chief. The photo was also in the Vancouver Sun."*

Photo by James Clifford.

Thunderbird also took off their masks. That is the reason that we Kwagu'l are many groups, for each group had its own original ancestor."

A chief visiting from Nawitti disagreed, and the Kwagu'l of all four groups became angry. For the Nawitti believe that the Transformer (or Creator) went about creating the first ancestors of all the tribes from people who already existed. But the chiefs of the Kwagu'l scoffed at this, saying, "Do not say that the Transformer was the creator of all the tribes. Indeed, he just came and did mischief to men, when he made him into a raccoon, land otter, and deer, for he only transformed them into animals. We of the Kwagu'l know that our ancestors were the Seagull, Sun, Grizzly Bear, and Thunderbird."

—Adapted from a discussion recorded by George Hunt, 1903

This text is one of a dozen displayed along the entry corridor, where creation stories are paired with old village photographs (in this case "Tsaxis, Fort Rupert, Kwagu'l," by Edward Dossetter, 1881). The pairings represent each of the principal native communities of the region, whether currently inhabited or not. The impression, as in the text just cited, is of difference and debate, diversity within a shared social and linguistic context (the feast and discussion). Introducing the paired photos and texts, the center's opening statement directly challenges the way these different but related peoples have been identified by outsiders.

Ever since the white people first came to our lands, we have been known as the Kwawkewlths by Indian Affairs or as the Kwakiutl by anthropologists. In fact, we are the Kwakwaka'wakw, people who speak the same language, but who live in different places and have different names for our separate groups.

And introducing the origin stories, the statement ends with a strong claim:

Each group of people on earth has its own story of how it came to be. As Bill Reid says in his Prologue to Indian Art of the Northwest Coast:

"In the world today, there is a commonly held belief that, thousands of years ago, as the world counts time, Mongolian nomads crossed a land bridge to enter the western hemisphere, and became the people now known as the American Indians.

There is, it can be said, some scant evidence to support the myth of the land bridge. But there is an enormous wealth of proof to confirm that the other truths are all valid."

These are some of our truths.

From the outset the U'mista Cultural Centre strikes an oppositional note, highlighting the politics of identity (conflict over the right to name, circumscribe, and essentialize specific groups) and of history (discordant true stories about where a people have come from and are going; the conflict of scientific history and local myth or political genealogy). From the outset, the power to reclaim and recontextualize texts and objects "collected" by outside authorities is demonstrated. Many of the creation stories quoted in the entryway are "adapted from Boas and Hunt, *Kwakiutl Texts*, 1903–6." The gleanings of "salvage ethnography" are recycled, part of a renewed articulation of Kwakwaka'wakw identity and authority.

At the end of the long entry corridor the visitor enters the "Potlatch Collection" in its big-house setting. Here the regalia from Dan Cranmer's great potlatch are displayed around the walls of a large room in the approximate order of their appearance at the ceremony.

Fig. 14-10. *U'mista Cultural Centre, Alert Bay. The potlatch collection along one wall of the big-house gallery.* Photo by James Clifford.

At the door one reads two recollections by elders present at the sur-
render of the objects in 1922.

> And my uncle took me to the Parish Hall, where the chiefs were
> gathered. Odan picked up a rattle and spoke. "We have come to say
> goodbye to our life;" then he began to sing his sacred song. All of the
> chiefs, standing in a circle around their regalia, were weeping, as if
> someone had died.
>
> —James Charles King, Alert Bay 1977

> My father took a large copper, it is still there. He took a large copper
> and paid our way out of gaol. For the white people didn't know that
> it was worth a lot of money. They didn't believe that it was expen-
> sive.
> Every one alive on earth has a story of their people; this is now
> part of our story, that we went to gaol for nothing.
> There was no end to the things that Dan Cranmer did; even if
> people wanted it to end, it will be remembered.
>
> —George Glendale, Alert Bay, Oct. 19, 1975

In the dark big-house room, spotlights illuminate the regalia. The
smell of wood is pervasive. Massive cedar beams and posts support a
high ceiling. The objects on display are bolted to iron stands on raised
platforms against the walls—where at an actual potlatch, the audience
would sit. (As Patrick Houlihan remarks in his article in this section,
sometimes it seems as if the artifacts are observing us.) Two large
doors at the far end of the room can be opened on ceremonial occa-
sions, giving direct access to the beach. While the big house is primar-
ily a museum (there's no smoke hole, and security cameras are
mounted atop the great beams) the room can be used for other pur-
poses. Elders teach young children songs and stories. Dance groups
meet here (one notes a large log for rhythm pounding that is mounted
on casters). And an elaborate Maori carving lying on a bench recalls
a recent trans-Pacific encounter in which a Maori delegation was re-
ceived at the center.

Inside the big-house gallery the atmosphere is intimate; no glass
separates observer from observed. The regalia, massed in a ritual pro-
cession, function as a group with a collective tale to tell. While it is
possible to admire their individual formal properties, aesthetic atten-
tion is interrupted by historical and political discourses. (Indeed, some
critics of the display find that its crowded presentation and lighting

style do not bring out either the objects' formal strengths or the way they would appear at a potlatch, dramatic in the firelight.) Here coppers, masks, and rattles represent a very specific potlatch. Any other uses and meanings the objects may have had for their owners are subsumed (as are their owners' individual names) by the history of Dan Cranmer's ceremony and the regalia's return. *U'mista* is a Kwak'wala term denoting a state of luck or good fortune enjoyed by those captured in war who manage to return home safely.

Visitors to the exhibit learn about the 1921 potlatch, the surrounding climate of repression, and local memories of this history. The information is conveyed by interspersed quotations from oral testimonies and the historical archive. Contrary to a guiding rule of aesthetically oriented presentation, visitors are offered a good deal to read in close proximity to the objects. And in contrast to familiar ethnographic contextualizations, the objects are not specifically labeled or located by function (as they are at the other three museums). Indeed, they are not labeled at all, in the usual referential sense. Instead, large white cards are propped on the platform among the regalia, bearing texts and quotations selected by Kwagiulth community members. The cards include recent reminiscences by elders; quotations from the In-

Fig. 14-11. *U'mista Cultural Centre, Alert Bay. Masks from the potlatch collection with historical texts.* Photo by James Clifford.

dian agent Halliday's reports, paternalistic in tone; descriptions by other agents and missionaries of "heathen" customs; a 1919 petition by chiefs protesting the suppression of the potlatch (they note the economic loss to those possessing important coppers, listed by name and dollar value, and ask to be left alone); a message to Franz Boas from a Kwagiulth chief (essentially, "if you come to change our customs then leave; if not, you're welcome"); a quotation from a 1922 letter by the Chief Inspector of Indian Agencies (pointing out that Dr. Boas is an American; he should mind his own business and not get mixed up with defending potlatches); and so forth. The texts are powerfully evocative: voices from a troubled past that provoke curiosity, admiration, dismay, regret, anger. . . . One of the briefer cards bears quotation in full:

> I am returning to you cheque N. 3799 for $22.00, in favor of Abraham which he refuses to accept for his paraphernalia as he says the sum is absolutely too small for the paraphernalia he surrendered. He wants me to tell you that he would rather give them to you for nothing than accept $22.00 for them.
>
> Most of the other cheques have been paid out to the Indians and while some have thought the price very small, they have accepted them.
>
> —W. M. Halliday, Indian Agent, Kwawkewlth Agency,
> Alert Bay, May 1, 1923.

> With regard to the cheque for $22.00 in favor of Abraham, I am returning it herewith and would ask you to request him to accept this amount. All these articles are now in the museum and the valuation was fixed by officials of that institution.
>
> —Duncan C. Scott, Deputy Superintendent General,
> Dept. of Indian Affairs, Ottawa, May 16, 1923.

Michael Baxandall's article in Part 1 reminds us that labels are not, properly speaking, descriptions of the objects to which they refer. Rather, they are interpretations that serve to open a meaningful space between the object's maker, its exhibitor, and its viewer, with the latter given the task of intentionally, actively, building cultural translations and critical meanings. In the U'mista Cultural Centre's big house the space between label and object has been widened dramatically, thus openly soliciting the viewer's constructive role. No relationship of direct reference remains between text and artifact. Evidence of an

important story about the objects has simply been brought nearby. While reacting to the visually evocative carvings, the visitor pieces together a history. Since the objects' very visibility and presence here is inextricably tangled in that history, they can never be treated as icons of pure art or culture. The display's effect, on me at least, was of powerful storytelling, a practice *implicating* its audience. Here the implication was political and historical. I was not permitted simply to admire or comprehend the regalia. They embarrassed, saddened, inspired, and angered me—responses that emerged in the evocative space between objects and texts.

There are, of course, at least two principal audiences for the exhibit. For local Native Americans the display tells their history from their standpoint, drawing on oral memory as well as archival sources. (The resulting history may be contestable in some particulars by other groups of Kwakwaka'wakw, as we shall see.) Overall, a message of hope and pride is salvaged from tragedy. The simple presence of the regalia in Alert Bay is a sign of cultural resilience and an open-ended future, confirming George Glendale's feeling that "there was no end to the things that Dan Cranmer did." But a casual visitor can only guess at Native American responses. I wonder what effects are felt when the printed cards propped in the big-house gallery are removed? And what about those visitors who have not internalized what Baxandall calls "the museum set"? How does the museum as Kwakwaka'wakw "box of treasures" continue and transform traditional forms of wealth, accumulation, collecting, and display?[19] What stories do these objects tell and retell? I know very little about how this exhibition instructs and implicates a diverse Native American audience. What do they say to each other? What specific tribal authority is displayed here?

For outsiders such as myself and white Canadians of the region, the exhibit tells our history, too. It is a history of colonization and exploitation for which we, to the extent we participate in the dominant culture and an ongoing history of inequality, bear responsibility. We encounter an informing and a shaming discourse. Any purely contemplative stance is challenged by the unsettling mélange of aesthetic, cultural, political, and historical messages. This history forces a sense of location on those who engage with it, contributing to the white person's feeling of being looked at. The historical display at the U'mista Cultural Centre is thus markedly different from the historical installation at the Royal British Columbia Museum in Victoria, which has the sweep, the nonoppositional completeness characteristic of majority History. To identify an object as "used in the potlatch" is not the

same as showing it to be property from a specific potlatch and part of an ongoing cultural struggle. The narratives of (objective) History and (political) genealogy do not coincide.

The difference between the guiding emphasis at UBC (majority, aesthetic) and at U'mista (tribal, historical) should be equally clear. To portray an object as fine art in an ongoing Northwest Coast tradition downplays its role as contested value in a local history of appropriation and reclamation. The objects in the U'mista collection of potlatch items are community treasures, not works of art. But while the two emphases do not coincide, neither do they entirely exclude each other. I have said that one of the most effective current ways to give cross-cultural value (moral and commercial) to a cultural production is to treat it as art. In the temporary galleries following the big-house room at the U'mista Cultural Centre, old and especially new art is displayed, including transitional work from the 1940s and 1950s by master carver Chief Willie Seaweed of Blunden Harbour.[20] (At the UBC Museum, while both old and new art are featured, the historical links between them are downplayed: there is no work by Willie Seaweed or Mungo Martin, a bit by Charles Edenshaw.) All of the art represented at Alert Bay retains a strong historical cast. And it is difficult to separate art from culture in a print of a killer whale by Tony Hunt, which contains a statement of the work's destination for use in a potlatch. In

Fig. 14-12. *U'mista Cultural Centre, Alert Bay. Masks from the potlatch collection.* Photo by James Clifford.

one display area two recent acquisitions are juxtaposed: an old mask and an antique sewing machine, the latter identified as belonging to Mary Ebbets Hunt, Anisalaga, 1823–1919, originally from Alaska and wife of the Hudson's Bay agent in Fort Rupert. Her handsome machine more than holds its own among the artworks while recalling an important lineage. (Mary Ebbets Hunt was the mother of George Hunt, Franz Boas's collaborator and an ancestor of many important Kwagiulth community members.)[21]

The different cultural and political inflections of art and history in Vancouver, Victoria, Cape Mudge Village, and Alert Bay do not preclude overlap and communication. The museums have cooperated during the past decade, sharing curatorial expertise and exhibits. One of my aims in bringing out the strengths and limitations of majority and tribal institutions has been to argue that none can completely cover or control the important meanings and contexts generated by the objects they display. Thus exchange and complementarity, rather than hierarchy, ideally should characterize their institutional relations. Of course, there are real obstacles to such relations: inequities in endowment, prestige, access to funding. But as tribal perspectives gain in national visibility, and as majority collections lose their claim to completeness and universality, it is to be hoped that institutional relationships will reflect the changes.[22]

The emergence of tribal museums and cultural centers makes possible an effective repatriation and circulation of objects long considered to be unambiguously "property" by metropolitan collectors and curators. The idea of majority institutions such as the Canadian Museum of Civilization and the Museum of the American Indian representing Native American cultures to the nation as a whole is increasingly questionable. So is the very existence of elaborate, enormously valuable, noncirculating collections. With better professional communication, with the manifest ability of local communities to do sophisticated, different things with artifacts from their heritage, and with the increased ability of citizens (and research scientists) to visit remote places, even the dominant scientific and political rationales for centralized collections may be questioned on their own terms. A more diverse, interesting, and fair distribution of cultural "property" should be actively encouraged by governmental agencies and private funding sources.

After visiting the U'mista Cultural Centre I found myself reacting impatiently to accounts of protracted negotiations over the fate of the Museum of the American Indian and its cavernous Bronx warehouse

bursting with Native American artifacts, most of which have never been, and may never be, displayed. Should this major, "irreplaceable" collection be attached to the American Museum of National History, subsumed by the Smithsonian Institution, or located in the Customs House in lower Manhattan? Should H. Ross Perrot be allowed to move it to Texas? Does it belong to New York State? Or is it a national treasure that belongs under the Mall in Washington? (Eventually it was decided to create a new museum at the Smithsonian and use the Customs House as an adjunct.) Reading about the many millions of dollars being raised to save the unwieldy collection, I couldn't forget that the Alert Bay and Cape Mudge Village museums must constantly struggle to obtain grants for the most basic operating costs, thus diverting energy from community projects. Several large crumbs from the tables in New York and Washington could support them and dozens of emerging tribal museums. A worse irony: somewhere in the cavernous Bronx warehouse are thirty-three pieces of regalia from the Village Island potlatch. George Heye, the ever-acquisitive architect of the New York collection, bought them from W. M. Halliday in Alert Bay. (A card in the U'mista Cultural Centre display documents this purchase for "an excellent price," remitted to Ottawa. Halliday is reprimanded by his superiors for losing the pieces, for *Canada*.) To date, the Museum of the American Indian has refused to return these last missing regalia.[23]

Having contrasted the majority institutions in my collection with each other and with the tribal centers, it remains to suggest some differences between the two tribal museums. The U'mista Cultural Centre and the Kwagiulth Museum on Quadra Island adopt quite different strategies for displaying their shares of the returned regalia. In Alert Bay the permanent exhibit represents the colonial history of the potlatch and particularly the story of Dan Cranmer's great ceremony of 1921 on Village Island. In Cape Mudge Village, this history is recounted but not featured; the name Cranmer has no prominence. In Alert Bay a dozen or so Kwak'wala-speaking communities and origin stories are invoked, and the Cranmer potlatch story comes to stand for their common colonial history. The home to which the regalia have returned is a broad Kwakwaka'wakw unity-in-differences—a "tribal" unity forged by a common culture and history of alliance, oppression, and collective resistance.

In Cape Mudge Village, the word *Kwagiulth* in the museum's name refers to a broader unity *and* to a limited group of families. The

home to which the objects have been repatriated is a community composed of named chiefs and families with continuous claims to specific objects. In his recently published memoir, Chief Harry Assu of Cape Mudge Village (a Lekwiltok) expresses the two agendas:

> Here at Cape Mudge we set up the Nuyumbalees Society to get a museum going and bring back the potlatch regalia. We chose the name Kwagiulth Museum because we wanted it to be for all our people not just our Lekwiltok tribe. At Cape Mudge we are located where all people can easily call on their way down from our northern villages to the city—Victoria or Vancouver. It's a good place for getting together. Nuyumbalees means "the beginning of all legends." The legends are the history of our families. That is why our chiefs show our dances in the potlatch, so that our legends are passed on to the people.[24]

Harry Assu portrays the museum as primarily a place of gathering and display of family histories within a diverse larger unity now denoted by the term *Kwagiulth*. Objects in the returned collection are linked to empowering family stories; they are shown in a manner analogous to the way dances are performed in the potlatch.[25] The audience for the museum is Kwagiulth, and the institution is conceived within a distinct idiom and practice of ownership, rights, and display. The museum institution, imposed as a condition of repatriation, has been reconceived in traditional Kwagiulth terms. Harry Assu continues:

> It has all worked out pretty well. All our stuff that was brought back from Ottawa is in glass cases in the museum according to the family that owns them. That's what the masks and other things mean to us: family ownership. We are proud of that! It tells our family rights to the people. With our people you don't talk about what rights and dances you've got; you call the people and show them in the potlatch.[26]

The museum speaks *for* family rights *to* the (Kwagiulth) people. It does not foreground the different goals of speaking *for* all the Kwagiulth *to* each other and *to* a nontribal audience. The museum's primary role, in Chief Assu's account, is the expression of local family pride and rights—in objects, stories, dances, political authority. This is the prime significance of the exhibition design organized by family ownership.

Similar family claims exist in Alert Bay, but they are not featured in the U'mista display. Reflecting the fact that after sixty years there are conflicts over proper family attribution (not everyone agrees with all the Kwagiulth Museum's labels), the U'mista Cultural Centre asserts ownership at a broader level: the objects appear in the museum as treasures and historical witnesses for the Kwakwaka'wakw. In effect, the U'mista Cultural Centre aspires to a kind of majority status within the dispersed but emerging tribal unity formerly called Southern Kwakiutl.

Perhaps we can distinguish cosmopolitan and local emphases within the shared spectrum of tribal institutions, emphases that suggest somewhat different audiences, aspirations, and politics. The U'mista Cultural Centre is both a community center (with oral-history, language, video, and education programs) and an outward-looking institution (producer of programs for wide distribution, collaborator with majority museums on traveling shows, etc.) The U'mista Society shares the aims of the Cape Mudge Nuyumbalees Society in its capacity as community catalyst and as site of storage and display for objects and histories of tribal power and significance. It also acts in the wider world of museums. For example, its tenth-anniversary exhibit on the crucial work of Mungo Martin during the worst decades of oppression will travel to Cape Mudge Village, Victoria, and UBC, as well as several other museums in Canada and possibly the United States. Gloria Cranmer Webster, as center director, has a background of collaboration with majority institutions in Victoria and with UBC.[27] And the center involves prominent local artists, notably Hunts and Cranmers, whose audiences reach well beyond Vancouver Island.

The U'mista Cultural Centre also appropriates majority anthropological tradition. Franz Boas, the white authority who put "Kwakiutl" on the social-scientific map, figures as a kind of house anthropologist. His collected Kwakiutl texts are adapted and quoted; he emerges as an ally in the potlatch exhibit. A "family" tie runs through Boas's ethnographic collaborator, George Hunt, grandfather of the important Kwagiulth artist Henry Hunt, many of whose family now live and work in Alert Bay and nearby Fort Rupert. In 1986 the U'mista Cultural Centre organized a reunion attended by thirty-four members of the Boas family, including Franz Boas's daughter Franziska, and many Hunt descendants. Among the gifts exchanged were copies of correspondence between George Hunt and Franz Boas. Pursuing these Boas contacts, the center has tracked down early recordings of local songs, currently held in remote places such as Washington, D.C., and Indiana.[28] Salvage anthropology is repatriated.

The Quadra Island museum does not range as widely. It does not surround its collection with Kwakwaka'wakw art, history and myth, thus reclaiming in a new context the scope of Boas's "Kwakiutl" culture. Its aims are more modest and even, in certain areas, implicitly critical of the U'mista agenda. The fact that Dan Cranmer's potlatch is highlighted in a museum directed by his daughter cannot be politically neutral. Indeed, authorities from other Kwagiulth families have taken somewhat different views of the Village Island potlatch, its animating personalities, and its continuing significance. The leading role of the Cranmers, Hunts, and the U'mista Cultural Centre has not gone unquestioned.

At the end of the potlatch sequence in Alert Bay we read the following testimony:

> When he came home your father (Dan Cranmer) was dressed like this, bare feet in his shoes. He gave away everything. He did everything at once, to make us proud. At one time, to do all the different great things among our people. Others did one thing at a time; he was the only one who did it all at one time, because his wife was a wise woman.
>
> —Agnes Alfred, Alert Bay 1975

The praise for Dan Cranmer is complicated by a final phrase giving credit to his wife. The phrase, enigmatic to an outsider, is elaborated in a book by Agnes Alfred's granddaughter, Daisy (My-yah-nelth) Sewid Smith, *Prosecution or Persecution*, published in connection with the opening of the Kwagiulth Museum and Cultural Centre in 1979. The book, which contains recorded memories of their imprisonment by potlatch participants Agnes Alfred and Herbert Martin, portrays the Village Island ceremony as collaborative work by three families, the Cranmers (Nimpkish) of Alert Bay, the Mamalillikulla nobility of Village Island, and Chief Billy Assu, a Lekwiltok of Cape Mudge Village. Daisy Sewid Smith's account gives the initiating role in the affair to Dan Cranmer's wife, Emma Cranmer, and her family. A large quantity of goods and money was gathered by Emma Cranmer's relatives and Billy Assu to facilitate Dan Cranmer's marriage repayments. Cranmer also received help from his own family (Agnes Alfred and others) to make possible the great giveaway. In Daisy Sewid Smith's version of the Village Island ceremony, Dan Cranmer appears as a central participant in a collaborative event, not as its leader. Her account brings into prominence the organizing role of Emma Cranmer

and her sense of deep responsibility and guilt for those who went to prison. (She was spared, since her Nimpkish family-by-marriage surrendered their regalia.)

According to Daisy Sewid Smith, her father, Chief James Sewid, initiated the repatriation process. He insisted that Ottawa should "remember that these artifacts belonged to individual Chiefs, not the tribe, and no one had the right to speak for it." A committee of elders representing the families principally involved decided that the required museum should be built at Cape Mudge Village. "Later certain members of the Nimpkish Band changed this and wanted it to be in Alert Bay. So it was decided to have two museums and that each family decide where they wanted their artifacts displayed."[29] The division of the artifacts in two museums was not accomplished without disagreement over the proper way to commemorate the Village Island potlatch and to display its regalia. *Prosecution or Persecution* counterbalances any appearance of Nimpkish prominence.

I have mentioned briefly the family histories active in the aftermath of the great potlatch and in the creation of the two museums. My intention in opening up issues I can only begin to understand is not to assert the truth of one version of events over another, or the authenticity of one museum relative to the other; I want simply to make visible to outsiders the complexity that is hidden behind words such as *local*, *tribal*, and *community*. For it is too easy to speak about "local history," "the tribe," or "the community" as if these were not differently interpreted and often contested. We need to keep in mind the constitutive disagreement featured in the Kwagiulth creation story quoted above—emblematic of a vital diversity within a shared culture and history.[30]

It would be wrong, indeed, to overstate the rivalries. The communities formerly called Southern Kwakiutl are united by a strong sense of common history, culture, kinship, and ongoing oppression. The sense of a broader Kwakwaka'wakw identity represented at the U'mista Cultural Centre is a strong reality. And wider still, the domain of Northwest Coast culture and cooperation is itself an important tribal force. (A painting by Bill Reid is displayed at the U'mista Cultural Centre; the Nimpkish Doug Cranmer worked with the Haida Bill Reid on the houses and poles behind the UBC Museum of Anthropology.) At an even more global level the alliances of postcolonial and "fourth-world" politics impinge. The name of a women's video crew at the U'mista Cultural Centre, the Salmonistas, puns on *salmon* and *Sandinista*, in reference to Alert Bay's sister relationship with a Nica-

raguan fishing village. There are plans for a Kwagiulth visit to New Zealand, answering the recent Maori delegation.

I returned from British Columbia with a more complex sense of distinct, but interrelated, contexts for displaying and circulating Northwest Coast artifacts. Each of the four museums is caught up in a postcolonial situation of shifting power relations and competing articulations of local and global meanings. Tribal identity and power have always been fashioned through alliances, debates, and exchanges—between local communities and, since the mid-nineteenth century, with intrusive whites. These processes continue in contemporary cultural life. And as institutions such as the two Kwagiulth centers gain in visibility, escaping a merely local or minor status, they challenge the global visions embodied in the major collections. Simultaneously they function as cultural centers, sites for community education, mobilization, and the continuity of tradition. Majority museums, cosmopolitan institutions for telling inclusive stories about art and culture, begin to appear as more limited national institutions, rooted in specific metropolitan centers. These "centers" are themselves the products of powerful cultures and histories, now contested and decentered by other cultures and histories. The effects of this decentering are beginning to be felt in the major museums of Victoria and Vancouver. How much they respond and how quickly remains to be seen.

On the Northwest Coast, as elsewhere, the economies and institutions of the modern nation-state have systematically exploited, repressed, and marginalized the traditional cultures of native peoples. An unequal struggle over economic, cultural, and political power goes on, continuous in many respects from the days of Dan Cranmer's potlatch of 1921. But at least one thing has changed. It has become widely apparent in the dominant culture that many Native American populations whose cultures were officially declared moribund, who were "converted" to Christianity, whose cultural traditions were "salvaged" in textual collections such as that of Boas and Hunt, whose "authentic" artifacts were massively collected a century ago, have not disappeared. In some parts of their life dramatically changed, in others profoundly connected to tradition and place, these tribal groups continue to resist, reckon with, adapt to, and ignore the claims of the dominant culture. Exploitation—substandard schools, inferior health care, poor job prospects—continues in many places. So does political resistance and the crucial resource of a strong, supple tradition.

On Vancouver Island the potlatch is back; so are most of the regalia confiscated in 1922. But at a price: objects illegally taken were not directly returned to the families that owned them. Rather, a museum, and in the end two museums, were imposed. It is hard to imagine a more Western, metropolitan, elite institution. And yet we have seen that it, too, can be taken over and displaced. Notice, for example, what happens to the word *museum* in a passage by Chief Harry Assu. He is evoking the Kwagiulth Museum's opening ceremony of 1979 (an event similar in spirit to the event inaugurating the U'mista Cultural Centre in 1980—recorded in the center's film, *Box of Treasures*):

> The Spirit of Dancing, referred to as "Klassila," had been imprisoned in Ottawa for many years and was now being released to the Kwagiulth people. The Power of the Spirit was symbolically thrown from ship to shore, where it was "caught" and set the catcher dancing. He in turn hurled the spirit across the beach and through the museum doors. The spirit had entered the ceremonial house (museum).[31]

NOTES

These reflections have benefited from critical readings by a number of individuals, none of whom approve of all I have written. I am very grateful to Michael Ames, Ira Jacknis, Aldona Jonaitis, Nancy Marie Mitchell, Dan Monroe, Dara Culhane Speck, and Gloria Cranmer Webster.

1. The name *Kwakiutl*, familiar in the anthropological literature, is currently disputed as a vague, "tribal" catch-all. The phonetically more accurate term *Kwagiulth* (or *Kwagu'l*) properly denotes only one of many village communities among the peoples formerly called Southern Kwakiutl on northern Vancouver Island and the nearby islets and inlets of the mainland. Recently, the U'mista Cultural Society of Alert Bay has proposed the name *Kwakwaka'wakw* (Those Who Speak Kwak'wala) for the larger group. Current usage is fluid. When I use *Kwagiulth* it refers loosely to native peoples in the regions of Cape Mudge, Alert Bay, and Fort Rupert. Name changes and specifications are occurring throughout Vancouver Island: Hesquiaht, mentioned several times in this essay, is a band in a "tribe" once called Nootka, then Westcoast, and now Nuu-Cha-Nulth.

2. James Clifford, "On Collecting Art and Culture," in *The Predicament of Culture* (Cambridge: Harvard University Press, 1988).

3. Two recent books recount aspects of this history in the context of current resurgence: Celia Haig-Brown, *Resistance and Renewal: Surviving the Indian Residential School* (Vancouver: Tillacum Library, 1988), and Dara Culhane Speck's historical ethnography set in Alert Bay, *An Error in Judgment: The Politics of Medical Care in an Indian/White Community* (Vancouver: Talonbooks, 1987), a remarkable work of engaged analysis.

4. For a sign of the times see the issue of *Muse* (the Journal of the Canadian Museums Association) devoted to "Museums and the First Nations" (6, no. 3 [Fall 1988]). The Lubicon Cree boycott of The Spirit Sings: Artistic Traditions of Canada's First Peoples, a 1988 exhibition at the Glenbow Museum, Calgary, had just sent ripples through the Canadian museum world. For a report on the situation around Vancouver see Michael Kimmelman, "Erasing the Line Between Art and Artifact," *New York Times*, 1 May 1989, B1.

5. If at times I have stressed the oppositional entanglement of the tribal museums, I do not claim that their *essence* is oppositional. Moreover, I have largely avoided calling them minority institutions, though they share characteristics with other locally or ethnically based cultural centers. Tribal status is fortified by an aboriginal claim that "we were here first," before the existence of any multicultural nation, "mosaic," or "melting pot" to contest or enrich. While living tribal institutions must function within (and against) dominant national orders, they also draw on autonomous sources of tradition, power, and identity. The opposition *majority/tribal* that organizes some of my comparisons cannot be reduced to *majority/minority*. (Particular thanks to Nancy Marie Mitchell who, with several others, pressed me to clarify these issues.)

6. A contrasting example is the Margaret Mead Hall of Pacific Peoples at the American Museum of Natural History. See Clifford, "On Collecting Art and Culture," 201–2, for a critique.

7. The relational approach does not go as far as a new installation at the Rochester (New York) Museum and Science Center called At the Western Door. Here the guiding principle is to focus on cultural exchange between Seneca and European society from contact to the present. At every point both white and Native American histories are on display. I am grateful to Margaret Blackman for a slide presentation on the exhibit.

8. See, for example, Doreen Jensen and Polly Sargent, *Robes of Power: Totem Poles on Cloth* (Vancouver: University of British Columbia Museum of Anthropology and University of British Columbia Press, 1986), the catalogue of an impressive exhibition on button blankets, covering mythology, written and oral history, design, and current production. The catalogue is predominantly composed of blanket makers' statements and reflects in its ordering the sequence of a potlatch.

9. Michael Ames, director of the UBC Museum of Anthropology, has forth-rightly articulated the institution's evolving, sometimes difficult and contra-dictory position. He has pressed consistently within the Canadian museum establishment for increased responsiveness to Native American concerns, and has sought to articulate compromises between the traditional role of major museums and the growing politicization of their activities. See, for example, Michael Ames, *Museums, the Public, and Anthropology: A Study in the An-thropology of Anthropology* (Vancouver: University of British Columbia Press, 1986), and Michael Ames, "Free Indians from their Ethnological Fate: The Emergence of the Indian Point of View in Exhibitions of Indians," *Muse* 5, no. 2 (Summer 1987). Ames has also defended the curatorial autonomy of museums in the face of strong, interventionist political pressure—as in the recent controversy over the Spirit Sings exhibition. See his intervention in *Muse* 6, no. 3 (Fall 1988). A cooperative museology presumes some real sharing of curatorial control, beyond simple consultancies. A current example is the large exhibit on the potlatch, Chiefly Feasts, planned for the American Museum of Natural History by Aldona Jonaitis, for which Gloria Cranmer Webster is curating the modern section.

10. Western appreciation (appropriation) of tribal objects as "fine art" dates most importantly from the modernist primitivism of Picasso and his genera-tion. (See William Rubin, ed., *"Primitivism" in Twentieth-Century Art: Af-finity of the Tribal and the Modern*, 2 vols. [New York: Museum of Modern Art, 1984].) However controversial this appreciation has been, the institution of tribal "art" is currently an important source of native power—and revenue.

11. On *art* as a translation device, both communicating and hiding meaning, see Brian Wallis's interview with James Clifford in "The Global Issue: A Symposium," *Art in America* 77, no. 7 (July 1989), 86–87, 152–53.

12. See also Donald Horne, *The Great Museum: The Re-presentation of His-tory* (London and Sydney: Pluto Press, 1984); and Annie E. Coombes, "Mu-seums and the Formation of National and Cultural Identities," *Oxford Art Journal* 11, no. 2 (1988), 57–68.

13. See Svetlana Alpers's article in this volume.

14. On the Cranmer potlatch, see Daisy (My-yah-nelth) Sewid Smith, *Pros-ecution or Persecution* (Cape Mudge: Nuyumbalees Society, 1979), and Douglas Cole, *Captured Heritage* (Vancouver: Douglas and McIntyre, 1985), 249–54.

15. *Potlatch . . . A Strict Law Bids Us Dance* and *Box of Treasures*. Available from the U'mista Cultural Centre, Box 253, Alert Bay, B.C. V0N 1A0, Can-ada.

16. Christopher Lyman, *The Vanishing Race and Other Illusions: Photo-graphs of Indians by Edward Curtis* (New York: Pantheon, 1982); Bill Holm

and George Irving Quimby, *Edward S. Curtis in the Land of the War Canoes: A Pioneer Cinematographer in the Pacific Northwest* (Seattle: University of Washington Press, 1980).

17. As told to Ruth Kirk, in *Tradition and Change on the Northwest Coast* (Seattle: University of Washington Press, 1986), 15. For an account of similar encounters with old photos (in this case research collections from the Lowie Museum at the University of California, Berkeley, becoming family history for California Pomo Indians), see Malcolm Margolin, "California Indian Library Collections," *News from Native California* 3, no. 3 (Spring 1989), 7–8.

18. The museum had already collaborated with the Musqueam to display their (recently revived) weaving. See Elizabeth Lominska Johnson and Kathryn Bernick, *Hands of Our Ancestors* (Vancouver: University of British Columbia Museum of Anthropology, 1986).

19. On the "museum set," see Michael Baxandall's contribution in Part 1 of this volume. The U'mista Cultural Centre's video on the potlatch collection's return (to Alert Bay only) is titled, after an elder's comment on the museum, *Box of Treasures*. The categories of treasure and work of art overlap, but do not coincide. "The Storage Box of Tradition" is Ira Jacknis's title for his doctoral dissertation, subtitled "Museums, Anthropology and Kwakiutl Art: 1881–1981" (University of Chicago, 1988). Jacknis writes in his abstract: "The 'storage box of tradition' is an appropriate and resonant Kwakiutl idiom for a museum. Boxes were central to the Northwest Coast emphasis on ranking and the accumulation of wealth, and they were regarded as receptacles, concretely, for inherited artifacts, and, metaphorically, for the transmission of ancestral privileges. The box idiom was used in potlatch oratory to stress the preservation of customs, Boas employed the phrase in trying to explain his work with George Hunt to the Kwakiutl, and it has also been used by contemporary Kwakiutl to refer to their native cultural center" (p. 3). Jacknis's important thesis, which goes into historical depth on many of the issues treated in this essay, is scheduled for publication in 1991 by Smithsonian Institution Press.

20. See the important study by Bill Holm, *Smoky-Top: The Art and Times of Willie Seaweed* (Seattle: University of Washington Press, 1983).

21. The only other sewing machines I saw on display were in the Royal British Columbia installation, where two antique models turned up in a case illustrating the varieties of wealth typically distributed at potlatches: masks, rattles, coppers, crockery, coffeepots, blankets, etc. The sewing machines make different statements in the cultural history traced at Victoria and the political and familial genealogy told at Alert Bay.

22. For a sensitive presentation of the (California) Hoopa Tribal Museum and a persuasive argument for both the profound differences and possibilities for

cooperation between tribal and majority (university) museums, see Lee Davis, "Locating the Live Museum," *News from Native California* 4, no. 1 (Fall 1989), 4–9.

23. See Gloria Cranmer Webster, "The 'R' Word," *Muse* 6, no. 3 (Fall 1988), 43–46.

24. Harry Assu, with Joy Inglis, *Assu of Cape Mudge: Recollections of a Coastal Indian Chief* (Vancouver: University of British Columbia Press, 1989), 106.

25. For an account of how Northwest Coast objects in a Western museum setting were translated by native (Tlingit) elders into powerful mythic, historical, and political stories and performances, see Brian Wallis's interview with James Clifford in "The Global Issue: A Symposium," *Art in America* 77, no. 7 (July 1989), 86–87, 152–53. The elders' performances as consultants to a reinstallation project called deeply into question the classification of traditional masks, rattles, drums, etc. as "objects" (art or artifact).

26. Assu, *Assu of Cape Mudge,* 106.

27. For example, she helped identify and commission contemporary art for the pioneering show and catalogue produced by the Royal British Columbia Museum (see Peter Macnair, Alan Hoover, and Kevin Neary, *The Legacy* [Vancouver: Douglas and McIntyre, 1984]).

28. *U'mista Cultural Centre Newsletter,* Alert Bay, April 1987.

29. Smith, *Prosecution or Persecution,* 3. See also Assu, *Assu of Cape Mudge,* 104–9, for another account reflecting Cape Mudge's role in the repatriation process. The view from Alert Bay counters that, from the beginning of the repatriation movement, many with legitimate claims on the regalia had wanted the museum in Alert Bay. Moreover, the owners of returned regalia were, predominantly, not members of bands from the Cape Mudge area. Most of those in the area with valid claims on parts of the potlatch collection, such as Chief James Sewid (originally from Village Island and a relative of Emma Cranmer), had migrated to central Vancouver Island from the Alert Bay region only in recent decades. The argument about locating the museum was complicated by counterclaims concerning ownership, sixty years of intermarriage, and migration toward new centers of tribal and economic power.

30. On the somewhat legendary Kwagiulth penchant for diversity and argument: "Anthropology still has a picture of traditional society as based on common consent. The Durkheimian concept of the mechanical society, in which everything and everyone works together to uphold the status quo, is still with us. It would be truer to say of Kwakiutl society that it was based on common dissent. Every member was carefully trained to be able to decide for himself. He was trained to 'look through' the symbolic structures he had

accepted in childhood to their meaning. Seeing that they were not given but man-made he learnt to use them creatively, becoming, in his time, a maker for others." Susan Reid, "Four Kwakiutl Themes on Isolation," in Donald N. Abbot, ed., *The World is as Sharp as a Knife: An Anthology in Honor of Wilson Duff* (Victoria: British Columbia Provincial Museum, 1981), 250. (Thanks to Dara Culhane Speck for pointing out this quotation.)

31. Assu, *Assu of Cape Mudge*, 127–28, 3.

CHAPTER 15

Why Museums
Make Me Sad

JAMES A. BOON

The museum, twentieth-century parody of a temple, is all that we
have, physically, of the past; and Joyce begins *Finnegans Wake* in a
museum. GUY DAVENPORT (1981)

The essential present character of the most melancholy of cities re-
sides simply in [Venice's] being the most beautiful of tombs. No-
where else has the past been laid to rest with such tenderness, such
a sadness of resignation and remembrance. Nowhere else is the
present so alien, so discontinuous, so like a crowd in a cemetery
without garlands for the graves. . . . The shopkeepers and gondo-
liers, the beggars and the models . . . are the custodians and the
ushers of the great museum—they are even themselves to a certain
extent the objects of exhibition. It is in the wide vestibule of the
square that the polyglot pilgrims gather most densely; Piazza San
Marco is the lobby of the opera in the intervals of the performance.
The present fortune of Venice, the lamentable difference, is most
easily measured there, and that is why, in the effort to resist our
pessimism, we must turn away both from the purchasers and from
the vendors of *ricordi*. HENRY JAMES (1892)

Any museum, any museum at all, makes me sad. Ethnological muse-
ums, art museums, ethnic museums, museums of these museums. Per-
manent museums, traveling museums, museums as travel; museums in
the rough or on the mall. Literal museums, and figurative: without
walls (ambiguous and permeable, anyway), or with. Williamsburg.
Books read as a museum (some of them designed to be, some not);
rituals enacted as a museum. Cities. Experience itself as museum: a
play of context-begging specimens, oddly captioned, regarded *de loin*

255

or à proche even by the one doing the experiencing. "Cultures." Museums are a locus of dislocated fragments, displayed in-coincidently with the motives of their production, revalued along other lines of exchange or schemes of competition, and not necessarily secondarily.

Museums perhaps make me sad because of what they reveal about representation—a sadness savoring resignation to the museumlikeness (perhaps even museuminess) of what the museum would on first thought appear to be a museum of. If there is no of to museums—only more museum: representations without immediate reference, makings for-the-removal—then that must be what makes me sad. Sad, or melancholy.

Yes, melancholy, like the perpetrator of that ultimate museum-book, so resembling and reassembling of the world, the museum-world of fragments: fragments wrested from their pasts and elsewheres to be exhibited and categorized, only to yield instead, through their juxtaposition, aphorisms of coincidence:

> The Anatomy looks like a crude assembly of quotations and it is indeed a vast mobilization of the notions and expressions of others, yet it is not they but the rifler who is revealed. Books are his raw material. . . . Burton makes a cosmos [really, a museum] out of quotations. He raids the writings of the past, which he often finds neglected or in ruins, and reassembles them in a structure of his own, much as the ruins of Rome were pillaged by the builders of the Renaissance and worked into the temples and palaces of a new civilization.[1]

The same quality of pillage attaches not just to the new Musée d'Orsay, the renewed Museum of Modern Art, and the old and new and in-between Smithsonian Institution, but to any old cabinet of curiosities, including the meanest matchbox collection hoarded by would-be Joseph Cornells, or just hoarded. The quality extends even to meditations on and analyses of—whether academic, professional, or casual—these crude assemblies.

Robert Burton's prose, so like a museum, was produced just when cabinets of curiosities were coming into fashion, like libraries before them, in the country houses of readers for whom Burton—that "squirrel-like collector of innumerable good things to learn" and "English importer of the world's wisdom"[2]—wrote. His collected quotations and commentaries both mimicked such cabinets and catalogued their exquisite rarities and varieties of pieces of men, birds, and beasts.

Burton rifled to a degree that smacks of parody, anticipating those satires of maniacal collecting by his successors. By 1676, for example, Thomas Shadwell's play, *The Virtuoso*,

> centers round the ridiculous exploits of the virtuoso himself, Sir Nicholas Gimcrack. . . . In 1710 Addison amused himself and his readers by making up Gimcrack's will, and publishing it in the Tatler. It was full of absurd legacies: one box of butterflies, a female skeleton and a dried cocatrice to his wife; "my receipt for preserving dead caterpillars" and "three crocodiles eggs" to his daughters; "my rat's testicles" to his "learned and worthy friend Dr. Johannes Elscirckius."[3]

No curator, or for that matter no enthusiast of museumgoing, could fail to blush when confronting such merry lists of outright obsessions. The other side of sadness is satiety, of melancholy mirth.

Those ruins of Rome likened above (in my collected quotation about Robert Burton) to *The Anatomy of Melancholy*'s raw materials (really oft-cooked quotations) were also pillaged by creators of the "first public museum." Or so I heard it explained in a wonderful lecture in 1974, which was aimed at rekindling the spirit of Erwin Panofsky at Princeton. I keep forgetting the distinguished art historian's name, emeritus even then, and have never traced the published version. But his hearty quest of iconographic evidence remains—fifteen years later, forgetfulness having accomplished its task—lodged in my museum-mind of fragmentary recall or invention; indeed, from the present vantage he seems to have altered my view of the very nature of art history, ethnographic activity, other cultures, and motives of museumgoing.

That "first public museum," the brainchild of agents of an early-Renaissance pope, assembled in one place various classical statues and fragments removed from their previous medieval reinstallations. The lecture's punch line of convergent detective work speculated on pitmarks marring the renowned "boy pulling the thorn from his foot." Might these scars result from the fact that the figure, which earlier adorned (Middle Ages–fashion) a column at a pilgrimage site, had been stoned and pelted by the faithful, whose lower vantage made him appear a representation of onanism (you have to picture it)? Did, then, a medieval reinstallation of Roman ruins, subsequently re-reinstalled into a Renaissance collection, inadvertently display traces of prior use, trails of earlier activities of misapprehending museumgoers?

Rome pillaged pillagers and was pillaged in turn, and not only by the Renaissance. My own fate of sadness, or museumy melancholy-mirth, seems now sealed by that lecture long ago, or before, and keeps being reconfirmed in museums, in lectures about museums, in collections about museum collections, and in books about these, including the one at hand. Pillage pillaged, and sure to be pillaged again. That may be what museums, museumgoing, remembering museumgoing, and writing of all three (afterward, in process, and in anticipation) are all about. These experiences help us ponder whether pillage isn't and wasn't our original, irreducible condition, and whether production possibly occurs in anticipation of inevitable plunder as much as hoped-for retention.

Such brooding is heightened in ethnographic museums, colonialist museums, and imperialist museums—indeed in any collection that arranges booty of conquest and expansion.[4] The many varieties of such spoils—"mobilizing the notions and expressions of others"—since the Age of Discovery include: sixteenth-century "fardles of fashion" that arranged monstrosities and curiosities according to Neoplatonist rhetorics of affinities and antipathies, conventions shared with apothecaries, *anatomies moralisées*, and hosts of alchemical and related worlds;[5] the triumph of Linnaean principles of classification, which, when harnessed to natural theology, Victorian piety, and bourgeois ethics of leisure, culminated in the "heydey of natural history";[6] our own museums that descend from both the post-Napoleonic impulse of "omnium gatherum," resulting in world expositions, and its more ludic counterpart of Barnumesque humbug and ballyhoo (see below). But the same quality of pillaging marks, contrapuntally, the devices displayed by ethnic, regional, or otherwise antinationalist museums that declare their aim to be the resistance of expropriation. In either case, I aver, museums became and remain places to convene with a historical and cultural muse of exponential plunder with its distanced classifications, exaggerations, captionings and codifyings, and exercises of visualization, making-visible, and fractured commentary.[7] Through such devices and spoils viewers progress, viewingly.

We all of us have our favorite instances of "bearded-lady" catalogues from those odd museums past, whose oddness may stem from their striking continuity with odd museums of the present. One long-ago and nowaday museum that makes me mirthful and mournful was the Brighton Aquarium, which exceeded its professed raison d'être (the new fashion and technology of displaying marine life) by mount-

ing an ethnological extravaganza that anticipated the Crystal Palace's unintentional representation of British colonial transgressions.[8] Brighton indeed both repeated and adumbrated all the midways of strange-but-true cultures before and since in places such as Peale's Philadelphia, Boas's Chicago, and all-America's Washington, D.C.:

> By the 1850s the attractions advertised at Brighton Aquarium consisted of giants, midgets, Zulu chieftains, Javanese temple dancers, and Dame Adelina Patti. No hint of "Piscatorial Science." Westminster was given over to Laplanders, human cannonballs, and Benedetti the sword-swallower, and every other aquarium had made similar adjustments or else closed down.[9]

Although Peale's Museum had first brought the spectacular and mis-nomered mammoth to the City of Brotherly Love, it failed to make sufficient adjustments of the kind devised at Brighton, particularly given (in Philadelphia's case) competition from the likes of P. T. Barnum's Grand Colossal Museum and Greatest Show on Earth.[10] Peale's thus closed by 1845, leaving the field open for the Smithsonian's future eminence. And the Smithsonian—who would deny it?—has also survived by juggling so-called science and so-called entertainment.

I draw here on childhood memories of storied Smithsonian exhibitions—retailed among prepubescent youths. (We biked over woodland trails maintained by the Mariner's Museum before the latter charged even the quarter admission later levied—today it costs abundantly more and sports a postmodern entrance pavilion—or replaced a Coke machine that often coughed back more change than it accepted. Such features meant much to boys then.) I also draw on two years' employment with the Smithsonian Institution's Center for the Study of Man, in the National Museum of Natural History, between 1969 and 1971. Those sad and unforgettable years contained some mirth produced by the early folklife performance festivals, plus much melancholy from protests then pitting against each other unlikely antagonists—willing and unwilling. Painful dilemmas surfaced in the interstices of public purposes, when history was trying to become young again. One that sticks in my museum-memory is represented by a lone guard in the then–Museum of History and Technology (wasn't it?). True to his charge, this modest and congenial individual—a worker who, unlike curators, could not easily be confused with a "power establishment"—tried to preserve order from an assault on the men's room by a band of flower child–looking females who must have

appeared, from his vantage, to be marauding. Galvanized perhaps by Disneyland-length lines blockading access to their (to him, only) rightful place, their only motive—I observed from the near distance—was to liberate unoccupied facilities for their biological relief. In every respect of rights for the dispossessed *his* political interests lay with theirs. But he could countenance neither contradictions of gender distinctions in certain unmentionable areas nor transgressions of his sanctum's regulations. The horde turned on him; it was not a pretty sight or sound; and in that instant, along with several more consequential upendings in 1969–71, the Smithsonian ceased cataloguing history and entered it. But to remark as much is to commit a distinction this essay is trying to beg.

I offer this digression and mention related issues treated elsewhere in this book—e.g., different parties' convictions as to what is proper to museums if they are to be relevant—not to decide them. I am echoing neither (or both) praises nor (and) criticisms of either anticurators or curators for: (1) staging carnivals, when presumably they should be advancing rigorous ordering of specimens; or (2) remaining mindlessly scientistic, when presumably they should be appealing to popular enthusiasm, mass demands, or aficionados' peccadillos—depending upon whether the institutions in question live off the backs of taxpayers, cater to the fancies of patrons, or both. Rather, I want to make several interrelated suggestions: that museums necessarily conjoin contradictory desires, including the mature (propertied) and the youthful (less so) and perhaps even the reactionary and the subversive; that classification and captioning have something potentially both ennobling and prurient about them; and that the nature of museumgoing enmeshes the seemingly serious and the apparently voyeuresque. Can anyone, moreover, think longitudinally about a lifetime of personal museum experience or recall diverse motives for entering things museumlike without recognizing the child-man or child-woman or child-something in each of us? This compositeness of motives, then, is another reason why museums—places such as P. T. Barnum's, the Louvre, and everything in between or on either side—make me sad, or melancholy. As they did, but differently, Henry James, autobiographically.

Let me add accordingly to this collection of quotations (including quotations about Burton's collection of quotations) specimens from James's *A Small Boy and Others*—not the celebrated climax of visual-sensual nightmare-ecstasy in the Galerie d'Apollon ("the Louvre being, under a general description, the most peopled of all scenes not less than the most hushed of all temples"), when James, although still

"uncorrectedly juvenile," "happily cross[ed] that bridge over to Style" by suddenly envisioning a "just dimly-descried figure that retreated in terror before my rush and dash . . . my visitant was already but a diminished spot in the long perspective, the tremendous, glorious hall, as I say, over the far-gleaming floor of which, cleared for the occasion of its great line of priceless vitrines down the middle, he sped for *his* life, while a great storm of thunder and lightning played through the deep embrasures of high windows at the right."[11] No, let me not cite that mock (or not) climax and resort instead to the astonishing Section 12, ten extraordinary pages of print stretched from P. T. Barnum's Manhattan to echoes of London's Crystal Palace, ten superlative pages that collapse into a figure of and for reminiscence the entire range of exhibits, exhibitions, and exhibitionism that history has slipped into human experience under the rubric of museum. In such places, by such an attitude, James "refined his gaping habit into a form of creative vision, thus liberating himself from the more paralyzing effects of his estrangement, his 'otherness.' "[12] I select, edit, and boil down—i.e., curate—these not-to-be-missed pages to display for readers' viewing; please linger:

> I turn round again to where I last left myself gaping at the old ricketty bill-board in Fifth Avenue; and am almost as sharply aware as ever of the main source of its spell, the fact that it most often blazed with the rich appeal of Mr. Barnum, whose "lecture-room," attached to the great American Museum, overflowed into posters of all the theatrical bravery disavowed by its title. It was my rueful theory of those days—though tasteful I may call it too as well as rueful—that on all the holidays on which we weren't dragged to the dentist's we attended as a matter of course at Barnum's, that is when we were so happy as to be able to; which, to my own particular consciousness, wasn't every time the case. The case was too often, to my melancholy view, that W[illiam]. J[ames]., quite regularly, on the non-dental Saturdays, repaired to this seat of joy with the easy Albert—*he* at home there and master of the scene to a degree at which neither of us could at the best arrive; he quite moulded, truly, in those years of plasticity, as to the aesthetic bent and the determination of curiosity, I seem to make out, by the general Barnum association and revelation. It was not, I hasten to add, that I too didn't, to the extent of my minor chance, drink at the spring; for how else should I have come by the whole undimmed sense of the connection?—the weary waiting, in the dusty halls of humbug, amid bottled mermaids, "bearded ladies" and chill dioramas, for the lecture-room, the true centre of the seat of joy, to open: vivid in

especial to me is my almost sick wondering of whether I mightn't be rapt away before it did open.[13]

James credits to Barnum's publicity announcements—"in their way marvels of attractive composition . . . bristling from top to toe" with an analytic "synopsis of scenery and incidents" casting its "net of fine meshes"—his "present inability to be superficial about which has given in fact the measure of my contemporary care."[14] That confessed, in a prose that had learned to echo these very effects, James goes on to "question memory as to the living hours themselves" in that "stuffed and dim little hall of audience, smelling of peppermint and orange-peel"; he treats ironically his own involvement in these invocations and recollections, and doubtless the reader's, too:

> The principle of this prolonged arrest, which I insist on prolonging a little further, is doubtless in my instinct to grope for our earliest aesthetic seeds. . . . Is it *that* air of romance that gilds for me then the Barnum background—taking it as a symbol; that makes me resist, to this effect of a passionate adverse loyalty, any impulse to translate into harsh terms any old sordidities and poverties? The Great American Museum, the down-town scenery and aspects at large, and even the up-town improvements on them, as then flourishing?—why, they must have been for the most part of the last meanness: the Barnum picture above all ignoble and awful, its blatant face or frame stuck about with innumerable flags that waved, poor vulgar-sized ensigns, over spurious relics and catchpenny monsters in effigy, to say nothing of the promise within of the still more monstrous and abnormal living—from the total impression of which things we plucked somehow the flower of the ideal.[15]

James's museum-memory runs from such tacky beginnings certain to be transcended (or not) to subsequent outings at Niblo's and then Franconi's; their harlequins and orthodox circuses under tents with Roman chariot-races later struck him as not unlike

> the vaster desolations that gave scope to the Crystal Palace, second of its name since, following—not *passibus aequis*, alas—the London structure of 1851, this enterprise forestalled by a year or two the Paris Palais de l'Industrie of 1855.[16]

James even offers a cure for museumgoers' fatigue: when dragging after his cousins through these courts of edification:

> I remember being very tired and cold and hungry there . . . though
> concomitantly conscious that I was somehow in Europe, since ev-
> erything about me had been "brought over." . . . Headaches quite
> fade in that recovered presence of big European Art embodied in
> Thorwaldsen's enormous Christ and the Disciples, a shining marble
> company arranged in a semicircle of dark maroon walls.[17]

This already-extraordinary quotation becomes even more so
when it fosters suspicions that James could have produced his body of
writing without ever going to Europe (even Venice), just from "expe-
riencing" by way of Barnum's *affiches* or this pseudo–Crystal Palace
(the pseudo squared) that "vast and various and dense" something or
other that "Europe was going to be."

> If this was Europe then Europe was beautiful indeed, and we rose to
> it on the wings of wonder; never were we afterwards to see great
> showy sculpture, in whatever profuse exhibition or of whatever pe-
> riod or school, without some renewal of that charmed Thorwaldsen
> hour, some taste again of the almost sugary or confectionary sweet-
> ness with which the great white images had affected us under their
> supper-table gaslight. The Crystal Palace was vast and various and
> dense, which was what Europe was going to be; it was a deep-down
> jungle of impressions that were somehow challenges.[18]

But to experience how truly subversive James's *Small Boy* be-
comes, visitors to this article should travel to the book itself, which
ultimately traces the origins, or at least the motive power, of James's
representations of Europe to an experience in a museum, and a tawdry
one at that. Yes, visit the book itself, for although its author is no
longer available, he has left a legacy of writing for us to despoil. James,
I assume, would be the last to claim or wish to escape museumy
appropriation or the cycle of relics.

In certain of their aspects—ones savored by James with that charac-
teristic hypersensitivity of self-consciousness that he mastered or
suffered—museums seem virtually designed to jumble, even to reverse,
signs of mature reflection versus those of more juvenile longings—
particularly the "juvenile" longings that adults characteristically
confess.[19] Regardless, what viewers do (even straighter ones than
James)—amidst the exhibitions and other viewers and captions of
museums—is view, and perhaps eavesdrop. I am uncertain that this
"way of seeing" can ever be simply ameliorative. No more so than,

say, opera, theater, politics, ritual, philosophy, or technology. Yet the unwholesome "spectacularity" of museums may be as authentic in its fashion as others. Nor, again, is the phantasmagoria I am calling "museum" exclusively the province of winners, whether Rome, Napoleon, Britannia, Fascists, America overall, or multinational expansionists-exhibitors-exhibitionists—all those political forces rightly critiqued in many of this book's essays. In the wake and eddies of established museum making swirls more museum, not just *salons des refusés* but collections that decontextualize, and differently, the vanquishers, made-seen from the vantage of those vanquished. Here is a striking, sad example:

> If young George III of England needed a crown to be king in 1760 and to sit on the Coronation Stone of Scotland and Ireland, then a twelve-year-old Pomare of Tahiti needed the maro ura to be arii nui, chief, in 1791, and to stand on the robing stone of his marae, that sacred preserve of his titles. . . . His maro ura was a feather wrap . . . parakeet . . . dove . . . man-of-war bird. . . . In the feathers was a history of sovereignty, more mnemonic than hieroglyphic, capable of being read by priests who had the custody of the past. . . . In 1792 William Bligh saw Pomare's maro at Tarahoi near Matavai. When he saw it, he drew it, and in that drawing we have our only relic of it. . . . Bligh saw something else in the maro ura besides Skinner's auburn hair. It was the most famous thing of all. He saw a British red pennant sewn into the body of the girdle, as a lappet or fold of its own. Tarahoi was a Tahitian museum of their contact with the European Stranger. The hair, the skulls, Cook's portrait, the red bunting were cargo. They were Strangers' things remade to Tahitian meanings and kept, as in some archive, as documents of past experiences that were repeatedly read for the history they displayed. They were products of the ethnographic moments between Native and Stranger, interpretations transformed into things and read for their meaning in ritual actions that displayed them and preserved them.[20]

The "othered," then, make museums, too. Needless to add, however, as Dening's account reveals, Pomare enjoyed power; in Tahiti's home factions one might even say he dominated.

Every culture, or more precisely all histories of encounters between self-styled Native and self-styled Stranger, yields products equivalent to the Tahitian relics of "their" skirmishes with the British "them." My anthropological work has pondered such deposits of com-

plex evidence from Bali. Since first doing fieldwork there in 1971, I
have interpreted some of the poetics and politics of representing
Hindu-Bali over a history and actuality of dislocations, borrowings,
countertypings, and ethnologizings by native and non-native alike.[21]

It is not just that all ranks of Hindu-Balinese have made museumy
emblems of "others"—Dutch and British colonials, Muslims, tourists,
anthropologists, all manner of non-Hindu-Balinese—but that they
make distanced representations of each other, or their relevant differ-
ences, as well. Moreover, what we now call Balinese culture has re-
sulted from processes of tradition-inventing[22] and indeed museumifi-
cation in a quite explicit sense. Thus, around 1817 Bali was, famously,
declared an archaeological remain of Java's pre-Islamic past by Sir
Stamford Raffles and approached accordingly by the British during
their brief reign over Holland's East Indies, when Dutch sovereignty
collapsed under Napoleon. Over a century later, in the 1920s, when
Balinese rajas became intent on preserving some autonomy not just
from Dutch but from Javanese dominance, one of them accordingly
hired away from a sultan's employ in Java an impresario of cross-
cultural, interlingual artistic life—Walter Spies—to help enhance the
appeal and international reputation of Hindu-Balinese courtly arts.
This cagey move marked, if not the beginning, certainly the consoli-
dation of Balinese studies as we know them today, including a virtual
cult by diverse outsiders of select lifeways and art forms on an island
of three million or so souls whose basic virtuosity remains wet-rice
cultivation. But even without the explicit and dramatic archaeologiz-
ing, curating, archivizing, philologizing, and "performance-
studifying" of Balinese ideas and practices, the long history of demar-
cating Hindu-Balinese culture (which took a distinctly European turn
only after 1597) is part and parcel of world-historical forces that have
produced convictions that certain places, in certain times, have been or
remain "living museums": Bali, Venice, Switzerland, Bayreuth, Nepal,
Vienna, certain royal courts, and some rural enclaves, to name a few.
Time is too short here to explain why representations of Balinese
culture since 1597, like a Tahitian feather cape, involve sadness and
melancholy, but sometimes mirth, too.[23]

Museums, then, or things or processes museumlike, may be said
to occur whenever viewers (or their equivalent) are guided, not always
willingly, among artifacts, samples, labels, captions, stereotypes, light,
categories, drawings, feathers, skulls, visual murmurs, and (in the case
of museums and zoos and theaters) other goers. Today we exercise our

eyes in as-if viewing much as Baxandall[24] shows that Renaissance artisans exercised their eyes in "voluming" and evaluating. Contemporary, not to mention postmodern, going-viewing—"just looking"—may indeed be a slow-motion way to sample-eye a world of as-if merchandise, not for purchase except in versions, quotations, and reprints offered at journey's end, "in the shop." Museums seem on the one hand to remove sacra from normal commodification; yet on the other hand they have fueled the circulation of simulations in the ages of mechanical and manual reproduction alike. Walter Benjamin's insights alluded to in this collection thus illuminate, beyond world exhibitions, any proclivity to demarcate detachable, visible goods. Museuming, we all become, each of us, little Grandvilles:

> The enthronement of merchandise, with the aura of amusement surrounding it, is the secret theme of Grandville's art. . . . This is clearly distilled in the term *spécialité*—a commodity description coming into use about this time [1798, 1855, 1867, i.e., the years of universal exhibitions] in the luxury industry; under Grandville's pencil the whole of nature is transformed into *spécialités*. He presents them in the same spirit in which advertising—a word that is also coined at this time—begins to present its articles. He ends in madness.[25]

To ensure a certain resistance toward the powers constricting my viewing habits (and perhaps to postpone madness), whenever I museum-go, I take along a book other than the exhibition catalogue, ready to intervene vagrant reading into the scene of spectacularity. (I employ the same tactic during fieldwork; I learned it from a native.) From now on, it could be this very book about museums and museumbooks. And I generally do ethnography of museumgoing even when participant-observing the strange haunts of museumgoers—not without resonance, not without wonder, not without irony. Perhaps these devices and tactics only make me sadder. May I, then, offer concluding notes from one museumgoer's museum-remembering and museum-reading, designed to reverberate with items in this collection of museum-essays, however misleading these essays (according to one of them), like the museums they inscribe (including ethnographic ones), have to be. Any such notes resemble a personal *maro ura* or Tarahoi from a museumed past. In no particular arrangement, they may be either curated or disposed; or selectively sketched or redrawn, by some other Bligh: the reader.

* * *

You can visit Den Haag (*deux étoiles*), enter the Mauritshuis Museum (*trois étoiles*), sit devotionally before Vermeer's *Delft*, and hear French passers-by reciting, as if by memory, not Proust on Vermeer but the *Guide Miche*'s quotation of Proust's narrator on Vermeer, which may be precisely what is proper to recite in this kind of going-viewing. That fitting caption from a not-so-prosy guidebook was repeatedly intoned by travelers, as I overheard them: "le plus beau tableau du monde." This pillaging of Proust by the *Guide Miche*[26] was thus pillaged in turn by guidees, who murmured aloud the accolade, despite the propinquity of a silence-seeking reader of Vermeer's *View*, or rather viewer of Vermeer's visual reading of Delft's "horizonal" curvature and "diffused circles of light, that form around unfocused specular highlights in the camera obscura image."[27] Now, so far as I, eavesdropping, could discern, this activity did not make the French passers-by themselves melancholy, or for that matter mirthful. But who knows? Such rhythms of reappropriation did, however, make Proust, or his narrator, sad, or melancholy, or musical, or mindful of memory's need to feed on layers of fragmentary captioning of residues from pasts and places already fragmented and captioned—like museums. Pillage upon pillage upon pillage was the prose of Proust, and his predecessors.

Proust pillaged and "pastiched" a mélange of prosers, including Ruskin; he even translated Ruskin's *Sesame and Lillies*, there discovering a calling to write cumulative remembering that superseded mere re-collection. Among the works of Ruskin despoiled by Proust under his mother's persuasion[28] were his celebrated verbalizings and visualizings that advocated a fresh sense of place and past for perhaps the most pillaged place of all: Venice. We should recall that Ruskin's *Stones of Venice*, indeed his entire corpus,[29] followed not just Byron's forebodings of Britain's parallel fate ("Albion! . . . in the fall of Venice think of thine . . ."), but a hundred years and more of Grand Touring:

> Venice had known a century and a half of tourism when Mr and Mrs John James Ruskin first brought their son to the city in 1835. Venice was not what it once had been—but then that was part of the romance of the place [only then?]. The eighteenth-century English visitor had come, ostensibly for educational reasons, as part of the Grand Tour, and the pleasures taken there had been set against the backdrop of a decadent but still lively and independent city state. Napoleon ended all that. In 1797 his army demanded the surrender of the city and the resignation of the Doge, thus bringing to an end the history of an aristocratic republic that once had ruled a Mediterranean empire. When in turn the Napoleonic empire was dis-

solved in 1815, Venice settled down to being a colony of the Aus-
trians. The great days were over.

Tourism, on the other hand, revived.[30]

Ruskin's museumizing of Venice both saved it from a certain kind of
touristic packaging (that had earlier saved it) and launched a new
wave and style of Venice-savoring that would save it again, and again.
And Venice has remained never as it was. Nor can Venice herself
(spouse of the sea) be absolved from guilt in plundering and profit-
eering. Venice began making herself a museum, or more precisely a
reliquary, many centuries before Ruskin-reading voyagers and voyeurs
joined in converting Venice into a composite emblem of politico-
aesthetics, hoping to redeem industrial Europe. Nine centuries, at
least:

Soon after the fall of Haifa [the Venetians] set sail for home bearing
with them, apart from the trophies and merchandise from the Holy
Land, the saintly relics they had brought from Myra. On their ar-
rival, which was neatly timed for St. Nicholas's Day, they received
heroes' welcomes from Doge, clergy and people, and the reputed
body of the saint was reverently interred in Domenico Contarini's
church on the Lido.

Did the ceremony have a slightly hollow ring? It should have
done, because the luckless churchwardens of Myra had told the
truth. Thirteen years before the Venetians arrived there, a group of
Apulian merchants had indeed removed St. Nicholas's body and had
carried it back in triumph to Bari, where work had immediately
begun on the basilica bearing his name. . . . Since the crypt of this
glorious building had been consecrated as early as 1089 by Pope
Urban himself, and . . . in the intervening years . . . must have been
seen by countless Venetian sailors, . . . it seems scarcely conceivable
that the Doge and his advisers were unaware of the Bariot claims. . . .
We can only conclude that . . . the Venetians, normally so level-
headed, were yet perfectly capable of persuading themselves that
black was white when the honor and glory and profit—for the fi-
nancial advantages from the pilgrim traffic were not to be despised—
of the Republic demanded that they should.

So far as they were concerned, the true corpse of St. Nicholas lay
in his tomb on the Lido. Several centuries were to pass before the
claim was discreetly withdrawn.[31]

If ever a city was destined to wind up museumed, and they all in a
sense may be, it is/was Venice.

When Proust's narrator inscribed Venice, he was writing in the wake of a seemingly exhaustive cataloguing by Ruskin, called by Proust's character Bloch (not by Proust) "one of the most tedious old prosers you could find."[32] Yet only through the reading of Ruskins and the seeing of Titians was Proust's narrator (in the retrospect of his writing) able to have anticipated a Venice and to hold preconceptions that, however faulty, figured in his "knowing Venice" ever after, including after having been there in earnest, with his Mamma, paying visits "upon the crest of a blue wave, by the wash of the glittering, swirling water, which took alarm on finding itself pent between the dancing gondola and the resounding marble. And thus any outing, even when it was only to pay calls or to leave visiting-cards, was threefold and unique in this Venice where the simplest social coming and going assumed at the same time the form and the charm of a visit to a museum and a trip on the sea."[33]

At a later point in *À la recherche du temps perdu*, such recall is depicted as impoverished into mere voluntary memory, even of Venice:

> I tried next to draw from my memory other "snapshots," those in particular which it had taken in Venice, but the mere word "snapshot" made Venice seem to me as boring as an exhibition of photographs, and I felt that I had no more taste, no more talent for describing now what I had seen in the past, than I had had yesterday for describing what at that very moment I was, with a meticulous and melancholy eye, actually observing.[34]

Later still, through a celebrated awakening of involuntary memory that linked uneven paving stones in the Guermantes' courtyard to a similar stumble in St. Mark's Baptistry, the narrator learns to credit both his anticipations and his recollections as mediators of any "experience itself"; or, more accurately, any experience itself is stretched between the irreducible poles of anticipation and recollection, and it is this stretch that the narrator can finally write. He thus narrates how he became emboldened to compose the very prose we have already read and how he ultimately managed not to discount his naive dreams of the Venice-museum that cannot be reached; such expectations form part of any placename's reality.[35] Accordingly, Proust's narrator (call him Marcel) recounted earlier in the volumes:

> Similarly, in later years, in Venice, long after the sun had set, when it seemed to be quite dark, I have seen, thanks to the echo, itself

imperceptible, of a last note of light held indefinitely on the surface of the canals as though by the effect of some optical pedal, the reflexions of the palaces displayed as though for all time in a darker velvet on the crepuscular greyness of the water. One of my dreams was the synthesis of what my imagination had often sought to depict, in my waking hours, of a certain seagirt place and its mediaeval past. In my sleep I saw a Gothic city rising from a sea whose waves were stilled as in a stained-glass window. An arm of the sea divided the town in two; the green water stretched to my feet; on the opposite shore it washed around the base of an oriental church, and beyond it houses which existed already in the fourteenth century, so that to go across to them would have been to ascend the stream of time.[36]

But don't mistake Proust to be yearning for the past; his resignation to prosing the synesthesic effects of an "optical pedal" is the opposite of romantic; he continues:

This dream [which? His? The dream that is Venice?] in which nature had learned from art, in which the sea had turned Gothic, this dream in which I longed to attain, in which I believed that I was attaining to the impossible, was one that I felt I had often dreamed before.

But as it is the nature of what we imagine in sleep to multiply itself in the past, and to appear, even when new, to be familiar, I supposed that I was mistaken. I notice, however, that I did indeed frequently have this dream.[37]

There was another writer between Ruskin and Proust who declared not only Venice a museum of pillaging but himself a pillager of his own past and his predecessors, including his near-contemporary Ruskin. This particular tedious old proser, reporting from Italy in 1873, 1877, 1882, 1892, and 1900–1909—a generation, more and less, before Proust (1871–1922)—was Henry James (1843–1916). James just kept writing and writing of Venice and Venice that there is no more to be written, just like Cicero saying that nothing needs to be said. Perhaps this resolve led James's descriptions to turn into comparisons; *The Aspern Papers*, for example, likens Venice's relative quiet to an apartment's or a theater's:

Without streets and vehicles, the uproar of wheels, the brutality of horses, and with its little winding ways where people crowd together, where voices sound as in the corridors of a house, where the human step circulates as if it skirted the angles of furniture and shoes never

wear out, the place has the character of an immense collective apart-
ment, in which Piazza San Marco is the most ornamented corner and
palaces and churches, for the rest, play the part of great divans of
repose, tables of entertainment, expanses of decoration. And some-
how the splendid common domicile, familiar, domestic and reso-
nant, also resembles a theatre, with actors clicking over bridges and,
in straggling processions, tripping along fondamentas. As you sit in
your gondola the footways that in certain parts edge the canals
assume to the eye the importance of a stage, meeting it at the same
angle, and the Venetian figures, moving to and fro against the bat-
tered scenery of their little houses of comedy, strike you as members
of an endless dramatic troupe.[38]

Now, museums lack brutal uproar and contain clicking heels, too; and
James's travel writing—in the respects that concern us here, perhaps
more complex than his fiction—availed itself of another parallel that
portended all future complaints by a century of tourists decrying the
proliferation of their own kind:

> The Venice of to-day [1882] is a vast museum where the little wicket
> that admits you is perpetually turning and creaking, and you march
> through the institution with a herd of fellow-gazers. There is nothing
> left to discover or describe, and originality of attitude is completely
> impossible.[39]

But don't mistake James to be sharing this craving to discover and
describe. His previous remarks have just assigned so humdrum an urge
to the creature against which he aims his every sentence: "The senti-
mental tourist's sole quarrel with his Venice is that he has too many
competitors there. He likes to be alone; to be original; to have (to
himself, at least) the air of making discoveries."[40] James's own origi-
nality of attitude absolves both himself of making discoveries and
Venice of providing secrets to disclose. Rather, he is willing repeatedly
to reread and rewrite over and under, after and before, all the reading
and writing that provides evidence of the palimpsest that is Venice,
even in the being in it: "Reading Ruskin is good; reading the old
records is perhaps better; but the best thing of all is simply staying on
. . . to linger and remain and return. . . . The danger is that you will
not linger enough."[41]

James's fiction sometimes countered the conventionality of famil-
iar descriptions from the catalogue of Venetian local color by imag-
ining twinkling reversals, as when *The Aspern Papers* turn into Am-
sterdam:

The gondola stopped, the old palace was there; it was a house of the class which in Venice carries even in extreme dilapidation the dignified name. "How charming! It's grey and pink!" my companion exclaimed; and that is the most comprehensive description of it. It was not particularly old, only two or three centuries; and it had an air not so much of decay as of quiet discouragement, as if it had rather missed its career. But its wide front, with a stone balcony from end to end of the *piano nobile* or most important floor, was architectural enough, with the aid of various pilasters and arches; and the stucco with which in the intervals it had long ago been endued was rosy in the April afternoon. It overlooked a clean, melancholy, unfrequented canal, which had a narrow *riva* or convenient footway on either side. "I don't know why—there are no brick gables," said Mrs. Prest, "but this corner has seemed to me before more Dutch than Italian, more like Amsterdam than like Venice. It's perversely clean, for reasons of its own; and though you can pass on foot scarcely anyone ever thinks of doing so. It has the air of a Protestant Sunday."[42]

But when travel-writing, James becomes like a museumgoer who lingers long enough to become jaded, yet then lingers longer to become something more, something resonant and plangent, although not merely that. His missives hang out the conventional dirty laundry of poverty, filth, scuffling peddlers: "There is a great deal of dishonour about St. Mark's altogether, and if Venice, as I say, has become a great bazaar, this exquisite edifice is now the biggest booth."[43] And no one could take a more jaundiced view than James's of the merchandizing of Venice, of the rifling of a past that history left behind:

The antiquity-mongers in Venice have all the courage of their opinion, and it is easy to see how well they know they can confound you with an unanswerable question. What is the whole place but a curiosity-shop, and what are you here for yourself but to pick up odds and ends? "We pick them up *for* you," say these honest Jews, whose prices are marked in dollars, "and who shall blame us if, the flowers being pretty well plucked, we add an artificial rose or two to the composition of the bouquet?" They take care in a word that there be plenty of relics, and their establishments are huge and active. They administer the antidote to pedantry, and you can complain of them only if you never cross their thresholds. If you take this [inevitable?] step you are lost, for you have parted with the correctness of your attitude. Venice becomes frankly from such a moment the big depressing dazzling joke in which after all our sense of her contradictions sinks to rest—the grimace of an over-strained philosophy.[44]

Yet even here James keeps viewing, lingering, remaining, and returning; he layers glimpses of these very "halls of humbug" with their "intervals of haggling" into the "soft plash of sea on the old water-steps" heard through the high windows of the homes laid waste, pillaged, to the profit of curiosity shops whose huge advertisements, nevertheless, offer "some of the most striking objects in the finest vistas at present."[45] James's sentences, moreover, push beyond the parody they offer of hackneyed comparatives and superlatives from guidebook opinionating: "If it's very well meanwhile to come to Turin first it's better still to go to Genoa afterwards. Genoa is the tightest topographic tangle in the world, which even a second visit helps you little to straighten out."[46] Indeed James, or his sentences, linger(s) so long that he/they become resigned to flirting with an incorrectness of attitude and perhaps more than willing to be ravished by the sight of the Grand Canal and gondoliers. Gondoliers, certainly:

> From my windows on the Riva there was always the same silhouette—the long, black slender skiff, lifting its head and throwing it back a little, moving yet seeming not to move, with the grotesquely-graceful figure on the poop. This figure inclines, as may be, more to the graceful or to the grotesque—standing in the "second position" of the dancing-master, but indulging from the waist upward in a freedom of movement which that functionary would deprecate. . . . Nothing can be finer than the large, firm way in which, from their point of vantage, they throw themselves over their tremendous oar. It has the boldness of a plunging bird and the regularity of a pendulum. Sometimes, as you see this movement in profile, in a gondola that passes you—see, as you recline on your own low cushions, the arching body of the gondolier lifted up against the sky—it has a kind of nobleness which suggests an image on a Greek frieze.[47]

This particular grotesque-graceful prose agglomeration of voyeurings and visionings by James of his museum-city's most conspicuous custodians was published in 1882; it was replete with both unexpected turns and not-a-little-hackneyed copy, even then, as it proceeded to apotheosize these "children of Venice . . . associated with its idiosyncrasy, with its essence, with its silence, with its melancholy."[48] Ten years later James was still wearing out through overuse, and therefore pushing beyond conventional views, still returning to and repeating—with choicest variations—the same kind of seeing garnished with old obsessions never outgrown and never left behind. His developing prose, in its fresh twists of Style, remains ever an attic of many pasts,

a museum of museums of museums, plundering everything that transpires there; thus, in 1892:

> Of the beautiful free stroke with which the gondola, especially when there are two oars, is impelled, you never, in the Venetian scene, grow weary; it is always in the picture, and the large profiled action that lets the standing rowers throw themselves forward to a constant recovery has the double value of being, at the fag-end of greatness, the only energetic note. The . . . solitary gondolier . . . is, I confess, a somewhat melancholy figure. Perched on his poop without a mate, he re-enacts perpetually, in high relief, with his toes turned out, the comedy of his odd and charming movement. He always has a little the look of an absent-minded nursery-maid pushing her small charges in a perambulator.[49]

Henry James, although of the view that "a rhapsody on Venice is always in order," knew full well that "the catalogues are finished."[50] His writing thus offers no completeness, only the accident. And his description delivers no references (even though it is full of the most familiar labels of places, paintings, standard sites, and architectural wonders), if only to counter what automatically accumulates in any visitor's gondola:

> The [museumy] Grand Canal may be practically, as an impression, the cushioned balcony of a high and well-loved palace—the memory of irresistible evenings, of the sociable elbow, of endless lingering and looking; or it may evoke the restlessness of a fresh curiosity, of methodical inquiry, in a gondola piled with references. There are no references, I ought to mention, in the present remarks.[51]

That remark will be the last reference in the present catalogue of rifled quotations, vantages, and points of view. Yes, that remark will be the last reference in this gondola of a paper, wishing that it, too, had none. But please don't mistake me. I am not saying that museums make me sad (or melancholy-mirthful) for the same reasons that the museum-city of Venice (and suchlike) made James or Proust—or Mann allegorizing "Death" there, or Wagner dying there—sad or melancholy. This luxury of self-identifying remains unopen to yours truly, if only because the works of James and Proust (and their like) are two of the relics now to be borne with us to museums, there to intervene their reading into such scenes of spectacularity. My power to curate James and Proust in and as part of the catalogue of fragments and

captions distanced into my eyes' and memories' purview can only keep the museumlikeness (even museuminess) going—the gift giving; and this power over "them" makes me sadder still.

NOTES

I must thank Ivan Karp, Steve Lavine, and Christine Mullen Kreamer for their patience, understanding, and insights; and other participants in the preconference and, through their writings, the conference (which circumstances finally precluded my attending) for their stimulation. My notes credit museum catalogues more than originals.

1. Holbrook Jackson, "Introduction," in Robert Burton, *The Anatomy of Melancholy: What It Is, with All the Kinds, Causes, Symptomes, Prognostickes, and Severall Cures of It* (New York: Random House, 1977 [1621]), ix.

2. Robert K. Merton, *On the Shoulders of Giants: A Shandean Postscript*, 2d ed. (New York: Harcourt Brace Jovanovich, 1985), 3, 280.

3. Mark Girouard, *Life in the English Country House* (New York: Penguin, 1978), 175.

4. George W. Stocking, Jr., ed., *Objects and Others: Essays on Museums and Material Culture.* History of Anthropology, vol. 3 (Madison: University of Wisconsin Press, 1985).

5. See Margaret Hodgen, *Early Anthropology in the Sixteenth and Seventeenth Centuries* (Philadelphia: University of Pennsylvania Press, 1964); James A. Boon, *Other Tribes, Other Scribes* (New York: Cambridge University Press, 1982); James A. Boon, *Affinities and Extremes: Crisscrossing the Bittersweet Ethnology of East Indies History, Hindu-Balinese Culture, and Indo-European Allure* (Chicago: University of Chicago Press, 1990).

6. Lynn Barber, *The Heyday of Natural History, 1820–1870* (Garden City, N.Y.: Doubleday, 1980).

7. Boon, *Other Tribes*, part 1.

8. On the latter point, see the recent allegorical reading by George W. Stocking, Jr., in *Victorian Anthropology* (New York: Free Press, 1986).

9. Barber, *Heyday*, 123.

10. As if eventually to outdo Peale's Mammoth Mastodon, Barnum later considered one of his culminating achievements to have been bringing from Siam to the West a "sacred white elephant, no such animal ever having been

permitted to leave the land of the Buddhists" (P. T. Barnum, *The Story of My Life* [Cincinnati: Forshee and McMakin, 1886], 458–59).

11. Henry James, *A Small Boy and Others,* in *Henry James, Autobiography,* ed. F. W. Dupee (Princeton: Princeton University Press, 1983), 197.

12. F. W. Dupee, "Introduction," in *Henry James, Autobiography,* ed. F. W. Dupee (Princeton: Princeton University Press, 1983), xii.

13. James, *Small Boy,* 89–90.

14. Ibid., 90.

15. Ibid., 95–96.

16. Ibid., 98.

17. Ibid.

18. Ibid.

19. See Susan Stewart, *On Longing: Narratives of the Miniature, the Gigantic, the Souvenir, the Collection* (Baltimore: Johns Hopkins University Press, 1984).

20. Greg Dening, "Possessing Tahiti," *Archaeologia Oceania* 21 (1986), 104–5.

21. See James A. Boon, *The Anthropological Romance of Bali, 1597–1972* (New York: Cambridge University Press, 1977), and Boon, *Affinities and Extremes.*

22. See Eric Hobsbawm and Terence Ranger, eds., *The Invention of Tradition* (Cambridge: Cambridge University Press, 1985).

23. See James A. Boon, "Between-the-Wars Bali: Rereading the Relics," in George Stocking, Jr., ed., *Malinowski, Rivers, Benedict, and Others.* History of Anthropology, vol. 4 (Madison: University of Wisconsin Press, 1986). See also Boon, *Other Tribes,* chap. 6; Boon, *Affinities and Extremes.*

24. Michael Baxandall, *Painting and Experience in Fifteenth-Century Florence* (London: Oxford University Press, 1973).

25. Walter Benjamin, *Reflections: Essays, Aphorisms, Autobiographical Writings,* ed. Peter Demetz, trans. Edmund Jephcott (New York: Harcourt Brace Jovanovich, 1978), 152.

26. *Guide Michelin: Benelux* (Paris: Pneu Michelin, Services de tourisme, 1974), 256.

27. Svetlana Alpers, *The Art of Describing: Dutch Art in the Seventeenth Century* (Chicago: University of Chicago Press, 1983), 31–32.

28. *Marcel Proust: Selected Letters, 1880–1903*, ed. Philip Kolb, trans. R. Manheim (Garden City, N.Y.: Doubleday, 1983), 114.

29. Paul L. Sawyer, *Ruskin's Poetic Argument: The Design of the Major Works* (Ithaca: Cornell University Press, 1985).

30. Robert Hewison, *Ruskin and Venice* (London: Thames and Hudson, 1978), 8.

31. John Julius Norwich, *A History of Venice* (New York: Knopf, 1982), 80–81.

32. Marcel Proust, *Remembrance of Things Past*, trans. C. K. Scott Moncrieff and T. Kilmartin. 3 vols. (New York: Random House, 1981), 1:795.

33. Ibid. 3:644.

34. Ibid. 3:898.

35. James A. Boon, *From Symbolism to Structuralism: Lévi-Strauss in a Literary Tradition* (New York: Harper and Row, 1972), 144.

36. Proust, *Remembrance of Things Past* 2:147–48.

37. Ibid. 2:148.

38. Henry James, *The Aspern Papers*, in *The Aspern Papers and Other Stories* (New York: Penguin, 1976), 103–4.

39. Henry James, *Henry James on Italy* [Selections from *Italian Hours*] (New York: Weidenfeld and Nicolson, 1988), 10.

40. Ibid.

41. Ibid.

42. James, *Aspern Papers*, 15.

43. James, *Henry James on Italy*, 14.

44. Ibid., 43.

45. Ibid.

46. Ibid., 65.

47. Ibid., 20.

48. Ibid., 22.

49. Ibid., 44–45.

50. Ibid., 38.

51. Ibid.

PART 4

Festivals

IVAN KARP

The introduction to this volume describes museum exhibitions as contested arenas, settings in which different parties dispute both the control of exhibitions and assertions of identity made in and experienced through visual displays. In this section we bring together four papers that examine how festivals present yet another public forum in which cultural displays tend to produce disputes over meaning.

Although these papers originally were commissioned for different purposes, each paper describes how issues of culture and representation emerge not only within the confines of the museum, but also in those often self-conscious, antimuseum settings called fairs and festivals. Fairs and festivals do differ from museum exhibitions in any number of ways. The organizations that produce fairs are often temporary, set up for special purposes and disbanded after the event. If they perpetuate themselves they do so not continuously but

periodically, such as in the annual community or regional festival. Still, there is a paradoxical sense in which the curatorial hand is both less and more evident in displays produced for festival settings. Since the "objects" on display are usually not objects but live performances, festivals frequently promote the notion that performers are primary agents determining the performance's content. Yet the greater the cultural distance between the performers and their audience, the greater the perceived need for an interpretation that explains and sets the scene for those attending the festival.

These interpretations can range from the relatively simple act of having the performer slipping frame and explaining the context, setting, or origin of the performance to the far more elaborate procedure practiced by the Smithsonian Institution's Festival of American Folklife, in which trained folklorists who have extensive experience with the performers' special genre interpret the performances for the audience. The professional interpreter of the festival has clear parallels with museum docents, who interpret exhibitions for special groups and tours.

"Living museums" provide a special case of professional interpretation, because a living person is both an interpreter and part of the exhibition. In these cases, guides assume both the costumes and the personas of people who would have occupied the settings that the audience is visiting. Their training can be extensive, as it is in Williamsburg, or more casual and seasonal, as when college students are used at theme parks during the summer. Both "living museums" and theme parks use costumed guides, "authentic" or playful; thus the same display technique can be used in settings that assert either authenticity or fantasy. But the purpose of a costumed, living interpreter-performer is the same—to guide and stimulate the audience to experience a world they know only through the faculty

of the imagination. Whether the world to be imagined ever existed is irrelevant to the display devices that are used. The larger metamessages of "authenticity" and "fantasy" are the product of the overall story spun by the exhibition, and not a product of the specific display forms used in exhibitions and festivals.

This point is essential. Far too many debates about the nature of exhibiting assume that a type of museum is defined by the poetics of display rather than by the politics of interpretation that exhibitions establish. Although exhibitions in natural-history and art museums (to take two museum genres) increasingly look alike, their politics remain separate. The appeal to "visual interest," for example, can be found in either museum setting. But in natural-history museums, the display of beautiful objects is usually a means to another end, such as the stimulation of interest in how crystals are formed or in the meaning and history of the peace pipe in Native American life.

The "living" dimension of the festival is the feature most frequently cited when the festival and the exhibition are contrasted. In his discussion at the conference, Richard Bauman sharply contrasted the sensory experiences of the exhibition and the festival. He noted, for example, that exhibitions are settings for restrained and sensually restricted experience, since most museums limit interaction between audience and object. Museums set up barriers between the audience and the display. If physical barriers are absent, as in some contemporary exhibitions, electronic devices emit alarms to warn that the space enclosing the object has been entered, just as guards placed at strategic intervals warn the audience about violating space.

A double message is communicated in exhibition spaces. First, the audience views objects that are believed to have "visual inter-

est" or "visual distinction."[1] Second, the audience is made aware of the high cultural and financial value inhering in the objects on display. Rareness, preciousness, or authenticity are communicated by the museum exhibition.

Festivals communicate messages about authenticity while they also invoke pleasurable, sensual experiences that more totally involve the person. Bauman described this totalizing participation—which engages acting, tasting, or feeling, in addition to looking—as "blowout." The stance that is stressed in festivals is active rather than passive, encouraging involvement rather than contemplation. We might contrast the relatively authoritarian learning experience implied by the classic museum setting, in which one member of the museum set—the audience—receives the experience provided by the exhibition makers[2] with the more democratic and nonjudgmental participatory and sensory aesthetics of the festival.

These differences place museum exhibitions and festivals on a continuum: the control exercised by one agent over another's experience contrasts with openness and participation by all parties. The museum exhibition, which strives to produce refinement of taste, is at the other end of the continuum from the festival, which strives to allow the fullness of the experience to be shared among all the participants. In the middle of the continuum are the interactive exhibits discussed by Elaine Heumann Gurian in this volume. In those settings, audience and exhibition makers interact, but they do so in a structured way, since the range of possible audience responses is both limited and guided toward predetermined ends.

These contrasts between the museum exhibition and the festival may have a familiar ring, for they are also the contrasts between elite and popular culture. These two forms of culture exhibit real divergences in style and claims to authority. On the other hand,

elite culture claims its authority on the basis of its possession of cultural resources and experience. Connoisseurship and training are claimed as central elements in the construction of exhibitions and the selection of objects.[3] Even where the purpose of an exhibition is didactic rather than aesthetic, the authoritative claim is based on possession of knowledge and those cultural resources we call "collections." The operative term is *possession*. Whether these possessions are skills and knowledge or material resources, claims to authority based on ownership or possession is a fundamental feature of elite culture.

Festivals, on the other hand, do not emphasize differences in taste or ownership among their participants. Festivals that display folk performers do make something of differences in skill and knowledge, but they characteristically assert that such knowledge and skill derive from nonelite settings and are available to everyone who comes to the festival. The central issues that are implicitly contested between museum exhibitions and festivals are ownership of culture and how it is defined.

Raymond Williams has shown how the meaning of the concept of culture has changed radically over time.[4] From its initial association with agriculture, culture has come to be conceived as the mark of the cultivated, civilized person and, more recently, as the common possession of a human group. Elite culture tells a story of cultivation that has universal implications. In this volume, the papers by James Clifford and Carol Duncan describe how museums with encompassing, universal stories arise out of and are mechanisms for the production of elite culture. Festivals tell stories that deny or ignore the universalizing themes of elite culture, in that they often entail just those cultural experiences and groups that resist the universal. Universal stories lead to tidy events; particularizing stories

do not allow their tellers to wrap them up into neat packages. Nor
are multisensory, "blowout" settings easy to predict or control. A
striking aspect of the papers in this section is how the diversity fes-
tivals celebrate can and usually does lead to messy events and disor-
derly, disputatious performances.

Yet the very essence of the festival—the inclusive, celebratory
nature of the event—makes it an attractive forum for the exhibition
of other agendas. The more important festivals become, the more
the tension between politics and control manifests itself in their his-
tory. This is certainly the history of festivals presented in this set of
papers. Ted Tanen describes his diplomatic program for using the
festival format to educate U.S. audiences about other countries, and
he does so in a modest and honest fashion. The result of that mis-
sion has been two remarkable events—the Festival of India and the
more recent Festival of Indonesia. If Tanen provides us with a view
of these festivals from above, and Richard Kurin describes the scene
from within, there is still considerable similarity in their agendas.
Both are very concerned to produce an attitude of respect toward
and an increase in knowledge about the culture of India. However,
their respective ideas about Indian culture are very different. Tan-
en's is a consumer's stance, while Kurin's anthropological engage-
ment with India leaves him with a committed, if ironic, point of
view. Kurin's paper is characteristically anthropological in that it
simultaneously stands both inside and outside; it appreciates while
it seeks to explain.

For Kurin, the Aditi and Mela exhibitions, part of the Festival
of India, were ultimately successful for two reasons. First, they
raised the status of despised groups of performers in India itself,
and gave these groups a measure of control over their lives. This is
one of the ironic consequences of diplomacy. (I was left wondering

if a similar effect wasn't produced by the 1893 World's Columbian Exposition, described by Curtis Hinsley; unfortunately the historical evidence is missing.) The second success of the festival derived from the inability of its organizers, including Kurin, to control the performers. Though its organizers conceived the festival as a series of carefully orchestrated, partial glimpses into the performers' lives, the audience instead often encountered endemic rebellion, in which the performers reframed the representation of a performance into a performance itself, regulations notwithstanding.

The discussion of Kurin's paper at the conference included a heated debate about some of the "exhibits" in Aditi. Members of the audience were very concerned about how some of the displays "museumified" craftspeople doing essentially everyday, nonperformance activities. They were distressed at observing live persons put on display as if they were objects. This is the underside of the festival frame. If festivals are difficult to control because they engage the total sensory person, they are also organized forms of display that often reduce the whole person to a partial performer.

Folk festivals have special problems. Often the folk activity is not an indigenous performance genre, and the square peg of an everyday craft is forced into the round hole of show business. This problem was evident in all three of the festivals described in this section. Richard Bauman and Patricia Sawin make this experiential contrast the key point of their paper. Essentially they provide us with a political ethnography of how a festival contains a dialectic of control and resistance. They show how ideas about folklife often force performances into an ill-fitting frame, and, as Richard Kurin does, they show that festivals reach beyond the event to the communities from which artists come. The legitimating function of the festival often takes unforeseen forms.

Curtis Hinsley describes the 1893 World's Columbian Exposition as a fair fighting against itself. The exposition was a remarkable event, one whose history questions some of the received wisdom about festivals I describe above. Despite the fantasy, fun, and sensual fullness, it is clear that part of the event was ultimately controlled by commercial interests. Though the primary goals of the exposition were educational and directed at increasing the respect paid to the groups exhibited—the same goals that animated the Festival of India—the anthropologists were definitely relegated to the periphery. Hinsley provides a picture of something like a Festival of India within a commercial exposition. Perhaps the "natives" who participated in the exposition received a degree of legitimacy upon their return home, but that is another research project. Clearly, the relativizing and legitimating goals of anthropological science had a place only on the periphery of American society, and the fair's displays were undercut by the assumptions held by anthropologists themselves. Festivals do not always succeed in all their goals, and the happy consequences described by Richard Kurin are neither automatically nor easily obtained. This is especially so when the subject matter displayed is the lives of members of non-Western cultures, which is the topic examined in Part 5, "Other Cultures in Museum Perspective."

NOTES

1. See the essay by Svetlana Alpers in this volume for a defense of art museums as temples of "visual interest."

2. It is interesting to consider the Hall of the North American Indian at the Peabody Museum, Harvard University. This brand-new anthropology exhibit (1990) uses virtually every traditional display technique known to museums, from almost-empty vitrines to dioramas with labels explaining why dioramas are a bad thing. The master narrative reproduces traditional museum anthro-

pology nonetheless. The exhibits are still arranged in terms of regions and the objects are chosen to demonstrate diversity among regions. The catalogue is even more striking in this regard. Primarily a book of pictures of decontextualized objects, it is organized by region alone and has no time dimension.

3. Acquiring the "best" examples of a type of art or a species is a passion museums share with individual collectors. To my knowledge, no one has studied how the reputations of museum directors are defined by the collections they acquire. Such an inquiry is long overdue.

4. Raymond Williams, *Keywords* (London: Fontana, 1976).

CHAPTER 16

The Politics of
Participation in
Folklife Festivals

RICHARD BAUMAN AND
PATRICIA SAWIN

F rom the invention of the concept in
the late eighteenth century, folklore
has always been about the politics of
culture. Whether motivated by a ro-
mantic vision of traditional, preindustrial ways of life as a critical
corrective to the discontents of modernity, or by a rationalist impulse
to expose the irrational, supernaturalist foundations of folklore as
impediments to progress, students of folklore have valorized certain
ways of life over others in the service of larger political agendas.[1] The
problematics of representation have also loomed large in the folkloric
enterprise from the very beginning. To what forms of representation
might folklore be susceptible, and with what effect on the material
itself? These problems might be articulated in terms of a quest for
standards of authenticity or aesthetic value, or techniques of rendering
oral forms in print, or the best uses of folklore as a resource for
modern forms of cultural production (painting, architecture, litera-
ture, music), and so on. Only in recent years, however, have the prob-
lematics of representation become the focus of politically informed
and analytically self-conscious examination.[2]

A powerful stimulus to this critical and reflexive study has been
the burgeoning, since the late 1960s, of publicly oriented programs
under the rubrics of folklore, folklife, or folk art.[3] The factors under-

lying the growth of folklore activity directed at public (as opposed to strictly academic) audiences are too complex to treat adequately here.[4] Suffice it to say that as academically trained folklorists have moved into extra-academic venues in increasing numbers over the past two decades, inevitably they have had to resort to different presentational modes, directed at different audiences and driven by imperatives and standards different from those that prevail in the world of academic scholarship. Prominent among these presentational—simultaneously representational—modes is the folklife festival.[5]

The folklife festival is a modern form of cultural production[6] that draws upon the building blocks and dynamics of such traditional events as festivals and fairs: complex, scheduled, heightened, and participatory events in which symbolically resonant cultural goods and values are placed on public display.[7] In folk festivals, what is put on display are forms of folk culture as conceived by folklorists and other cultural programmers and executed by practitioners they select.

Folk festivals have obvious affinities with museums, which also exist for the display of culturally valued forms, though where museums tend toward the display of material objects, folk festivals, in keeping with the ambience and dynamic of the festival form, are more participatory and oriented toward action and performance. These affinities, then, help to account for the interaction between museums and festivals, as when museums themselves feature live artists and craftspeople in conjunction with exhibits of artifacts,[8] or when the Smithsonian Institution produces the Festival of American Folklife as "a living museum without walls."

The ideological foundation of contemporary American folklife festivals is essentially a kind of liberal pluralism. Folk festivals promulgate a symbolically constructed image of the popular foundations of American national culture by traditionalizing, valorizing, and legitimating selected aspects of vernacular culture drawn from the diverse ethnic, regional, and occupational groups that are seen to make up American society. Folk culture is variously counterpoised against elite, mass, or official culture as embodying values and social relations that are a necessary, natural, and valuable part of human existence, worthy of preservation and encouragement. The sometimes tacit, often explicit, assumption is that folk festivals can serve as instruments of such preservation and encouragement. Folklorists are beginning to question, however, what the actual effects of such festive representations may be. Given the almost inevitably decon-

textualizing, fragmenting, centralizing, institutionalizing, officializing, and interventionist nature of folk festivals, what messages do they really send? What effects do they have on folk culture? What political ends do they serve? How can we do them better? Should we do them at all?

Thus far, much of this critical and reflexive examination of folklife festivals has been directed at the practice of the folklorists who stage them, questioning formerly tacit assumptions about the efficacy of festival representations in maximizing authenticity, accuracy, and verisimilitude. With few exceptions, the primary focus has been upon the actions of the folklorists themselves as agents within the larger social and political arena, and the issues have been posed in terms of the degree to which modes of representation achieve the folklorists' political agendas. Analytical exploration of these problems is still in its nascent stages. As yet, there is all too little publicly articulated recognition of notions such as authenticity or accuracy as symbolic, ideological constructions that are part of the larger political economy of culture,[9] or analytical examination of the complex semiotics of display.

Still less has there been any critical examination of the dynamics of participation in folklife festivals from the perspective of the participants themselves, beyond a rich store of anecdotes current among festival producers and staffers. The study on which this paper is based was undertaken to provide a modest beginning toward filling this gap in our knowledge. Our premise is that the conduct of a folklife festival is a political field in its own right, though with significant links to larger political arenas. The festival field is organized in terms of power relations, structures of authority and legitimacy, and differential control over values. The festival mode of representation tends to concentrate power and authority in the hands of the producers. They are, after all, the ones who in organizing, orchestrating, and financing the event promulgate their own ideology, and the participants can all too easily be taken as relatively passive and objectified communicative instruments in the service of the larger message. We would insist, however, that an understanding of the political operation and efficacy of a folklife festival must take close account of the orientation to the event of all who are involved in it, recognizing the agency of the participants themselves; they are not passive, inanimate museum objects. In this paper, we suggest one possible approach to the problem, drawn from a larger study.[10]

PROJECT DESIGN

The project on which we report, a cooperative venture of the Smithsonian's Office of Folklife Programs (OFP) and the Folklore Institute at Indiana University,[11] was an ethnographic study of participation in the 1987 Smithsonian Festival of American Folklife (FAF), from the vantage point of the "folk" participants themselves. The FAF, founded in 1967, has had an enormous influence on publicly oriented folklife programming in the United States because of the scale and vigor of the festival, its location in the nation's capital, and the caliber of its staff. The festival has served as a training ground for many public-sector folklorists who have subsequently moved on to other positions around the country, and the FAF format has become a model for like productions in many other locales.

The FAF is usually organized into several distinct program areas; the specific programs vary from year to year, but typically include the presentation of the folk culture of a featured state and of a foreign country as well as an issue-oriented program (e.g., cultural conservation) and perhaps others. (In 1987 the three program areas were: Michigan, Washington, D.C. [instead of a foreign country], and "America's Many Voices" [language conservation].) Four main presentational foci for the festival have evolved over the years: musical performance, occupational folklife (involving the representation of work skills), craft demonstrations, and foodways (the demonstration of the preparation of regional and ethnic dishes).

Participants involved in demonstrating crafts or occupational skills usually are provided with individual work stations where their tools and materials are set up and the products of their activity displayed. These participants have a definite place to belong amidst the bustle of festival activity, but they are also expected to work more or less continuously throughout the festival day and to be prepared to answer questions at any time from the spectators who wander by and periodically gather around their demonstration areas. For craft demonstrators these areas are usually compact, with tables, workbenches, and display racks for several participants grouped together under a large awning. Display areas for occupational skills may be large and spread out and may include mock-ups of buildings, large machinery, and even an entire fishing boat, rodeo arena, or racetrack.

Foodways demonstrators, in contrast, rotate through the single demonstration kitchen in each program area, averaging one hour-long

presentation per day. Spectators may drift in and out, but covered bleacher seating is provided to encourage an audience to stay for the entire demonstration. Musicians, similarly, usually give one formal, hour-long show per day on the large, elevated main stage, which provides covered seating for an audience of two hundred or more and serves as the organizational focus and most foregrounded display space in each program area. Main-stage music is highly amplified, and the current performance can often be heard all over the program area and out onto the Mall beyond the festival.

Most participants are also asked to appear approximately once every other day on a "talk stage." The term is used to designate both the sites (low, tree-shaded stage platforms with gentle amplification and seating for no more than 30–40 viewers) and the events that are held there (moderated discussions of the various skills on display and the social and cultural foundations of the various groups in which they are rooted). Talk stages frequently provide a comparative perspective by bringing together people from different cultures or groups who play the same instrument or practice similar crafts or occupations. The main themes for these presentations are worked out in advance, but the inspiration for specific topics and for the inclusion of specific participants often emerges during the course of the festival as present-ers learn more about the pool of talent that has been assembled, especially the relevant skills and interests that participants may have in addition to the specific ones for which they have been invited to the festival.

All presentational formats featured at the festival are mediated by designated presenters, who often, but not always, are the fieldworkers who originally contacted and recruited particular performers for the festival. The presenters are usually academically trained folklorists, historians, museum specialists, or cultural programmers, who are charged with introducing and contextualizing the cultural forms on display, moderating discussion sessions, and serving as intermediaries between the festival producers and the participants. Many of the pre-senters have prior experience at serving in this capacity, and all receive detailed briefings concerning what is expected of them. Participants, on the other hand, are given (from their point of view) little or no *systematic* briefing concerning how to adapt what they do to the for-mats and demands of the festival or even why they and their skills are appropriate. Some fieldworkers, presenters, and staffers have the op-portunity or desire to do more by way of preparing participants, some less. The general assumption, though, made explicit in the "Presenter's

Guide,"[12] is that the presenters are the ones who do the work of contextualization and the participants just do their thing. This situation raises very significant questions about how the participants actually do accommodate their activities to the complex representational demands of the artificial, staged event in which they are on display. This is the problem we set out to explore. Our central discovery, and the principal tenet of this paper, is that participating in a folklife festival is a far more complex and problematic undertaking than usually is recognized. The participants themselves—as much as or more than the folklorists who are their presenters—are called upon to adapt and reframe their usual activities so as to make of them a representation intelligible to the festival audience and acceptable to folklorists and to themselves.

The goal of this paper is to focus attention on the participants' experience of this reframing process and on the agency involved in their accomplishment of it. Participants' reorientation under these circumstances is further complicated by the lack of any clear and shared understanding about what constitutes the festival frame. Folklorists may differ among themselves over the definition of the frame and/or recognize the validity of several conceptual frames; participants are likely to have their own notions influenced by contact with jamborees, bluegrass or other music festivals, and the like. In consequence, we discovered, participants manage to orient what they do not in terms of a set definition, but rather in terms of a basic contextualizing question that lies at the heart of frame analysis—"What is it that is going on here?"—and they arrive at differential and shifting understandings, which require some work to achieve and sustain.[13] Much of the effort required of participants goes toward working out these frames in their own minds, negotiating and testing them in interactions with fellow participants, audience, and staff, and enacting or embodying them in their daily presentations. Participants' responses to the festival, their conclusions about what they are doing (and what they are *supposed* to be doing) in this novel situation, and the resulting performances emerge out of the participants' own agendas, expectations, and past experiences in festivals and other display events (or lack thereof) and are influenced by input from festival organizers and by the unfolding of the festival itself—the space, the ambience, the audience, the other participants, and the staff.

Our analysis is based on data collected at and in connection with the 1987 FAF from a core group of about twenty participants in the Michigan program (Michigan was the featured state in 1987). The

project design called for each of the six researchers from Indiana University, under the direction of Richard Bauman, to work closely with a small number of individual participants or groups.[14] We should stress that the selection of participants with whom we worked was in no way a systematic sample; while we did work with both male and female participants, people with a range of prior experience in public enactments (from none to considerable), and participants in all four presentational categories (music, crafts, occupational folklore, and foodways), for a number of pragmatic reasons we were not able to include African American or Native American participants in our study. In most cases the researcher was able to travel to Michigan and interview his or her chosen participants before the festival. We all spent the full two weeks at the 1987 FAF, living with the participants and staff and spending each day of the festival at the site on the Mall. Each researcher documented the performances or demonstrations of the people with whom he or she was working, interacted with them informally on a daily basis, and conducted several interviews with them about their developing impressions of the festival. Afterward, each researcher either traveled to Michigan again to conduct follow-up interviews or corresponded with the participants. Two researchers also observed the recreation of the Michigan component of the FAF at the 1987 Festival of Michigan Folklife in East Lansing in August. During and after the festival the research team met frequently to co-ordinate our efforts and ensure that we were collecting comparable data and producing complementary analyses. When the investigation was completed, each researcher submitted a report on the individuals or groups with whom he or she had worked that was based upon field notes, photographs, and audio- and videotape recordings. This article represents a partial synthesis of the individual reports.[15]

We want to emphasize as strongly as possible at the outset that the apparently critical cast of our discussion is not intended as an indictment of the FAF. Current and former members of the OFP have taken a strong lead in turning a critical lens on their own practice and on the festival as a form of representation more generally, as well as in according a fully collaborative degree of authority to participants in the design of their programs. Indeed, were it not for the OFP's strong interest in critical scrutiny of the FAF, we would not have been able to carry out our investigation. In what follows, the reader should bear in mind that in a study of this nature many of our insights inevitably have been generated around problems and points of friction and indeter-minacy. Reflexivity is heightened in situations of unfamiliarity or mo-

ments of crisis, as those involved examine and evaluate what has been going on in the search for a course of action.[16] What we zero in on here are the points at which participants had to do the most work, where their agency was at its most vigorous. This is not a characterization or evaluation of the festival in general, then, but focuses on the problematics of festival representation from the vantage point of only one set of parties to that representation, the folk participants. A more complete and balanced account would require corresponding investigations of other parties to the production of the festival (producers, staffers, presenters, and so on), but here we do not aim for completeness or balance. In a very fundamental way, then, this is a biased account. The bias, however, was built in consciously from the beginning: we are concerned here to represent (which brings up our own representational problem in the writing of ethnography) the experience of the participants, in full awareness that producers or staffers or presenters may well have intended or experienced or interpreted things differently; indeed, we would expect so. We foreground the participants' experience, though, because up to this point it has been so thoroughly backgrounded, while festival producers and folklorists have taken ample opportunity to present their own views of how folklife festivals work. And while we acknowledge our *perspectival* bias, we have striven to avoid an *evaluative* bias.

ANALYSIS: PARTICIPANT FRAMING

Participants in the FAF are invited to the festival because they have expertise in a particular skill or performance genre. As noted earlier, however, they are given little systematic guidance to assist them in figuring out how to transform their everyday involvement in that activity into a recontextualized presentation or enactment for a festival audience. In fact, in the "Presenter's Guide" and the orientation given to presenters for the Michigan section, great emphasis was placed on contextualization and recontextualization as the responsibility of the *presenter*. It appears that musicians and dancers are asked to "perform," while those involved in crafts, foodways, and occupational activities are asked to "demonstrate," with the presenter then held responsible for aiding "the 'nonperformer' participants in material, occupational and culinary demonstrations [to] present the nature and meaning of their activity so that it becomes a performance."[17]

The participant handbook and the participants' orientation ses-

sion (held on the Monday evening before the festival begins) concentrate on the practical aspects of living while at the festival: how to get there, how to do laundry, where to eat, when one will be paid, and so on. At the orientation session participants also receive an explanation about the role of the presenters as "people who will try to provide the context for the audience . . . and help to answer questions." However, from the participants' perspective, these instructions do not deal sufficiently with the question of what the participant is actually supposed to do down on the Mall in front of an audience. People may well be not especially reflective about their everyday activities, but they are forced to reflect when asked to re-present that activity in the context of a festival. Under these unusual circumstances, the participants with whom we worked found that they needed a more conscious concept of what it was they did at home in order to adapt it to this new context.

Thus from the very beginning there is potential for confusion, since the participants recognize that they have been hired or commissioned to represent something by relatively well-educated experts who must have some standard in mind, but who appear reluctant to articulate it. At least one participant who we interviewed regarded his own reflexive grappling with a more conscious understanding of what he was about as one of the benefits of the festival for him. Still, others were clearly confused and disturbed, at least beforehand, by their lack of understanding of the philosophical basis and artistic standards of the festival. Michigan fiddler Ray Leslie,[18] for example, had a hard time for a while understanding why he had been picked to play, especially since the Smithsonian staff had asked him to emphasize the older tunes in his repertoire but then objected to the participation of the young hammered-dulcimer player who usually accompanies him on those pieces on the grounds that he was an extracultural revivalist (the dulcimer player eventually was allowed to play as well as present). The fieldworker who recruited Mr. Leslie could only assure him, "Don't worry. You're just what they want."

Depending upon the type of activity to be presented and the individuals involved, there is usually more than one possible way to construe "what it is that's going on here." Lacking either explicit recontextualizing instructions or explanations of the concept of festival, participants frequently need to redefine what they are doing in terms of some other, more intuitively understood kind of activity in which they feel they could appropriately be involved. Frequent answers to the basic question, "What does my activity here count as an instance of?" included: performance, demonstration, instruction, ex-

hibition, work, and various combinations or layerings of these (for example, a demonstration of a performance). The *performance* frame involves an assumption of accountability to an audience for an authoritative display of communicative competence, subject to evaluation for the relative skill and effectiveness with which the act of communication is accomplished, above and beyond its informational content.[19] *Demonstration*, by contrast, is a representational frame in which "a tasklike activity" is done "out of its usual functional context in order to allow someone who is not the [demonstrator] to obtain a close picture of the doing of the activity."[20] Some demonstrations may be framed as *instruction,* in which the purpose is to teach the observer how a task is accomplished. While performance, demonstration, and instruction focus on process as much as or more than on product, *exhibition* displays products—objects. Some craftspeople, knowing that the FAF is an activity of the nation's most prominent museum and understanding museums to be in the business of exhibiting objects, brought special objects of their own to exhibit in their work areas. *Work* is a frame in which the carrying out of a task for its usual functional purpose is the dominant consideration, without direct regard for an observing audience.

It may be well to emphasize again that frames, as we employ the notion, represent participant orientations to situations. Frames may be relatively clear and stable in a situation or they may be ambiguous and shifting. They may be shared among participants or they may be held differentially. They seldom, if ever, occur singly, but are characteristically layered or combined in shifting hierarchies of dominance. It is also significant that the festival, in its very essence, is set apart from everyday life and the workaday world; festivity is a form of play ("not serious," "make-believe") in which work is either backstaged or markedly reframed if it is to be consistent with the overarching play frame of the festival itself. There is a basic structural tension between work and play that cannot be avoided, though it may be resisted or bracketed out of attention.

It is in this consideration of framing, we would note, that poetics as well as politics are implicated in our analysis, though we do not highlight poetics in our presentation. Taking poetics in the Prague School sense of a foregrounding of the formal features of an act of communication, all acts of display accord a position of relative prominence to the poetic function, performance most of all.

Those participants who, for a variety of reasons, were able to figure out and sustain a simple but flexible interpretation of what they

were doing at the festival generally felt most comfortable and most satisfied with their participation. Participants who remained unsure about what it was that they were doing frequently felt out of sync with the proceedings and were dissatisfied with the quality of their presentation or with the treatment they felt they were accorded. It is important to recognize, though, that every participant felt that his or her reputation was on the line (i.e., they were all "performing" in that sense) and that framing problems had the potential of threatening participants with loss of face.

Demonstration seems to be both the interpretive frame that was most frequently invoked by the participants and the basic idea behind the festival. All of these activities are recontextualized within the festival and thus become representations or demonstrations of the activity as it would occur in its usual context under normal circumstances. Even the main-stage performances are at least perfunctorily framed as demonstrations of performance (because the presenter introduces the act by talking about the culture the performers come from, which is precisely the sort of information that the usual audience for the performance genre would not need). And for the participants, the most obvious way to adapt their usual activities to public presentation appears to have been to add more explanation and try to adopt an instructional mode. Still, performance and several varieties of work were also easily available as frames that could be combined with the underlying idea of demonstrating.

Understanding one's activity as a demonstration worked well for many of the people we studied. In contrast especially to the performance frame, the demonstration frame is relatively forgiving. Participants and presenters explicitly recognize that they are to treat the process as engaged in at home as a routine or scenario to be replayed in slow motion, dissected, expanded, and commented upon. The demonstrator can talk about the fact that he or she is not able to do it quite as it would be at home, which provides a built-in excuse for failures. It is understood that adaptations have had to be made—unusual cookware used to facilitate display, smaller batches prepared, ingredients substituted, seasonal foods cooked out of season—so explaining the cultural conversion is an expected part of the demonstration.

To put it another way, demonstrators *are* performers as well, since they are talking and acting in front of an audience, though without the degree of accountability that performance demands, especially since their activity-frame can not only sustain, but also actually encourage, maneuvers that would constitute a frame-break for a

pure performance. Moreover, it is a significant aspect of crafts, occupational, and foodways demonstrations at festivals that the attention span of the audience members, the limited time available for certain demonstrations (principally of foodways), and other practical considerations means that the products of the tasks on display are not completed or available during the demonstration itself. Thus, we have food preparation without finished dishes, fishing demonstrations without fish, furniture carving without completed tables or chairs, and so on. The result, then, must be demonstrations of process without product, a focus on the task rather than on the result for which the task is usually done and by which it is evaluated. While this might be mitigated by accompanying displays of products or outcomes, the special nature of festival enactments before audiences makes demonstrations of process an adaptive mode of representation.

People who became comfortable in the relaxed frame of demonstration could sometimes slip frame and, leaving behind their self-conscious amateur-theatrical status, enter into the enviable realm (from an actor's standpoint) where displayed enactment and real activity merge. For example, Steve Jayton, a river guide and boat builder, got so wrapped up in one of his streamside-cooking demonstrations that he instinctively turned to rinse his hands in the (nonexistent) stream.

Demonstrators also found that when they needed a break from people, they could retreat into the activity itself, "ignore people and just work," as Steve Jayton put it. Even though this refocusing of energy was a welcome relief for them, their activity still counted as demonstration (i.e., what they were supposed to be doing) to the onlookers, since they were still on view. Several craft demonstrators were amazed at the tenacity of watchers. Bob Jameson, a wooden-shoe carver from Holland, Michigan, described the attentiveness of the audience as "almost startling," far more intense than he had experienced with tourists who see his demonstrations in the Wooden Shoe Factory. Carl Arnold, who does Ukrainian egg-decorating and embroidery, described some of his audience as "practically taking out an apprenticeship" and regretted the lack of chairs for them. Apprenticeship, of course, is a learning mode, with the potential to key an instructional framing of the situation by the demonstrator.

Demonstration is, in its essence, always a secondary frame, "laminated"[21] on top of a primary activity; thus it coexists fairly easily with most other interpretations. Note, for example, that Bob Jameson, who demonstrates the making of wooden shoes as his regular job, was

engaged in a demonstration of a demonstration at the FAF (fascinating to us, unproblematic to him). Still, given that there is often more than one way to construe one's activity at the FAF, conflicts do arise. Steve Jayton generally adapted quite well to the festival environment, especially after he had rearranged his boat-building area to make himself more comfortable. Nevertheless, he could never quite make the demonstration and work frames mesh in terms of proper clothing. He had brought along the clothes that he really uses at home for working on a boat, but was ashamed to be seen in them on the Mall. As a demonstrator he was also a representative of Michigan and a person making a first personal impression on the public. So his work clothes stayed wadded up in a corner of the hotel room while his good sports clothes got messy from being worked in.

Frame confusions caused the greatest difficulties for Great Lakes fishermen Dave Ray and Gary Richards and for the Simons, a family string band. For Ray and Richards the whole festival context remained tenuous and problematic (on which, see more below). For them, the FAF made more sense as just another one of the odd jobs with which both now support themselves (because the kind of fishing they once practiced is now banned where they live). They consequently had less access from the beginning to the kind of festival detachment that makes reenacting or objectifying one's own activity and experience easier. In addition, the kind of activity they were supposed to be demonstrating was more difficult to adapt than most because it involves whole-body movement and requires large movement through space (unlike cooking, woodworking, and sewing) and because its stage context (the Mall) was much more different from its usual context (Great Lakes) than was the case for the demonstration kitchens and workshops used for smaller-scale activities. This meant that the demonstration itself had to be much more like a dramatized enactment, even though (1) these two men were less prepared than most for "playacting" because of their work mind-set, and (2) the scale of movement made voices almost impossible to amplify adequately. Ray and Richards soon recognized that by standing around and talking to interested people who asked questions they were doing what could be done with a large and somewhat inconvenient site. They consequently redefined their site as "a show place, not a talk place," and the staff seemed to be satisfied with that definition. Will Ralston and Neil Charles approached the situation differently when they arrived in the second week. Their technique was, in effect, to split frames apart, setting up the net over the boat as a pure display that could more easily

speak for itself (although they felt that a more comprehensive photo display was required to tell the story fully) and then devoting their energies to talking individually to visitors, using the site less as a stage than as a backdrop and reference point.

For participants on the demonstration stages, demonstration and performance flowed together fairly easily. For performance groups on the main stage, however, the ambiguous status of these presentations (exemplified by the presenter, who frames the activity as a demonstration by his or her presence at the beginning, but then doesn't intervene again to offer interpretation or explanation) left the participants to do some crucial negotiating for themselves.

The Nowickis, who have plenty of energy, tremendous confidence in themselves and the appeal of their Polish polka music, and a designated (also voluble and creative) emcee, found little difficulty in adapting to and making use of this format, aided by a more-than-usually-collaborative presenter, who had worked with them before the festival. In fact, Jim Nowicki took over some of the presenter's functions, sliding back and forth (in a manner facilitated by his usual self-parodying style) between the role of hearty polka-band emcee and demonstration explainer (he never managed to comment on his own quite traditional talk style, however, which would have been interesting). For the most part they could just perform, riding on the force of their music. But if it seemed that audience interest was lagging, they could shift into demonstration format, take a reflexive step back, and talk about some aspect of the tradition and their relation to it. They essentially reframed their performance as a re-creation or re-presentation of a polka-fest performance; their goal seemed to be to tell the audience enough about the fun-time settings in which they usually play to bring that context along with them and give the audience a taste of what it would be like to be there.

In contrast, the Simons had considerable difficulty finding a comfortable balance between performance and demonstration. In general, they seemed a little unsure of themselves, especially of their status as representatives of a country-music tradition that has many more famous and more accomplished proponents/performers. In conversations with a fieldworker before the festival, they professed themselves quite interested in bringing out the deep roots of their tradition and performing traditional American ballads. These, however, are the kinds of songs that they only remember from their youth or perhaps used to sing together for fun. They rarely if ever perform them. At the festival, they received little support for bringing these forward, since

this kind of song is less familiar to the general population and thus has less obvious appeal. Also, this music would have called for more contextualizing explanation than was included in presentations on the Michigan-music stage. Nor were the Simons prepared to supply this contextualization themselves. Their presenter provided a general introduction at the beginning of the set and then (with the most complimentary intentions) stepped aside to let them show off their skill. Left on their own, however, the Simons resorted to the only means of framing they knew—as performers, not demonstrators—regarding and relating to the FAF audience as if its needs and expectations were the same as those of an ordinary bluegrass-festival audience, which would have been more familiar with the Simons' style of music. They therefore relied extensively on the kind of old-timey repertoire that they most often perform and that they can manipulate to enhance audience appreciation (e.g., by inserting a fiddle breakdown to bring up the energy level when audience enthusiasm is waning).

The Simons' performances were also hampered by accommodations on the Mall and by the stage set-up, which projects similarly ambiguous messages about the status of onstage activities. Perhaps because these are "really" just demonstrations, there may be no perceived need to commit a sufficient proportion of the limited festival budget to providing a true greenroom, a cool, quiet, private place where performers can warm up, tune instruments, and prepare themselves mentally for going on stage. Still, once on stage, the participants *are* performing and they experience all the concomitant requirements and stresses. The Simons felt that they never did their best because by the time they actually got warmed up and in sync with one another they were almost through with the first set, and then there was no second set.

We anticipated that people who had had some previous experience in framing or re-presenting the activity in which they were involved at the FAF would have an easier time adapting to the festival frame. This proved true, but we found that what counted as recontextualizing experience was quite variable and subtle. Actual involvement in another festival was not necessarily helpful, depending on whether the individual's experience at the FAF would allow him or her to sustain the same definition. Thus Ray Leslie's extensive experience in playing jamborees seemed to stand him in good stead as preparation for playing to FAF audiences—spending days performing, jamming, and hobnobbing with other musicians is already part of his life.[22] The Nowickis, similarly, appeared to have had so much experience at polka

festivals and the like (and to have done enough reflecting about the significance of their various performance contexts) that they could either do a straight performance or reframe the performance as a demonstration of a polka-fest performance, talking about the qualities of that setting and audience in order to give the FAF audience a taste of what it would be like to be there.

For the Simons, in contrast, their experience at bluegrass festivals was actually deleterious, because it provided them a model that seemed reliable but was not quite appropriate for the FAF. Without enough verbal commentary to frame their activities as a demonstration, they resorted to trying to do their sets as straight performance and fell back on the most obvious bluegrass crowd pleasers. They did not, however, have the support facilities (especially an offstage place to tune up and warm up) that would let them really perform up to their capacity and standards.

For Bob Jameson, his extensive practical experience with doing shoe-carving demonstrations at work and with arranging "remotes" for trade shows and nearby festivals made his FAF experience very simple and painless. The FAF was just another day of work, not nearly as special to him as to most other participants.

Like the Simons, Steve Jayton and his fellow river guide and boatbuilder, Will Davis, found that their previous experience with festivals (one in Michigan) was less than helpful because it was so unlike the FAF and led them to expect quite a different physical set-up and audience. They found, however, that their experience as river guides proved an important ongoing resource for them in adapting to the FAF. At one and the same time, guiding is practical activity, demonstration, instruction, and performance (of expert fishing or graceful propulsion of the boat), and requires the guide to become a "diplomat for a day," learning how to interact at close quarters with clients who exhibit a wide variety of personality types.

Practical, logistical aspects of the activity to be represented often had a significant influence. Those people who were involved in fairly small-scale activities (cooking, embroidery, egg decorating, fly tying, even woodworking and boat building), which in their usual contexts are taught to family members, apprentices, or assistants by showing accompanied by explaining, generally adapted easily to festival presentations. They already had experience (albeit essentially unrecognized as such) of doing a form of demonstration. The participant's intellectual conception of the activity was important as well, however. Those who already saw their activity as set aside slightly from the

everyday, as art or the maintenance of tradition or an essential part of an ethnic identity to be invoked on symbolic occasions, had already made one of the most crucial adjustments. Those, in contrast, who regarded what they were doing as simply their occupation had a much larger transition to make in order to understand how they could qualify as "folk" and their activity as "folklife."

For the most part, participants do enjoy their involvement in the festival: they receive various benefits that make up for the stresses endured and they get increasingly caught up in the festival spirit. An accurate understanding of these individuals must take into account, however, that they do not always agree with or appreciate the identities they feel are being ascribed to them by the staff (or, indirectly, by the structures of the festival) or by the audience, and that they find various ways (often creative and humorous) to offer resistance.

As noted above, several of the people involved in the FAF in 1987 did not perceive themselves as involved in a folk activity by any stretch of the imagination; this is particularly common with occupational folklife. Lewis Van Buskirk, a master furniture carver, treated his demonstrations at the FAF mostly as he would those at a crafts show, although he did make one gesture to separate himself from the folk woodworker when, on a visit to the cultural-conservation section, he scattered his cards around the work area of a Mexican American woodcarver whose work was less finely executed than his own.

Phil Stevens, representing Michigan cherry growers, tended to disassociate himself entirely from the notion of folklife. Stevens has a master's degree and serves as the agricultural extension agent for his area. As he saw it, he had been invited only because the Smithsonian couldn't get any of the people who do treat the skills of tree care as a sort of customary wisdom; they were all too busy making their living at cherry harvests at that time of year. On at least one occasion, however, he was criticized by a staff member/presenter for not including more folklife in his presentation. By his account, he appears not to have responded directly at the time, but when reporting on the incident over supper he capped the story with the exclamation, "Folklife? What do *I* know about *folklife?*" and received appreciative laughter from Davis, Jayton, and Jameson, who shared his ambiguous situation. Stevens and Jameson later collaborated on a song about the "zoo bus," borrowed from the National Zoo to transport participants to and from the Mall. The song suggested, although in a joking fashion, that the name was an accurate index of their sense that they were

treated at times more like animals on display than people with minds, egos, and objectives of their own.

Davis and Jayton, though acutely conscious and proud of the river-guide tradition in their families, also rejected what Davis labeled the "folksy" subtext of "folklife." Davis was worried about being treated as a backwoods hick. He consequently took great glee in turning the tables on the presenters on talk stages, "getting *them* to answer *my* questions, for a change." Davis's remark is especially suggestive in calling into question the appropriateness of the interview format for festival presentations. Interviewing is a form of interrogation, and interrogation is an exercise of power; in many traditional societies the asking of direct questions may be a form of impoliteness or presumption.[23]

Ukrainian embroiderer Karl Arnold similarly disliked talk stages because they "deify" the presenter, and commented that he wouldn't come to a presentation labeled "Ethnicity and Craft" and didn't think it conveyed enough of what he was really about. Dave Ray, who maintained that participating in the talk stage had not been part of his contract, simply balked and refused to take part at all. The leader of the Yemeni group (who had come to the United States to go to college) directly contradicted a presenter on stage when the presenter asserted that most of the people who had migrated to Michigan were from the working classes, but this kind of baldly serious refusal to play along was atypical.

Louis Kettunen, a member of a Finnish singing group, developed one of the most elaborate and reflexive responses to the uncomfortable situation of being studied by folklorists. Kettunen is himself a social worker, his wife teaches Finnish, and he is both dedicated to performing Finnish music and highly conscious of the ironies involved in putting on a folksy guise and playing an ethnic part. His response was to involve the audience in a joke at the expense of the folklorists. During a performance a member of his group stumbled over the words in a song in Finnish and then stopped singing for a couple of lines while getting his bearings again. Kettunen first explained, though no one in the audience was taken in, that it was an old Finnish custom to leave out the words to particularly racy parts of songs. Then he looked straight at Richard Bauman and commented, "I've got to stop lying to these folklorists!" as if to say to the audience, "We all know that we're just here to have a good time, only the eggheads are trying to interpret it and get all kinds of deep meaning, and we don't give them straight

answers anyway." Telling a joke with a straight face and having it taken for truth is one of the few kinds of power that the objectified subject has; it is a way to throw a monkey wrench into the scholarly works.[24] Kettunen used the technique adroitly, but with a further twist, since he knew that Bauman knew precisely what he was doing—in effect, taking a stab at the folklorists and simultaneously establishing himself as an intellectual, able to play the reflexive game.

As noted above, many of the participants were very impressed with the tenacity of people who came to watch them, and tried to come up with creative means to encourage and facilitate prolonged attention. At the same time, however, practically everyone who did continuous demonstrations (musical performers and people in foodways, who only did one or two shows a day, seemed relatively immune) soon grew bored with repeating themselves and answering the same questions, which appeared increasingly inane. This was a part of the festival experience that none of them seems to have anticipated, and participants' responses demonstrate nicely the ways in which they were continually testing the bounds of the possible in the festival realm, trying out their own needs against what was expected of them. Great Lakes fishermen Ray and Richards expressed a desire to make a tape that would "answer the same stupid questions" over and over again, but actually adapted by doing more demonstrations. Arnold, the embroiderer, and Davis, a river guide, contented themselves by simply describing in conversations with sympathetic fellow participants the outrageous responses that they would have liked to give to audiences. Arnold threatened that if one more person asked him, "What are you doing?" as he sat embroidering, he was going to respond, "Painting my toenails!" Davis often doubted that people really listened to his detailed responses and reported being sorely tempted to tell them that he was "the son of a Polish immigrant from Vietnam" just to test them, a commentary on the fetishization of ethnicity at the FAF as well. At the same time they agreed that one of the fishing-lure makers, who seemed perfectly happy to repeat his salesman's rap innumerable times, was fake and not doing what a festival participant should.

Bob Jameson, the wooden-shoe carver, actually did put up a sign saying, "The wood I use is aspen," about three days into the festival. He recognized that that stupid question was also the easiest opening question for someone who might want to start a more interesting conversation and felt bad because he knew he was cutting down on

audience interaction, but left the sign up anyway because he just couldn't stand the repetition any longer.

Behind-the-scenes humor was the most prominent means of dealing with these problems, however, since it enabled participants to renew their own self-definitions while maintaining an acceptable performance persona. A perfect example was Phil Stevens's oft-repeated story about a woman who looked at the cherry pitter and asked, "Does this machine *make* cherries?" Accounts such as this, by depicting the questioners as stupid, allowed the participants to laugh at the audience instead of being annoyed, and at the same time to reassert and enjoy their own expertise.

In addition to figuring out how to define their own activities at the festival, participants need to deal with and are affected by other definitions of what the festival as a whole should be. Besides the participants, there are two other major groups involved in the festival, the production staff and the folklorists, each of which has a distinctive concept of festival, and also its own agendas, investments of self, and standards for evaluating the proceedings. For the production staff, by and large, a festival is conceived principally as a show or spectacle. The success of this show (and their own value as producers) is determined by audience reaction and by the smoothness of the presentation from the standpoint of an audience (e.g., technical quality of sound production, no gaps in the program). These *are* important factors, but the participants react negatively when they feel that their own needs and desires are overridden by a show-must-go-on agenda that has been imperfectly explained to them. For example, the Simons were asked suddenly to fill in when the Yugoslav Tamburitza ensemble arrived late on the first day of the second week. They forfeited their one morning off, rushed themselves, endured resentment from other performers who were delayed while the bus waited for them, Mike Simon was injured, and then they discovered that another replacement had been found and they weren't needed after all.

Folklorists, too, have their own agendas in terms of educating the public, disseminating their own particular interpretations of folk culture, and maneuvering for position and recognition among other folklorists. When presenters and participants already knew each other well, they also tended to agree on the interpretations that should be presented and were able to work as a team. But in other instances, participants were unhappy at having to illustrate something that they did not agree with, but had not found out about until the show was

underway, so that they couldn't escape. Comparative talk sessions were the most common ground for this type of problem. Commercial fisherman Gary Richards had considerable difficulty with the "Comparative Fish Stories" sessions (especially the first one) because he recognized, quite correctly, that the recreational fishermen had traditional "lies" and tall tales to tell, while he was telling personal narratives about serious and in some instances painful experiences. Richards felt that he had been tricked into telling before an anonymous audience personal and sometimes painful stories, the circulation of which he would have preferred to restrict and which might have been made to seem slightly ridiculous because they were out of place among all the whopper tall tales. (Jayton and Davis were similarly unhappy about the requirement to "spill your guts" in front of people.)

The point of the "Migration to Michigan" sessions was equally confusing to musician Mike Simon. In an interview after the festival he stated, "Personally, I can't see why anybody'd be interested in why I came from Arkansas to Michigan. . . . I think everyone realizes that almost always migration is due to economic reasons." He also gave indications that he was embarrassed by the sessions, which seemed to type him as a poor hillbilly who had had to go north to make a living.

The Nowickis also were involved in a struggle over who should define them and the point of their performances. It quickly became apparent that they had a very specific notion about the impression they wanted to convey regarding Polish polka music: to show that their music is fun and enjoyable and thus to invalidate other stereotypes of Polish identity tied to polka. Significantly, this agenda clashed with a festival staffer's directive about what they should be representing. She urged them to do more singing in Polish. They wanted to do some of that to demonstrate their pride in their heritage, but they also wanted to show how everyone can get involved (i.e., polka is not just for ethnics) and to demonstrate their erudition regarding the many different kinds of American polka music and appropriate dance styles.

In smaller and more immediate matters, too, both staff and participants are subject to embarrassment when signals are crossed, but it is Steve Jayton who must endure public embarrassment when he can't make fish and pancakes come off the grill at the same time (because the fish supplier provided medium-size lake trout, which are five times the size of brook trout) or Phil Stevens who looks the fool when he tries to tell people that cherry-pitting machines do a good, neat job while the machine, equipped with sour-cherry cups, is turning the larger sweet cherries into mush.

Misunderstandings also arise because participants do not necessarily understand two of the most central dynamics of a folklife festival, namely that it is supposed to be a fun and slightly crazy variation from the normal work routine and that it operates on an underlying philosophy of liberal respect and cooperation. Many staff members and volunteers who come back year after year do so because they thrive on the euphoria of overextending themselves and forming close bonds in a stressful situation. They know that festivals always click at the last minute, and they enjoy that thrill. Participants are not necessarily prepared for this. They tend to take their own activity fairly seriously, in part because they probably have put a lot of time and energy into it and in part because they know they are being paid to be there and want to give the Smithsonian its money's worth. Thus they are not reassured by what they perceive as "fifteen different people doing fifteen different things and hoping and praying the damn thing works," in the words of one participant.

AFTER THE FESTIVAL

For the most part, participants interviewed three to eight weeks after the end of the festival demonstrated even more positive attitudes toward the experience in retrospect. With the passing of time, the perceived embarrassments and infelicities had faded. Several participants spoke enthusiastically in the follow-up interviews of benefits expected or received. Karl Arnold, who is himself involved in studying and documenting the Ukrainian embroidery tradition he demonstrated at the festival, felt sure that his having been recognized by the Smithsonian would "trigger the research sources to be more open" to him. Muskrat cook Polly Elder talked a lot about the education she had received by meeting so many different people and about the new friends from all over Michigan whom she and her husband planned to go visit in the fall. Fiddler Ray Leslie was less vocal, but gave evidence of having gained a certain increased confidence in himself. The benefits of the festival even spread beyond immediate participants, for example to two friends of the Elders (pictured in the festival handbook) who are also centrally engaged in muskrat cooking but were too sick and frail to consider a trip to Washington. They received vicarious enjoyment from this validation of the importance of their tradition, and the Elders felt very good about being able to make these friends happy. Bob Jameson benefited from the festival in a fashion not anticipated by

standard models of the folk. Stories abound regarding traditional craftspeople who get so many orders or such publicity from being in a festival that they are able to buy a new house, bring in running water, or implement some equally major lifestyle change. Jameson's personal economic situation did not change as a result of his participation in the FAF, but the Wooden Shoe Factory in Holland, Michigan, was still receiving an increased volume of orders in late August as a result of the festival, and Jameson (who holds a degree in marketing and works for the factory in that capacity as well as being a craft demonstrator) was receiving recognition for his business acumen.

Not surprisingly, the prestige of being invited to the festival can cause friction between those who go and those involved in the same tradition who were not asked.[25] Ray Leslie had a falling-out with a friend and fellow fiddler, but by the time Leslie was reinterviewed in August, they had put the bad feelings behind them. The Elders discovered that some of the other people who belong to the club where they serve muskrat dinners were jealous and were treating them rather coldly, although in other ways they were being regarded as minor celebrities: complete strangers would come up to them in the shopping mall to say, "It couldn't happen to a nicer couple!" Whether this recognition will have any lasting impact on the popularity of the muskrat-cooking tradition remains to be seen, but it is worth noting that in the interpretation of the folklorist who recruited them for the festival, people in Monroe, Michigan, were eager to celebrate the Elders mostly because they would like to find a symbol for the town a little more glamorous than the La-Z-Boy company's headquarters and a little less laughable than being General Custer's hometown.

As was the case with many other aspects of the festival, those called upon to folklorize occupational pursuits had noticeably different experiences from the majority. In Will Ralston's hometown hardly anyone knows he went to Washington as a representative of Great Lakes commercial fishing at the FAF, and although he had a good time (except for being rather overwhelmed by the number of people) he remains uncertain why he was even asked to go. Among Gary Richards's family, what people seemed to remember about his participation was that they were, in their interpretation, "lied to" about the size of the sign they were promised thanking Richards's cousin for donating the demonstration nets.

Not surprisingly, most participants found that their involvement in the Michigan-only festival at East Lansing in August was easier and more relaxed than it was the first time through, in Washington. In-

stead of being faced with a strange new experience, participants felt involved in a reunion of old friends, onstage and off. Those involved in comparative talk stages, for example fiddlers Mike Simon and Ray Leslie, had gotten used to each other and were more relaxed and humorous and also (perhaps as a result of having had time to reflect on the matter) more able to articulate their philosophies vis-à-vis performance and festivals. Those who had felt a lack of preparedness in Washington could now compensate, thereby taking more control over the shape of their presentations. The overall air was more informal, which also let people experiment with format. The Yemenis augmented their dancing and music with a fashion show featuring clothing modeled by two blonde American women (who, it had been determined previously, did not fit the Smithsonian's authenticity standards). Rowena Leslie taught dances to children while her husband played. The simpler organization of this smaller festival and the influence of the Michigan organizers' greater in-depth knowledge and long-term acquaintance with a majority of participants may also have contributed to participants' positive experiences.

CONCLUSIONS

We have attempted in this essay to share with readers some of the complexity of participation in a folklife festival in terms of the politics of participation from the experiential perspective of the participants themselves. There is a great deal more that could be said about the subject that we do not have the space to deal with here. In our more extended report, for example, we explore the participants' own political agendas that help motivate them to take part: lobbying for the restoration of certain outlawed fishing methods, influencing public opinion in favor of commercial access to muskrat meat, capitalizing on the prestige of participation in the Smithsonian festival to increase one's access to public arts funds, and so on. Taking representation in another sense, the political dimensions of the process by which participants come to view themselves—and are viewed by others—as representatives of groups, communities, or other constituencies are also worthy of investigation: a fiddler who takes himself to be an exemplar of a particular regional musical tradition, say, as against a practitioner of a craft rooted in a specific ethnic group who nevertheless resists personal affiliation with that group because of his distaste for the in-group politics of ethnicity. And of course, a comprehensive account

of the politics of representation in a folklife festival should attend equally to all who are involved: producers, staffers, sponsors, and audience members as well as participants. We have foregrounded the participants to redress an imbalance as well as to explore a method. In the face of a tendency to relegate participants to the status of passive display objects, we have approached them as agents, reflexive, adaptive, and critical, crafting the representations in which they are involved, working to figure out what they should and could be doing within a folklife festival, negotiating their way through structures of power and authority, and offering firm, if usually good-humored, resistance when they feel that their own sense of identity and self-worth is impinged upon by others. To understand this experience opens the way, at least, to a more humane and equal politics of festival representation.

NOTES

1. Richard Bauman, "Folklore," in Erik Barnouw, ed., *International Encyclopedia of Communications* (Oxford: Oxford University Press, 1989).

2. See, for example, Charles Camp and Timothy Lloyd, "Six Reasons Not to Produce a Folk Festival," *Kentucky Folklore Record* 26 (1980); Burt Feintuch, ed., *The Conservation of Culture* (Lexington: University Press of Kentucky, 1988); Elizabeth C. Fine, *The Folklore Text: From Performance to Print* (Bloomington: Indiana University Press, 1984); Barbara Kirshenblatt-Gimblett, "Mistaken Dichotomies," *Journal of American Folklore* 101, no. 400 (Apr.-June 1988); David E. Whisnant, ed., *Folk Festival Issues.* John Edwards Memorial Foundation Special Series, no. 12 (Los Angeles: John Edwards Memorial Foundation, 1979); and David E. Whisnant, *All That Is Native and Fine: The Politics of Culture in an American Region* (Chapel Hill: University of North Carolina Press, 1983).

3. The terminological distinctions have been and continue to be the subject of extensive debate, most of which is not germane to this paper. See Bauman, "Folklore," for a discussion of the principal issues. For the current mission statement of the Smithsonian's Office of Folklife Programs, whose Festival of American Folklife is the focus of this paper, see Office of Folklife Programs, Smithsonian Institution, *1988 Festival of American Folklife Program Book* (Washington, D.C.: Smithsonian Institution, 1988), 6.

4. See Feintuch, *Conservation of Culture,* and the references therein.

5. We employ the terms *folklife festival* and *folk festival* interchangeably.

6. Dean MacCannell, *The Tourist* (New York: Schocken, 1976).

7. Roger D. Abrahams, "Shouting Match at the Border: The Folklore of Display Events," in Richard Bauman and Roger D. Abrahams, eds., *And Other Neighborly Names: Social Process and Cultural Image in Texas Folklore* (Austin: University of Texas Press, 1981); Beverly J. Stoeltje, "Festival," in Erik Barnouw, *International Encyclopedia of Communications* (Oxford: Oxford University Press, 1989).

8. Ormond Loomis, "Folk Artisans under Glass: Practical and Ethical Considerations for the Museum," in Simon Bonner, ed., *American Material Culture and Folklife* (Ann Arbor: UMI Research Press, 1985); Charlie Seeman, "Presenting the Live Folk Artist in the Museum," in Patricia Hall and Charlie Seeman, eds., *Folklife and Museums* (Nashville: American Association for State and Local History, 1987).

9. Compare Pierre Bourdieu, *Distinction: A Social Critique of the Judgement of Taste* (Cambridge: Harvard University Press, 1984), and Michael Thompson, *Rubbish Theory* (Oxford: Oxford University Press, 1979).

10. Patricia Sawin, "The 1987 Smithsonian Festival of American Folklife: An Ethnography of Participant Experience" (Folklore Institute, Indiana University, Bloomington, 1988, photocopy).

11. The members of the Indiana University research team were Inta Carpenter, associate director for special projects of the Folklore Institute, Richard Anderson, Garry Barrow, Patricia Sawin, William Wheeler, and Jongsung Yang; Richard Bauman was project director. We would like to offer our sincere thanks to Peter Seitel, Richard Kurin, Laurie Sommers, Thomas Vennum, Jr., and virtually the entire staff of the Office of Folklife Programs for their unfailing support, assistance, and good will during the entire course of the project. Special thanks to Arlene Liebenau, who served as our liaison with OFP. Responsibility for this report rests with the authors.

12. Nicholas R. Spitzer, "Presenter's Guide: 1987 Festival of American Folklife" (Office of Folklife Programs, Smithsonian Institution, Washington, D.C., 1987, photocopy).

13. On frame analysis see Erving Goffman, *Frame Analysis* (New York: Harper and Row, 1974).

14. It is also likely that our attention to the participants increased their reflexivity still further.

15. Compare Sawin, "Ethnography of Participant Experience."

16. Our work could not have proceeded without the kind assistance of folklorists Kurt Dewhurst, Marsha MacDowell, Janet Gilmore, James Leary, Timothy Cochrane, Alan Cicala, Dennis Au, Eliot Singer, Thomas Vennum, Jr.,

Nicholas Spitzer, Laurie Sommers, and Glenn Hinson, none of whom is accountable for any errors of fact or interpretation that may occur in this paper.

17. Spitzer, "Presenter's Guide," 10, 14.

18. Pseudonyms for the festival participants have been used throughout this paper.

19. Richard Bauman, *Verbal Art as Performance* (Prospect Heights, Ill.: Waveland Press, 1977).

20. Goffman, *Frame Analysis,* 66.

21. Ibid., 82.

22. Compare Spitzer, "Presenter's Guide," 9.

23. See, for example, Esther Goody, ed., *Questions and Politeness* (Cambridge: Cambridge University Press, 1978), and William Samarin, *Field Linguistics* (New York: Holt, Rinehart and Winston, 1967), 144–45.

24. See Américo Paredes, "On Ethnographic Work among Minority Groups," *New Scholar* 6 (1977), 1–32.

25. Eliot A. Singer, "Anti-Celebrity: The Folkloric Imperative" (paper presented at the annual meeting of the American Folklore Society, Cambridge, Mass., 28 October 1988).

CHAPTER 17

Cultural Conservation through Representation: Festival of India Folklife Exhibitions at the Smithsonian Institution

RICHARD KURIN

A ccepting the current structure of national, regional, city, and local museums, why mount new exhibitions? After all, those out-of-date halls of evolution, the cases of stuffed birds reflecting the 1950s display aesthetic, mannequins dressed in first ladies' gowns, dioramas of Indians scalping settlers, and walls and walls of dusty landscapes, serious portraits, and well-priced contemporary abstractions on canvas have a certain charm to them. Kids visiting the museums don't seem to notice, so why spend millions on new museum shows for small numbers of discerning visitors?

Museum administrators and curators generally offer a number of public and private explanations. We mount exhibitions in order to disseminate new research and scholarly understandings in popular form (e.g., the Crossroads of Continents exhibition in the National Museum of Natural History). We promote selected cultural and social values (e.g., A More Perfect Union in the National Museum of American History). We conduct public relations for industries and political entities (e.g., Sweden: Paintings from the Royal Collection in the National Gallery of Art). We honor the tastes of connoisseurs and display newly acquired treasures bought by benefactors (e.g., A Jeweller's Eye in the Arthur M. Sackler Gallery). We help set standards of aesthetic and market value for art and artifacts (the Hemphill collection in the

National Museum of American Art). And now, with this volume, we might mount exhibitions to provide the raw material for a new field of museum criticism and scholarship.

Complex and multiform museums such as the Smithsonian (of which all the museums mentioned above are part) are likely to mount exhibitions for all of the above reasons. Indeed, the lack of a single goal in mounting exhibitions and sponsoring the research and collection activities that support them may be regarded as desirable. On the other hand, museums, particularly publicly supported museums, must continually ask themselves the question, who benefits from exhibitions? A diversity of motivations for producing exhibitions usually means a lack of focus. Because goals are unclear, the de facto result is that the people who work for and control museums often control the exhibitions. When the primary beneficiaries of exhibitions are people of the museum world, art dealers, scholars, critics, and sponsors, there is reason to rethink the museum's purpose, particularly in relation to those who are excluded.

Since their origin and expansion in the nineteenth century, museums of natural history, art, and cultural history have been faced with the challenge of collecting remnants and samples of natural and cultural forms before such are lost, diffused, or forgotten. As evidence of prehistoric species is dug out of the ground, recoverable bones and fossils find their way into museums. Art museums attempt to gather evidence of artistic careers and visions, lest such be scattered beyond retrieval. Cultural-history museums collect artifacts as symbols of events rapidly receding in the public memory.

Museum professionals generally define the challenge of museum work as how to understand and represent the whole by the part: how to represent the epoch of the dinosaurs from bones, the eye of Picasso from several paintings, the Civil War from guns and uniforms. Motivated by this challenge, museums collect and document before specimens, creations, and memories disappear.

Innovative programs arising from many museums, some national, some local, suggest a more active approach to museum work. In such programs, a museum curator of biology views his or her role not as that of a collector of dead specimens, but rather as that of a curator and conservator of the living rain forest. The art curator sees his or her role as that of encouraging and supporting aesthetic innovation among young artists from diverse contemporary communities. The curator of American social history encourages the children of recent immigrants from Southeast Asia to help document the achievements of their par-

ents. In these cases, it is the living whole rather than the dead specimen that is encouraged. The curatorial concern is directed not toward what is in the museum, but toward the living context—natural and/or cultural—from which the object, specimen, painting, or document is generated.

Given the massive destruction of world cultures in the twentieth century, including minority cultures in the United States, museum strategy is all the more important. The lesser goal involves the effort to collect artifacts and document lifeways before those cultures or memories of them disappear. The greater goal is for museums to play a role in the conservation of those cultures, to actually help those cultures survive in the contemporary world. The resource with which museums can accomplish this is not food nor money nor partisan political power. Rather, museums offer a somewhat unique social and intellectual platform that can be used to represent cultures. Museums are empowered with the discourse of scholarship and science. This discourse is potent, for while it supports, advertently or inadvertently, overtly or covertly, positions that are broadly political, it also allows museums to represent themselves as neutral, apolitical. This discourse, combined with the social position of museums, empowers the museum as an institution to publicly confer legitimacy—of knowledge, of an aesthetic, of a sense of history, of cultural value.

In this paper I report on two extraordinary exhibitions—Aditi: A Celebration of Life, and Mela! An Indian Fair—which took place in the summer of 1985 on the Mall in Washington, D.C., as part of the Festival of India program mounted by the Smithsonian Institution. I do so in order to consider how museum representation can play a role in the conservation of culture, and how representation in a museum context can itself enact and extend that culture.

ADITI AND MELA AS EXHIBITIONS—BACKGROUND

While organized under the aegis of the Festival of India, both the Aditi and Mela exhibitions had been discussed and were in the making prior to plans for the festival. The Smithsonian's Office of Folklife Programs had conducted research, supported collaborative planning, and carried out negotiations with Indian colleagues for some time—for Aditi since 1977 and for Mela since 1981.

The Aditi exhibition was mounted in the National Museum of Natural History from 4 June to 28 July 1985. The exhibition hall was

completely remodeled to suggest a rural Indian environment and house some two to three thousand objects ranging from museum pieces loaned by the queen's collection in London and more than fifty Indian institutions to contemporary craft items.

The exhibition was arranged thematically in terms of the life cycle—inspired by but only approximating the Hindu *samsara*. The exhibition began with symbols of fertility and continued through marriage, conception, birth, first feeding, childhood, growing up, and moving out. Rather than a linear representation of biography, the switch from parents having children to children becoming parents illustrated the truly cyclical nature of life evoked by Aditi, who is in the Vedas both the mother and daughter of Daksha. The thousands of objects were arranged in appropriate sections of the exhibition—fertility objects in the first section, wall paintings in the nuptial chamber, cradles in the section on birth, toys in the section on growing up, and so on. As an alternative to a chronological or spatial ordering, objects—royal and rustic, contemporary and ancient, Hindu and Muslim, southern and northern—were arranged according to the theme in an effort favoring cultural holism over atomistic particularism. It is important that only a small portion of the objects were in cases. Most were set in mud-wall niches, stood on platforms, displayed in stalls, and otherwise directly available to visitors (much to the dismay of our security people).

Complementing the objects and their settings were forty folk artists—craftspeople and performers—who worked in specially designed spaces, illustrating their creative role in the life cycle. A Baul sang of cosmic fertility, a Warli wall painter depicted tribal courtship dances, Rajasthani women applied *mehndi* to the hands of visitors in preparation for marriage, Muslim Langa musicians sang songs to welcome the newborn, and magicians, puppeteers, jugglers, and storytellers initiated children into India's history, myth, and wisdom. Ten of the artists were themselves children. A family with two sons, aged nine and four, were included in the forty people, who originally were from thirteen different Indian states.

In addition to objects, people, and settings, the exhibition included considerable descriptive, interpretive, and expressive commentary on signs, as well as translators, who interpreted questions, answers, and comments for both folk artists and visitors.

Mela! An Indian Fair was part of the nineteenth annual Festival of American Folklife held outdoors on the Mall from 24 June to 6 July

1985. Mela served as a much-expanded form of the last section of the Aditi exhibition, which was devoted to fairs and festivals.

Mela was a composite fair presenting rituals, crafts, performances, foodways, and commercial traditions from a variety of Indian regions. More than one hundred tons of terra-cotta tile, bamboo, coconut leaves, *shamiyana,* and *kanath* canvas were sent from India to construct the temporary *mela* site. Some forty-five structures were built, including a masonry facsimile of a temple, stalls for craft sales and demonstrations, and a tandoor kitchen.

Mela was organized conceptually on the basis of indigenous Indian models. Hindu action orientations (such as *moksha, dharma, artha, kama*) informed the selection of ritual, educational, commercial, and entertainment activities to be included in Mela. Traditional Indic notions of the elements (*panch mahabhuta*) and their associated sensations (i.e., sound, touch, sight, taste, smell) provided a model for the exhibition's spatial organization.

Animated by thirty-five artisans from India and thirty Indian Americans, ritual activities included daily Ganesha *puja* (worship), the mud-sculpting of a Durga mother-goddess icon, the construction of a paper-and-bamboo *taziya* (memorial) for the Muslim Muharram festival, and the building and burning of forty-foot-high effigies of the demon king Ravana and his allies. Educational exhibits included an elaborate photo-and-text-panel display on India and its fairs, festivals, pilgrimages, and religious communities.

Sections of the exhibition devoted to sound (which is associated with an etherlike element) were animated by drummers from different parts of India, performances of Punjabi *giddha,* Gujarati *garba,* and Bengali devotional songs, and featured stalls selling musical instruments. The touch section (associated with the element air) included cloth, mobile, and fan stalls, a kite maker, acrobats, and a juggler. The sight section (associated with fire and form) was replete with magicians, a trick photographer, a potter, a toymaker, impersonators, and shops of varying descriptions. Some forty cooks demonstrated their skills in the taste section—cooking in tandoors, making *jalebis,* and serving from *deghchis* more than five thousand meals per day. The smell section included incense, essence, and cosmetics stalls, as well as a flower-garland maker. In sum, the exhibition offered to visitors a sensual event within which, as in *melas* in India, ritual practice, education, commerce, and pleasure are interwoven and arguably more completely and appropriately understood than when considered in isolation.

The Aditi and Mela exhibitions were quite successful from the perspectives of the public, the local Indian American community, educators and staff, sponsoring organizations, and the participants themselves. Mela attracted 1.2 million visitors, Aditi 130,000 (the limit of the museum's capacity; there were two-hour waits to get into the exhibition on weekends). Both exhibitions were hailed by the popular media, art critics, area specialists, and scholars in the United States and India. Hosts of VIPs, including Prime Minister Rajiv Gandhi, Nancy Reagan, Jacqueline Onassis, and members of the U.S. and Indian cabinets, visited the exhibitions. Local Indian American community groups were mobilized and became involved in the exhibitions, supplying volunteers and materials and planning auxiliary events. Even local Indian restaurants and groceries benefited, gaining customers and attention. To accompany the exhibitions the Smithsonian produced a book/catalogue, *Aditi: The Living Arts of India*,[1] with essays by leading Indianists. It sold more than forty thousand copies and has subsequently won both scholarly and popular acclaim. In addition, the Smithsonian produced an award-winning documentary film on the Aditi exhibition; more than one hundred footlocker-sized educational kits on Indian culture, which were distributed to South Asia outreach centers and museums for primary and secondary schools; an ethnographic film series; a *Smithsonian* magazine article on the participating folk artists and their community; and workshops for both teachers and visiting children, in which Indian folk artists instructed hundreds in their artistic practice.

THE POLITICS: WHY THE EXHIBITIONS?

For the Indian folk artists, Aditi and Mela were not merely exhibitions. The core group of participants were members of a cooperative, Bhule Bisre Kalakar (Forgotten and Neglected Artists), who live as squatters in a makeshift tent-and-shanty village in Shadipur on the outskirts of Delhi.

These poverty-stricken, low-caste musicians, puppeteers, jugglers, acrobats, and street performers and their families came from all over India. Originally, and for some even until a generation ago, these families were patronized by local rulers and regional courts. Some were attached to patrons continuously; others combined patronage with seasonal cycles of itinerancy, visiting fairs and pilgrimage sites

and undertaking traditional rounds of villages. The political demise of local-level patrons, coming with a particular finality after independence (especially in Rajasthan), enforced harsher regimens of itinerancy. At the same time that such artists sought new patrons and audiences, popular forms of entertainment—the Indian cinema, radio, and more recently television and videos—militated against the public demand for traditional performance.

Many itinerant performers sought the cities for their promise of large audiences, new performance venues, and new forms of patronage. Some succeeded in playing for tourists, for business or celebrity functions at hotels, or even for government agencies seeking to advertise the benefits of family planning through puppet shows. But most, like those in the Delhi slums in the 1970s, had to perform on the streets or continue to travel to local and regional fairs.

Under the law, street performing artists are regarded as beggars. They are subject to at least harassment, if not arrest. Their art is regarded as a sham, a mere means to solicit donations. In the mid-1970s they were viewed as part of the illiterate, vulgar urban-slum-dwelling population engaged in nonproductive activity. The irony is clear to many of the artists, who perceive themselves as keeping alive valued traditions. The *bahrupiya* impersonators invoke the power of the gods to play their roles, the puppeteers inspire the young with tales of history, valor, and still-held Indian ideals, and acrobats preserve in their movements and feats the ancient yogic *asanas*.

In a drama recounted as well in Salman Rushdie's partially fictionalized *Midnight's Children*,[2] these artists were, among other slum-dwellers, bulldozed from their homes in old Delhi as part of slum-clearance and social-renewal programs. Some fled the region, some were involuntarily sterilized, and most settled under a bridge on the outskirts of Delhi in a place called Shadipur. In Shadipur they built a squatters' camp on unused public land and began to rebuild their lives.

They formed a cooperative, the purpose of which was to secure a legitimate place in Indian society. The cooperative advocated their right to practice their art and build homes upon the land they occupied. Bolstered by the talent of designer Rajeev Sethi and the support of folklorist and government adviser Pupul Jayakar, folklorists Komal and Keshev Kothari, ethnomusicologist Nazir Jairazbhoy, architect Hasan Fathy, and many others, this community has sought through political action, cottage industry, and artistic exhibitions recognition of its role and right to its land and livelihood. The guiding philosophy

of these artists has been that recognition of the value of their artistic and cultural achievements will bestow benefits on them as practitioners.

The exhibitions in Washington, as well as Aditi's two previous incarnations in Delhi (1979) and London (1982), were conceived by Rajeev Sethi and considered by him, by artists from Shadipur, and by the Smithsonian's Ralph Rinzler and Jeffrey LaRiche (at that time respectively director and deputy director of the Office of Folklife Programs) to be a means to this end. The exhibitions were not diversions from reality but tools for its reconstruction. That reconstruction, as it emerged in the cooperative and continues to evolve, envisions an economically and aesthetically viable role for the exemplary practice of particular traditional arts.

At the Smithsonian, the massive media attention—network television, *Time*, the *New York Times,* the *Washington Post,* National Public Radio—huge crowds, critical acclaim, and visits by personages from George Schultz to Mary McFadden to Ravi Shankar forced a recognition of these performers' and craftspeople's artistic and cultural achievements. Despite their tenuous survival, the verbal, musical, and material artistry was exemplary and still grounded in community life. When Prime Minister Rajiv Gandhi visited the Aditi exhibition, he acknowledged the participating folk artists as India's "foremost cultural ambassadors." This transformation of status was not lost on the people from Shadipur, who a decade earlier had been regarded with contempt by Indian officials.

In India, the success of the exhibitions led the prime minister to promise to work for revocation of the beggary law affecting folk artists. He also promised to help the people of Shadipur obtain title to land. The government of India initiated a National Cultural Festival and established various regional centers for the study and presentation of the folk arts. High-volume sales of Indian crafts through the Smithsonian convinced Indian government corporations of the viability of such items on the international market. The Handicrafts and Handlooms Export Corporation, which cosponsored Aditi and Mela, sought to revitalize its original Gandhian philosophy by supporting and strengthening folk artistic activity at the local level. Organizations such as the Birla Academy and the India Tourism Development Corporation (another cosponsor) drew up plans for developing permanent means for presenting the folk arts.

The expectations of individual folk artists who participated in Aditi and Mela have been raised. Some have directly benefited from

their celebrity status upon returning to India. Others have fared less well. Overall the publicity, attention, and acclaim received by the Aditi and Mela participants should extend to their brethren in terms of legitimating their role in Indian society and insuring their right to practice their art and, in some cases, their right to own the land that they have been promised. The establishment of regional centers, festivals both national and international in scope, and new programs by government agencies and a heightened awareness of the worth of traditional arts speak to the possible fulfillment of this hope.

This effect was somewhat mirrored in the Washington, D.C., area among members of the Indian American community. A Friends of India committee, organized with the help of Elizabeth Moynihan and the Indian embassy, enabled the active recruitment of interested volunteers. Of the more than three hundred volunteers who participated in the Mela and Aditi exhibitions, well over ninety percent were Indian or of Indian descent. With only a few exceptions, these volunteers were middle-class people, from relatively high-status groups, and from families of white-collar professionals. Most volunteers fell into one of two categories—older, retired or semiretired professionals or housewives born in India, and bright, motivated teenagers and college students either born in the United States or well acculturated to contemporary American life.

Prior to the opening of the exhibitions, we held training sessions for volunteers to inform them about the particular exhibits, performing groups, and craft demonstrators, their role as translators and helpers, and other logistical matters. My assistant for Aditi, Mark Kenoyer, who grew up in India, explained in frank terms the social status of the folk artists who would animate the exhibition. "These people" (I paraphrase Kenoyer) "are like those who come up to you on the streets of New Delhi. If you saw them there, you would walk away from them, or if driving, roll up your window and tell them to go away."

Thus the volunteers were supposed to serve and help these poor, low-caste, "vulgar" street people. There was a lot of squirming in the room, but little doubt of the honesty both in Kenoyer's remarks and in the way they were received.

While we may have lost a few volunteers, and while some volunteers may have been squeamish about the project, most did participate. Because the exhibitions were such a big success, and because they drew such incredible media and VIP attention, the folk artists became celebrities of a sort, certainly in the eyes of volunteers. Vol-

unteers felt they were helping the Smithsonian with the exhibitions, and were proud of their daily interactions with the artists from India who were so famous and well received by the American public.

Some of the older volunteers, who in India might have refused to eat or drink with most of the artists, were now serving food to them, eating next to them, and even carrying water and tea to them in the exhibitions. Many of the teenagers, who were initially ambivalent about Indian culture generally (vis-à-vis American popular culture) and who were familiar with the high value placed on Indian classical dance and music, discovered artistic traditions and lifeways unknown to them. This discovery led some of the volunteers to take instruction from the folk artists on how to play folk instruments, how to dance, and how to perform magic tricks. It led others to intimate, sometimes romantic, personal involvements. The effort to identify with the Indian artists perhaps reached a peak with our good-bye party, during which many of the volunteers dressed up in the clothing of the folk artists and imitated their personal and artistic mannerisms in humorous but revealing skits, much to the hilarious laughter and enjoyment of all.

The status inversion and leveling apparent in the relationship between volunteers and folk artists had several consequences. First, local Indian families and organizations invited folk artists as distinguished guests to their homes or community functions. Folk artists were continually receiving awards, gifts, and invitations. Second, vitalized older volunteers became more active in presenting their traditions, through lectures, demonstrations, and community events, to the broader U.S. public. Third, younger volunteers became more interested in Indian culture, a culture about which they knew little and in which they had not invested much energy. They began talking more to their parents about India, taking courses, and reading books. Several volunteers traveled to India after the exhibitions to meet participants and conduct amateur fieldwork. One volunteer, brought in because her mother, an Indian immigrant, was a participant in Mela, is now pursuing a graduate degree in Indian studies.

The volunteer program also helped bring into the consciousness and programs of the Smithsonian a relatively recently arrived immigrant group that heretofore had not identified the Smithsonian as being concerned with their culture or history. The Festival of India exhibitions helped the Smithsonian reach a new and broader audience. Members of the Indian American community used the opportunity to carry over their participation beyond just the exhibitions or the Festival of India. In 1986, for the Festival of American Folklife, our chief

volunteer and perhaps twenty-five percent of our volunteers for the Japan program were Indian Americans who first had been exposed to the festival through Mela. Some of our volunteers became docents in the National Museum of Natural History; others took staff positions in other museums and offices in the Smithsonian. And still others began research projects in collaboration with Smithsonian scholars.

THE POETICS OF AN ETHNOGRAPHICALLY REAL EXHIBITION

As both museum visitor and cultural anthropologist I am more often than not assaulted with the generic U.S. museum exhibition. In the generic exhibition objects find their way into cases (purportedly for insurance and security reasons), removed from makers, users, and viewers. If considered an art object, it gets a pedestal or a nice place on the wall and a spotlight. If a craft object, it is often displayed in some artistic-looking but arbitrary grouping of like items. Usually the people who make or use the object are not included in exhibitions; if they are, it is generally vicariously, through photographs or mannequins—frozen representations of people as objects. When authentic practitioners are included in a living exhibition they usually sit at standard tables or perform on proscenium stages according to a schedule, occupying a space and a time neither designed for them nor suggestive of the usual context of artistic practice. An alternative mode of representation, living-history museums such as colonial Williamsburg, may replicate physical settings, but in substituting actors or revivalists for authentic practitioners they generally disarticulate demonstrated traditions from their biographical, historical, and social contexts.

Museums and museum exhibitions may be considered as forms of presentation with their own cultural roots and richness of meanings. In a museum we expect to see exhibitions; exhibition halls or spaces tend to be separated from people-function spaces. Rest rooms, cafeterias, information desks, and shops are kept distinct from exhibition areas—enforcing divisions between education, on one hand, and commerce, provisioning, and maintenance, on the other. Whether offering a presentation or reconstruction, we understand an exhibition to be just that, removed from the reality of those represented as well as from our own. Exhibitions are bounded spatially by entrances, exits, and walls and temporally by daily and grand openings and closings. Exhibitions have their own routinized organization and processes of formation involving institutional structures, curatorial and support staffs,

funding arrangements and sponsors, building management, loan agreements, and so on.

If exhibitions are a nineteenth- and twentieth-century mode for the presentation of culture, one may ask whether the format and aesthetics of that form are appropriate to that which is represented. If folk art is distinguished from elite and commercial art in its unification of object and context, pleasure and utility, meaning and audience in familiar contexts, does it then make sense to have exhibitions that generically present the objects of folk art as if they were paintings in the National Gallery or concert performances in the Kennedy Center? In short, folk arts and folklife (particularly that of India) suggest aesthetic and organizational notions that are at odds with generic museum exhibitions. It makes sense for our presentational formats to be consistent with the features of those arts and cultural activities we seek to represent.

The Smithsonian's Office of Folklife Programs, with two decades of experience in the presentation of living cultural traditions through the annual Festival of American Folklife, was able to achieve such a format in the Aditi and Mela exhibitions. This was accomplished partially through design—as a result of Indo-U.S. scholarly, bureaucratic, and technical collaboration—and largely by providing an appropriate context for Indian craftspeople and performing artists to act socially, structuring their own environment.

For the Indian folk artists the exhibitions were real in a way different from that in which they were perceived by Smithsonian staff and the general public. For the Indians the exhibitions represented a political act; the very existence of the exhibitions, rather than their texts, constituted their most compelling feature. For the Smithsonian, exhibition semantics, rather than pragmatics, were foregrounded, with attention focused on installation, exhibition texts, their interpretations, exhibition artistry, and the relationship of these elements to an overall thematic message. For the public it was a show—a good, engaging, and entertaining one that taught them something about India.

The Indian artists also did not share with the Smithsonian personnel the culture of museums. The Smithsonian's notion of an exhibition as a rationally planned, statically ordered, and—above all—predictable set of activities was only vaguely understood, and not very realistic or comforting. Despite initial and in some cases continuing efforts from a variety of quarters, Indian artists obfuscated the boundaries that define exhibitions as such. For these participants, the exhi-

bitions were part of life, an organic event calling for creativity and improvisation as a means of dealing with life's contingencies. "What do you mean, an exhibition?" asked one of the participants on the opening day of Mela in response to my context-setting speech. "I perform at fairs in Rajasthan, in Gujarat, in Haryana. This is just another *mela*, only it's in Washington." And this participant came prepared—his magic to perform and his rings and gemstones to sell as he bantered with the crowd.

Despite such differences, both the Smithsonian and Indian participants had to deal jointly with the selection of folk artists who would come to Washington. The Smithsonian's approach, developed over years of mounting the Festival of American Folklife, is to choose exemplary practitioners of the tradition as recognized within the community. Root forms of the tradition are preferred to derived or evolved forms, and performances and crafts intended for in-group audiences or users preferred over those intended for outsiders or tourists. Traditions to be represented are chosen on the basis of program content—theme, curatorial statement, or the need to survey accurately a geographic or political unit.

In this case, the development of the exhibition themes came about through the efforts of Rajeev Sethi. A brilliant designer, adept at community development, grass-roots social organization, and cultural representation, Sethi developed exhibition themes over the years with Shadipur artists and others. The themes were broad enough to serve as a mechanism for including a wide range of artistic activity. The themes resonated with Smithsonian notions concerning the types of activities amenable to public presentation on the Mall. The idea of celebrating the life cycle and staging a rural fair were consistent with the folklorists' comfort with presenting display events—expressive forms that artists use to represent themselves publicly. Hence the folk artists would enact in the Smithsonian exhibition context the types of performances and demonstrations usually enacted publicly in India.

Similarly, Smithsonian interest in exemplary practitioners was mirrored by the concerns of Sethi, Indian folklorists, and the artists themselves. Discord over who was selected was quite limited, involving only the case of the puppeteers. It was within this community, the most populous of Shadipur, that issues of participant selection were tied to larger factional and economic conflicts.

In almost all cases artists had to make choices about repertoire. Smithsonian concerns for authenticity, root forms, and community-

oriented performance were variously debated, rejected, heeded, or ig-
nored, depending upon specific cases. Sethi and other Indian colleagues
understood rootedness perhaps more spiritually than literally. In most
of the cases root forms and community-oriented performances made
sense—they were practiced as meaningful parts of the repertoire. Folk
artists themselves made distinctions between traditional songs and
film songs, old forms and modern ones. The encouragement of older
root forms generally meant valuing the types of artistic production
over which the folk artists had a comparatively larger degree of con-
trol. Hence *kathputli* puppeteers were encouraged to sing the Mewari
songs and enact the traditional tale of the Rajput hero Amar Singh
Rathore rather than sing Hindi film songs and enact skits about family
planning. The latter were created by a commercial film industry and
government agencies for audiences attuned to aesthetic and social
standards quite different from those of *kathputli*-nurturing audiences.

Smithsonian staff, Sethi, other scholars, and artists themselves
remained in a continual dialogue about the nature of tradition, inno-
vation, and adaptation. Encouragement of traditional practice was
seen by the organizers as a necessary counterbalance to the tremen-
dous weight of commercial forms, exogenous influences, and other
factors that generally devalue and delegitimate the skills, knowledge,
and artistry of traditional artists. I think artists understood this very
well. We were much more concerned with the expressions of artists
than with appeasing a culturally illiterate American audience. Indeed,
artists and organizers operationally conspired to exert control over the
traditional, since they were well positioned to do so and because strong
commercial competition was lacking. At the same time, we all recog-
nized that several artistic forms had developed beyond traditional
venues, audiences, and means of transmission. Yet they still illustrated
continuities with tradition and provided contemporary means of aes-
thetic and economic self-empowerment. We did not want to rule out
these expressions for the sake of enforcing a set of perpetually prob-
lematic academic categories. Hence Chandrakala Devi from Mithila
demonstrated traditional skills on nontraditional life-size papier-
mâché wedding figures, the lost art of glass painting was demonstrated
by a Tanjore Brahman trained by nontraditional means, and, Pala-
niappan the Aiyanar potter, left his horse sculptures unpainted.

Smithsonian and Indian organizers thus defined the larger exhi-
bition themes, selected participants, and encouraged certain items of
repertoire with a large degree of (but not complete) consistency. This
was done with a considerable amount of scholarly expertise and a

clear commitment to cultural-conservation goals. It was also done through active, generally good-willed but sometimes acrimonious dialogue, debate, and conversation among artists, scholars, organizers, and sponsors, both Indian and American.

Within this context, Indian participants in Aditi and Mela crafted the exhibitions as products (albeit not usual ones) within which traditional attitudes, skills, and creative expressions came to the fore. This made the exhibitions quite different from those typically found at the Smithsonian or similar museums. Here, I offer several brief ethnographic vignettes that illustrate the ways in which folk artists defined and modified the exhibition context in terms of their own aesthetic and organizational notions, while at the same time forcing Smithsonian staff assumptions into relief.

Aditi Puja

The Aditi exhibition filled the Evans Gallery in the National Museum of Natural History much as any exhibit would have. *Aditi* in Sanskrit literally means "unbound" and was a most appropriate name for the exhibition. On arrival in Washington, Aditi participants expressed the desire for a place to perform *puja* (worship) prior to the exhibit's grand and daily openings. The appropriate site for this was of course at the beginning of the exhibition, the entryway. This, much to the chagrin of museum security and staff, meant placing it in the building's Constitution Avenue foyer, which is a normal entry rather than an exhibition space. To build the shrine, the older women in the group searched for stones and boulders, eventually finding in the museum's collection several meteorites that in their pattern of cleavages and gouges bore a construed likeness to the mother goddess. The shrine was elaborated by several women who then decorated the marble floor of the museum's foyer with rice-flour-drawn *alpana, kolam,* and *rangoli* designs that made the space receptive to divine presence. Visitors to the museum and its staff were confronted daily with the group's *puja,* singing of *bhajans* (devotional songs), and distribution of *prasad* (blessed foodstuffs) in the reconstituted foyer. The *puja* was done solely for the group and not intended as part of the exhibition or for demonstration purposes. It was a real *puja* for a real event, which transformed the nature of the museum's public space—appropriating it as Indian sacred space under the control of the participants rather than museum personnel.

Mela Temple

Since *mela* sites in India usually host a shrine or temple, marking its association with divine figures or saints, it was appropriate to build such a structure on the Mall grounds. After consulting architects, Brahman priests, and scholars, a small masonry temple structure was constructed by Smithsonian workers. In keeping with our attempts to produce an exhibition and avoid overt sectarian displays, we cordoned off the structure and placed signs around it saying that it was a *facsimile* of a temple, illustrating the architectural form and its association with *mela* sites. The notion of a facsimile temple did not sit well with Mela participants. On the first day of the festival, the signs came down. In ensuing days, the Aditi potter made a clay *yoni* (divine womb) to match and serve as a receptacle for the exhibited polished stone *lingam* (phallus). The priest painted symbols on the structure indicating a Shiva temple. This precipitated rather heated debate among the Indians about the use of certain symbols and the correctness of their drawing. Once the *lingam* and *yoni* were installed, the flower-garland maker made appropriate decorations. A sculpted Nandi, consort to Shiva and mother goddess, also appeared. By the end of the first week, daily *puja* was performed in the now-no-longer-facsimile temple. Gujarati dancers performed in its previously undefined courtyard, and *bhajans* were sung there. Space and a structure intended for one use by Smithsonian staff were appropriated for other uses by participants. This appropriation was achieved in an organic and creative way, as participants contributed their various talents to bring to life not only the temple but also their own status as a community.

Building the Mela

Smithsonian staff, including construction personnel, were inexperienced in working with bamboo, terra-cotta tile, coconut leaves, *shamiyana, kanath* canvas, and other building materials sent from India. Production plans called for an Indian crew of carpenters and craftspeople who could work with the Smithsonian crew to build the *mela* structures. The tool kits, techniques, flexibility, and improvisation of the Indian carpenters confounded the Smithsonian labor crew, engineers, and carpenters, who valued mechanization, precision of measurement, standardization, and square-angle construction. After some days of mutual denial of each other's abilities, American and

Fig. 17-1. *Aditi artist Ganga Devi creates an artifact on the redone walls of the National Museum of Natural History by painting a traditional* kohbar, *or wall painting, heralding marriage.* Photo courtesy of the Smithsonian Institution.

Indian crews developed an appreciation of each other's craft—Indian carpenters experimented with power drills and augers and Americans discovered the need for flexibility when dealing with bamboo and came to understand the rationale of interlocking terra-cotta tiles. Indian carpenters, communicating through their work, demonstrated the contingent nature of construction at an Indian *mela*—building around trees and roots, making use of materials at hand, etc. Smithsonian personnel and contractors, who idealized construction as a closed system in which measured plans were actualized, gained from these carpenters a new perspective on their own work. In the end, while Smithsonian engineers reworked stress equations on their calculators and puzzled as to why the structures stood, scores of American volunteers, including builders and roofers, came down to the Mall to help and learn from the Indians.

In one instance, the difference between Indian and American standards could not be bridged. Our plan was to have coconut-leaf roofs for the *mela* stalls. Woven mats of coconut leaves make for excellent roofing in India. It is a lightweight material, and when it rains the soaked leaves mesh together, making the surface relatively imperme-

Fig. 17-2. *Dowry items, papier-mâché figures of the wedding party, and icons used in marriage rites surround visitors and Aditi craftsperson Chandrakala Devi.* Photo courtesy of the Smithsonian Institution.

able. Since we often get summer thunderstorms in Washington, this type of roofing seemed ideal for conveying the aesthetics and utility of a traditional architectural form.

In order to bring a ton of dried coconut leaves into the United States, we had to have the shipment fumigated in India. This allowed us to meet certain requirements meant to prevent unintended importation of potentially harmful insects and parasites. Unfortunately, the fumigant made the coconut leaves more flammable than usual, as fire marshals from the District of Columbia discovered when they tested the in-place roofs two days before opening. The roofs constituted a fire hazard that had to be corrected. The Smithsonian spent $10,000 on fire retardant; staff and volunteers worked through the night to dip and spray all the coconut leaves. The coconut-leaf roofs were reinstalled. Later that night it rained, and to our surprise and dismay the roofs leaked. The fire retardant had in effect laminated each leaf with a chemical substance that prevented the leaves from meshing together. We spent the next night installing plastic wrap under the coconut leaves.

In this case, the chain of actions and consequences—Indian and

Fig. 17-3. *Eighteen-year-old magician Mohammad Yusef makes his brother disappear into a basket. Yusef belongs to the Shadipur cooperative and usually performs on the streets of Delhi.* Photo courtesy of the Smithsonian Institution.

American—did not work out very well. Traditional architectural materials and ideas about their use were confounded by American practices and notions of safety. The interpenetration of functional requisites from the two cultures was dysfunctional in building terms, although the ironies were well appreciated by Indian and Smithsonian construction crews.

Presentation

While the Smithsonian planned the exhibitions to be living ones, the Indian folk artists really meant it. The registrar for the Aditi exhibition did not expect to see new objects come into the exhibition every day. Participants would hang new items on the walls or place them on stands or platforms. The Warli wall painter ran out of room to paint in his designated area—so he continued down the hallway. A Mithila painter was moved to embellish a blank wall in the fertility section. So, too, did performing artists throughout the exhibitions expand them beyond their boundaries. The Aditi *bahrupiyas* would often leave the exhibition hall to wander through the museum and inflict their im-

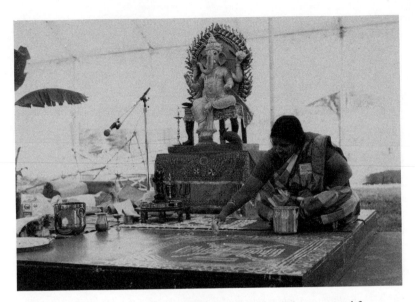

Fig. 17-4. *Pichammal Nagarajan uses rice paste to paint a* kolam, *or ritual floor painting, in front of the god Ganesha before and after daily demonstrations of* puja, *worship, at Mela.* Photo courtesy of the Smithsonian Institution.

personations on the unknowing, much as they do in India. Acrobats would accost the Internal Revenue Service, across the street from the museum, with their loud drumming in order to stir up a larger crowd. The monkey-men of Mela, *langur bahrupiyas,* would hide in trees, throw branches onto the crowd, and scamper and yell, as befitting their role. My daily exhortations to them, "Get down from there. The trees on the Mall are national monuments. You will be arrested by the National Park Service police," were taken neither as official warnings nor as stage directions but as straight lines to be incorporated into the performance routine for the enjoyment of the audience. Similarly, standard festival operations such as tightly scheduled presentations on stages were routinely disregarded—as were, at times, the stages themselves. For the Indian folk artists the exhibitions were living events that had their own dynamic rhythm and flow, different from a preset and prescribed order.

Bazaar Culture

Of the forty stalls in Mela, ten were devoted to the demonstration of various crafts—toy making, kite making, bangle making, and the like. The remainder were intended to evoke the bazaar setting so integral to

Fig. 17-5. Bahrupiyas *are those who "take many forms." At Mela, Krishan and Gurmukh take on the guise of the mischievous god Hanuman. In addition to riding bicycles, they picked imaginary lice from the heads of visitors, rode on the Metro, stole fruit, and broke the noses of four tourists with their tails.* Photo courtesy of the Smithsonian Institution.

Indian fairs. Sethi, site designer Subroto Bhowmick, and I all believed the creation of a functioning bazaar or market at Mela was necessary to give visitors a sense of its economic dimension. By inspecting items, asking questions, bargaining, and buying merchandise, visitors would gain a better appreciation of the overall event. We also thought it was a financially viable way to help fund the exhibition, since it would cost a great deal of money to put items on display only in all the stalls. Sales would assure the stalls were well stocked and would pay for the acquisition of merchandise in India, shipping, and staffing.

Other Smithsonian officials and staff were divided in their opinion of this arrangement. Although a concern was raised that sales of merchandise would detract from the craft demonstrations and performances, it was agreed that the idea had enough countervailing programmatic merit. Stronger objections came from the Smithsonian's business people, who saw sales as their institutional function. Embedding sales in an exhibition was anathema to their idea of a museum

Fig. 17-6. *Most of the stalls in the Mela bazaar had items available for sale in order to convey the atmosphere of commerce associated with fairs in India.* Photo courtesy of the Smithsonian Institution.

shop's operation. They had the expertise and the infrastructure to sell merchandise, and they did not want to lose possible profits.

Our counterargument was that sales were part of the ethnographic event we were representing. Commerce is not culture-neutral, but rather embedded in a particular event and sociology of exchange. In the end, Smithsonian officials gave their approval to allow bazaar sales. After Mela, and in light of the volume of sales (over $100,000 in ten days), the business people vowed that it would never happen again, and traded acrimonious memos with the Office of Folklife Programs.

Still, concessions had to be made. Bargaining, so intricate a part of the social exchange in Indian bazaars, could not take place because of accounting procedures and the need to conform to sales tax collection codes. Sales were handled by local Indian Americans, not real shopkeepers. And due to the economics of stocking the stalls, some stalls had merchandise for display only.

Aesthetics and Social Order

The Aditi and Mela participants lived in accommodations with Indianists who spoke their languages. They had Indian cuisine, redesigned squat toilets, and various other appropriate amenities. Over the years,

the Office of Folklife Programs has evolved means for dealing with participant culture shock. One standard procedure is to have various cultural liaisons live with and serve as counselors to participants, aiding their adaptation to a different environment. The model is generally one of individual counseling. For the Indian artists, particularly those of Aditi, who spent two months in Washington, this model was of limited value. The housing, working, and general living situation more closely simulated a small community or village than it did a collection of individuals. The Indians themselves recognized this quite quickly and constituted a group *panchayat* (council) to discuss and regulate their internal behavior toward one another. The group would meet when needed, squeezing into one of the apartments to talk about someone's drinking, another person's verbal abuse, and so on. Problems were openly discussed. Some of the older and wiser artists would be asked to give their opinions. Yelling matches might erupt. Distractions were continuous. The group often proposed restitutive actions and levied fines; entertainments often followed. Operating much as it might in India, the group exerted a measure of social control over community activities.

One of the major points of group discussion and conflict concerned the sales of items made by Mela and Aditi craftspeople at the exhibitions. During Mela, the staff operated a special stall in the bazaar. Most of the craft items made by craftspeople or brought to Washington by participants were sold there. In exceptional cases items were sold by staff or volunteers from the stalls of the makers.

Many of the craftspeople felt they should get the full profit from their items. But most of the musicians and performers objected. They argued that it was their music and performance that attracted so many people to Mela. Since they helped to draw customers, they deserved a share of the profits. The issue was hotly debated for two days and nights by the group. Finally a consensus agreement emerged. Craftspeople would set a price they wanted for an item. Smithsonian staff would attempt to sell the item at double that price. The income minus the cost of sales would be divided into shares. The craftsperson or owner would receive half the proceeds. The remaining half would be divided evenly among all participants (musicians, craftspeople, and others). Smithsonian staff would keep records and handle disbursements. If anyone was found to be cheating (through selling directly to the public without reporting sales), they would sacrifice their share of the profits for that day.

In this manner, the group exerted control over a fairly complex

and sensitive matter. While some individuals complained about the arrangement, it was generally quite popular and successful. Two people were fined one day's profits each. Otherwise, the agreement held and perhaps mirrored the kind of consensus building, group cooperation, and conflicts that characterized the larger Bhule Bisre Kalakar cooperative, of which many of the folk artists were members.

Aesthetic control was also exerted by individuals over their own experience. The teenaged Krishnagar toymaker, having visited the National Gallery of Art, reduced its sculpture to his own scale by making clay models. The Indian street performers, not satisfied at being mere curiosities, learned enough English to banter effectively and engage American audiences much as they do Indian ones. And Banku Patua, the Bengali *chitrakar,* approached his American experience as an artist and storyteller. Painting a scroll and composing lyrics in the traditional style, Banku Patua took back with him the story of Washington, D.C., replete with his pictures of the Washington Monument and the Potomac River, of people from many different religions eating together, of people in wheelchairs coming to Aditi, of Ravana burning on the Mall, of the retreat of the American gods and goddesses from daily public life and the absence of sociality on the streets of the nation's capital. And now, in the villages of West Bengal, Banku Patua, with both pride and humility, displays his scroll and sings his song, "Come and listen, all my friends gathered here, all people present. I will tell you of America."

CONCLUSIONS: REPRESENTATION AND CONSERVATION

During the conference presentation upon which this article is based, Richard Bauman and Barbara Kirshenblatt-Gimblett raised the issue of how so-called living-museum exhibitions can contain human beings. Such containment takes several forms. Most tangibly, humans can be set into museums like objects, occupying wall space, framed by niches, and identified by labels. More subtly, people and their cultural expressions may be contained by a type of symbolic biopsy. Music, narrative, ritual, craft making, and other actions are abstracted from their usual cultural context and injected into another. This other context, that of a festival or a museum or even a concert hall, reduces the semiotic richness of the social enactment. People become signs of themselves; a dance becomes a sign of a larger performance, in itself a sign of the larger community, culture, or country. In this view, extended

chains of such signification amount to reductions of self and meaning, so that as these chains become elongated the freedom of action open to participants is lost. Organizers, familiar with the context of presentation, are in charge of signification, and thus both orchestrate participants and tell them what they are supposed to mean.

Whether or not this assessment is accurate is to me an empirical question, depending in large part on the kinds of performances and demonstrations, the museum settings, and the actions of participating artists and museum staff. I do not believe it to be an indictment of a genre or a statement of the theoretical impossibility of adequately presenting living culture in a museum setting. If we are surprised or shocked to see people in museums, it is not because they do not belong there. It is because museums have, I am sad to say, become places where we do not expect to encounter other people. This is often evident in the ways in which museum visitors avoid one another in exhibition halls and in the hushed tones that characterize museum conversations.

In their fundamental design, Aditi and Mela provided space and facilities for living people to demonstrate their arts. As indicated above, the performers, craftspeople, and musicians extended their art far beyond those spaces. There was no attempt to insulate participation. Indeed, to the contrary, in every case, volunteers and staff were provided to help translate and interpret so that artists could answer questions and speak for themselves. Unlike objects, artists went to lunch, had cigarette and tea breaks, moved around, changed their presentations, and went to the lavatory. I seriously doubt people were mistaken for objects.

If in the structuring of the experience the Indian folk artists became signs of themselves and other entities such as Indian folk culture or India itself, there was certainly an advantage in doing so. By being placed, and placing themselves, in a position of representing other members of the cooperative, folk artists, and Indian culture more generally, individual voices were strengthened. Street acrobatics, juggling, and puppetry were legitimated as artistic practice by the national museum of the United States and presented as such back to the Indian community. The ability of the people of Shadipur to advocate their rights was advanced. Many of those involved in the exhibitions understood that they were representing larger traditions, larger communities, larger cultural and national bodies. This they generally interpreted as an honor, as a responsibility, and sometimes as something that could be turned to personal advantage and profit.

But there is another side to the semiotic question. What are the psychological ramifications, if any, of becoming a sign of oneself, or of other signs? If the folk artists participating in Mela and Aditi really felt themselves becoming more and more removed from their home setting, more reduced in meaning, signifying less and less about more and more, then might not it be interpreted as their realization of Indian ideals such as *nirvana* or *moksha*—the loss of self in a larger universe? But I don't think this was the case. As Milton Singer argues in his answer to Max Weber,[3] psychological patterns for groups and individuals are not to be derived mechanically or inferred from philosophical principles articulated by or in the ideological repertoire of the group. Simply, a semiotic analysis that says people are becoming signs of themselves tells us about the categories of semiotics; it does not tell us anything about the thoughts, feelings, or actions of those people.

I think the Aditi and Mela participants brought with them their own cultural repertoire, which included their own sense of performance and its contexts. Aside from the elaborate physical construction of the exhibitions, they carried with them strong notions of why and how they do what they do, and for whom. Exemplary artists have the power to create or recreate these contexts just about wherever they go. And given the chance, they can convey the strength and the beauty of what they do. Rather than conceiving of the participants as living a self- and meaning-negating experience derived or surgically removed from everyday reality, I would suggest that people bring with them their repertoire of self- and culture-defining ways, and that this particular experience allowed for a great deal of cultural creativity, a heightened or magnified sense of culture and self.

The importance of Aditi and Mela was not that they in some literal way recreated village arts and crafts or a rural fair. The exhibitions and the events and actions they engendered were exciting, rich, and memorable because it was in and through them that new culture was being created in a way that gave value to the old. Aditi and Mela artists, staff, and volunteers were not acting out some ethnographic script created in India or the American academy. Rather, a multitude of the signs and symbols and possible ways of acting from those worlds were brought to the here-and-now of the experience to take on new combinations and variegated forms in light of the personal choices, social interactions, and emergent situations occasioned by the exhibitions. This occurred even in highly technical spheres. The Aditi

potters had to use clay and sand drawn from the Washington area, build their kilns in Maryland, and fire them with locally available wood. Ethnoarchaeologists studied how these potters made do with the new materials and how they adjusted their techniques, production routines, and predictions of success.[4] The potters engaged fully the reality of producing pottery in Washington, D.C., for an exhibition while conversing with scholars interested in what they did.

The Smithsonian staff, Indian American volunteers, Rajeev Sethi, Indian scholars, and Smithsonian officials encouraged participating artists to demonstrate their art, skill, and knowledge, to speak for themselves and for others of their community. This they did, extending their talent far beyond the domain of exhibit and museum. The encouragement was competent and conscientious, perhaps due to the right mixture of staff, experience, and resources. I can imagine that poor staffing and lack of knowledge, sensitivity, expertise, resources, or time could lead to discouragement, deprecation, and disgruntlement.

If the people who came, and those they stood for, were adequately represented, was it then worth doing? After all, as it was argued in our conference, there are real issues out there, issues of power and control. Museum exhibitions would seem to be a minor and relatively ineffectual means to social change.

But museums, I argue, can play a role in effecting social change, as I think the cases of Aditi and Mela demonstrate. Museums do not equip people bearing endangered cultures with guns, votes, or plumbing. But they can provide communities and people with useful products. As social institutions with standing, museums can legitimate beliefs, practices, people, accomplishments, and interpretations. By their exhibitions and programs, museums can assist in the generation and articulation of the symbols and statements by which a community might represent itself. The production of ideology and rhetoric is something museum professionals and academic scholars are trained to do, and can be of great importance to those they seek to study and represent.

The people of Shadipur and folk artists in India more generally have not yet achieved all their goals. But their participation in the Festival of India folklife exhibitions was worthwhile because it brought attention to their cause, generated useful rhetoric, elicited promises of help, and even stimulated concrete programs. As of this writing, land has been designated for, but not yet granted to, the people of Shadipur.

Plans have been developed for a new village, with performance areas, workplaces, shops, and homes.

If culture is to be conserved, it must live. It cannot be frozen in time and preserved by museums, anthropologists, folklorists, or historians. For a culture to live, its bearers must be empowered to practice that culture, to revise, transform, and adapt it to new and changing circumstances—to find new meanings for old practices and old meanings for new practices.

The Aditi and Mela exhibitions were as good as they were because the Smithsonian did not follow its normal curatorial course. This did not mean abandoning Indian participants to do whatever they felt like doing. The exhibitions themselves became a field or arena for the practice of cultural representation. In this arena, museum culture and the cultures of folklorists, Indian officials, designers, and, most important, the folk artists themselves were played out in dialogical—even multilogical—ways. The reality of the exhibitions was continually negotiated, not on paper but through actions and events, bringing into relief conflicting interpretations and wonderful cultural juxtapositions.

In a world of growing economic hegemony permeated with the mass cultures of Western capitalism and state socialism, the drive toward cultural homogenization seems relentless. In terms of cultural policy, museums need to stand somewhere. There are good reasons for museums to be advocates of cultural diversity and promoters of cultural conservation. But even if for no other reason than insuring against the day when all museum exhibits will of necessity look alike, museums have an interest in promoting the diversity and continuing creativity of human cultures. Exhibitions can be a vehicle for cultural self-help, engaged in by those who stand both to gain and to lose by the way they are represented. And there are many more Shadipurs in India, in the United States, and throughout the world.

NOTES

A portion of this essay first appeared as "Making Exhibitions Indian: Aditi and Mela at the Smithsonian Institution," in Michael Meister, ed., *Making Things in South Asia: The Role of Artists and Craftsmen*, copyright 1988 by the South Asia Regional Studies Program, University of Pennsylvania, Philadelphia. Reprinted with permission.

1. *Aditi: The Living Arts of India* (Washington, D.C.: Smithsonian Institution Press, 1985).

2. Salman Rushdie, *Midnight's Children* (New York: Avon, 1980).

3. Milton Singer, *When a Great Tradition Modernizes* (New York: Praeger, 1972).

4. Marilyn Beaudry, J. Mark Kenoyer, and Rita Wright, "Traditional Potters of India: Ethnoarchaeological Observations in America," *Expedition* 29, no. 3 (1988).

The World as Marketplace: Commodification of the Exotic at the World's Columbian Exposition, Chicago, 1893

CURTIS M. HINSLEY

The world exhibitions glorify the exchange-value of commodities. They create a framework in which commodities' intrinsic value is eclipsed. They open up a phantasmagoria that people enter in order to be amused. The entertainment industry facilitates this by elevating people to the level of commodities. They submit to being manipulated while enjoying their alienation from themselves and from others.[1]

The second half of the nineteenth century was the age of the industrial exposition in the North Atlantic metropolitan world. Beginning with the Great International Exposition in London's Crystal Palace in 1851 and the American response, New York's "Crystal Palace" fair of 1853, for seven decades—until World War I—every few years saw the organizing, funding, and launching of a new exhibition enterprise: London, New York, Paris, Philadelphia, Chicago, St. Louis, Buffalo, San Francisco, Seattle, Atlanta, New Orleans, Nashville, and many others announced regional, national, and international pretensions. Like most of the buildings that housed them and the landscapes on which they stood, these exhibitions were ephemeral constructions, at once catalytic and celebratory events, economic risks taken in expectation of future return. They were carnivals of the industrial age, communal activities undergirded and directed by corporate boards and interests of state. None lasted more than six months; collectively their ideological impact was profound and permanent.

The London Crystal Palace exhibition was classically imperialist in conception and construction: on display was the material culture of an industrial, commercial empire, with an emphasis on manufactured goods derived from colonial raw materials. The Paris Exposition of 1867 celebrated another form of colonial appropriation in featuring archaeological and ethnological materials. Virtually all subsequent fairs embodied these two aspects: displays of industrial achievement and promise for the regional or national metropolis, and exhibits of primitive "others" collected from peripheral territories or colonies. As a collective phenomenon the industrial exposition celebrated the ascension of civilized power over nature and primitives. Exhibition techniques tended to represent those peoples as raw materials; within the regnant progressivist ideology they occupied the same category.

The display of touring or stationary human groups, especially Native Americans, for profit, entertainment, or public edification has a long and problematic history.[2] The first American exposition, presided over by Phineas T. Barnum in New York in 1853, adopted "Machinery" as its motto and publicly introduced the sewing machine. But Barnum also introduced the Lady in Red, a mysterious dancer; and on the edge of the fairground stood Shantyville, more than a mile of amusements, including the Wild Man of Borneo, Fijian man-eaters, a Pennsylvania oil well (twenty-five cents admission), and an encampment of three hundred Indians from fifty tribes under the charge of "George Anderson, the famous Texas scout."[3] But the practice of dispatching agents to remote regions for the sole purpose of bringing back groups of exotic types for public display and private profit seems to have originated in the late 1870s with Hamburg animal trainer and zoo master Carl Hagenbeck. Sometime around 1876 Hagenbeck hired Johan Adrian Jacobsen to bring a collection of artifacts and a Greenland Eskimo family of six to Hamburg, then travel with them through Europe for eight months. This tour was so profitable that in 1878 Jacobsen repeated the experiment with Lapps (and reindeer), then toured with three Patagonians, and in 1880 set out again with eight Labrador Eskimos. This last *Völkerschau* ended in tragedy, as the troupe all died of smallpox, somewhat dampening Hagenbeck's enthusiasm for human displays. Two years later he resumed his efforts. They resulted in an eleven-month tour by nine Bella Coolas through Germany in 1885–86—twenty-seven cities, including three weeks dancing in Hagenbeck's Hamburg Thierpark. The tour, which was accompanied by a collection of about two thousand artifacts, received sober reporting in the German press.[4]

While a few live Native Americans did appear at the 1876 Centennial Exposition in Philadelphia, the introduction of ethnographic villages as a central component of the fair was initiated at the Paris Exposition of 1889. Otis T. Mason, curator of ethnology at the U.S. National Museum, came away deeply impressed by the educational power of the exposition's live groups. The entire fair, which he thought the "most thoroughly anthropological" to that time, taught the history of human culture by means of models of habitation and working scenes set out along the banks of the Seine. Mason reported enthusiastically on the twelve African villages and the Tonkinese temple with Buddhist priests performing rites. The crowds, he noted, thronged like children to watch exotic peoples in their daily routines. "It was an exposition," he wrote home, "whose presiding Genius was a teacher, a professor of history, whose scholars were the whole world."[5]

By 1890 two traditions of human display were established: the Hagenbeck-type tour, which occasionally made some claim to ethnographic authenticity and sobriety, and the Barnum-type sideshow of human freaks and oddities. Both were already being incorporated into world's fairs for the public, and each usually had elements of the other. Hagenbeck's Arena, an exhibition that appeared on the Midway Plaisance in Chicago, for example, featured "Dwarf Elephant Lily, 35 inches High."[6] Still, as the Smithsonian Institution set about planning the upcoming celebration of four hundred years of New World settlement, Otis Mason and his colleagues were confident that vital lessons could be taught at Chicago. George Brown Goode, who had organized the U.S. National Museum in 1881, had a single theme for 1893: "The fair, he wrote, would illustrate 'the steps of progress of civilization and its arts in successive centuries, and in all lands up to the present time.' It would become, 'in fact, an *illustrated encyclopedia of humanity*.' " The exposition would be in essence "an effort to educate and 'to formulate the Modern.' "[7]

Frederick Ward Putnam, director and curator of the Peabody Museum at Harvard, shared the views of the Washington group and after his appointment in 1891 as head of the Department of Ethnology and Archaeology for the Chicago fair, he and his chief assistant, Franz Boas, worked assiduously and cooperatively with the government scientists toward an anthropologically informative exposition. Putnam deeply believed in the public function of anthropological presentation. He explained his vision and his proposed method to the Committee of Liberal Arts in Chicago on 21 September 1891:

The part of the ethnological exhibit, however, which will prove of the greatest popular interest and at the same time be regarded as an essential and appropriate display, will be the out-of-doors exhibit of the native peoples of America, in their own houses, dressed in their native costumes and surrounded by their own utensils, implements, weapons, and the results of their own handiwork.

I have used the words "essential" and "appropriate" in this connection, and have done so after due consideration; for we must never lose sight of the fact that this Exposition is a Columbian Exposition; that its very existence is due to the fact that the voyage of Columbus 400 years ago led to the discovery of America by our race, its subsequent peopling by the Europeans and the consequent development of great nations on the continent. This development, as we shall show, has been of a most remarkable character upon this continent; and all nations of the world will show what they have done in the great struggle during four centuries. The result will be such a wonderful exhibition of the works of man that even those of us who know in part what it is to be will be surprised and astounded when we see it from day to day as a grand whole.

But what will all this amount to without the means of comparison in the great object lesson? What, then, is more appropriate, more essential, than to show in their natural conditions of life the different types of peoples who were here when Columbus was crossing the Atlantic Ocean and leading the way for the great wave of humanity that was soon spread over the continent and forced those unsuspecting peoples to give way before a mighty power, to resign their inherited rights, and take their chances for existence under the laws governing a strange people? We know the results, and we know well that four hundred years has [sic] brought the last generation upon the stage of action, when it will be possible to bring together the remnants of the native tribes, with probably a few exceptions in South America, in anything approaching purity of stock, or with a precise knowledge of the ways of their ancestors. These peoples, as great nations, have about vanished into history, and now is the last opportunity for the world to see them and to realize what their condition, their life, their customs, their arts were four centuries ago. The great object lesson then will not be completed without their being present. Without them, the Exposition will have no base.[8]

Putnam then described a charming "ramble" through a wooded island on the fairground, with the natives working quietly in their houses, far removed from the Machinery Building and the bustle of industrial-exposition life. Central American ruins and monoliths would grace the

pathway. "After such a stroll amid the scenes I have only briefly sketched, one will visit the other departments of the Exposition with singular feelings and with an appreciation which could only be aroused by such contrasts."[9]

Investors in the Fair had different ideas. Thomas W. Palmer, president of the National Commission for the Fair, had also been deeply impressed by the popularity of the villages at the 1889 Paris Exposition, and he insisted on native groups living on the Midway Plaisance, a mile-long strip of land set aside for amusements and sideshows. Thus, in addition to the Anthropological Building and the live outdoor ethnographic exhibits adjacent to it at the southern end of the fairground, Putnam received responsibility for the Midway exhibits, too. Their installation, though, lay in the hands of a very different type of man: Sol Bloom, a future real-estate developer, who had also attended the Paris Exposition. As it turned out, Bloom worked largely independently of Putnam. Years later he observed, with some justice, that placing Putnam in charge of the Midway was "tantamount to making Albert Einstein manager of Barnum and Bailey's circus."[10]

BOAS, PUTNAM, AND POPULAR ANTHROPOLOGY

Be it known in the first place that the Anthropological Building is the most serious place on the face of the earth. The man who enters there leaves fun behind. The man who has studied its mysteries, like King Henry of the song, never smiles again. Before you study anthropology, you must have learned all about history, physiology, geology, zoology, and all the other topics ending in y. Your hair must grow long and your tongue must caress with the familiarity of an old love words of fifteen syllables. You must know at a glance the touching history of a piece of flint, and you must become enraptured with the tales expressed by a long buried image.[11]

For nearly two years (1891–93) Putnam and Boas supervised archaeological and anthropological expeditions throughout the Western Hemisphere. The collections, photographs, and data poured into Chicago—from the Southwest, the Great Plains, Alaska, Yucatan, Peru. They oversaw fifty-five fieldworkers. But from the moment of his arrival in Chicago every conceivable obstacle seemed to be placed in Putnam's way by the exposition's directors; they were far more solic-

itous of the commercial and industrial exhibits and showed less and less interest in serious public anthropology.[12] Putnam's promised space in the Anthropological Building was reduced by more than sixty percent. He moved his office nine times in eight months. Desperate for a place to put the mass of exhibit materials, he managed to secure a dairy barn as an annex, but eventually he was removed from there as well to make room for a cheese exhibit. As it turned out, the Anthropological Building was not ready for visitors until one month after the fair had opened.

It was at the Chicago fair that Mayan architecture first came to North American public attention—with invigorating results for future Mayan archaeology, epigraphy, and ethnography. In addition to the casts of Mayan stelae inside the Anthropological Building, and case after case of specimens, just to the north of the entrance stood a model of Yucatecan ruins (Uxmal) and, a few feet away, a reproduction of a Southwestern cliff dwelling. The juxtaposition was intended to emphasize evolution in house structures. Each edifice was surrounded by well-manicured, rope-bounded lawns and pathways. Near the entrance to the cliff dwelling was a convenient lemonade stand; within, Anasazi shards and pots were placed about. An American flag flew overhead (Figure 18-1).

A few yards north of the model ruins stood the outdoor ethnographic exhibits, notably Boas's group of Kwakiutl Indians from Fort Rupert, British Columbia. Working through George Hunt, his informant among the Kwakiutl, Boas had brought fourteen individuals to Chicago (Figure 18-2). To add to the authenticity a village from Skidegate, on the Queen Charlotte Islands, was disassembled, complete with doorposts, and brought as well (Figure 18-3). In these environs, Boas intended, the Kwakiutl would perform various ceremonials and live as normally as possible. They slept on the floor in the Stock Pavilion.

The Northwest Coast village was set up in the outdoor exhibits area adjacent to the Leather and Shoe Trades Building. Here, Boas engaged in ethnographic production, as his Indians, placed in front of a white sheet backdrop, performed dances for his own study and for the public (Figure 18-4). He hired Chicago photographer John H. Grabill to record several dances, arguing to the administrators that copies of the photographs could be profitably sold to visitors and promising copies to the Kwakiutl dancers and singers—a promise that he kept the following year.[13] In Chicago Boas's Kwakiutl performers

Fig. 18-1. *Model of Southwestern cliff dwelling at the World's Columbian Exposition*. From *Glimpses of the World's Fair: A Selection of Gems of the White City Seen through a Camera* (Chicago: Laird and Lee, 1893).

reproduced rituals that in some cases were no longer practiced—certainly not under such conditions. They were aiding Boas in his effort to recapture a presumed pristine, pre-Columbian condition. In their determination to establish a baseline against which to measure civilized progress, Putnam and Boas were risking erasure of the past and current dynamics of history, literally blocking out the changes of time.

Other ethnographic exhibits, even outside the Midway, displayed more commerce than science. The Eskimo village, for example, was owned and run by J. W. Skiles and Company of Spokane, Washington, which charged an entrance fee and sold Eskimo manufactures. From July to November the small group of Eskimos paddled about North Pond in their kayaks and, enclosed by fences and surrounded by fairgoers resting at safe distances on benches, gave demonstrations of the uses of whips (Figure 18-5).

Fig. 18-2. *Kwakiutl Indians at the fair, 1893*. From F. D. Todd, *World's Fair through a Camera: Snap Shots by an Artist* (St. Louis: Woodward and Tiernan, 1893).

THE MIDWAY

> It will be a jumble of foreignness—a bit of Fez and Nuremberg, of
> Sahara and Dahomey and Holland, Japan and Rome and Coney
> Island. It will be gorgeous with color, pulsating with excitement,
> riotous with the strivings of a battalion of bands, and peculiar to the
> last degree.[14]

Julian Ralph's description of the Midway appeared before the expo-
sition opened and was intended to shape rather than report on the
Midway experience. Ralph reveals intentions that are radically differ-
ent from the public education of Putnam and Boas. The terms he
uses—"jumble," "bit"—are deliberately imprecise and piecemeal.
They suggest purposeful confusion: the Midway would be deliberately
constructed chaos. The repeated phrase "of . . . and" and, more tell-
ing, the strings of equivalent conjunctions, further suggest a linear,

kaleidoscopic passing of scenes, appearing quickly and discouraging valuation or judgment. All are different yet somehow equally fascinating. The observer is led on to the next scene. He or she is invited to suspend certain faculties, relax, and simply let the stream of phenomena pass before him. "Gorgeous," "pulsating," "riotous," "peculiar": Ralph's adjectives present sensual energies loosened, defying categorization or even pause for analysis. There is barely time to take it all in, none to reflect.

This is the language of the Midway. The pace has quickened noticeably from the serenity of the Anthropological Building, Uxmal in the grass, and the cheese exhibit. The striking aspect, however, is the ambiguous position of the fairgoer. The scenes of this world appear to pass before the eyes of the passive observer/consumer, but both colonialist ideology and the dynamic demographics of the Midway demand that control remain with the strolling crowd. The central concourse, with its escalatorlike movement of humanity, indicates both a

Fig. 18-3. *Partial reconstruction of Skidegate village.* From *Glimpses of the World's Fair: A Selection of Gems of the White City Seen through a Camera* (Chicago: Laird and Lee, 1893).

Fig. 18-4. *Kwakiutl dancers at the fair. Note the white sheet used as backdrop and, in the distance, the Leather and Shoe Trades Building.* Photo by Hillel Burger. Reproduced courtesy of the Peabody Museum, Harvard University.

successful history in the New World and a successful fair. Thus, as the fairgoer strolls among the bazaar of exotica, he or she steps from the concourse of history and commerce into the sidestreets of stasis, clamor, and sensual temptation. H. H. Bancroft, in his four-volume *Book of the Fair* (1894), describes the process:

> Entering the avenue a little to the west of the Woman's Building, [the fairgoers] would pass between the walls of medieval villages, between mosques and pagodas, Turkish and Chinese. . . . They would be met on their way by German and Hungarian bands, by the discord of Chinese cymbals and Dahomeyan tom-toms; they would encounter jugglers and magicians, camel drivers and donkey boys, dancing-girls from Cairo and Algiers, from Samoa and Brazil, and men and women of all nationalities, some lounging in oriental indifference, some shrieking in unison or striving to outshriek each other, in the hope of transferring his superfluous change from the pocket of the unwary pilgrim. Then, as taste or length of purse determined, for fees were demanded from those who would penetrate the hidden mysteries of the plaisance, they might enter the Congress of Beauty with its plump and piquant damsels, might pass an hour in one of the

Fig. 18-5. *"Esquimaux Snapping Whips."* From F. D. Todd, *World's Fair through a Camera: Snap Shots by an Artist* (St. Louis: Woodward and Tiernan, 1893).

theatres or villages, or partake of harmless beverages served by native waiters.[15]

Bancroft's verbs suggest a specific behavioral stance. They constitute the passive/active vocabulary of early tourism: foreigners "would pass . . . would be met . . . would encounter . . . might enter . . . might pass an hour . . . or partake." Entering this literary/Midway passage, the reader/fairgoer witnesses a bewildering human display "pass" before his or her eyes, "hears" a cacophony of sounds. It is a moving chamber of horrors and delights, leading ever deeper to penetration of the hidden sexual mysteries and dark energies of the plaisance: "plump and piquant damsels." The exotic and forbidden erotic merge as commodity. The change purse mediates this world, for the promised indulgence in the fantastic underside of the White City and civilized reason comes at a price. It can and must be bought.

Like Julian Ralph, Bancroft establishes a rhythm of language, a staccato of repeated and compounded pairs: "by German and Hun-

Fig. 18-6. *Title page of* Portrait Types of the Midway Plaisance, *published in Chicago in 1893 with an introduction by F. W. Putnam*. Photo by Hillel Burger. Reproduced courtesy of the Peabody Museum, Harvard University.

garian bands, by the discord of Chinese cymbals and Dahomeyan tom-toms," and so on. The effect is a linear parity, as successive image-experiences move like a film past the stroller. The observer does not stop to learn; rather, he or she strolls, window-shopping in the department store of exotic cultures. The White City's Midway, indeed, combined street and department store, as Walter Benjamin perceived:

> The bazaar is the last hangout of the *flâneur*. In the beginning the street had become an *interieur* for him, now this *interieur* turned into a street, and he roamed through the labyrinth as he had once roamed through the labyrinth of the city.[16]

The Midway was a mile-long strip of land between 59th and 60th streets, extending from Jackson Park and coming into the main fairground from the west, at a right angle, by the Woman's Building. Figure 18-7, taken from the Ferris wheel in the center of the Midway, spans the concourse looking eastward. In its message it is typical of hundreds of such photos and illustrations of the Midway: traffic, exchange, and movement are the heart of the fair and of human progress.

Fig 18-7. *View from the Ferris wheel along Midway Plaisance.* From H. H. Bancroft, *The Book of the Fair: Columbian Exposition, 1893* (Chicago: Bancroft, 1893).

Contemporary pictorial representations of the fairground stressed the static and formal: statuary, colossal buildings, paintings, cases of exhibits, and massive machinery. Not so the Midway. Here one found an unmediated commerce among peoples. The flow of human traffic occupied the center of the picture.

Julian Hawthorne, author of a popular book on the Chicago exposition, observed that Barnum should have lived to see the Midway. But the modernism of the Midway was neither the hucksterism of Barnum nor the public science of Goode, Mason, Putnam, or Boas. Rather, it was the modernism of Baudelaire as described by Benjamin: here the *flâneur* "goes botanizing on the asphalt."[17] The eyes of the Midway are those of the *flâneur*, the stroller through the street arcade of human differences, whose experience is not the holistic, integrated ideal of the anthropologist but the segmented, seriatim fleetingness of the modern tourist "just passing through."

The most famous section of the Midway was the narrow and dark Street in Cairo, where donkey-boys accosted the visitor and Little Egypt lured him with the belly-dance. Modeled on the Rue de Caire of the 1889 Paris Exposition, the street was advertised as presenting "a theater, mosque, bazaar, private dwellings, and a full representation of

life in the open street by Egyptians in costume. . . . Of course," Ralph added, "all will sell wares and meals, and give performances for which there will be a charge."[18] In one of the hits of the exposition, twice a day camel drivers led a chain of bespangled beasts through the street to reenact a desert wedding procession. The troupe was constantly photographed. In Figure 18-8, from Bancroft's book, the group is removed from background context and an American flag has been artistically added.

Such misrepresentation was typical of the exposition-publication genre. By one count, some six hundred photograph albums were published during or immediately following the fair. Scenes from the Midway, as well as other ethnographic images, supplied decorative offset to text. Figure 18-9, a typical example, is one of three images from the Street in Cairo, displayed together on a page along with a small peephole view of a "Turk." But the illustrations, of a Moorish barbershop, an Algerian donkey, and an Egyptian shoe store, bear no relation to the text. There is, in fact, no textual description whatever of these images in Bancroft.

Alternation and ambivalence mark the exposition-photo-album genre. It seems clear that the central problem of the exposition as a psychological construction of white Americans was to determine distances and relative placement between peoples, physically and ideo-

Fig. 18-8. *Page 835 of volume 4 of H. H. Bancroft,* The Book of the Fair (Chicago: Bancroft, 1893).

Fig. 18-9. *Page 81 of volume 1 of H. H. Bancroft,* The Book of the Fair (Chicago: Bancroft, 1893).

logically. Where the gaze can be returned, specular commerce becomes uneasy (Figure 18-10). Lines must be drawn, and they are drawn in telling ways. On the simplest level, frequently a fence, chain, rope, bench row, or other physical boundary demarcated visitor and performer spaces. Fairgoers spent much time looking over fences. A September 1893 cartoon in the *Chicago Herald* (Figure 18-11), poking fun at the mundaneness of the exotic lives on display, has one central element: a horizontal fence dividing the fairgoers (rendered in light lines) from the dusky female subject. It also presents a second, common element of distancing: the fairgoers wear certain pieces of clothing or carry accessories such as the woman's parasol or the man's cane or umbrella. In the exposition context these easily served as personal emblems of civilized status. In modern tourism the camera serves as the central portable element of distancing and self-definition.

Most distinctively, the exposition produced a humor that revealed deep uneasiness and uncertainty about boundaries. It was a humor

evidently intended to encourage sympathy with the exotic and simultaneously to keep a certain ironic distance. When ethnographic images were not purely decorative they appeared heavily captioned, as if to add lighthearted weight. "Mohammedan with Wife and Child"(Figure 18-12) was a particularly popular photograph because it depicted a nuclear family and because the baby boy, Columbus Chicago, had been born at the exposition. One photograph album captioned the picture in part as follows:

THE BABY ARAB, COLUMBUS CHICAGO. Selim, a Bedouin Arab, and one of the tribe of Hassan, was presented with a son and heir in the encampment on the Midway Plaisance. The picture above does not represent Selim as being very pleased. But that is nothing. These people do not express their pleasure by wreathed smiles. "Columbus Chicago" does not appear to have the wide-awake characteristics of his geographical namesake. He is asleep. Chicago never is. The moth-

Fig. 18-10. *Watching natives parade in the Samoan village.* From *Glimpses of the World's Fair: A Selection of Gems of the White City Seen through a Camera* (Chicago: Laird and Lee, 1893).

GREAT EXCITEMENT—INDIAN LADY THROWING
OUT DISHWATER.

Fig. 18-11. *"Great Excitement—Indian Lady Throwing Out Dishwater."* From *Chicago Sunday Herald,* 17 September 1893.

er's name is Bander. She is not very attractive as to features but for all that she possessed sufficient influence over Selim to induce him to forswear his Christian faith and become a Mohammedan for her sweet sake. As Arabs go this is undoubtedly a happy family. Selim has his hookah stem in his mouth and his scimeter [*sic*] in one hand, and though he is scowling fiercely it is no doubt his habitual expression. He would probably look much worse should he attempt to smile.

This passage expresses simultaneously a fondness for the family as a unit and an admission that they are incomprehensible as a group or as individuals: "as Arabs go this is undoubtedly a happy family." It is futile, in other words, to try to grasp exotic peoples' values and tastes. Implicitly, anthropology is a fool's errand. This stance is particularly apparent in the cases of two aesthetic subjects: female beauty

Fig. 18-12. *"The Baby Arab, 'Columbus Chicago.'"* From H. H. Bancroft, *The Book of the Fair: Columbian Exposition, 1893* (Chicago: Bancroft, 1893).

and dancing. "Three Island Beauties," in the same volume, presents three seated female figures but leaves aesthetic judgment curiously suspended. While granting that one of the women "is undoubtedly a very attractive creature," the author adds that "one hardly expects to find any great beauty" in the Indian Ocean.[19]

In defending the great anthropological lessons of the fair, Putnam at one point suggested that a certain tolerance had been instilled where dance was concerned, due to the great variety on display in Chicago. It is an interesting consideration that dance played such a large part in the ethnographic exhibits, but the public evidence does not bear out Putnam's hopeful assertion. However, one uncomprehending observer of the Egyptian dances, who saw nothing but "a series of unnatural and awkward muscular twitchings . . . entirely foreign to the poetry of motion," nonetheless felt constrained to qualify himself by adding, "at least it so appeared to western eyes."[20] Verbal vacillation pushes and pulls the observer/reader, preserving reservations, establishing bonds with the subject while retaining a psychological exit. The "other" remains roped off; the fairgoer remains uncommitted.

In the end, the fair itself provided a means of resolving the ambivalence, and it offered a single, powerfully familiar measure of human relationships: money. The Columbian Exposition was in the final analysis a celebration of market flow. Ultimately the magic of trade and exchange promised to resolve the troubling questions of human difference. The process of commodification rested on the premise that at bottom everything is for sale and everyone has a price—that the world, no matter how bizarre, is reducible to cash terms.

The 1890s saw, in American political and economic circles, the nineteenth century's high-water mark of free-trade rhetoric, since widely held dogma taught that domestic overproduction required open markets overseas for dumping manufactures and obtaining cheap raw materials. Only in this way would America's capitalist culture be restored and reinvigorated, it seemed. Bancroft begins *The Book of the Fair* with an extended discussion of the history of fairs, markets, and bazaars. He opens with the significant statement: "Of all the distinguishing features which separate mankind from the brute creation, perhaps there are none more noticeable than that man is a trading animal."[21] Whether in the near-worshipful attitude toward engines of trade (ships or trains), or in the sliding railway that paralleled the Midway, or in the photographic focus on human traffic, the exposition was a monument to movement of goods, services, and people.

The primary flow of movement was colonial: from center to periphery and back. Not surprisingly, the nature of the peoples at the peripheries was of some interest. Equally unsurprisingly, they tended to be imagined and evaluated in terms of the market and its functions. In other words, the ultimate judgment of these peoples was levied not on aesthetic or cultural grounds but on economic ones: *Do these people know their price? Can we do reasonable business with them?* Status followed the answers to these questions, and the Chicago fair provided reassuring images. Thus, Bancroft writes humorously of the Midway that it "will be filled with things calculated to draw a visitor's last nickel, and to leave his pocket-book looking as if one of Chicago's twenty-story buildings had fallen upon it." In an admiring vein he follows the entrepreneurial exotics who did well:

> Most of the orientals employed on the plaisance took home with them a considerable sum of money; the Turks from $200 to $300, the dancing girls at least $500, and the donkey boys a larger amount. Of the last many had enough to purchase a camel or a number of donkeys on their return to Cairo, where they would probably start in

business for themselves. Nearly all carried their funds in sovereigns or napoleons, exchanging therefor the silver which they received and hoarded until it amounted to a larger sum than they had ever seen before. They were experts on coin, it is said, and neither Turk nor Egyptian was ever known to accept a counterfeit piece.[22]

With luck and pluck, in short, the "other" could go into business for himself.

The World's Columbian Exposition provided the first of a series of shocks to Franz Boas's faith in public anthropology. The second came with the Spanish-American War of 1898, and by 1900 he had begun to retreat from American museum anthropology as a tool of education or reform. By 1916, Boas had come to recognize with a certain resignation that "the number of people in our country who are willing and able to enter into the modes of thought of other nations is altogether too small. . . . The American who is cognizant only of his own standpoint sets himself up as arbiter of the world."[23] The Chicago experience clarified some disturbing truths. The temptation of the dark energies of the Street in Cairo or the Midway is made all the more alluring by the knowledge that the sensual feast can be bought. From cigar boxes to cartographic emblems to public statuary, the continents have always brought their offerings to the sandaled feet of Columbia. It is but a short step in such an ideological construction of the world to an Open Door policy, gunboat diplomacy, and banana republics. Chicago suggested that wherever we traffic in the world, there are those market informants who understand the commodity premise and are prepared to authenticate their cultures accordingly. As economic man overspreads the globe, the market vision prefers these "reasonable others," eroding peripheral lives. At Chicago in 1893, public curiosity about other peoples, mediated by the terms of the marketplace, produced an early form of touristic consumption.

NOTES

An early version of this paper was presented in the spring of 1988 at the conference on "Displaying Difference: Gender, Ethnicity, and the Marketplace" at the Pembroke Center for Teaching and Research on Women, Brown University. I wish to thank Barbara Babcock for providing that opportunity and for her helpful criticism. Warren Wheeler of Hamilton, New York, did most of the photographic work, and Christopher Hinsley provided technical assistance.

1. Walter Benjamin, *Reflections: Essays, Aphorisms, Autobiographical Writings,* ed. Peter Jemetz, trans. Edmund Jephcott (New York: Harcourt Brace Jovanovich, 1978), 152.

2. Carolyn Foreman, *Indians Abroad* (Norman: University of Oklahoma Press, 1943); Christian Feest, ed., *Indians and Europe: An Interdisciplinary Collection of Essays* (Aachen: Edition Herodot, Rader Verlag, 1987).

3. Edo McCullough, *World's Fair Midways* (New York: Arno, 1976), 34–35.

4. Wolfgang Haberland, "Nine Bella Coolas in Germany," in Christian Feest, ed., *Indians and Europe: An Interdisciplinary Collection of Essays* (Aachen: Edition Herodot, Rader Verlag, 1987).

5. Otis T. Mason to George Brown Goode, 31 July 1889, 3 August 1889, and 16 August 1889, Smithsonian Institution Archives; compare Otis T. Mason, "Anthropology in Paris," *American Anthropologist,* o.s., 3 (1890).

6. *Glimpses of the World's a Fair: A Selection of Gems of the White City Seen through a Camera* (Chicago: Laird and Lee, 1893).

7. R. Rydell, *All the World's a Fair: Visions of Empire at American International Expositions, 1876–1916* (Chicago: University of Chicago Press, 1984), 45–46.

8. Frederick Ward Putnam, draft of speech, 21 September 1891. Frederick Ward Putnam Papers, Pusey Library, Harvard University.

9. Ibid.

10. Rydell, *All the World's a Fair,* 62.

11. *Chicago Sunday Herald,* 12 September 1893.

12. Ralph W. Dexter, "Putnam's Problems Popularizing Anthropology," *American Scientist* 54 (1966).

13. Ira Jacknis, "Franz Boas and Photography," *Studies in Visual Communication* 10, no. 1 (1984), 6.

14. Julian Ralph, *Harper's Chicago and the World's Fair* (New York: Harper and Brothers, 1893).

15. H. H. Bancroft, *The Book of the Fair: Columbian Exposition, 1893,* 4 vols. (Chicago: Bancroft, 1893), 4:835.

16. Walter Benjamin, *Charles Baudelaire: A Lyric Poet in the Era of High Capitalism,* trans. Harry Zohn (London: NLB, 1983), 54; compare R. Lewis, "Everything under One Roof: World's Fairs and Department Stores in Paris and Chicago," *Chicago History* 12, no. 3 (1983).

17. Benjamin, *Charles Baudelaire,* 54.

18. Ralph, *Harper's Chicago*, 208.

19. *The Columbian Gallery: A Portfolio of Photographs from the World's Fair, including . . . Marvels of the Midway Plaisance. Correct and Graphic Descriptions with Each View* (Chicago: Werner, 1894), n.p.

20. *Portrait Types of the Midway Plaisance,* with an introduction by F. W. Putnam (Chicago: 1893), n.p.

21. Bancroft, *Book of the Fair* 1:22.

22. Ibid., 4:883.

23. Franz Boas, *The Shaping of American Anthropology, 1885–1911: A Franz Boas Reader,* ed. George W. Stocking, Jr. (New York: Basic Books, 1974), 332.

CHAPTER 19

Festivals and Diplomacy

TED M. G. TANEN

M ost countries tend to look inward, but their neighbors may affect what they do and how they react to given problems, and other, powerful countries may influence their actions. For most countries, if not all, the United States plays a part in the way they view the world. This may not be true for the average citizen, but it is certainly true for governments.

How many countries, in their turn, affect the United States? Certainly not all, and certainly there are various degrees of influence. The problem is that too many Americans pay too little attention to any other country unless it is one that they already know, or unless there is threat of war or disaster that may mean the United States will send military or economic aid. I have been surprised at how little most Americans care about the cultures of other lands, at how often they seem to believe that everyone in the world thinks and acts as they do, or worse, wants to. This seems paradoxical. Americans do recognize and appreciate differences among cultures within the United States. Why, then, this reluctance to know about the cultures of other countries, to learn how those elsewhere think and act or react to something we do?

There are various ways of addressing this problem in the United States. One would be through media more attuned to the world. An-

other would be through education. Yet another is through the festival, a concentrated and carefully directed presentation of another country's culture in the United States. I see the festival as a way of approaching a particular need in the United States. My ideas regarding the festival's components have evolved, and will continue to evolve, as I work with different countries.

A large part of my experience in the United States Foreign Service was taken up with the attempt to project American culture in other countries. There were exhibitions, concerts, performing-arts events, seminars, and even festivals. I was never confident, however, that those of us working in this field were or could be very effective. One reason for this, I believe, is that no country can project its culture effectively without the involvement of the private sector—visual- and fine-arts centers, universities, community organizations—that is, without at least some nongovernmental outlets.

Upon leaving the Foreign Service in 1987, I became aware of the Today series being sponsored by the National Endowments. Among the programs in this series were Mexico Today, Japan Today, Scandinavia Today, and Belgium Today. These programs were an effort to concentrate a number of cultural programs, focusing on both contemporary as well as traditional culture, within a given time period, in order to make more Americans aware of specific foreign cultures.

Out of government, when I was working as executive director of the Indo-U.S. Subcommission on Education and Culture at the Asia Society in New York, I approached the endowments about a Today program for India but found they had gone on to other things. They did encourage us to move ahead, however, and promised to look at what we were doing on a project basis.

The Indo-U.S. Subcommission is an organization that is binational—created by a formal document between the United States and India to improve relations between the two countries. It receives financial support from both governments, as well as from foundations and private sources. Because it is not an official part of the government (at least in the United States), it has a binational board of directors and a certain amount of autonomy. A wider spectrum of programs is thus possible than would be the case if it were completely official. With the approval of the board, the subcommission has been able to present innovative programs that have made India better known to Americans. With the cooperation of the United States Information

Agency, it has been possible to enlarge upon programs about the United States that are being held in India.

From my point of view, it has been an ideal way of putting some theories in cultural exchange to work. A Mini-Festival of India, organized in 1982 in New York, Philadelphia, Washington, D.C., and a few other cities, included exhibitions, a film festival, seminars, and events in the performing arts. The success of this program led to the Festival of India in 1985–86, an undertaking that certain officials in India had been contemplating for the United States, having held something similar in England. This festival became a mammoth affair that included almost eight hundred programs in 140 cities in forty-four states. The Indo-U.S. Subcommission on Education and Culture acted as the American coordinator for the festival in the United States.

I will anticipate a question on the bilateral aspects of the subcommission's program: Why wasn't there a festival of the United States in India? There were two reasons: (1) money, or lack thereof, and (2) more important, the Indian organizers of the Festival of India made it clear at the start that their concern was with presenting India in America, not the other way around. Because this was the plan agreed upon by the president of the United States and the prime minister of India, this was the program we developed. In spite of this constraint, we did present a number of cultural programs in India during the festival period—although not as a festival. What pleased us most was the number of programs we were able to develop in both the United States and India after the festival.

Why have a festival? First and foremost, a festival should make Americans aware of the culture of the other country. There are other reasons. A country may wish to have a more positive image in the United States, or it may wish to encourage tourism and build up new markets for its products.

Whenever a program is undertaken on behalf of a country, its initiators should have as clear an idea as possible of what they expect to accomplish. They should also realize that there are organizational constraints—the availability of funds, host institutions, and so forth—that must be considered, as well as limits to the effect that they can expect a festival to have. The United States Congress and administration are not likely to change their views of a country on the basis of a festival.

Once the Festival of India was well on its way, certain Indian officials wanted a Festival of the United States in India. At least, they

wanted some major art exhibitions, not necessarily of American art, to travel to India. Others in India saw the possibilities for increased tourism and for seminars on business opportunities. It was too late, however, to incorporate these programs effectively into festival plans. It would have been better if these goals could have been agreed upon before the festival began.

Recently, I have been working with a group in Indonesia, a private foundation called the Yayasan Nusantara Jaya, in an effort to hold a major cultural festival on Indonesia in the United States in 1990–91. The Indonesian organizers stated from the time of our earliest discussions that one of the programs they wanted to include was a training program for museologists. Consequently, we were able to bring this program into our plans from the very beginning, including assuring the collaboration of appropriate museums in the United States willing to host trainees. We are also looking for ways of facilitating other exchanges: through research projects, in the performing arts, possibly in the sciences, and so on. It is too early to say what will develop, but these are our goals. We hope that these programs will extend well beyond the festival.

Although the Indonesians' primary goal for the festival is to present a positive image of their country to as broad an audience as possible in the United States, they are also interested in increased tourism and business collaboration between the two countries. Programs in support of these latter goals will not be organized directly within the Festival of Indonesia. They will, however, be timed to take advantage of the festival's events.

One thing becomes clear in the process of organizing a festival composed of many elements: each and every element looks upon itself as *the* festival. For me, the program becomes a festival when it brings together many elements and concentrates them in given communities. It also becomes a festival if it utilizes a diplomatic approach, if it brings in officials from both governments. A program of this kind does not, of course, have to be called a festival. It is simply a major cultural presentation, a way of making a more-than-fleeting impression on a given group. It should tell something about a country's past, present, and future.

What I am talking about with regard to a festival in the United States is a multifaceted and concentrated program to make more Americans aware of the ways in which others see the world, the ways in which they think, and what they have to offer. An exhibition may

come and go, with relatively few people aware that it was shown. Concentrating a number and variety of events around the exhibition, however, will increase the impact and provide an opportunity to include a great many others.

Is a major cultural presentation of this sort suitable for every country? I think not. Countries such as the Soviet Union, Germany, and Japan have had and will continue to have ongoing cultural presentations in the United States. They are also frequently in the media. Although I would not rule out major cultural presentations for these countries, I would suggest that there are others in the world that are also important geographically, militarily, economically, and culturally but that are little known in the United States. India and Indonesia are two examples. Others are Mexico, Brazil, Turkey, Egypt, Nigeria, Iran, Canada, Thailand, Morocco, and Vietnam. We could each develop our own lists.

Countries undertaking a festival should concentrate on quality rather than size. However, quality and size are not incompatible. The Festival of India is an example of this. The Indian ambassador to the United States during the festival was concerned that we were concentrating too much on major cities and institutions in the United States. He wanted to be certain that smaller towns would also be included. He had a point, but he need not have worried. The Festival of India reached far beyond the major cities, into the communities, and even the homes, of Americans throughout the country. There were a number of reasons for this, including a widespread but largely latent interest of Americans in India; the presence of an Indian community in the United States of about 500,000 people; and last, but far from least, an influx of feature films about India in theaters and on television in the United States. I wish the festival could take credit for *Gandhi, A Passage to India, Heat and Dust,* and *The Jewel in the Crown.* We were lucky. I doubt that future festivals will find such serendipitous circumstances.

We were not displeased with the growth of the festival and with the vast majority of its many programs. They created public relations opportunities beyond our wildest dreams. We made an effort, either through the subcommission office or the Indian Embassy/festival office, to keep track of them all, but it simply was not possible.

With the question of quality in mind, we have approached the Indonesian festival somewhat differently. Size has been a consideration from the beginning, not only from the point of view of quality control,

but from the point of view of the burden that could reasonably be placed on the administrative system in Jakarta.

Consider a festival of the Americas. The year 1992 will be the five-hundredth anniversary of the arrival of Columbus, and many excellent programs are being planned. How I would love to see a concentrated effort to bring all the countries of the Americas to the United States in 1992, each sending whatever it thinks is its best: an exhibition, a performing-arts program, a symphony orchestra, a poet, whatever. The other side of the coin would be a major cultural presentation from the United States in countries to the north and south in the hemisphere. It could make quite an impact. But to make these programs really worthwhile, we would want to build into them a framework to support programs of mutual exchange that would extend far beyond the festivals themselves.

Through the years, many have spoken of the common heritage of the Americas, the entire continents of North and South America. It is not possible to resolve the many problems that exist among countries on this continent. It *is* possible to ask for more awareness of one another during this five-hundredth anniversary.

My approach to festivals may appear simplistic. Carrying out what I have in mind is not. Although I do not expect every festival to meet all of the above criteria, I do hope that those putting programs together will at least think about these goals. The purpose of a festival should be twofold: it should make a broad spectrum of Americans aware of the many facets of another country's culture, and it should initiate and develop exchange programs that will ensure continued binational dialogue long after the festival is done.

PART 5

Other Cultures in Museum Perspective

IVAN KARP

The editorial page of the Saturday *Washington Post* carries an array of political cartoons that have been published by other papers during the preceding week. For 7 May 1988 the *Post* reprinted a remarkable cartoon by Wright that originally appeared in the *Miami News*. It showed black figures of Ronald and Nancy Reagan in "native" grass skirts, dancing around what appears to be a sacrificial shrine. Ronald holds a goat over his head and Nancy a chicken in each hand. Ronald says to Nancy, "What's the astrologer say to do next, Nancy?" Answers she, "Sacrifice the goat, singe the chickens and pound the lizard to powder!" This cartoon was a response to previous news reports that the Reagans had used astrological advice to schedule presidential events.

The cartoon evoked a curious echo for me. The image of the Reagans reproduced, quite deliberately, the popular imagery of the

"witch doctor." Herbert Ward's 1890 travel book, *Five Years with Congo Cannibals*, contains a strikingly similar illustration, drawn without the same satirical intent. It portrays a "witch doctor," again a black figure against a light background, dancing around a fire, clothed in a similar costume, and holding over his head a "fetish" figure. Patrick Brantlinger, in whose article on Victorian writing about Africans this illustration was reproduced, describes it as "a typical portrayal of African religion as idol or devil worship."[1]

The parallels between Ward and the *Washington Post* editorial cartoon are striking. I am not suggesting that the editorial cartoonist was copying Ward. Both drew, however, upon a stock of deeply held and patently enduring cultural imagery about the "other," that generalized artifact of the colonial and imperial encounter. Even more striking was the observation made by a colleague that both the Reagans and the Ward "witch doctor" had assumed standard classical-ballet positions. The effect is singular. Here we have combined in two illustrations the paradox of representing the "other." On the one hand, the "other" is clearly portrayed as lacking the qualities of dominant, usually colonial, cultural groups. The "other" lacks what "we" have; in this case rationality, symbolic (as opposed to true) animal sacrifice, and an orderly, bourgeois attitude toward the conduct of everyday life. The implication is that these are savages, controlled by emotions and unable to calculate rationally. On the other hand, the cultural resources used to produce an image of the "other" are not derived from a cross-cultural encounter. If the "other" is defined simply in terms of negative features, what it lacks, then it becomes impossible to produce a positive account. The ballet pose is no accident. Negative imagery needs positive associations to make it work, otherwise the consumers of the image would have nothing to grasp. The politics of producing the image

of the "other" requires a poetics not just of difference but also of similarity.

Museum exhibitions draw on the resources of public culture and popular imagery to produce their effects. They are as much an arena of discourse about the "other" as editorial cartoons or travel books. They also use the organizing principles of difference and similarity to produce the imagery of the "other."[2] Which principle predominates in the account or image of a cultural "other" often determines the strategy for how the "other" is portrayed. Usually we think of the "other" as represented primarily as different. Quite the opposite can occur, however. Similarity can be used to assert that the people of other cultures are no different in principle than the producer of the image, or that the differences that appear so great are only surface manifestations of underlying similarities.

An exhibiting strategy in which difference predominates I call *exoticizing,* and one that highlights similarities I call *assimilating.* We are more familiar with exoticizing strategies; they predominate in popular-culture forums such as travel accounts, as well as in some academic writing. Assimilating strategies are less easy to read. They appeal to the audience's sense of the familiar and natural. They don't stop exhibition-goers in their tracks and produce a "what in the world is that?" response.

Exoticizing often works by inverting the familiar, showing how a well-known practice takes an inverted form among other peoples. The common accusation that African peoples practice "animism" is an example. The anthropomorphic tendency of most Western religious belief is inverted to produce a class of people who worship divine beings created not in their own image but in the image of nature. That no non-Western religion has ever been known to have

such beliefs has not stopped legions of writers from describing Africans, for example, as "animists."

Assimilating is a more subtle exhibiting strategy. In fine-art museums that exhibit so-called primitive art the isolation of the object in a vitrine with minimal information is done to emphasize similarities between the aesthetic that is involved in appreciating the object in a museum and the aesthetic assumed to have been involved in its making. The controversial Museum of Modern Art exhibition "Primitivism" in Twentieth-Century Art: Affinity of the Tribal and the Modern is a classic instance of the assimilating strategy. Objects are brought together either because they are known to have provided models for modern artists or because they exhibit "affinities."

For William Rubin, the curator of the exhibition, affinities exist because artists working independently on similar formal problems arrive at similar solutions. This is pure structuralist interpretation. Considerations of content, such as iconography, or questions about intentionality, such as the religious purposes for which objects may have been made, and even examination of contexts of production and use are all omitted from an analysis of factors that may serve to shape the final form of the object. History also is omitted from consideration. Objects are defined as the products of individuals who accidentally derive their works from a limited stock of available forms. The result is assimilating because cultural and historical differences are obliterated from the exhibiting record. Rubin's exhibition turns the African, Native American, and Oceanian makers of the objects displayed in the show into modern artists who lack only the individual identity and history of modern art.[3] Using these criteria, their work can be only a footnote to the development of art in the West.

Still, Rubin's intentions are laudable. He desires to place "prim-

itive" aesthetics on a par with modernist aesthetics. In the end, however, he only assimilates the aesthetics of other cultural traditions to a particular moment within his own tradition. As a consequence of what he allows and omits in his history of art, he ends up constructing cultural "others" whose beliefs, values, institutions, and histories are significant only as a resource used in the making of modern art. If Rubin had chosen to examine how a "tribal" artist and Picasso each used similar forms in combination with forms not chosen by the other, a more textured and culturally diverse exhibition would have been the result, and he still would have been able to remain faithful to his project.[4]

Natural-history museums often manage to exoticize and assimilate within the same exhibition. The subordination of culture to nature that is so characteristic of exhibitions concerned with hunters and gatherers is revealed by displays that often show how the foraging strategies of animal species and human groups are similar. As a result, hunters and gatherers are assimilated to our ideas about nature at the same time as we exempt our own forms of culture and technology from the same examination. The history of the Smithsonian Institution illustrates this process in a grand manner. Out of the U.S. National Museum, which was a natural-history museum, developed the Museum of History and Technology (the forerunner of the National Museum of American History), leaving behind the Department of Anthropology in what is now the National Museum of Natural History. Thus the Smithsonian, unintentionally but palpably, maintains a nineteenth-century evolutionist distinction between those cultures that are best known and exhibited as part of nature, primarily Native Americans and peoples of the Third World, and Americans, whose primary defining feature was originally conceived as the possession of sci-

ence and technology, and who now possess history, in contrast to natural history.[5]

No genre of museum is able to escape the problems of representation inherent in exhibiting other cultures. The two perils of exoticizing and assimilating can be found in the exhibitions of virtually every museum that devotes any part of itself to exhibiting culture. Nor are museums that restrict themselves to examining diversity within their own societies able to escape the difficulties described above. Some of the most recent studies of images and ideas about imaginary or unknown worlds (which as a group are coming to be called either the "history of the 'other' " or the "anthropology of the imaginary") demonstrate how the image of the "other" is formed partly from images of class, ethnicity, and gender in Western cultures, partly from negation and inversion, and partly from the "other's" images of their own "others," as they have been recorded and transmitted by explorers, colonials, and other occupants of cultural and imperial frontiers.[6] I am sure that the reverse is also true. Portrayals of African American family life are no doubt affected by the notion that Africans have female-headed households. A vicious circle of mutually reinforcing cause and effect in the history of representing the "other" reinforces the problems inherent in exhibiting culture that *all* museums face.

One special problem faces museums whose mission is ethnographic. The decline of museums during the period preceding World War II, chronicled by Neil Harris, has been reversed.[7] Public subsidy and private philanthropy have made many museums relatively prosperous. Ethnographic museums, however, generally have been scenes of neglect. One need only consider the shabby Musée de l'Homme in contrast to the resources put into other national museums in Paris, or that the United States is the only major Western

nation without a museum of cultures, mankind, or civilizations. At a recent conference a British participant pointed out that the winds of change associated with the independence of Third World countries have had the ironic consequence of causing Western public culture to turn inward. Thus ethnographic museums become museums of another sort; they exhibit ideas about the "other" in the earlier, cruder forms left over from the time in which the ideas came into being, and not in the glossier, disguised forms into which they have developed and in which they are found in many art and history museums.

The ironies are multiple: because their exhibitions are unchanged and unmediated by modern and attractive exhibiting devices and techniques, ethnographic museums often present the imaginary "other" in purer form. That this is so is not because these museums are more retrograde than other institutions. Rather, they suffer from the same neglect that the Third World faces vis-à-vis the First World. And they are subject to many of the same attitudes that characterize colonial social relations. Frantz Fanon observes that poverty is a defining feature of colonial attitudes. The poverty of the subject masses is believed to be the result of their cultural or personal inferiority.[8] The shabbiness of ethnographic museums is often assumed to be the product of the attitudes of the personnel who now staff them. There is a serious need to examine museums systematically not only in terms of attitudes toward the "other," but also in terms of how the strategies of exoticizing and assimilating fit with public culture in the West.

I am going to suggest that art museums that present the art of other cultures in terms of universal aesthetics (which are actually Western) or natural-history museums that exploit middle-class anxieties about the environment in their exhibitions will have an easier

fit with their publics and supporters than ethnographic museums that strive to represent cultural specificity. The attitudes manifested in public culture toward the "other" may take new forms but remain basically unchanged.

Many of the other papers in this volume describe how other cultures are viewed in museum perspective, and could have been included in this section. Part 2, which focuses on the exhibition Hispanic Art in the United States, examines disputes over whether the exhibition used an assimilating strategy, and concludes with a plea by Tomas Ybarra-Frausto for exhibitions that construct a space for displaying cultural specificity. Curtis Hinsley's paper on the World's Columbian Exposition, in Part 4, provides a textbook case study of the politics of assimilation and exoticizing in a cultural event cast on a grand scale. The full range of representations of the "other" was played out in Chicago in 1893, and the evidence presented by the papers in this volume reveal that the story is not over.

In this section, "Objects of Ethnography," by Barbara Kirshenblatt-Gimblett, provides a history of exhibiting other cultures, their objects, and their people. She usefully distinguishes between two styles of exhibiting, which she calls *in situ* and *in context*. In-situ exhibiting is realist in its appeal, the object surrounded by as full a recreation as possible of its original setting. Authenticity and knowledge, at least as far as external features are concerned, are the hallmark of in-situ exhibitions. In natural-history and ethnographic museums, the diorama offers in-situ exhibiting in its purest form. Donna Haraway's article on the dioramas in the American Museum of Natural History shows that one purpose of the diorama was to present nature in its ideal form. Only perfect animal specimens were sought, and natural settings were meticulously documented and recreated in the museum.[9] The rhetorical appeal of the

diorama is that the audience should experience nature, or exotic cultures, as they *really* are. No interpretive work is necessary for the audience. Ironically, museums end up purveying a tourist experience for audiences unable to pay for the "real thing." At the California Academy of Sciences in San Francisco, members of the audience come to the diorama hall of African mammals, called "African Safari," dressed in appropriate safari costumes, to be photographed in front of a very elaborate diorama of a waterhole in Ngorongoro crater in Tanzania.[10] The illusion of close fit between the representation and what is represented is sustained by in-situ exhibiting styles. The extension of these styles and accompanying realist conventions of representing to human actions and products is a major theme in Kirshenblatt-Gimblett's article. The absence of any appeal to the audience to engage in mutual acts of interpretation parallels Elaine Heumann Gurian's account of authoritarian styles of exhibiting.

In-context exhibiting is the alternative considered by Kirshenblatt-Gimblett. In-context exhibitions take a step toward acknowledging the constructed nature of the knowledge presented in the exhibition, and thus also take a step toward inviting the audience to recognize the arbitrary nature of all representations. They do so by using devices such as long labels, charts, and educational programs. By asserting more control over the *objects* and making the interpretive context publicly accessible, in-context exhibits exert less control over the *audience*.

Kirshenblatt-Gimblett uses this distinction to reply to many of the other papers in the conference. She considers the phenomenology of the museum experience, and how resonance and wonder are produced, by contrasting in-situ and in-context aspects of experience. Most important, she examines how the museum effect either distances or engages the audience with exhibitions of culture. More

than any other paper in this volume, Kirshenblatt-Gimblett's contribution takes up the question addressed earlier in this introduction: how do styles of exhibiting position exhibitors and audiences vis-à-vis the people of the cultures exhibited? The strategies of exoticizing and assimilating described above posit both relative distance to and degrees of kinship with other cultures. Kirshenblatt-Gimblett's consideration of questions of detachment and engagement also addresses whether the audience is invited to participate with the "other" as coeval or not.[11]

Dawson Munjeri's paper on the national museums of Zimbabwe presents a case of denial of coevalness in its most extreme form. Munjeri describes the situation inherited by the Zimbabwean museums at independence. Indigenous African cultures had been obliterated from the museum record by a political process that had its effects not so much through the assertion of values as through the setting of priorities. This has a familiar ring; the colonial fate of Zimbabwe's cultures is not unlike the fate of contemporary ethnographic museums, described above. The dilemma faced by the national museums is poignant. Their first task is collecting and reconstructing what has been passed over in silence. The second task is for them to define how they will insert themselves into the process of defining national identity. In the 1960s, museums in many newly independent African states were not allowed to exhibit indigenous cultures, as new nations were striving to fashion national culture and identity out of exceedingly diverse cultural groups, languages, and histories. Their initial solution was to attempt to build national institutions that would act as melting pots, to use an American metaphor. Zimbabwe achieved independence twenty years later, as African nations were coming to realize that melting-pot cultures are neither achievable nor desirable. Whether they will be able to tran-

scend the politics of representation that set up such polar categories as traditional versus modern, poor versus developed, and scientific versus custom-bound remains to be seen. At the least, they have the dubious privilege of having had colonial experience firsthand and knowing how colonial culture defines even the most intimate details of everyday life.

Kenneth Hudson notes the sorry state of most ethnographic museums and attributes their lack of influence to a fundamental limit on how they can represent the conditions under which the people of Third World societies live. Hudson takes a strict materialist perspective and argues that the exhibiting process is simply unable to convey the sensuous experience of living under different environmental conditions and often material deprivation. From his point of view ethnographic museums are not capable of becoming museums of influence, museums that serve as models for others.[12] Hudson's paper generated a lively discussion at the conference, several people contending that the limitations he sees as specific to ethnographic museums are endemic in all forms of representation.

Barbara Kirshenblatt-Gimblett and Kenneth Hudson may have written the most opposed papers in the volume. Kirshenblatt-Gimblett would assert that Hudson's strictures derive from an essentially in-situ view of the role of exhibition in presenting the world, while Hudson might counter that the moral task of exhibiting culture imposes limits on the story one is able to tell. One issue highlighted by the debate over Hudson's paper, but found throughout the entire conference, is that the solutions museums find to the problems of exhibiting culture are profoundly affected by the genre of museum as much as by the overt content of the exhibition. The different styles and strategies of exhibiting discussed in this section are not used equally by all genres of museums. The next task may

be to examine systematically how the history of museums relates to the history of exhibiting culture and to the anthropology of the imaginary. This is a task that has just begun.

NOTES

1. See Patrick Brantlinger, "Victorians and Africans," in Henry Louis Gates, Jr., ed., *"Race," Writing and Difference* (Chicago: University of Chicago Press, 1986).

2. I differ here from the account of how the "other" is constructed presented in Edward Said's pathbreaking book *Orientalism* (New York: Pantheon, 1978). Said stresses the negation of the imputed qualities of the West, while I emphasize the mutual dependence of the tropes of similarity and difference in the construction of any image of the "other." I use the term *similarity* to refer to what other authors call *identity*. Actually, both identity and similarity are asserted in the strategy of assimilation, discussed below.

3. My account of Rubin's account of "primitive" artists should show why I prefer similarity to identity. Even assimilating strategies conclude that identity is modified by critical differences. Rubin's "primitive" artists are identical to modern artists except for those features of modern art that they do not have. An initial assertion of identity concludes with a declaration of difference. Even Rubin's decision to retain the term *primitive* gets him into trouble. How can he avoid the sense that so-called primitives are what we once were, our "contemporary ancestors," whose only history is our past? Anthony Burgess defines *primitivism* as "the sense of a stumbling amateur striving towards a hard-won perfection and not quite achieving it" ("Native Ground," *Atlantic* 261, no. 1 [Jan. 1988], 89). No matter how Rubin chooses to define his terms, his classificatory practices reveal the sense conveyed by Burgess's definition.

4. See Rubin's introductory essay, "Modernist Primitivism," in *"Primitivism" in Twentieth-Century Art: Affinity of the Tribal and the Modern* (New York: Museum of Modern Art, 1984), especially 27–30.

5. The establishment of the National Museum of the American Indian at the Smithsonian does not solve this problem. The master narrative of the museums on the Mall still assert the dominion of nature over *some* cultures. The emphasis on fine art in the National Museum of African Art and in the collection of what will be the National Museum of the American Indian only serves to underscore how the aesthetics and history of the dominant culture define the missions of these museums.

6. See especially the meticulous research in Peter Mason's *Deconstructing America: Representations of the Other* (London: Routledge and Kegan Paul, 1990).

7. Neil Harris, "Museums, Merchandising and Popular Taste: The Struggle for Influence." In *Material Culture and the Study of American Life* (New York: Norton, 1977).

8. Frantz Fanon, *The Wretched of the Earth* (New York: Grove, 1968).

9. Donna Haraway, "Teddy Bear Patriarchy: Taxidermy in the Garden of Eden, 1908–1936," *Social Text* 11 (Winter 1984–85).

10. The diorama is not identified as Ngorongoro crater. In keeping with the idealized and eternalized messages conveyed by dioramas, it has no geographical location.

11. See Johannes Fabian, *Time and the Other* (New York: Columbia University Press, 1983) for a consideration of how texts create or deny coevalness to the other through the uses of concepts of time.

12. See Kenneth Hudson, *Museums of Influence* (Cambridge: Cambridge University Press, 1987).

Objects of Ethnography

BARBARA KIRSHENBLATT-GIMBLETT

Moon rocks, a few small strips of meat dried Hidatsa-style before 1918, dust from Jerusalem, "a knot tied by the wind in a storm at sea," bottle caps filled with melted crayon made for skelley (a New York City street game), "a drop of the Virgin's milk," pieces of the dismantled Berlin Wall.[1] Each object is shown to the public eye, protected and enshrined. Were the criteria of "visual interest" to determine what should be exhibited, such rocks, bits of meat, knots, dust, wire, and toys, if saved at all, would await attention of another kind— perhaps by microscope, telescope, laboratory test, nutritional analysis, written description, diagram, or report of miracles. Why save, let alone display, things that are of little visual interest? Why ask the museum visitor to look closely at something whose value lies somewhere other than in its appearance?

The suggestion that objects lacking visual interest might be of historical, cultural, religious, or scientific interest, while seeming to offer an answer, actually compounds the problem because it leaves unexplored several fundamental assumptions, first among them the notion of artifactual autonomy. It is precisely this autonomy that makes it possible to display objects in and of themselves, even when there is little to inspect with the eye.[2] The ethnographic object raises issues of artifactual integrity and autonomy.

Fig. 20-1. *Dried meat.* Reproduced from *The Way to Independence: Memories of a Hidatsa Indian Family, 1840–1920,* by Carolyn Gilman and Mary Jane Schneider, copyright 1987 by the Minnesota Historical Society.

Ethnographic artifacts are objects of ethnography. They are artifacts created by ethnographers. Objects become ethnographic by virtue of being defined, segmented, detached, and carried away by ethnographers. Such objects are ethnographic not because they were found in a Hungarian peasant household, Kwakiutl village, or Rajasthani market rather than in Buckingham Palace or Michelangelo's studio, but by virtue of the manner in which they have been detached, for disciplines make their objects and in the process make themselves. It is one thing, however, when ethnography is inscribed in books or displayed behind glass, at a remove in space, time, and language from

the site described. It is quite another when people themselves are the medium of ethnographic representation, when they perform themselves, whether at home to tourists or at world's fairs, homeland entertainments, or folklife festivals—when they become living signs of themselves.

EXHIBITING THE FRAGMENT

The artfulness of the ethnographic object is an art of excision, of detachment, an art of the excerpt. Where does the object begin and where does it end? This I see as an essentially surgical issue. Shall we exhibit the cup with the saucer, the tea, the cream and sugar, the spoon, the napkin and placemat, the table and chair, the rug? Where do we stop? Where do we make the cut?

Perhaps we should speak not of the ethnographic object but of the ethnographic fragment. Like the ruin, the ethnographic fragment is informed by a poetics of detachment. Detachment refers not only to the physical act of producing fragments, but also to the detached attitude that makes that fragmentation and its appreciation possible. Lovers of ruins in seventeenth- and eighteenth-century England understood the distinctive pleasure afforded by architectural fragments, once enough time had passed for a detached attitude to form. Antiquarian John Aubrey valued the ruin as much as he did the earlier intact structure.[3] Nor were ruins left to accidental formation. Aesthetic principles guided the selective demolition of ruins and, where a ruin was lacking, the building of artificial ones.[4] A history of the poetics of the fragment is yet to be written, for fragments are not simply a necessity of which we make a virtue, a vicissitude of history, or a response to limitations on our ability to bring the world indoors. We make fragments.[5]

In Situ

In considering the problem of the ethnographic object, it is useful to distinguish *in situ* from *in context,* a pair of terms that calls into question the nature of the whole, the burden of interpretation, and the location of meaning.

The notion of in situ entails metonymy and mimesis: the object is a part that stands in a contiguous relation to an absent whole that may or may not be recreated. The art of the metonym is an art that accepts

the inherently fragmentary nature of the object. Showing it in all its partiality enhances the aura of its "realness." The danger, of course, is that museums amass collections and are, in a sense, condemned ever after to exhibit them. Collection-driven exhibitions often suffer from ethnographic atrophy because they tend to focus on what could be, and was, physically detached and carried away. As a result, what one has is what one shows. Very often what is shown is the collection itself, whether highlights, masterpieces, or a collection in its entirety. The tendency increases for such objects to be presented as art.

The art of mimesis, whether in the form of period rooms, ethnographic villages, recreated environments, reenacted rituals, or photomurals, places objects (or replicas of them) in situ. In-situ approaches to installation enlarge the ethnographic object by expanding its boundaries to include more of what was left behind, even if only in replica, after the object was excised from its physical, social, and cultural settings. Because the metonymic nature of ethnographic objects invites mimetic evocations of what was left behind, in-situ approaches to installation often result in environmental and recreative displays. Such displays, which tend toward the monographic, appeal to those who argue that cultures are coherent wholes in their own right, that environment plays a significant role in cultural formation, and that displays should present process and not just products. At their most mimetic, in-situ installations include live persons, preferably actual representatives of the cultures on display.

In-situ installations, no matter how mimetic, are not neutral. They are not a slice of life lifted from the everyday world and inserted into the museum gallery, though this is the rhetoric of the mimetic mode. On the contrary, those who construct the display also constitute the subject, even when they seem to do nothing more than relocate an entire house and its contents, brick by brick, board by board, chair by chair. Just as the ethnographic object is the creation of the ethnographer, so, too, are the putative cultural wholes of which they are part. The exhibition may reconstruct Kwakiutl life as the ethnographer envisions it before contact with Europeans, or Polish peasant interiors, region by region, as they are thought to have existed before industrialization. Or the display may project a utopian national whole that harmoniously integrates regional diversity, a favorite theme of national ethnographic museums and American pageants of democracy during the first decades of this century. "Wholes" are not given but constituted, and often they are hotly contested.[6]

Representational conventions guide mimetic displays, despite the

illusion of close fit, if not identity, between the representation and that which is represented.[7] Indeed, mimetic displays may be so dazzling in their realistic effects as to subvert curatorial efforts to focus the viewer's attention on particular ideas or objects. There is the danger that theatrical spectacle will displace scientific seriousness, that the artifice of the installation will overwhelm ethnographic artifact and curatorial intention.

In Context

The notion of in context, which poses the interpretive problem of theoretical frame of reference, entails particular techniques of arrangement and explanation to convey ideas. Objects are set in context by means of long labels, charts, and diagrams, commentary delivered via earphones, explanatory audiovisual programs, docents conducting tours, booklets and catalogues, educational programs, and lectures and performances. Objects are also set in context by means of other objects, often in relation to a classification or schematic arrangement of some kind, based on typologies of form or proposed historical relationships. In-context approaches to installation establish a theoretical frame of reference for the viewer, offer explanations, provide historical background, make comparisons, pose questions, and sometimes even extend to the circumstances of excavation, collection, and conservation of the objects on display. There are as many contexts for an object as there are interpretive strategies.

In-context approaches exert strong cognitive control over the objects, asserting the power of classification and arrangement to order large numbers of artifacts from diverse cultural and historical settings and to position them in relation to one another.[8] Even when the objects themselves are arranged not according to such conceptual schemes but according to geographic area, the viewer may be encouraged to "frame for himself a few general principles for which he can seek out specimens."[9] Whether they guide the physical arrangement of objects or structure the way viewers look at otherwise amorphous accumulations, exhibition classifications create serious interest where it might be lacking. For instruction to redeem amusement, viewers need principles for looking. They require a context, or framework, for transforming otherwise grotesque, rude, strange, and vulgar artifacts into object lessons. Having been saved from oblivion, the ethnographic fragment needs also to be rescued from triviality. One way of doing this is to treat the specimen as a document.

RESCUING THE FRAGMENT FROM TRIVIALITY

The problematic relationship of in-situ and in-context approaches, which are by no means mutually exclusive, is signaled by Oleg Grabar in his comment about Islamic objects: "They are in fact to be seen as ethnographic documents, closely tied to life, even a reconstructed life, and more meaningful in large numbers and series than as single creations."[10] Such objects, in Grabar's view, are inherently multiple, documentary, and contingent. They were never intended to hold up to scrutiny as singular creations. Moreover, they are at their most documentary when presented in their multiplicity, that is, as a collection. Grabar diffuses their status as artifacts by according them higher value as "documents," as signs that point away from themselves to something else, to "life." At the same time, he hyperbolizes their status as artifacts by advocating that they be examined in "large numbers and series," a task anticipated and facilitated by the collecting process itself and well suited to typological exhibition arrangements.

Though once multiple, in becoming ethnographic many objects become singular, and the more singular they become, the more readily are they reclassified and exhibited as art. The many become one by virtue of the collection process itself. First, collecting induces rarity by creating scarcity: escalating demand reduces the availability of objects. Second, collectors create categories that from the outset, even before there is demand, are marked by the challenges they pose to acquisition: "By creating their own categories, all collectors create their own rarities."[11] Third, the very ubiquity of the kinds of objects that interest ethnographers contributes to their ephemerality. Commonplace things are worn to oblivion and replaced with new objects, or are viewed as too trivial in their own time to be removed from circulation, to be alienated from their practical and social purposes, and saved for posterity.[12] But no matter how singular the ethnographic object becomes, it retains its contingency, even when, by a process of radical detachment, it is reclassified and exhibited as art.[13]

Indeed, the litmus test of art seems to be whether or not an object can be stripped of contingency and still hold up. The universalizing rhetoric of "art," the insistence that great works are universal, that they transcend space and time, is predicated on the irrelevance of contingency. But the ability to stand alone says less about the nature of the object and more about our categories and attitudes, which may account for the minimalist installation style of exhibitions of "primitive art." By suppressing contingency and presenting the objects on

their own, such installations lay claim to the universality of the exhibited objects as works of art.

Ethnographic objects move from curio to specimen to art, though not necessarily in that order. As curiosities, objects are anomalous; by definition they defy classification. Nineteenth-century advocates of scientific approaches to museum exhibition complained repeatedly about collections of curiosities that were displayed without systematic arrangement. But how could exhibitors be expected to arrange systematically what in their terms was the unclassifiable? In what category might one exhibit the knot tied by the wind during a storm at sea that was donated to Peale's Museum at the end of the eighteenth century? Probably indistinguishable in appearance from a knot tied by human hands on land during calm weather, this object was an episode in an amazing story waiting to be retold, rather than a member of a class of objects relevant to scientific taxonomies of the period.

What we see here are objects that had outlasted the curatorial classifications that once accommodated them in Renaissance cabinets and galleries. Singularities, chance formations that resulted from the "shuffle of things," did fall into a broad category, namely *mirabilia*.[14] Defined in terms of that which is not normal or commonplace, this category included the very large and the very small, the misshapen and the miraculous, and the historically unique—for example, a hat with bullet holes associated with a specific historic event.[15] By the nineteenth century, such objects had become anomalous to natural historians: they were interested in taxonomies of the normal, not in the singularities of chance formation.

Exhibition classifications, whether Linnean or evolutionary, shift the grounds of singularity from the object to a category within a particular taxonomy. For a curiosity to become classifiable it had to qualify as a representative member of a distinguishable class of objects. Charles Willson Peale, for example, was reluctant to show items that fell outside of the Linnean classification according to which he arranged objects in his museum in Philadelphia during the late eighteenth and early nineteenth centuries. His exhibits of plants and animals were normative: they featured typical members of each class. The comprehensiveness of the classification and orderly arrangement of Peale's collection testified to the purposiveness and goodness of God's creation, a message that was reinforced by quotations from the Bible mounted on the walls. A mark of the seriousness and scientific nature of such exhibitions was the absence of freakish aberrations.[16]

In contrast, a eugenics exhibition subjected to orderly arrangement the very anomalies (trembling guinea pigs, triplets, a picture drawn by a color-blind man, deformed eyeballs) that a century earlier would have appeared as curiosities defying classification. The structure of genetic inheritance now provided not only the matrix for the orderly display of nature's mistakes, long an attraction in cabinets and freak shows, but also the basis for eliminating such errors in the future through sterilization, antimiscegenation laws, and selective mating.[17] Exhibits in the dime museum challenged credulity—Ripley's Believe It or Not. Scientific exhibits challenged intelligibility—George Brown Goode's object lessons.

The exhibition of objects as art is predicated on the singularity of each object. Jewels and gems dazzle. They invite appreciation, not analysis. There is no place in this empire of things, ruled by the collector, for copies, photographs, models, homologues, dioramas, or tableaus. There is no place here for displaying continuous series of objects—without regard for the artistic excellence of each and every one—to make some historical point, no place for a system of classification that would subsume objects within theoretical hierarchies. Unmitigated excellence in everything shown, ubiquitous singularity, and the unifying principle of the collector's power—this is the message of the jewel box.

No matter how perfect an art collection and each object within it, things could be reclassified for scientific purposes, and in the various exhibitions where they were featured, such objects moved from category to category.[18]

Fig. 20-2. *This participatory exhibit at the Third International Congress of Eugenics required visitors to rank ten fur samples as a test of their sense of elegance—an example of the idea of aesthetics as innate, independent of context and culture.* From *A Decade of Progress in Eugenics,* copyright 1934 by the Williams & Wilkins Co., Baltimore. Reproduced with permission.

THE LIMITS OF DETACHMENT

But not all that the ethnographic surgeon subjects to cognitive excision can be physically detached, carried away, and installed for viewing. What happens to the intangible, the ephemeral, the immovable, and the animate? The intangible, which includes such classic ethnographic subjects as kinship, worldview, cosmology, values, and attitudes, cannot be carried away. The ephemeral encompasses all forms of behavior—everyday activities, storytelling, ritual, dance, speech, performance of all kinds—that are there one moment and gone the next. The immovable, whether a mesa, pyramid, cliff dwelling, or landform, can be recorded in photographs but presents formidable logistical obstacles to those who would detach and carry it away. The animate has been collected both dead and alive. Dried, pickled, or stuffed, botanical and zoological specimens become artifacts for the museum. Alive, flora and fauna present storage problems that are solved by gardens and zoos in which living collections are on view. But what about people? Bones and mummies, body parts in alcohol, and plaster death masks may be found in museums. Living human specimens have been displayed in zoos, formal exhibitions, festivals, and other popular amusements.

If we cannot carry away the intangible, ephemeral, immovable, and animate, what have we done instead? Typically, we have inscribed what we cannot carry away, in field notes, recordings, photographs, films, and drawings. We have created ethnographic documents. Like ethnographic objects, these documents are also artifacts of ethnography, but—true to what I would call the fetish-of-the-true-cross approach—ethnographic objects, those material fragments that we can carry away, are accorded a higher quotient of realness. Only the artifacts, the tangible metonyms, are really real. All the rest is mimetic, second order, a representation, an account undeniably of our own making. We have here the legacy of Renaissance antiquarians, for whom "visible remains" were used to corroborate written accounts. Objects, according to Giambattista Vico, were "manifest testimony" and carried greater authority than texts, even contemporaneous ones.[19]

The priority of objects over texts in museum settings was reversed during the second half of the nineteenth century. George Brown Goode, director of the U.S. National Museum, operated according to the dictum that "the most important thing about an exhibition was the label," a point restated by many who worked with him:[20]

The people's museum should be much more than a house of speci-
mens in glass cases. It should be a house full of ideas, arranged with
the strictest attention to system.

 I once tried to express this thought by saying "*An efficient ed-
ucational museum may be described as a collection of instructive
labels, each illustrated by a well-selected specimen.*"[21]

Museums were to teach "by means of object lessons," but objects
could not be relied upon to speak for themselves.[22]

 The curatorial charge was to create exhibitions that would "fur-
nish an intelligent train of thought" by using objects to illustrate
ideas.[23] Reacting to the apparent lack of logical arrangement in dis-
plays of art collections in many European museums and the low status
to which so many private museums in America had descended, Goode
had long insisted that the museum of the past was to be transformed
from "a cemetery of bric-a-brac into a nursery of living thoughts" and
serve, in its way, as a library of objects.[24] Curators were to objectify
texts and textualize objects; hence the importance of an organizational
scheme for arranging objects and labels to explain them, and the
willing acceptance of copies, casts, impressions, photographs, dia-
grams, and other surrogates for primary artifacts. Since the main pur-
pose of a public museum was to educate, "for the purposes of study a
cast was as good as an original," and in some cases better.[25] Copies
came to play a special role.

 Though proclaimed as a new approach to the exhibiting of
objects, the textualized object was not new, having been featured in
demonstrations and illustrated lectures for centuries. The increasing
emphasis on ostension during the nineteenth century suggests a shift
in the foundation of authoritative knowledge from a reliance on
rhetoric to a leading role for information, particularly in the form of
visual facts.[26] In many ways, the approach to museum exhibi-
tions advocated by Goode during the latter part of the nineteenth
century should be seen in relation to the illustrated lecture's his-
tory and requirements. Complaining in 1891 about the decline of
"entertainments worthy of civilized communities—concerts, read-
ings, lectures," and the rise of illustration, including the diagram,
blackboard, and stereopticon, Goode wanted the museum to fill
the gap left by the decline of lectures and scientific, literary, and
artistic societies.[27] The written label in an exhibition was a sur-
rogate for the words of an absent lecturer, with the added ad-
vantage that the exhibited objects, rather than appearing briefly to

illustrate a lecture, could be seen by a large public for a longer period of time.

It is precisely in these terms that Washington Matthews introduced his lecture "Some Sacred Objects of the Navajo Rites" at the Third International Folklore Congress, held at the World's Columbian Exposition in Chicago in 1893:

> Someone has said that a first-class museum would consist of a series of satisfactory labels with specimens attached. This saying might be rendered: "The label is more important than the specimen." When I have finished reading this paper, you may admit that this is true in the case of the little museum which I have here to show: A basket, a fascicle of plant fibres, a few rudely painted sticks, some beads and feathers put together as if by children in their meaningless play, form the total of the collection. You would scarcely pick these trifles up if you saw them lying in the gutter, yet when I have told all I have to tell about them, I trust they may seem of greater importance, and that some among you would be as glad to possess them as I am. I might have added largely to this collection had I time to discourse about them, for I possess many more of their kind. It is not a question of things, but of time. I shall do scant justice to this little pile within an hour. An hour it will be to you, and a tiresome hour, no doubt; but you may pass it with greater patience when you learn that this hour's monologue represents to me twelve years of hard and oft-baffled investigation. Such dry facts as I have to relate are not to be obtained by rushing up to the first Indian you meet, notebook in hand. But I have no time for further preliminary remarks, and must proceed at once to my descriptions.[28]

In this demonstration of connoisseurship, the ethnographer is a detective who toils long and hard to decipher material clues. This master of induction competes both with the native informant and with other ethnographers, not for the objects, but for the facts that comprise his or her descriptions. The ethnographer's lecture is a long label, a performed description, that elevates what would otherwise be viewed as "trifles." Neither the modest specimens nor the dry facts are expected to interest the listener. Rather, it is the ethnographer's own expenditure of time and effort—his or her expertise—that creates value.

This effect is achieved rhetorically, for the more unprepossessing the evidence, the more impressive the ethnographic description. Characterizing his own recounting of the facts as "minute to a tedious degree" and "not one half the particulars that I might appropriately

have told you," Matthews admits to having reached the limits of his ability to describe when challenged by the drumstick on the table. Not even the Navajo can describe in words how the drumstick is made, "so intricate are the rules pertaining to its construction." Apologizing for not having fresh yucca on hand with which to demonstrate the process, he offers to take anyone who is interested to the "yucca-covered deserts of Arizona," where Matthews can "show him how to make a drum stick." In this way, Matthews confronts two basic problems in ethnographic display. First he makes the apparently trivial interesting by performing ethnography (the illustrated lecture). Then he addresses the limitations of verbal description by offering to play Indian (the demonstration). [29] The profusion of facts that Matthews presents to his listeners, his apologies for their dry and tedious character notwithstanding, are a classic case of what Neil Harris has identified as the operational aesthetic—"a delight in observing process and examining for literal truth."[30]

EXHIBITING HUMANS

Not only inanimate artifacts but also humans are detachable, fragmentable, and replicable in a variety of materials. The inherently performative nature of live specimens veers exhibits of them strongly in the direction of spectacle, blurring the line still further between morbid curiosity and scientific interest, chamber of horrors and medical exhibition, circus and zoological garden, theater and living ethnographic display, dramatic monologue and scholarly lecture, staged recreation and cultural performance. The blurring of this line was particularly useful in England and the United States during the early nineteenth century because performances that would have been objectionable to conservative Protestants if staged in a theater were acceptable when presented in a museum, even if there was virtually nothing else to distinguish them. This reframing of performance in terms of nature, science, and education rendered it respectable, particularly during the first half of the nineteenth century. If in the scientific lecture the exhibitor was the performer, ethnographic displays shifted the locus of performance to the exhibit proper, and in so doing, made ample use of patently theatrical genres and techniques to display people and their things.

In what might be characterized as a reciprocity of means and a complementarity of function, museums used the theatrical craft of

scene painting for exhibits and staged performances in their lecture rooms, while theaters used the subjects presented in museums, including live exotic animals and humans in their stage productions. Museums served as surrogate theaters during periods when theaters came under attack for religious reasons, while theaters brought a note of seriousness to their offerings by presenting edifying entertainment. In the drama of the specimen, the curator was a ventriloquist whose task it was to make the object speak. Through processual scenarios of production and function, curators narrativized objects: they showed the process by which ceramics and textiles were manufactured, step by step, or how they were used in daily life and ceremony. Smithsonian anthropologist Otis T. Mason was explicit on this point in 1891 when he defined "the important elements of the specimen" as "the dramatis personae and incidents."[31]

Living or Dead

Human displays teetertotter on a kind of semiotic seesaw, equipoised between the animate and inanimate, the living and the dead. The semiotic complexity of exhibits of people, particularly those of an ethnographic character, may be seen in reciprocities between exhibiting the dead as if they are alive and the living as if they are dead, reciprocities that hold as well for the art of the undertaker as they do for the art of the museum preparator. Ethnographic displays are part of a larger history of human display, in which the themes of death, dissection, torture, and martyrdom are intermingled.

Ethnographic subjects were easily incorporated into such modes of display.[32] The remains of the dead had long been excavated and shown as ethnographic specimens—tattooed Maori heads, Aztec skulls, and bones removed from Native American graves. Live subjects provided expanded opportunities for ethnographic display. While live, human rarities figured in museological dramas of cognitive vivisection. When dead, their corpses were anatomized and their bones and fleshly body parts incorporated into anatomical exhibits. The *vanitas mundi* was a way of exhibiting dissected materials: one such anatomical allegory was created out of the skeleton of a fetus, tiny kidney stones, a dried artery, and a hardened vas deferens. Articulated skeletons, taxidermy, wax models, and live specimens also offered conceptual links between anatomy and death in what might be considered museums of mortality.[33]

Wax models as a form of three-dimensional anatomical illustra-

tion were commonly used to teach medicine and were featured in anatomical displays open to the public. With the rising interest in racial typologies and evolution, Sarti's Museum of Pathological Anatomy in London during the mid-nineteenth century, and others like it, became the place to exhibit culturally constructed anatomical pathologies (parts of a Moorish woman's anatomy), missing links in the evolutionary sequence (wax figures of African "savages" with tails), and wax tableaus of ethnographic scenes.[34] As early as 1797, Peale had completed wax figures for "a group of contrasting races of mankind" that included natives from North and South America, the Sandwich Islands, Tahiti, and China. The faces are thought to have been made from life casts. The figures were outfitted with appropriate clothing and artifacts. Half a century later, the Gallery of All Nations in Reimer's Anatomical and Ethnological Museum in London featured "the varied types of the Great Human Family."[35]

The "gallery of nations" idea, which since the late sixteenth century had served as the organizing principle for books devoted to customs, manners, religions, costumes, and other ethnographic topics, was easily adapted to the exhibition of ethnographic specimens.[36] A logical spinoff was the monographic display. Nathan Dunn's celebrated Chinese collection, which was installed in Peale's Museum in 1838 and moved to London in 1841, offered, according to a diarist of the period, "a perfect picture of Chinese life":

> Figures of natural size, admirably executed in clay, all of them portraits of individuals, are there to be seen, dressed in the appropriate costume, engaged in their various avocations and surrounded by the furniture, implements and material objects of daily existence. The faces are expressive, the attitudes natural, the situation & grouping well conceived, and the aspect of the whole very striking and lifelike. Mandarins, priests, soldiers, ladies of quality, gentlemen of rank, play-actors and slaves; a barber, a shoemaker and a blacksmith employed in their trades; the shop of a merchant with purchasers buying goods, the drawing room of a man of fortune with his visitors smoking and drinking tea & servants in attendance; all sitting, standing, almost talking, with the dress, furniture and accompaniments of actual life. Some of the costumes are of the richest and most gorgeous description. Models of country houses and boats, weapons, lamps, pictures, vases, images of Gods, and porcelain vessels, many of them most curious and beautiful, and in number, infinite. Mr. Dunn was in the room himself and explained to us the nature and uses of things.[37]

Fig. 20-3. *Saloon of a Chinese junk*. From *Illustrated London News*, 20 May 1848. Photo courtesy of Guildhall Library, City of London.

The attention in this description to the individuation of faces reflects the more general preoccupation with "types" and the notion of physiognomy as a key to moral character.[38]

Physiognomic types and their racial implications were presented not only in galleries of nations and in the later "types of mankind" exhibitions, but also in crowd scenes and group portraits of life in contemporary European and American cities, as well as in the literature of the period. So great was the fascination with physiognomy that at Peale's Museum, where portraits of great men "etched the outlines of genius" and those of "savages" revealed their physiognomy, museum visitors could take home as a souvenir their own silhouette, made with great exactitude thanks to a mechanical device, the "physiognotrace," invented in 1803 and demonstrated in the museum gallery.[39]

Dunn's Chinese exhibition inspired other such displays, notably scenes of daily life at the Oriental and Turkish Museum during the 1850s in London. Viewers were astonished by the wax figures, which a journalist of the time praised for their realism: "The

arms and legs of males are rough with real hair, most delicately applied—actual drops of perspiration are on the brows of the porters."[40] Clearly, the mannequins were more than clothes hangers, for not only ethnographic artifacts but also physiognomy was on display.

It is precisely the mimetic perfection of such installations, and perhaps also their preoccupation with physiognomy, that so disturbed Franz Boas, who resisted the use of realistic wax mannequins in ethnographic recreations. They were so lifelike they were deathlike. Boas objected to "the ghastly impression such as we notice in wax-figures," an effect that he thought was heightened when absolutely lifelike figures lacked motion.[41] Furthermore, wax as a medium more nearly captured the color and quality of dead than living flesh, and in their frozen pose and silence, wax figures were reminiscent of the undertaker's art, a connection that wax museums capitalized on in deathbed and open-casket scenes featuring famous persons. As a result, Boas not only rejected hyperrealistic mannequins, but also advocated that the human body be displayed at rest rather than in a state of arrested motion.

Fear of verisimilitude did not inhibit Artur Hazelius, who in his effort to present Sweden "in summary" began installing wax tableaus—"folklife pictures"—in the 1870s. Inspired by genre paintings, these sentimental scenes in wax integrated costumes, furniture, and utensils that Hazelius had collected in Sweden and other parts of Scandinavia. Featured not only in his Museum of Scandinavian Ethnography, which opened in 1873, but also at world's fairs in 1876 (Philadelphia) and 1878 (Paris), these displays utilized techniques Hazelius had seen at the many international expositions and museums he visited: he used the habitat group, a fixture of natural-history museums; the wax tableau, which, like the *tableau vivant,* was often modeled on a painting or sculpture and captured a dramatic moment in a narrative; the period room; and the travel panorama. By 1891, he had realized his dream of exhibiting Swedish folklife in "living style" at Skansen, his open-air museum. In addition to buildings, plants, and animals, the museum featured peasants in native dress, traditional musicians and artisans, costumed receptionists and guides, restaurants, craft demonstrations, and festivals. Hazelius's Skansen museum became the prototype for hundreds of other open-air museums throughout Europe, many of them still functioning today.[42]

Fig. 20-4. *Open-air museum of Skansen.* Reprinted with permission from the American Association of Museums, copyright 1927. All rights are reserved.

Animal or Actor

People have been displayed as living rarities from as early as 1501, when live Eskimos were exhibited in Bristol. A Brazilian village built by Native Americans in Rouen in the 1550s was burned down by French soldiers, an event that pleased the king so much that it was restaged the following day.[43] "Virginians" were featured on the Thames in 1603.[44] Over a period of five centuries, audiences flocked to see Tahitians, Laplanders, "Aztecs," Iroquois, Cherokees, Ojibways, Iowas, Mohawks, Botocudos, Guianese, Hottentots, Kaffirs, Nubians, Somalis, Singhalese, Patagonians, Terra del Fuegans, Ilongots, Kalmucks, Amapondans, Zulus, Bushmen, Australian aborigines, Japanese, and East Indians. They were exhibited in various cities in England and on the continent, in taverns and at fairs, on the stage in theatrical productions, at Whitehall, Piccadilly, and Vauxhall Gardens, along the Thames, at William Bullock's London Museum (better known as the Egyptian Hall because of its architectural style), in zoos and circuses, and, by the latter half of the nineteenth century, at world's fairs.[45]

Basically, there were two options for exhibiting living ethnographic specimens: the zoological and the theatrical. During the first

Fig. 20-5. *Hagenbeck's Singhalese Caravan.* From *Die Gartenlaube* no. 34, 1884.

half of the nineteenth century, the distinction between zoological and theatrical approaches was often unclear and both were implicated in the production of wildness. The zoological option depended on traditions of displaying exotic animals. The circus featured trained animals. In the zoo, live exotic specimens were shown in cages, fantastic buildings, or (eventually) in settings recreating their habitat in realistic detail (though here, too, animal acts could be found). It was not uncommon in the nineteenth century for a living human rarity to be booked into a variety of venues—theaters, exhibition halls, concert rooms, museums, and zoos—in the course of several weeks or months as part of a tour.

William Bullock's Egyptian Hall was dubbed the "ark of zoological wonders" by at least one observer of the period because of the wide range of live exhibits, human and animal, presented there.[46] While the term *ark* evokes the discourse of natural theology, as opposed to natural history, and suggests that the sheer variety of divine creation rather than scientific classification was the focus, Bullock found in environmental displays a fine way to combine theatrical effect, the experience of travel, and geographic principles.

During the eighteenth and early nineteenth centuries, geography

was an omnibus discipline devoted to all that is on the earth's surface, including people in their environment; geography subsumed anthropology and ethnography as subfields. Location on the earth's globe and relationships of specimens to landforms, climate, and local flora and fauna offered an alternative principle for arranging exhibitions of animals and people and encouraged environmental displays that showed the interrelation of elements in a habitat. Those who collected their own specimens had firsthand knowledge of their habitats. When they controlled how their materials were exhibited, they were more likely to present animals and people in their home environments. Like Bullock, who collected material for his displays while traveling and then tried to recreate the places he had been, Charles Willson Peale hunted for many of his specimens himself, mounted them, and created settings for them based on his observations while hunting.

The passion for close visual observation on the spot had transformed how landscapes were experienced and described during the eighteenth century and shaped how specimens brought into galleries were exhibited, to the point that the experience of travel became the model for exhibitions about other places.[47] Visitors were offered the display as a surrogate for travel, and displays in turn participated in the discourse of travel. Billed as travel experiences, panoramas were narrated by travelers who served as guides-at-a-distance through landscapes they had personally traversed. Individuals who had assisted hunters and collectors abroad were brought into exhibitions both to complete the scene and to comment on it, thus transferring to the recreated travel setting the roles of native guide and animal handler.

Returning from Mexico in 1823 with casts of ancient remains, ethnographic objects, specimens of plants and animals, and a Mexican Indian youth, William Bullock designed an exhibition that would make visitors feel like they were in Mexico, enjoying a panoramic view of Mexico City painted on the wall and intimate contact with its inhabitants. An observer of the period reported that "in order to heighten the deception, and to bring the spectator actually amidst the scenes represented, [he presented] a *fac simile* [*sic*] of a Mexican cottage and garden, with a tree, flowers, and fruit; they are exactly the size of their natural models, and bear an identity not to be mistaken." To complete the effect, Bullock installed the Mexican Indian youth in the cottage and had him describe objects to the visitors "as far as his knowledge of our language permits," thus making him do double duty as ethnographic specimen and museum docent.[48]

Fig. 20-6. *Bullock's exhibit of Mexico. Lithograph by A. Aglio, 1825.* Photo courtesy of Guildhall Library, City of London.

Living Style

The moment live people are included in such displays, the issue of what they will do arises. In considering the options for presenting people in "living style," it is useful to distinguish staged recreations of cultural performances (wedding, funeral, hunt, martial-arts display, shamanic ritual) and the drama of the quotidian (nursing a baby, cooking, smoking, spitting, tending a fire, washing, carving, weaving).[49]

In a highly popular African display mounted in 1853 at St. George's Gallery, Hyde Park, thirteen Kaffirs "portrayed 'the whole drama of Caffre life' against a series of scenes painted by Charles Marshall. They ate meals with enormous spoons, held a conference with a 'witchfinder' . . . and enacted a wedding, a hunt, and a military expedition, 'all with characteristic dances,' the whole ending with a programmed general mêlée between the rival tribes."[50] Two decades earlier, in 1822, Bullock had had a Laplander family and live reindeer perform at the Egyptian Hall, where they drove their sledge around a frosty panorama fitted out with their tents, utensils, and weapons—the Laplanders had been brought to care for the reindeer, which, it had been hoped, could be introduced into England, but when this proved

Fig. 20-7. *Bullock's exhibit of Laplanders. Engraving by Thomas Rowlandson, 1822.* Photo courtesy of Guildhall Library, City of London.

impractical, the Laplanders were recycled as ethnographic exhibits.[51] Ethnologists in London kept track of new ethnographic arrivals and took advantage of their presence for their research.[52]

Whereas the notion that native life was inherently dramatic allowed it to be staged and billed as theater, the ability of natives to perform, and particularly to mime, was taken by some viewers as evidence of their humanity. Charles Dickens, who was otherwise disdainful of the people in live ethnographic displays, commented on seeing the Bushmen in the Egyptian Hall in 1847, "Who that saw the four grim, stunted, abject Bush-people at the Egyptian Hall—with two natural actors among them out of that number, one a male and the other a female—can forget how something human and imaginative gradually broke out in the ugly little man, when he was roused from crouching over the charcoal fire, into giving a dramatic representation of the tracking of a beast, the shooting of it with poisoned arrows, and the creature's death."[53] The Bushmen were installed against a scenic African background, and in addition to offering the "cultural performances" that so captivated Dickens, they slept, smoked, nursed an infant, and otherwise went about the business of daily life.[54] What is so extraordinary about Dickens's statement is the implication that what makes the Bushmen human is not their ability to hunt, but their ability to mime the hunt—that is, their ability to represent.

Fig. 20-8. *Bushmen with their agent, on display at Egyptian Hall.* From *Illustrated London News*, 12 June 1847. Photo courtesy of Guildhall Library, City of London.

As the everyday life of others came into focus as a subject for exhibition, ethnography, at least for some, offered a critique of civilization. In his 1911 account of the British Museum, Henry C. Shelley commented, "Perhaps the hilarity with which the ordinary visitor regards the object lessons of ethnography arises from his overweening conceit of the value and importance of his own particular form of civilization. No doubt he has much in common with that traveler who lost his way on his journey and described the climax of his experience in these words: 'After having walked eleven hours without having traced the print of a human foot, to my great comfort and delight, I saw a man hanging upon a gibbet; my pleasure at the cheering prospect was inexpressible, for it convinced me that I was in a civilized country.' "[55] This is the ethnological effect in reverse: our own barbarity is experienced as civilized.

EXHIBITING THE QUOTIDIAN

Genre Errors

The drama of the quotidian feeds on what John MacAloon calls a genre error: one man's life is another man's spectacle.[56] Exhibitions institutionalize this error by producing the quotidian as spectacle; they do this by building the role of the observer into the structure of events that, left to their own devices, are not subject to formal viewing.

Following Dean MacCannell's analysis of "staged authenticity," such exhibitions "stage the back region," thereby creating a new front region.[57] In what is a logical corollary of the autonomous object, people, their realia, and their activities are mounted in a hermetic aesthetic space—fenced off in a zoological garden, raised up on a platform in a gallery, placed on a stage, or ensconced in a reconstructed village on the lawn of the exhibition grounds—and visitors are invited to look.

There is something about the seamlessness of the common-sense world, its elusiveness, that makes such genre errors so appealing. For the quotidian, by virtue of its taken-for-grantedness, presents itself as given, natural, just there, unnoticed because assumed. It becomes available for contemplation under special conditions, most commonly through the repetition that produces boredom, or through the comparisons (induced by contrast, incongruity, violation, and impropriety) that call the taken-for-granted into question.[58] The task of creating fissures that offer evidence that the ordinary is really there

Fig. 20-9. *Hungarian booth in the homelands exhibition at the Albright Art Gallery in Buffalo, New York, 1919.*

propels the fascination with penetrating the life space of others, getting inside, burrowing deep into the most intimate places, whether the interiors of lives or the innermost recesses of bodies. In making a spectacle of oneself, or others, "what is private or hidden becomes publicly exhibited; what is small or confined becomes exaggerated, grand or grandiose."[59] The everyday lives of others are perceptible precisely because what they take for granted is not what we take for granted, and the more different we are from each other, the more intense the effect, for the exotic is the place where nothing is utterly ordinary. Such encounters force us to make comparisons that pierce the membrane of our own quotidian world, allowing us for a brief moment to be spectators of ourselves, an effect that is also experienced by those on display.

Imagine being installed in a room at an exhibition in, say, Bangladesh, where one's only instruction was to go about one's daily chores just like at home—making coffee, reading the *New York Times*, working at the computer, talking on the phone, walking the dog, sleeping, flossing, opening the mail, eating granola, withdrawing cash from a money machine—while curious visitors looked on.[60] The challenge in such displays is to avoid performance, that is, to maintain an asymmetrical reciprocity, whereby those who are being watched go about their business as if no one were paying attention to them, though we have long known that what we observe is changed by virtue of being observed.

The reciprocity of the museum effect can be triggered by a simple "turn of the head," which bifurcates the viewer's gaze between the exotic display and his own everyday world. A visitor to the Bushman exhibition at the Egyptian Hall in 1847 commented, "It was strange, too, in looking through one of the windows of the [exhibition] room into the busy street, to reflect that by a single turn of the head might be witnessed the two extremes of humanity."[61] The pane of glass that separated the illusion of being somewhere else from the immediacy of life on London streets was eliminated in presentations that depended in part for their effect on intensifying just such incongruities. In George Catlin's display in London in 1844, "the spectacle of Red Indians encamped [in four wigwams] and demonstrating their horsemanship on the greensward at Vauxhall, where eighteenth-century beaux had strolled with the belles of Fanny Burney's set, must have been one of the more striking sights of the day."[62]

To those who complained that "to place the savage man in direct contrast with the most elaborate of man's performances is too abrupt

a proceeding, besides being useless," Dr. John Conolly, president of the Ethnological Society of London, answered in 1855 that the inclusion of ethnological exhibits at the Crystal Palace in Sydenham offered valuable contrasts. In his view, these displays "set off the splendour of . . . [man's] performances when his social advantages are enlarged" and showed that everyone can "emerge from barbarism and want to refinement and enjoyment"—a message both of British superiority and of optimism in the perfectibility of humankind.[63]

The incongruity of intercalating two different quotidians reaches an apotheosis of sorts in displays that presented exotic people not in their native habitat but in ours. Ironically, at least one observer of pygmies playing the piano in the well-appointed drawing room on Regent Street in 1853 thought this arrangement preferable to having them "set up on a platform to be stared at, and made to perform distasteful feats," for among other things, "the visitor literally gives them a call, and becomes one of their society," which is to say one's own society. These pygmies had learned English and acquired the "rudiments of European civilization."[64]

The Museum Effect

Once the seal of the quotidian is pierced, life is experienced as if represented: the metaphors of life as a book, stage, and museum capture this effect with nuances particular to each metaphor. Like the picturesque, in which paintings set the standard for experience, museum exhibitions transform how people look at their own immediate environs. The museum effect works both ways. Not only do ordinary things become special when placed in museum settings, but also the museum experience itself becomes a model for experiencing life outside its walls. As the gaze that penetrated exhibitions of people from distant lands was turned to the streets of European and American cities, urban dwellers such as James Boswell reported that walking in the streets of London in 1775 was "a high entertainment of itself. I see a vast museum of all objects, and I think with a kind of wonder that I see it for nothing."[65]

Bleeding into the ubiquity of the common-sense world, the museum effect brings distinctions between the exotic and the familiar closer to home. Calibrations of difference become finer. The objects differentiated draw nearer. One becomes increasingly exotic to oneself, as one imagines how others might view that which we consider normal: writing about the *danse du ventre* in the Little Cairo area of

the Midway Plaisance at the 1893 Chicago World's Fair, Frederick Ward Putnam commented that visitors might misunderstand this dance as "low and repulsive" because they did not understand it, but that "the waltz would seem equally strange to these dusky women of Egypt."[66]

In America and England during the 1890s, recently arrived immigrants became the ethnographic "other," in part as a way of creating social distance under the threatening conditions of physical proximity: a paper entitled "Mission-Work among the Unenlightened Jews," which was delivered at the Jewish Women's Congress in 1893 at the World's Columbian Exposition in Chicago, characterized immigrants in London and New York as "half-dressed, pale-skinned natives in our towns," and noted that "Borrioboola Gha has been supplanted by 'Whitechapel,' 'Mulberry Bend,' and the nearest district tenements."[67]

The trope of the city as dark continent and the journalist and social reformer as adventurer/ethnographer was common in such mid-nineteenth-century accounts as Henry Mayhew's *London Labour and the London Poor* (1861–62).[68] One of the attractions of poor neighborhoods was their accessibility to the eye, their "intimacy at sight." Any stranger could see openly on the streets what in better neighborhoods was hidden in an inaccessible domestic interior, in a closed carriage, or under layers of clothing. At the turn of the twentieth century in New York City, one writer remarked:

Mankind is not only the noblest study of man, but the most entertaining. People are more interesting than things or books, even newspapers. The East Side is especially convenient for observation of people, because here are such shoals of them always in sight, and because their habitat of life and manners are frank, and favorable to a certain degree of intimacy at sight. Where each family has a whole house to itself and lives inside of it, and the members never sally out except in full dress—hats, gloves, and manners—it is hopeless to become intimately acquainted with them as you pass on the sidewalk. You may walk up and down Fifth Avenue for ten years and never see a mother nursing her latest born on the doorstep, but in Mott or Mulberry or Cherry Street that is a common sight, and always interesting to the respectful observer. When the little Fifth Avenue children are let out, if they don't drive off in a carriage, at least they go with a nurse, and are clothed like field daisies, and under such restraint as good clothes and even the kindest nurses involve. But the East Side children tumble about on the sidewalk and

Fig. 20-10. *Maypole on a Lower East Side Street.* From E. S. Martin, "East Side Considerations," *Harper's New Monthly Magazine* 96 (May 1898).

pavement hour after hour, under slight restraint and without any severe amount of oversight, hatless usually, barehanded and barefooted when the weather suffers it.[69]

The blend here of repulsion and attraction, condemnation and celebration so typical of the reception of ethnographic displays in exhibition halls reveals that the source of the critique is also the basis of the appeal. "Intimacy at sight," which suggests a kind of social nakedness,

combines with the "view from the sidewalk" to verge on what might be termed social pornography—the private made public. Or rather, the disparities in cultural definitions of private and public are exploited here: the discrepancy between what others make public that we consider private also generates voyeuristic excitement in zoos, particularly in primate displays. Similarly, in madhouses, which from the early seventeenth century in Europe also combined confinement with display, the public was free to enter and observe the ravings of lunatics.[70] While respectability has the power to conceal, to control access to sight, poverty, madness, children, animals, and the "lower" orders of humankind reveal by exposing themselves fully to view. Historically, ethnography has constituted its subjects at the margins of geography, history, and society. Not surprisingly, then, in a convergence of moral adventure, social exploration, and sensation seeking, the inner city is constructed as a socially distant but physically proximate exotic—and erotic—territory. Visits to this territory tempt the adventurer to cross the dangerous line between voyeurism and acting out.[71]

Slumming, like tourism more generally, takes the spectator to the site, and as areas are canonized in a geography of attractions, whole territories become extended ethnographic theme parks. An ethnographic bell jar drops over the terrain. The vitrine, as a way of looking, is brought to the site. A neighborhood, village, or region becomes for all intents and purposes a living museum in situ. The museum effect, rendering the quotidian spectacular, becomes ubiquitous.

The Panoptic Mode

In contrast with the panoramic perspective of all-encompassing classifications, in-situ approaches to the display of the quotidian work in a panoptic mode. The panoramic approach lays out the whole world conceptually in a Linnean classification or evolutionary scheme, or experientially in a scenic effect; this is the appeal of such technologies of seeing as the eidophusikon, theatrical panorama, and diorama. Offered a supreme vantage point, the viewer is master of all that he or she surveys. The view is comprehensive, extensive, commanding, aggrandizing. As a prospect, it holds in it scenarios for future action.[72] In contrast, the panoptic approach offers the chance to see without being seen, to penetrate interior recesses, to violate intimacy. In its more problematic manifestations, the panoptic mode has the quality of peep show and surveillance—the viewer is in control.

Fig. 20-11. *Slumming in Chinatown*. From William Brown Meloney, "Slumming in New York's Chinatown," *Munsey's Magazine* 41, no. 6 (Sept. 1909).

In its more benign mode, the panoptic takes the form of hospitality, a host welcoming a guest to enter a private sphere.[73] A recent guide to ethnographic recreations of "homes" at the Field Museum in Chicago exemplified the panoptic mode: "Each of the houses has had part of the walls and roof removed so you may peek inside."[74] The issue is the power to open up to sight differentially, to show with respect to others what one would not reveal about oneself—one's body, person, and life.

Live exhibits as a representational mode make their own kinds of claims. Even when efforts are made to the contrary, live exhibits tend to make people into artifacts because the ethnographic gaze objectifies. Where people are concerned, there is a fine line between attentive looking and staring. To make people going about their ordinary business objects of visual interest and available to total scrutiny is dehumanizing, a quality of exhibitions that was not lost on some nineteenth-century viewers in London who complained about live displays on humanitarian grounds.[75]

Live displays, whether recreations of daily activities or staged as formal performances, also create the illusion that the activities one watches are being done rather than represented, a practice that creates the illusion of authenticity, or realness. The impression is one of unmediated encounter. Semiotically, live displays make the status of the performer problematic, for people become signs of themselves. We

Fig. 20-12. *Polish, Hungarian, and German booths at homeland exhibition in the State Museum, Trenton, New Jersey, 1930–31.*

experience a representation even when the represeters are, if you will, the people themselves. Self-representation is representation nonetheless. Whether the representation essentializes (one is seeing the quintessence of Balineseness) or totalizes (one is seeing the whole through the part), the ethnographic fragment returns with all the problems of capturing, inferring, constituting, and presenting the whole through parts.

PERFORMING CULTURE

We might distinguish the museum as a form of interment—a tomb with a view—and the live display. These metaphors have historical roots in the history of interment and incarceration as display traditions in their own right. Differences between them are expressed in the sensory organization of display.

The Senses Compartmentalized

The partiality so essential to the ethnographic object as a fragment is also expressed in the fragmentation of sensory apprehension in conventional museum exhibitions. With the important exceptions of popular entertainment, opera, masques and banquets, and avant-garde performance, among others, the European tendency has been to split up the senses and parcel them out, one at a time, to the appropriate art form. One sense, one art form. We listen to music. We look at paintings. Dancers don't talk. Musicians don't dance. Sensory atrophy is coupled with close focus and sustained attention. All distractions must be eliminated—no talking, rustling of paper, eating, flashing of cameras. Absolute silence governs the etiquette of symphony halls and museums. Aural and ocular epiphanies in this mode require pristine environments in which the object of contemplation is set off for riveting attention. Rules posted at the entrance and guards within ensure that decorum prevails. When reclassified as "primitive art" and exhibited as painting and sculpture, as singular objects for visual apprehension, ethnographic artifacts are elevated, for in the hierarchy of material manifestations, the fine arts reign supreme. To the degree that objects are identified with their makers, the cultures represented by works of art also rise in the hierarchy.

In contrast with conventional exhibitions in museums, which tend to reduce the sensory complexity of the events they represent and to

offer them up for visual delectation alone, indigenous modes of display, particularly the festival, present an important alternative. As multisensory, multifocus events, festivals may extend over days, weeks, or months. They require selective disattention, or highly disciplined attention, in an environment of sensory riot. The closeness of focus we expect to sustain in silence for a one-hour concert is inappropriate for events so large in scale and long in duration. Participants in the Ramlila, a festival and ritual drama that extends over many days in northern India, bring food, sleep through parts of the event, talk to their neighbors, get up, walk around, leave, return. All the senses—olfactory, gustatory, auditory, tactile, kinesthetic, visual—are engaged. The experience tends to be environmental, as episodes of the drama are enacted in various locations, rather than hermetically sealed into an aesthetic space created by a proscenium, frame, or vitrine. Sensory saturation rather than sensory atrophy or single-sense epiphany is the order of the day. Sensory apprehension and attention must be structured differently in such events.

Every Day a Holiday

The festival, both as it occurs locally and as an anthology of ethnographic performances, can be seen as a form of environmental performance governed by an aesthetic of pure theatricality. Though museum exhibitions also can be considered a form of environmental theater—visitors moving through the space experience the *mise en scène* visually and kinesthetically—museum exhibitions tend to proceed discursively. Festivals are generally less didactic and less textual. They depend more on the performative, reserving extended textual analysis, to the degree that it is offered, for the program booklet, in this way avoiding the awkwardness of discoursing about living people in their very presence.

There is a convergence of sensibility here between ethnographers interested in the festival as a display genre and the discovery by the historical avant-garde of the theatricality of everyday life and vernacular genres. Rejecting the conventions of classical European theater, with its dependence on the dramatic text, formal theater architecture, and mimetic conventions, Antonin Artaud, Bertolt Brecht, and East European directors working during the interwar years looked to Balinese, Chinese, and European folk and popular forms for new artistic possibilities. Their artistic sensibility valorized performative forms that were otherwise of strictly local or ethnographic interest, and offered

the possibility of experiencing them with a distinctly modernist sensibility as models of pure theatricality. They created new audiences for ethnographic performances and a hospitable climate for festivals that excerpted and re-presented them.

Tourists who have difficulty deciphering and penetrating the quotidian of their destination find in festivals the perfect entrée. Public and spectacular, festivals have the practical advantage of offering in a concentrated form and at a designated time and place what the tourist would otherwise search out in the diffuseness of everyday life, with no guarantee of ever finding it. Typically, local festivals are simply put on the tourist itinerary. A 1981 brochure issued by India's Department of Tourism does just this:

> Why festivals? Because they celebrate the joy of life. The Indian calendar is a long procession of festivals. The traveler may come when he pleases, a spectacle always awaits him. If you find yourself in the right place at the right time, it is possible to go through the calendar with a festival daily! It may be the harvest in the south, the golden yellow of short-lived spring in the north, the seafront spectacle of Ganesh's immersion in Bombay, the fantastic car festival of Puri, the snake-boat races in Kerala or the Republic Day pageant in New Delhi. Each is different. Every region, every religion has something to celebrate. . . . Take in a festival when you come to India. No land demands so much of its legends—or, in celebrating the past, bedecks the present so marvellously.

While large festivals can usually absorb tourists with ease, producers may take steps to keep casual observers away from smaller events they might overwhelm. Still other local ceremonies that are extremely costly to produce thrive as a result of tourist interest and dollars: cremations in Bali, which require vast sums of money, can now occur on a larger scale and more often thanks to the revenues generated by tourists who pay to attend them.

Festivals are cultural performances par excellence. Their boundaries discernible in time and space, they are particularly amenable to encapsulation. Because whole festivals generally offer more than the casual traveler can consume, and because such complex events do not travel well, entrepreneurs often excerpt local festivals and incorporate their parts into other kinds of events. In an effort to make such attractions more profitable, as well as to restrict the access of tourists to areas of local life declared off-limits, events are adapted to the special needs of recreational travelers. Events staged specifically for visitors

are well suited for export because they have already been designed for foreign audiences on tight schedules. Also, exported events developed for international expositions may be brought back home in the hope of attracting tourists into the local economy. Balinese performances developed for the Paris World's Fair in the 1930s were brought back to Bali, where versions of them continue to be presented to tourists.

Import the tourist? Or export the village and festival? These processes are reciprocal. Ethnographic displays are not only a way to recreate the travel experience at a remove. Increasingly, these displays are introduced at the travel destinations themselves, where they may displace the travel experience altogether. All of Polynesia is represented on forty-two acres of the Hawaiian island Oahu, at the Polynesian Cultural Center: according to a 1985 promotional brochure, "more people come to know and appreciate Polynesia while touring these beautifully landscaped grounds than will ever visit those fabled islands."[76]

As mass tourism has grown in the postwar period, festivals of all kinds have proliferated with the explicit intention of encouraging tourism. A 1954 guide to festivals in Europe makes this very point:

> [The abundance of festivals] means fun for everyone who wants to frolic with our friends abroad when they are in their most festive moods, or they can frolic with us if they are so inclined. . . . [Americans want to satisfy their] curiosity about how other people live. . . . As everyone knows, just about the best time to see the most people in any region is at a festival. That is also a fine time to learn what interests or amuses them, because a festival invariably reflects the character of the region in which it takes place and dramatizes the economic and recreational attractions, as well as the spiritual and aesthetic aims of the people.[77]

We have here the major tropes of ethnographic display, from the perspective of the tourism industry—the promise of visual penetration, access to the back region of other people's lives, the life world of others as our playground, the view that people are most themselves when at play, and festivals as the quintessence of a region and its people.[78] To "frolic with our friends abroad" becomes the paradigm for intercultural encounter. The foreign vacationer at a local festival achieves perfect synchrony—everyone is on holiday, or so it seems. To know a society only in its festival mode, filtered through the touristic lens of spectacle, is to raise another set of problems: the illusion of cultural transparency in the face of undeciphered complexity and the

image of a society always on holiday. To festivalize culture is to make every day a holiday.

Folkloric Performance

The living quality of such performances does not obviate the issue of artifactual autonomy, for songs, tales, dances, and ritual practices are also amenable to ethnographic excision and to presentation as autonomous units, though not in the same way as artifacts. One can detach artifacts from their makers, but not performances from performers. True, artifacts can be photographed and performances can be recorded. But artifacts are not photographs and performances are not recordings. While the pot can survive the potter (though it, too, will eventually crumble to dust), music cannot be heard except at the moment of its making. Like dance and other forms of performance, musical performance is evanescent and in need of constant renewal. To achieve for drumming the sense of realness conveyed by the physical presence of the drum, we need the drummer. But a drummer drumming is no less an ethnographic fragment. The proscenium stage, master of ceremonies, and program booklet are to the drummer what the vitrine, label, and catalogue are to the drum. The centrality of human actors in performance and the inseparability of process and product are what distinguish performances from things. While an artifact may be viewed as a record of the process of its manufacture, as an indexical sign—process is there in material traces—performance is all process. Through the kind of repetition required by stage appearances, long runs, and extensive tours, performances can become like artifacts. They freeze. They become canonical. They take forms that are alien, if not antithetical, to how they are produced and experienced in their local settings, for with repeated exposure, cultural performances are routinized and trivialized. The result is events that have no clear analogue within the community from which they purportedly derive and that come to resemble one another more than that which they are intended to re-present.

Embedded in the flow of life, artifacts and performances that historically have interested ethnographers are contingent: they are not generally made to stand alone, set off for exclusively aesthetic attention. Forms that are perfectly satisfying in their indigenous settings—chants, drumming, a cappella ballads, repetitive dance steps—challenge audiences who are exposed to them on stages where they are used to seeing opera and ballet. Professional folkloric companies adapt

such forms to European production values. To hold the interest of new audiences, folkloric troupes design a varied and eclectic program of short selections. They also depend upon musical accompaniment (such as piano or orchestra), European harmony, concertized arrangements and vocal styles on the model of European opera, and movement styles on the order of ballet to reduce the strangeness and potential boredom of a cappella song, unison music, and repetitive (and not apparently virtuosic) dance for unfamiliar audiences. To meet strict time requirements and deliver exactly what has been advertised and announced in a printed program, improvisation is curtailed, if not eliminated. A tightly coordinated ensemble of trained professionals, often more or less the same age and physical type, wear stylized, often uniform, costumes, while executing highly choreographed routines with great precision. A frontal orientation accommodates the proscenium stage, to which are added theatrical effects (sound, lighting, sets). There is a tendency toward the virtuosic, athletic, and spectacular.

The repertoires of folkloric troupes typically include excerpts from festivals and rituals—weddings, healing ceremonies, and hunting rituals are favorites. While such excerpts allude to the contingent nature of music and dance, they partake of theater, for they have been severed from their local social and ceremonial settings and reclassified as art. At the same time, the proprietary rights to the material have been transferred from local areas to the nation, where regional forms are declared national heritage. National troupes typically perform traditions from across the land, no matter what the personal histories of the performers. Since everyone can perform everything and everything belongs to everyone, differences do not differentiate. Polyglot programs, besides offering variety, generally represent an imagined community in which diversity is harmoniously integrated, where difference is reduced to style and decoration, to spice of life. Cultural difference is then praised for the variety and color it adds to an otherwise bland and dull scene.

Such choices in repertoire and style are ideologically charged. They attempt to find a middle ground between exotic and familiar pleasures and to bring these forms (and their performers) into the European hierarchy of artistic expression while establishing their performances as national heritage. The more modern the theater where the troupe performs the better, for often there is a dual message: powerful, modern statehood, expressed in the accouterments of civilization and technology, is wedded to a distinctive national identity. The performance offers cultural content for that identity. Such asser-

Fig. 20-13. (top) *Factory workers in Troy, New York, present a Ukrainian wedding party, as remembered from their native village, at the homelands exhibition in the State Educational Building in Albany, 1920;* (bottom) *Ukrainian folk dancers, New York City;* (facing page) *Russian children at the Buffalo homelands exhibition, 1919.*

tions are not confined to the concert stage. They are implicated in claims to territorial sovereignty, the drawing of political boundaries, the choice of official language, and many other matters of vital concern in the tension among nation, state, and culture. Claims to the past lay the ground for present and future claims. Having a past, a history,

a "folklore" of one's own, and institutions to bolster these claims is fundamental to the politics of culture: those who are concerned with demonstrating the possession of a national folklore, particularly as legitimated by a national museum and troupe, cite this attribute as a mark of being civilized.

Folk Festival

As a venue for the representation of culture, the festival derives its celebratory tone and environmental approach to staging from the joyful events associated with the traditional feasts and fêtes that honor a religious anniversary, event, or personage. But unlike feasts (the etymological root of festival), which do what they are about, festivals of

the kind that interest us here re-enact, re-present, and re-create activities and settings in a discrete performance setting designed for specular (and aural) commerce.[79] Such events acquire a distinctive (if plural) semiotic status. Quivering with issues of authenticity and iconicity, these events tend to make a clear separation between doers and watchers—or among kinds of doers—even with efforts to encourage "participation."

These issues are dramatized by the highly successful Festival of American Folklife, produced annually since 1967 on the Mall in Washington, D.C., by the Office of Folklife Programs at the Smithsonian Institution. This pioneering program is sensitive to the issues raised here and addresses them by experimenting with new ways to present folklife to the public. Two cases are particularly instructive: the Festival of India and the Old Ways in the New World programs. Seen in historical perspective, these programs blend the national and state pavilions, long a staple feature of world's fairs in America, and the homeland exhibitions and festivals that celebrated immigrant "gifts" during the first half of this century.[80]

FESTIVAL OF INDIA Recognizing the festival as a participatory genre of presentation, the 1975 guidelines for the Festival of American Folklife advised the following:

> Because many genres survive in the context of esoteric community celebrations and rituals, large scale traditional celebration events should be used as organizing structures for "Old Ways in the New World" programs. Such events can be parades, processions, picnics, festivals, religious ceremonies, wedding festivities, or any similar event in which performing arts are closely associated with other traditional expressive forms. . . . Celebration events should allow direct participation by Festival visitors.[81]

However connected they may be to what communities do at home, the festival within a festival is a re-creation. At its most mimetic, it offers a sumptuous alternative to the sensory atrophy of the bare stage.[82] The festival-within-a-festival format also presents formidable ethnographic and logistical challenges, particularly at the points where the two festivals are incompatible.

This insight guided the decision to embed a festival within a festival, the Festival of India within the Festival of American Folklife, in 1985:

Fig. 20-14. *Scenes from the Mela exhibition, Washington, D.C., 1985:* (top) *Punjabi drummers perform on a low, intimate, nonproscenium stage;* (bottom) *Habib-ur-Rehman fashions a* taziya, *a facsimile tomb of Hussein, out of tied bamboo and cut paper. In the background are photo-text panels explaining Indian religions, fairs, festivals, cosmological concepts, and aesthetic traditions.* Photos courtesy of the Smithsonian Institution.

The Mela program on the Mall is really a fair within a fair. It is a composite mela, compressing both space and time to present selectively only a few of India's many traditions. Just as a mela would in India, the program encourages visitors to learn about and participate in Indian culture. The structures on the Mall have been built largely with natural and handcrafted materials from India, while the site itself has been designed to reflect indigenous Indian concepts.[83]

The *mela,* the fair that accompanies religious festivals in India, did indeed offer an ingenious format for displaying many kinds of artifacts, activities, and people (dance, music, acrobatics, street performance, religious observance, food, architecture, crafts) as they are integrated in their native setting. But of course this *mela* was to occur during a festival of our own making, and our festivals and those of India are not necessarily compatible. Smithsonian festivals are events produced for the public with the taxpayers' dollars: they are not-for-profit ventures and studiously avoid the slightest hint of commercialism. In general, things are not for sale, except at one small gift shop inconspicuously positioned at the edge of the main events. Goods are carefully selected for their appropriateness and salespersons are expected to be well informed about the objects, their makers, and their makers' communities. They offer items relating to all the exhibits.

Indian fairs, by way of contrast, are full of things to buy. Each craftsperson and stallkeeper competes to sell goods. The Smithsonian *mela* on the Mall was a representation of a commercial environment, which, while mimetically very complete, stopped short of the thoroughgoing commercial exchange that is one of an Indian *mela*'s defining features. Indeed, the representation was so complete that it was necessary to post signs in some stalls to indicate that the goods were *not* for sale. Perhaps as a concession to "authenticity," visitors could make purchases at designated stalls, as well as in the sales tent. What happens when a commercial Indian fair is embedded inside a noncommercial Smithsonian festival? Stalls of goods for sale that cannot be sold.[84]

Food presented a similar problem. Clearly, the Department of Health would not countenance licenseless vendors from India feeding visitors to the Mall. Instead, an Indian hotel chain catered the festival from a central post in the *mela.* Even were Department of Health requirements met, those planning festivals would probably encounter the resistance of local vendors to any intrusion on their economic turf by traditional cooks brought in for the day. This effectively inhibits efforts to recreate the culinary environment of traditional festivals.

Though intended as an evocative recreation, ethnographically accurate and authentic in most details, the festival within the festival is a distinct type of performance event, and whatever else happens, the visitor experiences it as such. Though the intention may be to create an illusion of being in India, it is the re-creation itself that is experienced, with all of its tensions and ambiguities. When carried to extremes, as in the case of first-person interpretation at Plimoth Plantation, visitors experience the thrill of the hyperreal and at the same time the fragility of the membrane that has been constructed to separate the present place and time from that which has been reconstructed.[85]

OLD WAYS IN THE NEW WORLD Raising yet another set of problems, the Old Ways in the New World program integrated the national pavilion and the homeland exhibition in an attempt to juxtapose folk artists in immigrant communities with their counterparts in their home countries. This was also a way to involve foreign countries in a festival of American folklife. But in the case of Jews, the assumption that there was an Old World presented insurmountable problems, as the European Jewish communities were largely destroyed during the Holocaust.[86] Eliding differences between Old World and homeland, Israel was selected as the Jewish Old World for the purposes of the festival. But the "old ways" of American Jews were not to be found in the newly formed Jewish state, which was itself a case of new ways in the New World. Nor was Israel willing to be cast as the old ways of American Jews.

When working with the Ministry of Education and Culture in Israel to identify appropriate performers for the Jewish section of the Bicentennial Festival of American Folklife in 1976, I was instructed to bring the finest exponents of "authentic" traditional art forms. Some of the performers that met this standard were born in Yemen, Morocco, or Iraq and were advanced in years. Officials responsible for Israeli participation wanted to send Israeli folk-dance troupes, arguing that they were young, athletic, lively, versatile, and specially adapted for the stage. Not only were the professional folk-dance troupes costumed and choreographed, but, I was told, they had been trained to perform the music and dance of the many different Jewish communities living in Israel. Their performances conformed to professional standards and were stylized to reduce their strangeness. These were precisely the groups the Smithsonian's Office of Folklife Programs had instructed me *not* to bring. The Israeli officials complained further that my choices would present entirely the wrong image of contemporary

Israel and would offer a poor performance to boot: Israel and its culture were not to be represented by old immigrants performing exotic music of the diaspora. Even to the extent that we succeeded in bringing traditional performers of our choice, we still faced the problem of relating these traditions to Jewish immigrants in America.

Staging Culture

A key to the appeal of many festivals, with their promise of sensory saturation and thrilling strangeness, is an insatiable and promiscuous appetite for wonder. The irreducibility of strangeness, a feature of tourist discourse more generally, inscribes on the geography of the exotic a history of receding thresholds of wonder: as exposure exhausts novelty, new ways to raise the threshold of wonder must be found.[87] The passion for wonder also accounts for the primacy of spectacle as a presentational mode, and for the tension between the very unspectacular nature of much material that we might want to present and the expectation of audiences that they will get a good show. Given the special way that spectacle works (clear separation of observer and actor, primacy of the visual mode, and an aggrandizing ethos), the spectacle of festival evokes what MacAloon has characterized as diffuse wonder or awe and precipitates intellectual and moral ambiguity, even with efforts to mitigate the effects.

We complain of ritual degenerating into spectacle, into sheer show. Historically, however, we have long valued the inscrutable strangeness of the exotic as an end in itself. The appeal of villages on the Midway of the World's Columbian Exposition in Chicago depended largely on such mystification, and many multicultural festivals today still feed this appetite while encouraging understanding and reflection by offering "interpretation." That we objectify culture has long been recognized; festivals, however, also objectify the human performers and implicate them directly in this process. This is an inherently problematic way to confront cultural questions, for spectacle, by its very nature, displaces analysis, and tends to suppress profound issues of conflict and marginalization. The more that ethnographic festivals and museum exhibitions succeed in their visual appeal and spectacular effect, the more they reclassify what they present as art, aestheticize that which is marginal, and risk appealing to prurient interest.

Fighting the spectacular and the illusion of re-creation, the Office

of Folklife Programs at the Smithsonian Institution has long advocated what might be called an ascetic approach to staging:

> Costumes only for stage performances, or for other exoteric purposes, are not appropriate for the Festival. This matter should be thoroughly reviewed in the field and reiterated in formal invitations and correspondence with participating groups and individuals.
>
> In 1974, all the Greek-American participants, and most of the foreign Greek participants wore ordinary clothes throughout the five-day presentation. Costume was not a part of the two Greek-American *glendis* held on the Mall, because it is not customarily worn at *glendis* in this country. A few elderly participants from Greece wore traditional clothes every day, as they always do at home.[88]

The concern that costumes that are only worn for stage performances not be donned for the Smithsonian presentation presents a paradox—from the perspective of many participants, the folklife festival is a stage performance, so why not wear costumes? There is a conflict here between two aesthetics.

As the Smithsonian's guidelines suggest, festivals organized by dominant cultural institutions such as museums and state folklife programs or funded by state and federal agencies share a performance discourse that often stands in contrast (if not in opposition) to the ways communities stage themselves. These differences are more than matters of taste and style; they offer different approaches to the marking of authenticity. Hallmarks of the festivals mounted by professional folklorists in the past have included a focus both on performers who claim the forms they perform as their birthright and on the traditional components of their repertoire. Performance practices that entail an adaptation to the concert stage have been discouraged, despite the fact that communities have often developed their own troupes, costumes, repertoires, choreography, musical arrangements, interpretations, dramatizations, and other conventions for presenting their performing arts on the concert stage for themselves and for outsiders.

Such adaptations, viewed as touristic kitsch, have been studiously avoided by folklorists in favor of a very different set of conventions they have evolved specifically for this type of festival. Typically, solo performers and ensembles are selected from among those who normally play at a community's festivities. Wearing ordinary clothing, they play on a bare stage within a large tent, the audience seated on bleachers or benches, or on a concert stage in an indoor auditorium.

High-tech sound equipment and professional stage technicians ensure the best possible acoustics and documentary recording of the event. Explanatory text panels may be mounted near the entrance to the tent, and a large photomural of the performer's home environment may serve as a backdrop. An informed presenter introduces the performers, with sensitive explanations about the history, context, and meaning of what the audience is about to hear. The program booklet supplements the presentation with illustrated essays about the communities and traditions featured at the festival. Formal concerts are complemented by interactive and didactic workshops, demonstrations, lectures, and films.

Performers are discouraged from the use of electronic instruments (though there are exceptions), "ethnic costumes," nontraditional repertoires, concertized performance styles, choreography adapted for the stage, and other overtly theatrical concessions. There is thus a suppression of representation markers and a foregrounding of presentation markers, an avoidance of the suggestions of theater, and an attempt to achieve the quality of pure presence, of a slice of life. Given the history of national troupes and pavilions and homeland exhibitions, it is easy to see why groups would expect to appear in costume and in organized groups. This is after all the public face, as they have constructed it, of their private lives. And given the way that spectacle brings authenticity into question, it is easy to see why an ascetic aesthetic to staging should appeal to festival producers aiming to present rather than represent that life.

PERFORMING DIFFERENCE

The interest in displaying performance or in using performance as a way of displaying culture is, like the series of objects arranged to show a continuous historical process, linked to particular theoretical orientations. First, performance-oriented approaches to culture place a premium on the particularities of human action, on language as spoken and ritual as performed. Such approaches resist stripping the observed behavior of its contingency in order to formulate norms, ideals, and structures of competency.[89] Second, cultural performances as units of analysis have offered a distinct methodological advantage to those grappling with large and complex societies, where approaches that worked well in small settings are inadequate.[90] The Manchester school of social anthropology found in social dramas—events that involve a

breach of some kind and efforts to deal with it—a useful way to focus cultural analysis.[91] Sociologist Erving Goffman brought a dramaturgical approach to the analysis of ordinary social life in his own milieu. Third, performance, whether a focus for research or the basis of ethnographic display, is compatible with efforts among folklorists and anthropologists to deal with issues of diversity, pluralism, cultural equity, and empowerment, particularly when participants can control how they are represented.[92]

The issue of who is qualified to perform culture is thorny because it reveals the implicit privileging of descent over consent in matters of cultural participation.[93] Though the guidelines for producing folklife-festival programs stress visitor participation, they are also usually clear in specifying that the performers at the festival are to be those to whom the arts "belong" by virtue of their having been acquired in a traditional manner and setting, that is, by insiders from insiders—by descent, though this distinction is not rigidly applied. "Outsiders," those who have chosen to learn the art even though they were not born into the communities that transmit it, are generally considered revivalists and may be excluded on this count, though here, too, the matter is more complicated. Thus there operates a distinction between those who are licensed to do and those who are mandated to watch. The event is to be structured, however, in ways that will allow the watchers

Fig. 20-15. *Czech father teaching his son to dance at the Buffalo homelands exhibition, 1919.*

to "participate," a notion that generally stops short of performing the tradition themselves, except as they are invited to join a procession or the group dancing and singing.

The curatorial problem in folk festivals is the delicate one of determining not only what meets certain standards of excellence, but first and foremost, what qualifies as authentic folk performance. As a result, performances at folk festivals are often artifacts of the discipline of folklore, whatever else they may be. We speak of the Child ballads, the Grimm *märchen*, and other traditional forms that have been canonized in printed collections, museum exhibitions, commercial recordings, and folk festivals. We also create the criteria by which the multiplicity of forms we find can be sorted into their "preferred" and "residual" categories.[94]

The danger here is what Stuart Hall calls self-enclosed approaches, which, "valuing 'tradition' for its own sake, and treating it in an ahistorical manner, analyze cultural forms as if they contained within themselves from their moment of origin, some fixed and unchanging meaning or value." [95] The pressure is there to do just this. Further, those who organize folk festivals must accept the responsibility for representing those they include in "their most traditionalist form."[96] While folklife festivals attempt to represent traditions that would otherwise not be exposed, it is also the case that those who perform tend to be represented exclusively in traditional terms.

Following Stuart Hall, we might consider the opposition of folklore/not-folklore not as a descriptive problem or a matter of coming up with the right inventory of cultural forms, but rather in terms of the "forces and relations which sustain the distinction, the difference" between what counts as a genuine tradition, a revival, fakelore, or elite culture. Hall suggests that the categories tend to remain, though the inventories change, and that institutions such as universities, museums, and arts councils play a crucial role in maintaining the distinctions: "The important fact, then, is not a mere descriptive inventory—which may have the negative effect of freezing popular culture into some timeless descriptive mould—but the relations of power which are constantly punctuating and dividing the domain of culture into its preferred and its residual categories."[97] Similarly, by aestheticizing folklore—no matter what is gained by the all-inclusive definition of folklore as the arts of everyday life—we are in danger of depoliticizing what we present by valorizing an aesthetics of marginalization.

Though there are still many festivals devoted to the traditions of a single ethnic group, large-scale events sponsored by city, state, and

Fig. 20-16. *Greek exhibit of sponge fishing at the America's Making Exhibition, New York City, 1921. The Greeks developed the sponge-fishing industry after their arrival in the United States. For this exhibition they brought the boat and diving equipment from the Gulf of Mexico.*

federal agencies are generally multicultural in nature. They participate in the discourse of pluralism, of unity in diversity. They risk what might be termed the banality of difference, whereby the proliferation of variation has the neutralizing effect of rendering difference (and conflict) inconsequential. This is the effect, by design, of the pageants of democracy so popular during the first decades of this century.[98] Though offered as an alternative to the brutal efforts of nativists to suppress difference and preserve the preeminence of Anglo stock and culture, the unity-in-diversity discourse can also have a neutralizing effect.

In festivals of cultural performances, respectability and decorum—values of the dominant cultural institutions that stage the event—tend to coopt the oppositional potential that is so essential to a festival. For this and other reasons, these events have a tendency to reinforce the status quo even as enlightened organizers and performers struggle to use them to voice oppositional values. Carnival represented is carnival tamed. In the case of the homeland exhibitions and festivals, immigrant organizations were already doing a good job of supporting a wide variety of cultural activities. Festivals of national culture organized by immigrant groups in American cities during the last decades of the nineteenth century attracted tens of thousands of par-

ticipants. In the homeland exhibitions and festivals organized during
the first half of this century, cooperation between immigrant groups
and organizations promoting Americanization, however well intention-
ed, also involved cooptation. Homeland exhibitions were designed to
gain the trust of immigrants, who, it was hoped, would allow them-
selves to be helped by Americanization organizations. These events
were not only displays of immigrant gifts—crafts, music, dance, and
wholesome values. Equally important—and the organizers were ex-
plicit on this point—was that these events were good public relations
for the Americanization workers and social reformers, who were them-
selves on display. Through such exhibits and festivals, they could show
their success in working with immigrants and lobby for increased
support.

Exhibitions, whether of objects or people, are displays of the artifacts
of our disciplines. They are for this reason also exhibits of those who
make them, no matter what their ostensible subject. The first order of
business is therefore to examine critically the conventions guiding
ethnographic display, to explicate how displays constitute subjects and
with what implications for those who see and those who are seen.
Museum exhibitions, folkloric performances, and folklife festivals are
guided by a poetics of detachment, in the sense not only of material
fragments but also of a distanced attitude. The question is not whether
or not an object is of visual interest, but rather how interest of any
kind is created. All interest is vested.

NOTES

I would like to thank my colleagues in the Department of Performance
Studies at New York University's Tisch School of the Arts, particularly
Sally Charnow and Naomi Jackson, for their able research assistance;
Michael Taussig, who convened a stimulating faculty colloquium,
"Mimesis and Alterity," during the 1988–89 academic year; and Ed-
ward M. Bruner, Allen Feldman, Brooks McNamara, and Richard
Schechner. I am also grateful to William Taylor, William Leach, and
Peter Buckley, who convened the Commercial Culture Seminar at the
New York Institute for the Humanities, to Diana Fane and Charles
Musser for bibliographic leads, and to Max Gimblett for his critical
suggestions.

1. According to Richard D. Altick, *The Shows of London* (Cambridge, Mass.:
Belknap, 1978), 6, Virgin's milk is listed in inventories of the reliquaries of

medieval French cathedrals. See the following publications, each of which accompanied an exhibition of an object listed here: Carolyn Gilman and Mary Jane Schneider, *The Way to Independence: Memories of a Hidatsa Indian Family, 1840–1920* (St. Paul, Minn.: Minnesota Historical Society Press, 1987); Amanda Dargan and Steven Zeitlin, *City Play: A Photographic History of Play in New York City* (New Brunswick, N.J.: Rutgers University Press, 1990); Cyrus Adler and I. M. Casanowicz, *Biblical Antiquities: A Description of the Exhibit at the Cotton States International Exposition, Atlanta, 1895* (Washington, D.C.: Smithsonian Institution, 1898); Charles Coleman Sellers, *Mr. Peale's Museum: Charles Willson Peale and the First Popular Museum of Natural Science and Art* (New York: W. W. Norton, 1980), 42. No doubt the pieces of the Berlin Wall will be exhibited—they are being frantically collected at the time of this writing—if they have not been shown already.

2. In the wake of the historical avant-garde and the challenges it posed to "the autonomy of art . . . [as] a category of bourgeois society," the problem of visual interest, a term I take from Svetlana Alpers's provocative essay in this volume, is refigured—Duchamp's readymades, his urinal, were offered not primarily for their visual interest but as provocations. See Peter Bürger, *Theory of the Avant-Garde,* trans. Michael Shaw. Theory and History of Literature, vol. 4 (Minneapolis: University of Minnesota Press, 1984), 46, 51–52. Such provocations, which have the potential to make anything of interest, also challenge our assumptions about visual interest.

3. As William Insley, an artist working in New York City, commented upon reading this paper, "What was absent from the ruin is often less marvelous than we imagine it to have been. The abstract power of suggestion (the fragment) is greater than the literal power of the initial fact. Myth elevates" (pers. comm., 16 Nov. 1989). Insley makes architectural drawings of an imagined future city.

4. See M. W. Thompson, *Ruins: Their Preservation and Display* (London: British Museum Publications, 1981), and Barbara Maria Stafford, *Voyage into Substance: Art, Science, Nature, and the Illustrated Travel Account, 1760–1840* (Cambridge, Mass.: M.I.T. Press, 1984).

5. See, for example, Oliver Impey and Arthur MacGregor, eds., *The Origins of Museums: The Cabinet of Curiosities in Sixteenth- and Seventeenth-Century Europe* (Oxford: Clarendon Press, 1985), on the mannerist fondness for the fragment and quotation and the uses to which body parts were put after anatomical dissections. See also Lawrence D. Kritzman, ed., *Fragments: Incompletion and Discontinuity* (New York: New York Literary Forum, 1981).

6. On cultural and national wholes, see Benedict Anderson, *Imagined Communities: Reflections on the Origin and Spread of Nationalism* (London:

Verso, 1983); Richard Handler, *Nationalism and the Politics of Culture in Quebec* (Madison: University of Wisconsin Press, 1988); and Johannes Fabian, *Time and the Other: How Anthropology Makes Its Object* (New York: Columbia University Press, 1983).

7. On the representational conventions informing the nature dioramas at the American Museum of Natural History, see Donna Haraway, "Teddy Bear Patriarchy: Taxidermy in the Garden of Eden, New York City, 1908–1936," *Social Text* 11 (Winter 1984–85). On the period room, see Stephen Bann, "Poetics of the Museum: Lenoir and Du Sommerard," in *The Clothing of Clio: A Study of the Representation of History in Nineteenth-Century Britain and France* (Cambridge: Cambridge University Press, 1984). On the recreation of historical sites, see Michael Wallace, "Visiting the Past: History Museums in the United States," *Radical History Review* 25 (1981).

8. See William Ryan Chapman, "Arranging Ethnology: A.H.L.F. Pitt Rivers and the Typological Tradition," in George W. Stocking, Jr., ed., *Objects and Others: Essays on Museums and Material Culture*. History of Anthropology, vol. 3 (Madison: University of Wisconsin Press, 1985).

9. Henry C. Shelley, *The British Museum: Its History and Treasures* (Boston: L.C. Page, 1911), 304.

10. Oleg Grabar, "An Art of the Object," *Artforum* 14, no. 7 (Mar. 1976), 39. See also George Kubler, *Shape of Time: Remarks on the History of Things* (New Haven: Yale University Press, 1962).

11. Joseph Alsop, *The Rare Art Traditions: The History of Art Collecting and Its Linked Phenomena* (New York: Harper and Row, 1982), 74.

12. Alsop, *Rare Art Traditions*, 99, offers the example of a twelfth-century *armilla*, which the Nuremberg Museum bought for $2,034,450: "the *armilla* looks like what is has become—a tremendous collectors' prize of the utmost rarity. But neither to the eye nor in almost any other way does the *armilla* look in the museum as it formerly looked, when it served as an epauletlike ornament of the hieratically grand ceremonial robes of Frederick Barbarossa—the purpose the *armilla* was originally made to serve."

13. Detachment and circulation are by no means a unique feature of ethnographic objects. It is the manner of detachment that makes an object ethnographic, historical, or fine art, a point underscored by Sir E. H. Gombrich: "Nearly all the objects in our collections were once intended to serve a social purpose from which they were alienated by collectors. . . . The image was pried loose from the practical context for which it was conceived and [was] admired and enjoyed for its beauty and fame, that is, quite simply within the context of art." (Quoted in Alsop, *Rare Art Traditions*, 99.)

14. Francis Bacon referred to "the shuffle of things" in 1594. See Oliver Impey and Arthur MacGregor, "Introduction," and Rudolph Distelberger, "The Hapsburg Collections in Vienna during the Seventeenth Century," in Impey and MacGregor, eds., *Origins of Museums*.

15. Th. H. Lunsingh Scheuleer, "Early Dutch Cabinets of Curiosities," in Impey and MacGregor, eds., *Origins of Museums*.

16. Sellers, *Mr. Peale's Museum*, 202.

17. International Eugenics Conference, "Part II. The Exhibit," *A Decade of Progress in Eugenics: Scientific Papers of the Third International Congress of Eugenics Held at the American Museum of Natural History, August 21–23, 1932* (Baltimore: Williams and Wilkins, 1934).

18. On things, their collection, classification, exchange, transvaluation, and social life, see Arjun Appadurai, ed., *The Social Life of Things: Commodities in Cultural Perspective* (Cambridge: Cambridge University Press, 1986); Jean Baudrillard, *For a Critique of the Political Economy of the Sign,* trans. Charles Levin (St. Louis: Telos, 1981); Pierre Bourdieu, *Distinction: A Social Critique of the Judgement of Taste,* trans. Richard Nice (Cambridge, Mass.: Harvard University Press, 1984); James Clifford, "On Collecting Art and Culture," in *The Predicament of Culture: Twentieth-Century Ethnography, Literature, and Art* (Cambridge, Mass.: Harvard University Press, 1988); and Mihaly Csikszentmihalyi and Eugene Rochberg-Halton, *The Meaning of Things: Domestic Symbols and the Self* (Cambridge: Cambridge University Press, 1981).

19. Eric Cochrane, *Historians and Historiography in the Italian Renaissance* (Chicago: University of Chicago Press, 1981), 426.

20. Cyrus Adler, *I Have Considered the Days* (Philadelphia: Jewish Publication Society of America, 1941), 69.

21. George Brown Goode, "The Museums of the Future," *Annual Report of the Board of Regents of the Smithsonian Institution for the Year Ending June 30, 1889; Report of the National Museum* (Washington, D.C.: Government Printing Office, 1891), 433. Goode delivered this lecture before the Brooklyn Institute on 28 February 1889.

22. Goode, "Museums of the Future," 427.

23. Cyrus Adler, "Museum Collections to Illustrate Religious History and Ceremonials," in U.S. Congress, House of Representatives, *Miscellaneous Documents,* 53d Cong., 2d sess., 1893–94, vol. 30, 759. This paper was read at the International Congress of Anthropology at the World's Columbian Exposition in Chicago in 1893.

24. Goode, "Museums of the Future," 427.

25. The quotation is from Adler, *I Have Considered the Days,* 67; see also Goode, "Museums of the Future," 435.

26. Trevor Fawcett, in "Visual Facts and the Nineteenth-Century Art Lecture," *Art History* 6, no. 4 (1983), 442, contrasts the pedagogic mode of the illustrated medical and scientific demonstration lecture with the literary and rhetorical approach used by Sir Joshua Reynolds in his discourses on art to the Royal Academy, which were "purely verbal statements read aloud with a minimum of gesture or 'performance' " and without illustrations.

27. Goode, "Museums of the Future," 433. On the rise and decline of lecturing as a profession, see Donald M. Scott, "The Profession That Vanished: Public Lecturing in Mid-Nineteenth-Century America," in Gerald D. Geison, ed., *Professions and Professional Ideologies in America* (Chapel Hill: University of North Carolina Press, 1983).

28. Washington Matthews, "Sacred Objects of the Navajo Rites," in Helen Wheeler Bassett and Frederick Starr, eds., *The International Folk-Lore Congress of the World's Columbian Exposition* (Chicago: Charles H. Sergel, 1898), 227.

29. Anthropologists frequently "played Indian" as a way of demonstrating what was difficult to describe verbally: see, for example, Curtis M. Hinsley, *Savages and Scientists: The Smithsonian Institution and the Development of American Anthropology, 1846–1910* (Washington, D.C.: Smithsonian Institution Press, 1981), 105.

30. Neil Harris, *Humbug: The Art of P. T. Barnum* (Chicago: University of Chicago Press, 1981 [1973]), 79. According to Harris, "In place of intensive spiritual absorption, Barnum's exhibitions [which exemplify the operational aesthetic] concentrated on information and the problem of deception. Onlookers were relieved from the burden of coping with more abstract problems. Beauty, significance, spiritual values, could be bypassed in favor of seeing what was odd, or what worked, or was genuine."

31. Otis T. Mason, "The Natural History of Folklore," *Journal of American Folklore* 4, no. 13 (1891), 99.

32. Saartjie Baartman, who was exhibited in London in 1810 as the "Hottentot Venus," is a case in point. See Sander L. Gilman, "Black Bodies, White Bodies: Toward an Iconography of Female Sexuality in Late Nineteenth-Century Art, Medicine, and Literature," *Critical Inquiry* 12, no. 1 (1985).

33. See Scheuleer, "Early Dutch Cabinets of Curiosities."

34. Altick, *Shows of London,* 340–41.

35. Ibid., 285, 341.

36. The *Kleiderkammer,* which featured costumes from around the world, appeared in Germany as early as the sixteenth century. See Franz Adrian Dreier, "The *Kunstkammer* of the Hessian Landgraves in Kassel," in Impey and MacGregor, eds., *Origins of Museums,* 104–6.

37. Quoted in Sellers, *Mr. Peale's Museum,* 280–81.

38. See Mary C. Cowling, "The Artist as Anthropologist in Mid-Victorian England: Frith's *Derby Day,* the *Railway Station* and the New Science of Mankind," *Art History* 6, no. 4 (1983).

39. Coleman, *Mr. Peale's Museum,* 192–93.

40. Quoted in Altick, *Shows of London,* 496.

41. Quoted in Ira Jacknis, "Franz Boas and Exhibits: On the Limitations of the Museum Method of Anthropology," in Stocking, ed., *Objects and Others,* 102.

42. See Edward P. Alexander, "Arthur Hazelius and Skansen: The Open Air Museum," *Museum Masters, Their Museums, and Their Influence* (Nashville, Tenn.: American Association for State and Local History, 1983), and Mats Rehnberg, *The Nordiska Museet and Skansen: An Introduction to the History and Activities of a Famous Swedish Museum* (Stockholm: Nordiska Museet, 1957).

43. Steven Mullaney, "Strange Things, Gross Terms, Curious Customs: The Rehearsal of Cultures in the Late Renaissance," *Representations* 3 (Summer 1983), 45–48.

44. D. B. Quinn, "Virginians on the Thames," *Terra Incognita* 2 (1978).

45. See Altick, *Shows of London;* Carl Hagenbeck, *Von Tieren und Menschen: Erlebnisse und Erfahrungen* (Berlin: Vita Deutsches Verlagshaus, 1909); and Stefan Goldmann, "Zur Rezeption der Völkerausstellungen um 1900," in Hermann Pollig et al., eds., *Exotische Welten, Europäische Phantasien* (Stuttgart: Edition Cantz, 1987).

46. See Altick, *Shows of London,* 280.

47. See Stafford, *Voyage into Substance.*

48. Quoted by Altick, *Shows of London,* 248.

49. I take the notion of cultural performance from Milton Singer, "Search for a Great Tradition in Cultural Performances," *When a Great Tradition Modernizes: An Anthropological Approach to Indian Civilization* (New York: Praeger, 1972), 71.

50. Altick, *Shows of London,* 282.

51. Ibid., 273–75.

52. In his *Address to the Ethnological Society of London, delivered at the Annual Meeting on the 25th of May, 1855* (London: Ethnological Society of London, [1855]), 4, John Conolly noted "the benefits that might be expected from the immediate direction of the observation of the Fellows of the Ethnological Society to any such [new importations of natives of other regions to this metropolis] that may be brought to our shores; and particularly to those brought to this country for exhibition. These benefits would partly consist of the counteraction of fraud; and would be partly derived from the additional illustration of the science we cultivate; as well as from the attention that could scarcely fail to be given to such efforts in favor of defenceless and ignorant natives of uncivilized nations, as ought to be forgotten by the happier inhabitants of Christian countries."

53. Altick, *Shows of London*, 281.

54. Ibid.

55. Shelley, *British Museum*, 299–300.

56. The discussion of spectacle is indebted to John J. MacAloon, "Olympic Games and the Theory of Spectacle in Modern Societies," in John J. MacAloon, ed., *Rite, Drama, Festival, Spectacle: Rehearsals Toward a Theory of Cultural Performance* (Philadelphia: ISHI, 1984).

57. Dean MacCannell, *The Tourist: A New Theory of the Leisure Class* (New York: Schocken, 1976), 91–107. Following Erving Goffman's dramaturgical analyses of social interaction, MacCannell discusses these phenomena in terms of front and back regions.

58. See Alice Kaplan and Kristin Ross, eds., "Everyday Life," special issue of *Yale French Studies*, 73 (1987).

59. MacAloon, *Rite, Drama, Festival, Spectacle*, 244.

60. Such installations can be found today in New York City, where performance artists exploring the problematic boundaries between life and art present ordinary life activities for consideration as artistic statements. See *High Performance: A Quarterly Magazine for the New Arts Audience* for reports on this work.

61. Quoted by Altick, *Shows of London*, 281.

62. Ibid., 278.

63. Conolly, *Address*, 4.

64. Quoted by Altick, *Shows of London*, 286.

65. Ibid., 33.

66. Ralph W. Dexter, "Putnam's Problems Popularizing Anthropology," *American Scientist* 54, no. 3 (1966), 325.

67. Minnie D. Louis, "Mission-Work Among the Unenlightened Jews," in *Papers of the Jewish Women's Congress held at Chicago, September 4, 5, 6, and 7, 1893* (Philadelphia: Jewish Publication Society of America, 1894), 171–72. I would like to thank Shalom Goldman for making his copy of this volume available to me. Borioboola Gha appears in *Bleak House* as the far-away place where misguided philanthropists such as Mrs. Jellyby devote their energies to caring for the "natives," meanwhile neglecting the welfare of their own families and the poor in their midst.

68. See Christopher Herbert, "Rat Worship and Taboo in Mayhew's London," *Representations* 23 (Summer 1988).

69. E. S. Martin, "East Side Considerations," *Harper's New Monthly Magazine* 96 (May 1898), 855.

70. See Altick, *Shows of London*, 44–45; Henri F. Ellenberger, "The Mental Hospital and the Zoological Garden," in Joseph and Barrie Klaits, eds., *Animals and Man in Historical Perspective* (New York: Harper and Row, 1974); and Michel Foucault, *Madness and Civilization: A History of Insanity in the Age of Reason,* trans. Richard Howard (New York: Random House, 1965).

71. See, for example, William Brown Meloney, "Slumming in New York's Chinatown, A Glimpse into the Sordid Underworld of the Mott Street Quarter, where Elsie Sigel Formed Her Fatal Associations," *Munsey's Magazine* 41, no. 6 (Sept. 1909).

72. On the prospect, see Stafford, *Voyages into Substance,* 431–35. On the panorama as a discursive convention, see Mary Louise Pratt, "Conventions of Representation: Where Discourse and Ideology Meet," in Heidi Byrnes, ed., *Contemporary Perceptions of Language: Interdisciplinary Dimensions,* (Washington, D.C.: Georgetown University Press, 1982).

73. On the panoptic, see Michel Foucault, *Discipline and Punish: The Birth of the Prison,* trans. Alan Sheridan (New York: Pantheon, 1977).

74. Nancy L. Evans, *'By Our Houses You Will Know Us': A Tour of Homes at the Field Museum* (Chicago: David Adler Cultural Center, 1989), 3.

75. John Conolly, *The Ethnological Exhibitions of London, Read at a Meeting of the Ethnological Society* (London: J. Churchill, 1855).

76. See Robert O'Brien, *Hands Across the Water: The Story of the Polynesian Cultural Center* (Laie, Hawaii: Polynesian Cultural Center, 1983). This site deserves extended analysis. The Polynesian Cultural Center is an outgrowth of the earlier Mormon mission settlement and the Hawaii campus of Brigham Young University. The center features Mormon Polynesians and serves as "a

showcase for what the Mormon Church stands for." Here, in our own time, ethnographic performance serves "a Christian missionary effort of major magnitude" (p. 89).

77. Robert Meyer, Jr., *Festivals Europe* (New York: Ives Washburn, 1954), ix–x.

78. I discuss these tropes more fully in my article "Authenticity and Authority in the Representation of Culture: The Poetics and Politics of Tourist Production," in Ina-Maria Greverus, Konrad Köstlin, and Heinz Schilling, eds., "Kulturkonakt/Kulturkonflikt: Zur Erfahrung des Fremden," *Notizen* 28, no. 1 (Oct. 1988).

79. See Haraway, "Teddy Bear Patriarchy," 25.

80. See, for example, Allen H. Eaton, *Immigrant Gifts to American Life: Some Experiments in Appreciation of the Contributions of Our Foreign-Born Citizens to American Culture* (New York: Russell Sage Foundation, 1932).

81. "Festival of American Folklife: Presentation-Oriented Guidelines" (Office of Folklife Programs, Smithsonian Institution, Washington, D.C., 1975, photocopy), 20.

82. The festival is in its way a corollary to the habitat group, only here an event structure guides a performance, where in the habitat group, an arrested moment in an implied narrative structures a physical installation.

83. Richard Kurin, "Mela! An Indian Fair," *Festival of American Folklife Program Book* (Washington, D.C.: Smithsonian Institution, 1985), 70.

84. My impression of the Mela exhibition was very different from that of Richard Kurin, one of the exhibition's organizers (see his essay in Part 4). I was struck by the relative absence of the activities associated with selling that one would encounter at an Indian *mela*, while Richard Kurin—who had to deal with the Smithsonian's rules and regulations—feels selling was in fact a notable feature of the Smithsonian *mela*.

85. See Steve Snow, "Theater of the Pilgrims: Documentation and Analysis of a 'Living History' Performance at Plymouth, Massachusetts" (Ph.D. dissertation, New York University, 1987), and Richard Schechner, "Restoration of Behavior," in *Between Theater and Anthropology* (Philadelphia: University of Pennsylvania Press, 1985).

86. These problems arose in homeland exhibitions, too, but for different reasons, namely the preoccupation with citizenship. Diasporas were anomalous, though the Exposition of the Jews of Many Lands in Cincinnati in 1913 addressed the issue by representing the Jewish diaspora as a little world's fair of its own. I analyze this case at length in "From Cult to Culture: Jews on

Display at World's Fairs," *Plenary Papers: Proceedings of 4th Congress of SIEF (Société Internationale d'Ethnologie et de Folklore)* (Bergen, 1990).

87. See Kirshenblatt-Gimblett, "Authenticity and Authority."

88. "Festival of American Folklife: Presentation-Oriented Guidelines," 22.

89. I have in mind sociolinguistics and the ethnography of communication, particularly the pioneering work of Dell Hymes and William Labov, and performance approaches to expressive behavior more generally—verbal art, ritual, and music—as seen in the work of Richard Bauman, Steven Feld, Richard Schechner, and others.

90. See Singer, "Search for a Great Tradition."

91. I have in mind the work of Max Gluckman and Victor Turner, among others.

92. See, for example, David Whisnant, *All That Is Native & Fine: The Politics of Culture in an American Region* (Chapel Hill: University of North Carolina Press, 1983).

93. See Barbara Kirshenblatt-Gimblett, "Mistaken Dichotomies," *Journal of American Folklore* 101, no. 400 (1988), an earlier discussion of the issues raised here, and Werner Sollors, *Beyond Ethnicity: Consent and Descent in American Culture* (New York: Oxford University Press, 1986).

94. Stuart Hall, "Notes on Deconstructing 'the Popular,' " in Raphael Samuel, ed., *People's History and Socialist Theory* (London: Routledge and Kegan Paul, 1981), 234.

95. Ibid., 237.

96. Ibid., 230.

97. Ibid., 234.

98. See Naima Prevots, *America Pageantry: A Movement for Art and Democracy* (Ann Arbor, Mich.: UMI Research Press, 1989).

CHAPTER 21

Refocusing or Reorientation? The Exhibit or the Populace: Zimbabwe on the Threshold

DAWSON MUNJERI

"Tonderai Kawisi of Katiyo village, Chief Nyajina, Murewa was crushed to death when the tunnel in which he was panning for gold collapsed on Thursday afternoon."[1] Thus ran a front-page article in a local weekly paper. The National Museums and Monuments of Zimbabwe should have been the principal respondent at an inquest arising from this incident. Had this occurred, the judge probably would have ruled, correctly, that National Museums and Monuments of Zimbabwe, a corporate body, was guilty of dereliction of duty. The *corpus delicti* would be that the deceased was not informed by an exhibition on ancient mining that was on display in the Bulawayo and Harare museums that the methods depicted in the exhibition were fraught with danger—a fact of which the respondent was aware. Fortunately or unfortunately, no one sued the Museums and Monuments parastatal—because neither the judiciary nor the would-be plaintiff was aware of the duties and responsibilities of museums.

That in essence typifies the position of museums vis-à-vis their publics both before and after 1980, the year of independence for Zimbabwe. It is a situation I wish to outline at length in this essay, for it is one that society no longer will tolerate. "What is it that museums are doing to be known by the majority of the population? What is it

that they are doing for the population?" These were direct questions asked of me by a Parliamentary Estimates Committee in December 1987. These were the same questions that the minister responsible for the parastatal was asked in Parliament.[2] Upon the answers to these questions hinge the level of activities and the future of the museum network in Zimbabwe. Like a sword of Damocles, the threat of a reduction or termination of public funds hangs over our heads—but at least the thread holding it there is still intact. The onus lies with the museum; the choice is plain, victory or demise. It is a situation similar to one prevailing in the 1960s and 1970s in Western Europe, when museums there voluntarily had to take a plunge in icy waters, the alternative being the possibility of being pushed in unceremoniously. The problems of Zimbabwe's museums, which are just now emerging from years of isolation resulting from the imposition of international sanctions following the white minority's 1965 unilateral declaration of independence, are compounded by years of foolhardy and myopic museum policies. The poetics and politics of the position of Zimbabwe's museums can never be understood fully unless the historical factors are comprehended. The historical factors also provide a historical perspective on the poetics and politics of representation.

As presently constituted, the Museums and Monuments parastatal is responsible for acquiring or establishing museums in the whole country; to date it runs six: Human Sciences (Harare), Mutare (in Mutare), Natural History (Bulawayo), The Military (Gweru), Great Zimbabwe (Masvingo), and Kwekwe Gold Mine Museums. Because of the geographical spread of the museums, the country is divided into five museological regions, with each museum (except Kwekwe) serving as headquarters of a region. The regions are also responsible for all monuments therein.

The present set-up is a culmination of a process that commenced in 1899 when "a group of men met to consider the formation of a society for the investigation of both natural and human sciences" and built up a collection to which the public later added on.[3] The situation can be described best as typically European, given that almost without exception, European museums began as collections. In this instance, the patron, the Chamber of Mines, insisted on a geological bias until 1910, when the country's administering authority, the British South Africa Company (itself a commercial concern) and the City of Bulawayo made it the Rhodesia Museum. In 1932, two commissioners from the Museums Association of Great Britain, sponsored by the

Carnegie Corporation, arrived in Zimbabwe to look into the setting-up of a national museum. They defined its role as the collection and storage of objects of cultural and *educational value,* along with rendering those objects accessible to the general public, those *seeking instruction, advanced* students, and investigators. The point was to aid the *educational service* of the territory in which the museum was situated.[4] On the basis of these recommendations the Bulawayo Museum became the National Museum in 1936; the other museums were either created or incorporated later. The recommendations of the Carnegie Commission became our charter. The key elements of this charter were products of the colonial era; characteristics of the system were an obsession to serve the white minority (blanketly referred to as "European") and the inculcation in the black of a feeling of inferiority.

Until the 1950s, Africans were not included in visitor statistics and were actively discouraged from patronizing the museums. Typical reports of the institution read, "The admission of natives is now limited to one day a week, the number amounting to well over 150 on each of these days."[5] The advent in the 1950s of the notion of "partnership," under which all races were supposed to march in unison for the good of the Federation of Rhodesia and Nyasaland, was not matched by a partnership spirit in the country's museums. With alarm, the director of the museums noted an increase in African visitors, who in 1959 numbered 160,000, in contrast to the white attendance figure of 40,000: "I cannot deny this popularity [of the museums] is a great embarrassment," he reported.[6] If one of the roles of museums is to promote cross-cultural awareness with a view to improving human relations, then the country's network was doing the very opposite. But in any case, the charter had not been designed to improve those relations, because the "native" was not considered a human being. The Rhodesia National Affairs Association, a body that was supposed to be "enlightened," had on its program of lectures in February 1947 a talk by Sir Garfield Todd, "The Native as Human Being"!

By discouraging Africans from patronizing museums, policy makers were playing a political game. National policy discouraged the education of "natives" lest they eventually equate themselves with the whites. The Carnegie Commission had stressed the educational role of the National Museum, but what the African could not obtain from the classroom he or she certainly would not obtain from the museum. Ironically, the African had realized the educational role of museums and had begun to frequent them. In the early 1950s there was a large increase in the number of school classes visiting the museum, but if

African students insisted on coming, there was the possibility of shunning them and ensuring that they had as little knowledge upon leaving the museum as they had had prior to the visit. "European school children were given lectures on specific subjects by Museum Staff members," while "African teacher classes and Mission Schools . . . were conducted by their own teachers . . . on days reserved for African visitors."[7] Again, whereas one of the goals of museums should be to counter an educational imbalance that rewards those who already have the largest share of resources—to the detriment of the majority, which may not have the same access to formal education—the museum network in Rhodesia was doing the very opposite: enhancing the inequality of cultural opportunity and serving an elite minority. When at ten o'clock on 11 November 1965 Ian Smith, the prime minister of Rhodesia, signed the Declaration of Independence, launching the country into the wilderness, the country's museum network did likewise and consolidated its anti-black stance.

The whole approach had serious implications for collections, preservation, research, and exhibition policies. Initially the collections were essentially geological, the primary aim being to serve prospectors, who by comparing their samples with museum specimens would ascertain whether or not their samples were of commercial value. In time other items, albeit those that fit with the scientific bias, began to be collected with the aim of increasing the reputation of the museum as a scientific institution, concentrating on research and education.

In 1952 the chairman of the museum boldly asserted that "the functions of the museums are not generally understood and too often interpreted as being limited to the exhibition of material in their public galleries. The vital part which they play in research *which is their prime function* does not come to the public."[8] One can, of course, sense in this a deliberate withdrawal from the public, which was becoming increasingly African. It would have been dangerous if Africans saw their cultural heritage, for it was one that they could be proud of: "the people of Zimbabwe had developed technology appropriate for the manufacture of tools, implements, weapons, vessels, musical instruments and ornaments of all kinds which demonstrate ingenuity and originality, a sophisticated understanding of the natural environment and above all, a quality of life in which cultural values were fully-appreciated. They developed a fine sense of aesthetic understanding."[9] Keep that out of museums!

From the outset the so-called ethnographers/anthropologists associated with the museum, none of whom had any training in the

disciplines (except Elizabeth Goodall), preferred collecting items of nonindigenous origin. Immense collections were brought in from as far away as the Tripolitania, Caspian, and Aterian cultures. Pride of place was given to the Godlonton collection from what was then Northern Rhodesia (now Zambia), for the collection included nine chief's ceremonial staves or emblems, taken when the stronghold of Chief Kazembe was stormed by the British South African Army in 1899. Such objects were taken to represent proof of white supremacy. Not only was the collection of ethnographic objects left to white "ethnographers," but these collectors even avoided dealing with Africans, choosing instead to rely on white farmers, missionaries, miners, and traders to do that for them. Up to 1980, lists reveal the donors to have been mostly whites, with a typical ethnographer's report reading, "A collection of 62 palaeolithic stone implements, chiefly large hand-axes, from Mooifontein, Transvaal [South Africa] and presented by Mr. S. Fraser is the most important accession received this year."[10]

Where the ethnographers chose to collect indigenous artifacts it was either because they dealt with subjects such as "witchcraft," implying that Africans were backward and superstitious, or because the objects reinforced the subjugation of Africans. How else can one read the acquisition in 1966 of "a drum from Goromonzi [near Harare] said to have been used at the lamentations for the death of Queen Victoria"? The drum in Zimbabwe has a long history and comes in shapes and sizes as varied as its functions; the drum plays a central role in the social and religious life of Zimbabwe, where it is used at virtually any gathering. In the case of the Goromonzi drum, its importance lay not in its cultural context, but in its dubious connection with Queen Victoria of Great Britain. The drum, like "Zimbabwean music as a whole, suffered a decline during the dark days of the Colonial era. In keeping with the attitudes of the time 'Native' musical instruments were regarded as primitive, crude or simple, not being able to produce music as a pure and aesthetic art form."[11] The example of the drum also emphasizes the fact that there is indeed an "imperialist culture," as Said puts it.[12]

Because the artifacts were being collected by third parties, there was no relationship among the collecting museum, the ethnographer, and the object, because interposed between the ethnographer and the object was a farmer, a missionary, etc. Needless to say, the original environment of the object, let alone the social context, was of no concern to the museum. The result was often that a culture was reduced to an artifact—but was that not the supreme aim of cultural

imperialism? This sad state of affairs was reinforced between 1979 and 1981, when a policy of centralization of research collections was adopted. This exercise—conceived in Rhodesia and born in Zimbabwe—was the last kick of a dying horse, as a tide of African rule was approaching. The kick was lethal to the human sciences in a number of museums; that, of course, was in keeping with the demonstrated tradition. Under centralization, museums could have only collections relevant to their designated role (except for a few display artifacts). Thus, carted away from all other museums were cultural objects whose final resting place was the Harare Human Sciences Museum; similarly, all natural-science objects were placed in Bulawayo. The argument was that this was the best means of facilitating research; also, there were some cost benefits. As P. J. Ucko points out, the policy made (and continues to make) little sense: "to gather all archaeological material in Salisbury [Harare] is to divorce the cultural material from its cultural and environmental context—[in any case] any archaeologist worth his salt would insist on seeing the site from which the material under study was derived."[13]

Because each museum could hold in storage only those artifacts directly related to its field of research specialization, donations from the public dwindled, because the final resting place of an artifact was determined not by what the donor wanted but by what category the artifact was assigned to. Donors normally have a sentimental attachment to a particular museum, and often require easy access to their donations. The human considerations were judged irrelevant, and so the problem hit ethnographic and artistic artifacts especially hard.[14]

As if that were not enough, cultural colonialism transformed itself into cultural vandalism. Preservation, that sacrosanct role of museums, was denied to the ethnographic collections. The Acting Honorary Keeper of Ethnography, Elizabeth Goodall, mourned that "the collections remain stored in former Royal Air Force premises at Cranborne, three miles out of town and in a basement kindly loaned for that purpose by the City Council. Any visitor with special interest in, for example, Stone Age material, had to be brought to these temporary storage rooms to see some of the specimens."[15]

The self-declared mission of research was not extended to the ethnographic and anthropological field because it was assumed that there was nothing to be learned from indigenous cultures. As an oral historian at the National Archives, a sister cultural institution, put it, "Discussions with those involved in Oral History work with tribal Africans and in particular, a very *fruitful* discussion with the District

Commissioner for Hartley showed that, despite several requests it would not be wise for the Historian to attempt to interview any African except those with an urban background and a good command of English."[16]

For many years—until 1977—no traditions were collected or researched at the National Archives. In the museum network, perhaps the record for serving longest as acting keeper would go to Elizabeth Goodall, the only veritable ethnographer of the colonial period. Research in that field was simply anathema.

The centralization of 1979–81 had equally disastrous effects on research and on collections. The raison d'être of centralization was the establishment of ludicrous "centers of learning." The dictates of the natural sciences and a xenophobia about indigenous cultures led to the eradication in one fell swoop of research on ethnographic and anthropological topics in Bulawayo, Mutare, and Masvingo. By some strange criterion, cultural material of white origin was first classified as historical and then as antiquarian, thereby finding its way to Mutare Museum, where in the words of P. J. Ucko, it would be proper to set up a white-culture house! The motive is clear: no African cultural object was to be accommodated or approximated to items of "European" origin or usage. That was cultural apartheid.

It was against all this background that Ucko, who had been commissioned in 1980 by the postindependence government to look into the state of museums, reported that the country's ethnographic collections were poor. To compound this, in line with the Rhodesian government's policy, there was no training available for ethnographers or anthropologists until 1983. In fact, the first black university graduate in any discipline was in 1978; by 1983 there were only two African curators out of a total of sixteen. If the orientation, quality, and quantity of research is dependent on the curators, the conclusion to be drawn from these statistics is obvious—of that, more anon.

Commenting on his visit to some of the museums, Ucko noted that the captioning for the human-sciences displays in Salisbury was out of date, uninformative, and in places offensive. In the Mutare museum, captioning was also offensive and uninformative, and standardization of spellings of the names of ethnic and cultural areas, both within a single museum and between one museum and the others, was lacking.

It would have been strange if the exhibitions had not supported these conclusions; after all, any exhibition is affected by the sum total of a museum's collection, preservation, and research policies and prac-

tices. As such, the exhibitions of the country's museum network were inadequate in the field of human sciences. Because they had been collected in a void, using third parties, they lacked the vital element of cultural context. As such, no one was able to demonstrate the artifacts' relationships to one another and to the human beings for whom they once had utility, aesthetic value, and meaning. A typical ethnographic exhibition staged in 1960 displayed a model "witch doctor" dressed in animal skins, wearing traditional ornaments, and surrounded by various "witchcraft" accessories. The subject— "witchcraft"—in itself indicates the contemptuous approach to traditional healers and their crafts. While this may have been a sin of commission on the part of the ethnographer, worse were the sins of omission committed by the museums when it came to ethnographic exhibitions. For one reason or another there was simply no space to display the cultural material. The statement "There are several specimens resting in the storeroom which cannot be exhibited at present on account of lack of space" typifies a situation prevalent in the museum world—but the simultaneous purchase of an expensive forty-drawer cabinet for the storage of *Orthoptera*[17] raises questions of priorities. Elizabeth Goodall found the position very frustrating in the late 1950s and 1960s. Her statement amply illustrates what the official exhibitions policy for ethnographic material was.

> It is very unfortunate that there is practically no space to display the Ethnography of the country as the part of the Museum formerly used for the purpose of displaying ethnographical and archaeological material had to be converted in order to make more room for the *Historic Exhibitions*; the inability to exhibit more of the life and arts of the indigenous people of the country is much regretted and regarded by the keeper of this section as a serious drawback.[18]

Is this not cultural sabotage?

In the same report, the Display and Technical Officer was proud of setting up in the stead of the ethnographic exhibition a historical exhibition dealing with white settlers and their achievements. The aim of the exhibition was to stimulate interest in that type of material. In time the whole ethnography/anthropology department was replaced by a history department that collected items such as military clothing, medals, Rhodes cups, coins, etc. It had on display early Rhodesian stamps, hand- and treadle-powered sewing machines, pioneers' handguns (British and American), and embroidery and costumes dating

from 1795 to 1900. That was history! In this view, Africans had no history.

In short, the Africans who had, under adverse circumstances, acquired a museumgoing tradition were compelled to look at exhibitions portraying white culture. Museums used this as a tool to dehumanize Africans and force them to accept white domination. As early as 1933 the ethnography department featured a display to mark the fortieth anniversary of the occupation of Matabeleland; thirteen years later was the celebrated Central African Rhodes Centenary Exhibition marking the achievements of the architect of colonialism, Cecil John Rhodes.

The pace of change in museum policy was accelerated after the 1965 declaration of independence, and with the outbreak of the war of liberation, museums took a militaristic stance on the side of the oppressor. In 1977 the Mutare museum put on a permanent exhibition entitled Rhodesians at War that was designed to give the viewer an idea of the role Rhodesians of all races played in major conflicts, beginning with earliest white settlement and extending through what was referred to as the "anti-terrorist campaign" ("terrorists" were the liberation forces). There was also an array of so-called communist weaponry allegedly used in an unprovoked attack on Mutare from Mozambique. The fact that white museum personnel, directors downward, were in active military service through the call-up system may explain this militaristic tendency and may also explain why they thought the attack on Mutare was unprovoked; in their minds, the Africans had not been provoked. In a recent publication a Zimbabwean author says,

> Imperialists and colonialists use various ways and means for keeping people in bondage:
> (a) They use naked force to subjugate people. . . .
> (b) To perpetuate such a state of oppression and exploitation, they develop institutions of coercion (e.g. colonial judiciary system).
> (c) They deliberately enter into acts of cultural vandalism aimed at defiling and where possible, obliterating the cultural heritage of the oppressed. Languages, crafts, customs and the music of the indigenous are all denigrated.
> (d) They encourage the teaching of false history to children of the oppressed. . . .
> (e) Psychological warfare is relentlessly waged on the minds of both young and old oppressed peoples. . . . The intense and all-

embracing manner in which this war is waged leads to a high incidence of an inferiority complex among the oppressed people.[19]

All five elements were applied by the museum network from the time of its inception through mid-1983. Indeed, some people succumbed to this prolonged warfare. The story is told of a white lecturer who used to leave his private collection of Zimbabwean material culture in the classroom in order to interest his black student teachers. The students were embarrassed by the objects and showed no interest in them as evidence of worthwhile cultural activities. This might sound like a victory for the museums of Rhodesia, but it was a hollow victory. In spite of the onslaught, the bulk of the black population withstood the warfare. In the main, cultures were not abandoned; they simply went dormant, only to resurface at independence. The lecturer mentioned above was surprised to find that after independence everything had changed so much that he no longer dared to leave his collection on public display.[20] As Ucko discovered, the repression of cultural activities by previous régimes had been made remarkably unsuccessful.

Ironically, in all this the greatest sufferers were not the Africans, who were exposed to Eurocentric exhibitions from which they learned the ways of their conquerors, but were not moved by them. The real sufferers were the white people who were denied the opportunity of learning about the real life and culture of their black counterparts. This is the worst damage inflicted by the museum network on the whites, whom it purported to serve. In 1897, following the first *chimurenga* (national war of liberation), an administrator remarked, "We had underrated the Mashonas. We knew nothing of their past history, who they were or where they came from. . . . We were inclined to look down on them as a downtrodden race who were very grateful to the White man for protection."[21] History repeats itself because the first time no one was listening: so wrote the historian A. J. P. Taylor. Nowhere is this more amply demonstrated than in what was then Rhodesia. Seventy-five years later, on 21 December 1972, the Rhodesian prime minister was saying, "I have been taken to task in certain quarters for describing our Africans as the happiest in the world but nobody has yet been able to tell me where there are Africans who are happier than in Rhodesia." A few hours later came the guerrilla attack that launched the country into an eight-year bloodbath, leading to African majority rule.[22] There would have been no surprises for the

whites if cultural institutions had done their part, as indeed they ought to have, in their self-declared role as providers of education and information. In their collections and in their galleries, cultural institutions have been aptly described as the central artery of communication; there should have been an emphasis on the truth about the country and all its peoples. Part of that truth was that the country was multiracial and its cultural wealth lay in the diversity of cultures, none of which was inferior to the others; together, these people would mold a progressive nation. Alas! that message was not to come from the galleries but from a politician who had been portrayed as a demon— this was none other than Robert Mugabe.

In a nation gripped with the spirit of revenge, on one hand, and fear, on the other, the first black prime minister of Zimbabwe declared to an unbelieving world, "Reconciliation!" To the world at large the word was interpreted in political terms, but in practice—and in the mind of the originator of the philosophy—it meant the reconciliation of the political, economic, social, and cultural identities of Zimbabwe. Professor Ucko heard someone openly declare that the whole service should be disbanded on the grounds that museums were a European concept. Fortunately, reconciliation meant there would be no cry like "To the Bastille!" Instead there was to be a relationship between different cultures, a relationship based on reciprocity and mutual respect; a relationship between the artifact and the environment; between the natural sciences and the human sciences; and among the past, the present, and the future.

All this has entailed a reassessment of the goals and objectives of the museums of Zimbabwe. The demand for museum services among the majority population is unequivocal and the museum is an accepted institution even though historically it has failed to deliver the goods. The traditional museum roles of collection, preservation, research, and exhibition have barely been addressed. But these have to be reconciled with other societal requirements, particularly those related to post–liberation war developments: an example is the postindependence renaissance in traditional art observed by Dewey.[24] This reconciliation not only recognizes the role that museums can play in the promotion and preservation of our cultural heritage, but also museums' positive contribution to economic development and nation building. The challenge of the present is therefore to play the traditional role, which no other agency of society can fill (and which was left to museums by default), and at the same time to address social issues. Our strategy entails expanding the base of the traditional role to cover

broader subject areas and to take in social and cultural issues. That is reconciliation on the museum front. The strides taken so far are immense, but so are the obstacles still remaining. The struggle continues—but victory is certain.

NOTES

1. *Sunday Mail,* 18 June 1988, 1.

2. This was Vote 27 in 1987.

3. C. K. Cooke, "The History of Museums in Bulawayo, 1902–1985," *Heritage of Zimbabwe* 6 (1986).

4. R. Smithers, "The National Museums and Monuments of Rhodesia," *Rhodesia Science News* 7 (1973), 275 (emphasis added).

5. *Rhodesian Museums Annual Report,* 1925, 5.

6. *Report of the Trustees and Director of the National Museums of Southern Rhodesia,* 1953, 5.

7. Ibid.

8. Ibid. (emphasis added).

9. H. Ellert, *The Material Culture of Zimbabwe* (Harare: Longman and Sam Gozo, 1984), 1.

10. *Rhodesian Museums Annual Report,* 5.

11. Ellert, *Material Culture of Zimbabwe,* 77.

12. E. W. Said, "Seeing through the Story," *Times Literary Supplement,* 12 October 1984, 1149.

13. P. J. Ucko, "A Proposal to Initiate Culture Houses in Zimbabwe" (Southampton, England: Southampton University, 1981, photocopy), 8.

14. O. D. Simela, "Accommodating the Cultural Dimension within the Natural History Museums in an Effort to Broaden the Base of Museum Service" (paper presented at the 1988 SADCC Museum Conference in Livingstone).

15. *Report of the Trustees and Director of the National Museums of Southern Rhodesia,* 1958, 20.

16. Historian's report, 1969. National Archives of Rhodesia, H2/1.

17. *Rhodesian Museums Annual Report,* 6.

18. *Report of the Trustees and Director of the National Museums of Southern Rhodesia*, 1957, 24 (emphasis added).

19. A.J.D. Patsanza, *Our Zimbabwe: An Element of Political Economy* (Harare: Govazvimwe Mukuruwenzira, 1988).

20. Ucko, "A Proposal to Initiate Culture Houses," 100.

21. Reminiscences of "Wiri" Edwards, National Archives of Rhodesia, ED 6/1/1.

22. D. Martin and P. Johnson, *The Struggle for Zimbabwe* (London: Faber and Faber, 1981), 1.

23. W. J. Dewey, "Shona Male and Female Artistry," *African Arts* 19, no. 3 (1986), 65.

24. A. Hancocks, "A Museum Exhibition as a Tool for Social Awareness," *Curator* 30, no. 3 (1987), 184.

CHAPTER 22

How Misleading Does
an Ethnographical
Museum Have to Be?

KENNETH HUDSON

n my 1987 book *Museums of Influence* I
tried to discover which museums in the
world had been the real pioneers during
the past two hundred years, which ones
had changed the direction in which museums were going. These are
my museums of influence, and I found thirty-seven of them. Six are in
the United States. I should perhaps emphasize that the book is not
necessarily about great museums or important museums or prestigious
museums. It is about museums of influence, true pioneers, and some of
them have been of very modest size, at least during the period when
their yeast was leavening the museum dough.

 In the preface to that book I wrote:

One feature is particularly likely to meet with surprise and possibly
criticism. No ethnographical museum as such will be found among
the thirty-seven, although many of them have gone to great pains to
reflect the crafts and customs of mankind. The Museum of Popular
Arts and Traditions in Paris, for example, is by any definition a
distinguished and highly successful ethnographical museum. The
omission and the apparent paradox are easily explained. The mu-
seum world contains a great many collections of the kind which is
generally referred to as 'ethnographical', that is, consisting of objects
relating to exotic cultures. Some of these are very large and therefore,
in professional museum jargon, 'important', but none that I have yet

seen or heard of contrives to communicate the essential features of the societies with which the museum or the collection is concerned, in a way that many films, television programmes or even lectures have contrived to do. Visually, these displays are often extremely attractive but, with very rare exceptions, they present the surface of a society. The picture they offer leaves too much to the imagination. The ambitions, the fears, the poverty, the disease, the climate, the cruelty and brutality, the satisfactions and the sufferings of these people are not there to give blood, sense and cohesion to the exhibits. In some ways, the situation is worse than it was fifty or even seventy years ago, because nowadays it is almost taboo to tell the truth about what are euphemistically called 'the developing countries', or even to hint that important parts of reality are not for discussion. Ethnographical museums may collect widely, but they do not dig deeply. The political consequences of doing so would be too serious, or so it is felt.

* * *

Meanwhile there are many technically excellent, but anaemic ethnographical displays. As three-dimensional pictures, what can be seen at, for example, the Museum of Mankind in London, the Übersee Museum in Bremen and the Tropenmuseum in Amsterdam mark a considerable advance on what was available half a century ago and, in pre-television days, they would undoubtedly have stirred the imagination of thousands of people. But I have found it impossible to say that any one of them has 'influenced' others to any marked extent. They have occurred together, which is another way of saying that social tastes and pressures have brought them together.

* * *

I think it is quite possible that the day of the ethnographical museum has already gone, and that, in the years ahead, the habits of man will be presented within a total environmental context, in much the same way as one of our chosen thirty-seven, the Noorder Dierenpark at Emmen, is already doing.[1]

That, so to speak, is the text—and now for the sermon. One has to recognize, I suppose, that there is still considerable difference of opinion as to what any museum is really for. Is it primarily didactic, existing in order to reach and convey information to the audience? Or is its main purpose to change attitudes, perhaps to crusade on behalf of a cause? Is it there in the first place to collect, conserve, and study objects, and only incidentally to display its possessions to the public? Does it see its exhibitions as the icing on the cake, a necessary nuisance, a smokescreen behind which scholars can follow their own specialist pursuits—a license to exist?

How one answers these questions depends to a great extent, of course, on who one is. The interests of the people who work in museums are by no means necessarily the same as those of their visitors, and different visitors have different needs and demands. Generalizations are extremely dangerous and in the last resort one can speak with reasonable certainty only about oneself, which is what I propose to do, hoping that there may be others who think and feel as I do. A great deal of nonsense is produced by refusing to speak in the first person. What one gets out of a museum depends largely on what one brings to it. The best of market research can be nothing more than an approximation for this reason.

It is also good to remember that many—perhaps most—of our fellow citizens do not have questioning minds. They feel comfortable with received ideas and they are not grateful to have those ideas disturbed or demolished. Whether the subject is Russia or railways, banking or Brazil, their minds are conditioned by the information that has reached them as they have grown up and they are likely to resist any attempt to induce them to think differently. Personal experience may or may not affect the situation. It is easy and natural to think badly of Italians after one has been struck down with food poisoning during a visit to Italy or of Mexicans after an encounter with a swindling taxi driver. Travel may well intensify old prejudices or create new ones. It does not necessarily broaden the mind.

One is, however, entitled to expect that the person responsible for an ethnographical museum or exhibition will have a wider, deeper, and better-balanced knowledge of particular peoples and cultures than one is likely to possess oneself. I have on occasion wondered if this is always the case. A number of the specialists who have come my way have appeared to me to be very knowledgeable about what is usually described as the "traditional culture" of this or that people, but to be much less well informed about what is going on in the same country today. Is it reasonable to expect that they should be, any more than one should reckon that an expert in the civilization of ancient Rome must be equally well briefed about what is going on in Italy today? There is, I think, a world of difference between the two cases. Nobody in their right mind believes that modern Italians behave like Romans in the time of Caesar and Cicero, but a great many people have the impression, if not the conviction, that the habits and customs of people in, say, Ghana today are very similar in many respects to what one would have found in the same area a hundred years ago. They are encouraged to hold this view by what they see in museums, where the

collections and displays are overwhelmingly of the shield, spear, boo-
merang, and war-canoe type. In today's world, to emphasize "tradi-
tional culture" is not, in my view, a particularly responsible or con-
structive thing to do, however attractive it may be from the point of
view of showmanship.

To present a truthful balance in these matters is admittedly ex-
ceedingly difficult. How, for instance, is one to convey in museum
terms the extraordinary mixture of wealth and poverty, generosity and
wickedness, idealism and corruption, old and new, beautiful and hid-
eous that characterizes the society and environment of Bombay or
Accra today? Or the quality of life and aspirations of people in a
Chinese village? Or the effects of the racial mix in an English city such
as Bradford? Can the job be done by objects alone, however well
selected and imaginatively presented?

I was encouraged to think along these lines recently when I visited
an exhibition called Hunters of the North at the Museum of Mankind
in London. This was quite a big affair, aiming to show how the Eski-
mos of the Canadian North live today and, in particular, how the need
to earn a living in different ways has been affecting their style of living.
Within its limitations, it was well done. I did not have a feeling that
significant facts were being suppressed for political reasons, nor did I
believe that Canadian Eskimos visiting the exhibition would have
found their life as it was depicted unrecognizable or seriously dis-
torted. What I was shown struck me as having been planned and
organized by people who had had recent firsthand experience of Es-
kimo life and who understood the problems of those who had to wrest
a living from and survive under these harsh conditions. What then, did
I feel was missing? In what way was I being misled or being given an
incomplete picture?

My first criticism—and it may be considered unreasonable—is
that although my mind was being adequately fed, my senses were not.
In one part of the exhibition I was looking at a family installed more
or less traditionally inside a snow-house, an igloo, and in another at a
similar group of people in a portable hut equipped with most, if not
all, of what are considered to be modern conveniences. They were
eating and drinking roughly what other Canadians eat and drink,
amusing themselves in the same ways, using the same type of equip-
ment and furniture, and wearing the same clothes. All this I found
convincing but—and it is a big but—I longed to know what kind of
smell or blend of smells I should have found inside the igloo and how
this would have compared with what I would have smelled inside the

hut. Smells distinguish one culture and one country from another more thoroughly and effectively than any other characteristic (unfashionable as it may be to say this) but, with very rare exceptions, museums refuse to deal in smells. I remember an argument I once had with the director (now dead) of the American Museum in Bath on this subject. One room in this museum, which really should be called the New England Museum, is devoted to quilts displayed in bedroom settings, and another, in the basement, to a reconstruction of Conkey's Tavern, an authentic New England inn of the old type. I pointed out to the director that neither room smelled of anything at all; both were totally sterile and neutral, although in the nineteenth century, the period in question, the tavern would have smelled of stale beer and tobacco and the bedroom of a subtle mixture of mothballs, damp, and lavender bags. Why, I asked, did he not add these smells to the atmosphere—no difficult matter—and in this way carry us back immediately and unerringly into the past? He was an intellectual through and through, and he was horrified at the idea.

The problem is to know how much one can safely leave to the imagination in these matters. Can most people, or any, imagine what dried seal meat tastes or feels like, how cold it is in the Canadian north in winter, or how hot in the Valley of the Nile in summer? Can they reconstruct the correct level of sound in a West African marketplace or a Canadian hut? Can they imagine what wine tasted like in classical Greek times, how easy it was to see with a Roman lamp or cut wood with a medieval saw? Can people who live in a highly mechanized civilization feel their way back into that slow-moving, not-so-far-distant age when people carried heavy weights on their backs or shoulders for the whole working day and moved across country at no more than four or five miles an hour? Do museums appreciate how difficult it is for modern people to feel and think their way back into the past?

The senses are highly important in communication. Under normal conditions, that is, in our daily life, we make regular use of all five of them, but museums, like films and television, restrict us to only two, sight and to a lesser extent sound. The result is that both their approach and ours is overintellectualized. We are given no chance to feel, to taste, and to smell. This is what I meant when I said in *Museums of Influence* that ethnographical museums are anemic. They are at best two-sense places and often only one-sense, whereas we all know perfectly well that life is a five-sense affair.

Feeling is not, of course, merely a matter of touching. Temperature has a profound effect on our behavior. People in temperate coun-

tries understandably tend to have more energy than those in very hot or very cold regions. Religious practices are influenced by the climate, and so are eating habits. It is a curious fact that, although the weather in Greece and Egypt, as throughout the Mediterranean area, is very hot for much of the year, museum displays relating to the culture of these countries are housed in rooms where pains are taken to keep both the collections and the visitors cool. The forms of art and religion that flourish under brilliant sunshine and intense heat are not the same as those developed in cooler climates, and many of their characteristics are misinterpreted as a result. It is interesting to speculate what the result would be if the temperature in the Egyptian galleries in, say, the British Museum or the Louvre were to be kept at the figure that is normal in the regions where the objects were found, and the same is true, of course, of an ethnographic or anthropological museum. If we choose to put objects from one climate in front of people from another, we can hardly be surprised if misunderstanding occurs. We are able to do this, of course, because the objects do not usually complain. Horticulturalists are in quite a different situation. Tropical plants will grow only under tropical conditions, so that if we want to see them in Boston, Glasgow, or wherever we may be, we have to give them an artificial environment in heated greenhouses and people have to look at them under these conditions. Any idea that the plants should be kept at one temperature and their visitors at another would be regarded as absurd. Why should we treat artifacts any differently?

I believe that with our greatly increased ability to create artificial environments nowadays, the days of plants, living creatures (including humans), and inanimate objects being displayed separately are numbered. There is no reason at all, apart from conservatism and a fondness for empire building, why we should not be thinking in terms of climate museums and region museums, rather than of ethnographical museums, anthropological museums, natural-history museums, art museums, historical museums, and the rest of the outdated spectrum of absurdly specialized establishments. If such a museum, disciplined by a climate rather than by an academic subject, were already in being, it would without doubt earn itself an honored place among my museums of influence. The world is waiting for it. "Snow and penguins in India, palm trees and monkeys in Alaska" should be the motto of the next generation of museums.

In any case, how much more interesting and meaningful it would be to end this quite unnecessary and unreal division between the natural and the manmade and between humans and other living crea-

tures. Humans see themselves differently when they are brought out of their ridiculously godlike isolation and are forced to think of themselves as only one kind of natural and cultural object among many others.

To a certain extent, television is carrying out this revolution for us already. We are presented with whole regions on the screen, but we should not exaggerate the degree of completeness that we are offered. We get sights, we get sounds, and things move, but we taste nothing, smell nothing, and feel nothing, and while we are watching we are living in our own climate, not that of the place where the camera was at work. And, of course, we are unable to have conversations with the people we see. In the kind of climate-region exhibition I dream of, there would be real people, not captions or labels, employed and paid to interpret the exhibits and to answer questions, probably through a translator. These people would come and go and form a very valuable international corps of explainers. One would expect them, I imagine, to be biased in favor of their own country, and one would make the necessary allowances. The advantages of having them, however, would outweigh the disadvantages. They would bring a much-needed element of reality into the situation.

I doubt if it is ever going to be possible to present a foreign culture without some degree of bias or without considering the political consequences to some extent, but I cannot see that this should cause one's presentation to remain on the surface, to concentrate overmuch on the past, or to avoid attempting a total and truthful picture. I have heard the view expressed that urban cultures are more difficult to communicate than rural cultures, partly, I suppose, because the countryside and its people are considered to be a less complex form of society than the town. In some ways this may be true, but I do not feel that this justifies avoiding urban communities. To do so in the case of a backward country that is trying to become less backward seems to be particularly dangerous. I am depressed when I watch television reports of the visits of royalty, presidents, or other distinguished personages to African countries and see black people performing "tribal" dances in front of the guests from abroad. Why, I ask myself, is it felt necessary or desirable to put on these demonstrations of long-outmoded customs, which always feel to me like ethnographical museums brought to life? Whose fantasy world does it represent, that of the performers or that of their audience? I find it degrading and I wonder if the dancers and singers do, too.

The tourist industry demands that the past shall be kept alive

because it is what its customers expect to see, and the result is the perpetuation of bogus culture throughout the world. How many tourists, however, realize that it *is* bogus, that Zulus and Fijians and Maoris no longer behave like this left to themselves in their home territory and that to bribe them to do so is to indulge in romantic escapism of a patronizing and not particularly pleasant kind?

This, in fact, is my major criticism of ethnographical museums: that by their overconcentration on "traditional cultures," they encourage a patronizing and escapist attitude toward the people involved. What matters to Africans, South Americans, Eskimos, and everyone else struggling to exist in the modern world is to find ways of adapting to new technologies and of protecting themselves against constant attempts to exploit them. They do not enjoy being poor, however attractive certain aspects of that poverty may appear to tourists from richer parts of the world, and the main challenge facing ethnographical museums today is to discover ways of exporting the visual evidence of their struggle in a form that makes sense abroad.

NOTES

1. Kenneth Hudson, *Museums of Influence* (Cambridge: Cambridge University Press, 1987), vii.

Contributors

SVETLANA ALPERS is professor of the history of art at the University of California, Berkeley, and cochair of the journal *Representations*. Her books include *The Art of Describing: Dutch Art in the Seventeenth Century* and *Rembrandt's Enterprise: The Studio and the Market*.

RICHARD BAUMAN is professor of folklore and anthropology and chair of the Folklore Institute at Indiana University. His research interests include oral poetics, performance theory, and festival drama. His publications include *Verbal Art and Performance* and *Story, Performance, and Event: Contextual Studies of Oral Narrative*.

MICHAEL BAXANDALL has been assistant keeper of the Department of Architecture and Sculpture at the Victoria and Albert Museum and lecturer and professor of the history of the classical tradition at the Warburg Institute, University of London. Since 1986 he has been professor of the history of art at the University of California, Berkeley. His books include *The Limewood Sculptors of Renaissance Germany* and *Patterns of Intention*.

JOHN BEARDSLEY is currently a graduate student in art history at the University of Virginia. With Jane Livingston, he curated the exhibition Hispanic Art in the United States: Thirty Contemporary Painters and Sculptors.

JAMES A. BOON is professor of anthropology at Princeton University, where he also teaches European cultural studies. He has previously taught at Cornell University and Duke University. His publications include *Other Tribes, Other Scribes* and *Affinities and Extremes*.

JAMES CLIFFORD teaches in the History of Consciousness Program at the University of California, Santa Cruz. He has written extensively on the history of anthropology and on the literary construction of the exotic. His publications include *Writing Culture: The Poetics of Ethnography*, which he edited with George Marcus, and *The Predicament of Culture*.

SPENCER CREW is presently chair of the Department of Social and Cultural History at the National Museum of American History, and was the curator for the exhibition Field to Factory: Afro-American Migration, 1915–1940. He formerly was an assistant professor of African American and American history at the University of Maryland, Baltimore County. His publications in-

clude the exhibition book for Field to Factory and articles on museological theory and African American history.

CAROL DUNCAN is a professor of history at Ramapo College and the author of several influential articles on public culture and the social history of museums.

B. N. GOSWAMY is professor of art history and dean of university instruction at Panjab University, Chandigarh, and is currently chair of the Chandigarh Museum. He has held many visiting professorships and fellowships, and has authored many books and research papers. His current research interests include Indian painting, Indian aesthetics, and land grants of the Mughal and Sikh periods.

STEPHEN GREENBLATT is the Class of 1932 Professor of English at the University of California, Berkeley. His books include *Renaissance Self-Fashioning* and *Shakespearean Negotiations,* and he is a founding editor of the journal *Representations.*

ELAINE HEUMANN GURIAN is deputy director for public programs at the National Museum of the American Indian, Smithsonian Institution. Prior to coming to the Smithsonian, she was for sixteen years director of the Exhibits Center at the Boston Children's Museum. Her training is in art history, studio art, and art education.

CURTIS M. HINSLEY is chair of the Department of History at Northern Arizona University. His publications include *Savages and Scientists: The Smithsonian Institution and the Development of American Anthropology, 1846–1910* and (with Melissa Banta) *From Site to Sight: Anthropology, Photography and the Power of Imagery.* He is currently at work on studies of the Hemenway Southwestern Archaeological Expedition of 1886–89 and the Peabody Museum at Harvard University.

PATRICK T. HOULIHAN received a Ph. D. in anthropology from the University of Wisconsin. He has been director of the Heard Museum in Phoenix, the New York State Museum in Albany, and the Southwest Museum in Los Angeles. He is currently director of the Millicent Rogers Museum in Taos, New Mexico.

KENNETH HUDSON is the author of numerous publications, including *The Archaeology of Industry, Men and Women: Feminism and Antifeminism Today,* and *Air Travel: A Social History of Aviation.*

IVAN KARP is curator of African ethnology in the Department of Anthropology, National Museum of Natural History, Smithsonian Institution. For the past twenty years, he has conducted research among the Iteso of Kenya, and writes on social organization, social theory, social change, and systems of thought. He is an editor of the series Explorations in African Systems of

Thought, and has edited *Creativity of Power* and *Personhood and Agency*. Among his publications is *Fields of Change among the Iteso of Kenya*.

BARBARA KIRSHENBLATT-GIMBLETT is professor and chair of the Department of Performance Studies, Tisch School of the Arts, New York University, and a research associate at YIVO Institute for Jewish Research. She is currently president of the American Folklore Society. Her publications include *Fabric of Jewish Life: Textiles from the Jewish Museum Collection*, (with Lucjan Dobroszycki) *Image Before My Eyes: A Photographic History of Jewish Life in Poland, 1864–1939*, and *Speech Play: Research and Resources for Studying Linguistic Creativity*.

RICHARD KURIN is acting director of the Office of Folklife Programs at the Smithsonian Institution and professorial lecturer in social change and development at the Johns Hopkins University School of Advanced and International Studies. A cultural anthropologist, he received a Ph.D. from the University of Chicago, and specializes in the study of South Asian conceptual systems. His publications include works on agricultural development, folk religion, kinship, and cultural policy.

STEVEN D. LAVINE is president of the California Institute of the Arts, and previously was associate director for arts and humanities at the Rockfeller Foundation, where he was responsible for museums and media programs. A specialist in eighteenth-century English poetry and twentieth-century American fiction, his publications include *The Hopwood Anthology: Five Decades of American Poetry*.

JANE LIVINGSTON was formerly chief curator at the Corcoran Gallery of Art. In addition to the exhibition Hispanic Art in the United States: Thirty Contemporary Painters and Sculptors, which she curated with John Beardsley, she has curated numerous exhibitions devoted to twentieth-century art and photography.

PETER C. MARZIO is director of the Museum of Fine Arts, Houston, and has been chair of the Department of Cultural History at the Smithsonian Institution and director of the Corcoran Gallery of Art. He serves on numerous committees and boards, including those of the American Association of Museums and the American Museum Association. He is currently working on a book entitled *The History of Printmaking in America*.

DAWSON MUNJERI is associate director of the National Museums and Monuments of Zimbabwe. In addition to his museum responsibilities, he has conducted extensive research on the oral histories of the peoples of Zimbabwe.

PATRICIA SAWIN is a Ph.D. candidate in folklore at Indiana University. Her research interests include the politics of representation, women's performance, and the poetics of everyday interaction. The *Journal of Folklore Research*

recently published her article on the representation of women in Finland's national epic, the *Kalevala*. Her dissertation examines a North Carolina ballad singer's self-presentation through performance.

JAMES SIMS is currently the acting director of the Office of Museum Programs at the Smithsonian Institution and a member of the faculty in museum studies at George Washington University. He was previously senior designer at the National Museum of American History. Among the exhibitions he has designed are Field to Factory: Afro-American Migration, 1915–1940 and Men and Women: A History of Costume, Gender, and Power.

TED M. G. TANEN is American executive director of the Indo-U. S. Subcommission on Education and Culture. He has served as the American coordinator for the Festival of India and the Festival of Indonesia.

SUSAN VOGEL is an art historian specializing in African art. She has done extensive fieldwork on the Baule in Ivory Coast. She received her Ph.D. from the Institute of Fine Arts, became assistant curator at the Museum of Primitive Art, then served as associate curator at the Metropolitan Museum of Art for ten years, during which time she oversaw the installation of the African art collection in the Rockefeller Wing. Since 1984 she has been executive director of the Center for African Art. She has organized over twenty exhibitions, and has published and lectured widely on African art.

MASAO YAMAGUCHI is a social anthropologist at the Tokyo University of International Studies. He has conducted research in Nigeria, Indonesia, and the Caribbean. He is the author of numerous articles and books on topics including the study of symbolic classification; divine kingship; the theatrical aspects of Japanese culture; and Russian formalism.

TOMAS YBARRA-FRAUSTO is associate professor in the Department of Spanish and Portuguese at Stanford University. His current research interests include Latin American literary theory and Chicano visual art and culture. Currently on leave from Stanford, he is associate director for arts and humanities at the Rockfeller Foundation.